Her Own Story

Her Own Story

Autobiographical Portraits of Early Methodist Women

Edited by

Paul Wesley Chilcote

KINGSWOOD BOOKS
An Imprint of Abingdon Press
Nashville, Tennessee

HER OWN STORY
AUTOBIOGRAPHICAL PORTRAITS OF EARLY METHODIST WOMEN

Copyright © 2001 by Abingdon Press

This book is printed on acid-free paper.

Library of Congress Cataloging-in-Publication Data

Her own story: autobiographical portraits of early Methodist women / edited by Paul Wesley Chilcote.
 p. cm.
 Includes bibliographical references and index.
 ISBN 0-687-05210-6 (alk. paper)
 1. Methodist women—Great Britain—Biography. 2. Methodists—Great Britain—Biography. I. Chilcote, Paul Wesley, 1954–

BX8493 .H47 2001
287'.5'0922—dc21
[B]

2001038655

All scripture quotations except those embedded in other quoted material are taken from the *New Revised Standard Version of the Bible,* copyright 1989, Division of Christian Education of the National Council of the Churches of Christ in the United States of America. Used by permission. All rights reserved.

All scripture quotations in quoted material are from the King James or Authorized Version of the Bible.

The Bicentennial Edition of the Works of John Wesley. Volumes 7 and 19. Eds. Frank Baker and Richard P. Heitzenrater. Nashville: Abingdon Press, 1983 and 1990 respectively. Used by permission.

"A Covenant Prayer in the Wesleyan Tradition," from *The United Methodist Hymnal* (Nashville: The United Methodist Publishing House, 1989), 607. Used by permission.

All excerpts from the Methodist Archives are reproduced by courtesy of the Director and Librarian, the John Rylands University Library of Manchester.

The July 2, 1774 excerpt from Sarah Crosby's Letterbook appears courtesy of the Frank Baker Collection of Wesleyana and British Methodism, Rare Book, Manuscript, and Special Collections Library, Duke University.

01 02 03 04 05 06 07 08 09 10—10 9 8 7 6 5 4 3 2 1

MANUFACTURED IN THE UNITED STATES OF AMERICA

For Janet

Contents

Part Four
Self-Images in Letters

Preface

Loss of memory is a terrible thing. The preservation of memory is not only a treasure but also an absolute necessity, for we are all formed and transformed by the stories in which we live. Those who shape our memory, therefore, are entrusted with a critical responsibility. One of the most painful aspects of the history of the church is that much of the memory of women—stories about the lives, faith, and ministry of women—has been lost. Women, who have always represented the vast majority of the Christian community down through the ages, have not been permitted to have a voice and thereby shape our memory. This is a tragedy, and it must be rectified for our Christian family ever to be truly healthy. And what is true of the larger Christian family in general is equally true of the spiritual descendants of the Wesleys. Methodist women have a story to share that has not been heard or well remembered; they must be allowed to tell their story, and tell it in their own voice.

This has been my conviction for some time—a conviction grounded in the strong biblical precedent for reclaiming the voice of women in our heritage. The Judeo-Christian understanding of creation affirms the equality of men and women as God's children. The voice of women is heard throughout the biblical narrative—from Miriam to Mary Magdalene—in proclamation and praise of the One in whom our lives are rooted. God's new reign in our world, articulated most potently by Paul, affirms that in Christ "there is neither male nor female" (Gal. 3:28). The church itself is born at Pentecost with the outpouring of the Spirit, who gives a voice to every daughter and son of God. And yet, we have so little memory of the precious daughters of God through the ages very simply because they were women. At a time in the life of the church when the place and role of women is being rediscovered in many Christian communities, there are also strong forces of opposition. Powerful denominations refuse women a place in their pulpits and, as one of my colleagues in Methodist theological education has claimed, "women in ministry are a seriously endangered species."

The voice of women needs to be heard. The stories of the women who shaped the early Methodist movement need to be known. We are poorer for lack of this memory, and, I firmly believe, nothing less than the future of the church is at stake. As I have argued in previous works, listening to the voices of the women and knowing their stories is not simply a matter of adding an addendum to the historical report. When we truly take their lives seriously it changes our whole understanding of who we are and what we are called to become. I hope this prospect does not strike fear into anyone; rather, my prayer is that it will stir your blood and make you all the more excited to be a part of this exciting adventure.

The collecting of the women's writings in this volume has taken place over the course of more than a decade in many different libraries and repositories on both sides of the Atlantic. It would be a lengthy and hazardous task to attempt anything approaching a truly thorough acknowledgment of all who graciously assisted me along the way. To each and every one who provided assistance, hospitality, and support, I am grateful. A number of special recognitions, however, are in order.

Several institutions and agencies have been particularly helpful in my quest to recover the voice of early Methodist women. I express my appreciation, first and foremost, to the staff of the Methodist Archives and Research Centre, John Rylands University Library of Manchester, for their assistance in identifying and providing access to critical collections and documents over the years. Likewise, friends and colleagues at Drew University, Garrett-Evangelical Theological Seminary, Wesley College (Bristol), Westminster College (Oxford), and Duke University graciously opened their archives for my scrutiny and use. Particular thanks to Roger Loyd of Duke University Divinity School for his help in identifying elusive material. I am extremely grateful to the Methodist Theological School in Ohio for a sabbatical (1997) from teaching responsibilities which made the collection of much of this material possible. The General Commission on Archives and History of The United Methodist Church also supported that period of intensive exploration and research very generously through a grant for research in women's history.

My personal debts are profound. Frank and Nellie Baker really set me out on this quest although Frank was not able to see—in this life—the fruit from the seed he planted. I am increasingly aware of

10

my indebtedness to them both—dear friends of the early Methodist women that they have been. Roberta Bondi, Ken Rowe, and Jean Miller Schmidt read portions of the manuscript in its evolution and made important contributions to my thinking about it along the way. I am grateful for their honesty, insight, and support. Others who have encouraged my perseverance through both subtle and tenacious means, through both direct words and the silent witness of their own publication are Earl Kent Brown, Judy Craig, Donald Dayton, Dorothy Graham, Steve Harper, Dick Heitzenrater, Margaret Jones, Rosemary Skinner Keller, Tim Macquiban, Randy Maddox, Sondra Matthaei, Janine Metcalf, Mary Elizabeth Moore, John Newton, Amy Oden, Priscilla Pope-Levison, Susie Stanley, Karen Westerfield Tucker, John Vickers, Charlie Wallace, Laceye Warner, David Lowes Watson, Chuck Yrigoyen, a whole host of students, and Diane Lobody, with whom I have been privileged to share the art of teaching and to be shaped by Methodist history. A special word of thanks to members of the Charles Wesley Society for their assistance in identifying elusive references to Wesleyan hymnody in the women's writings. The annotation would not have been nearly as complete without the help of Oliver Beckerlegge, S T Kimbrough, John Lawson, and Professor Dick Watson, among others. Likewise, I am indebted to Craig Spiller, my student assistant, for helping me identify scriptural passages in part 4 of the volume. I have especially appreciated the support of my editors at Kingswood Books of Abingdon Press, Rex Matthews who responded with exuberance to my initial proposal, and Ulrike Guthrie who has patiently worked with me through the entire process.

My wife, Janet, and my five girls, Sandy, Rebekah, Anna, Mary, and Ruth, have had a lot of competition with other women over these years (and all of them were dead). They have lived with these early Methodist women as much as I have in many ways. Janet, in particular, has been my constant conversation partner and has helped me to develop a more comprehensive memory of these women. Her insights have always called me to a greater appreciation for the witness of women, both then and now. I cannot thank her and my family enough for their patience and guidance throughout, but I dedicate this volume to Janet because, without her, I could never have made it even this far on the journey.

To the women of early Methodism I simply say, thanks be to God for your lives and for your amazing witness to the eternal nature of

God's love. Your written words have not been forgotten. At least another generation will hear your stories—in your own words—as much as possible. May those who read your own record of your lives here find their own place within the larger story of God's work in human history with your help.

Paul Wesley Chilcote
Asbury Theological Seminary, Florida
September 1, 2000
Anniversary of Mary Fletcher's birth (1739)

Introduction

"Her legacy must never be forgotten!" My first thought after writing those closing words to *She Offered Them Christ* was very clear. There needs to be an anthology of early Methodist women's writings to parallel Albert C. Outler's collection of writings by John Wesley, the Methodist founder.[1] Too many of these amazing women have been forgotten, and the church is impoverished by this tragic loss of memory. In *John Wesley and the Women Preachers of Early Methodism*, I have demonstrated how women figured prominently as pioneers and leaders of the Wesleyan Revival. I even went so far as to say that "[t]he Methodist Societies were, for all intents and purposes, organizations of women."[2] The central purpose of this volume, therefore—I hope the first of several volumes—is to pick up where these previous studies of Methodist women have left off, allowing the woman of early Methodism to tell *Her Own Story*.

Women helped make the Wesleyan Revival of the eighteenth century one of the most dynamic Christian movements in the history of the church. The vitality and continuing significance of Methodism is due, in large measure, to their presence and influence. Contrary to the typical stereotypes, most of these women refused to remain submissively in the home. They carried their faith into the marketplace, often at great risk to themselves, as daring disciples who had been liberated by God's grace in Christ. But while women pioneered, promoted, and shaped Wesley's Methodism, their story has yet to be fully told. The resulting general ignorance concerning the writings of early Methodist women has left the impression that they have no story to tell. This anthology is meant to dispel that myth; more important, it is meant to put us in touch with a lost heritage that has the potential to transform the life of the church today.

This collection is, in fact, the first of its kind.[3] While it is neither exhaustive nor all inclusive, being composed only of letters, accounts of religious experiences, diaries, journals, and other miscellaneous prose,[4] the early Methodist women's writings assembled here provide a new vantage point from which to view the exciting renewal of

Christianity in the Wesleyan Revival. They reveal a way of devotion (*via devotio*), a way of living out the Christian faith that conjoins personal piety and social action, conversion and growth in grace. They reflect an age of spiritual discovery with bursts of insight and stories that inspire and challenge. But all of this is part of a much larger story, and these writings can only be understood within the broader contexts of spiritual autobiography as an important religious genre, the liberating ethos of Wesleyanism, the gracious presence of the women themselves, and the purpose of their writings.

The Autobiographical Portrait

All Christian faith is autobiographical.[5] If the liberating experience of God in Christ is to be truly vital, it must always be "enpersonalized."[6] Whenever the Christian faith becomes *my* faith, there lies behind that transformation a story that begs to be told. Since this view of Christianity stands at the very heart of the Wesleyan spirit, it is no surprise that early Methodist women (and men) produced more "spiritual autobiography" than any other religious community in—and perhaps since—their time.[7] This is not to suggest that they invented the genre. Saint Augustine's *Confessions*, written shortly after A.D. 400, is generally accounted as the first spiritual autobiography in Christian history. While *Confessions* is unique in terms of its depth of insight and spiritual vitality, others followed in due course. Christian autobiography served many purposes as it arose in divergent historical and cultural contexts. George Fox's *Journal* illustrates the need of figures more current than Wesley to defend new religious movements and the validity of their own spirituality. This provides a clue to understanding the stories of the people called Methodists.

Wesley's chief literary endeavor during the closing years of his life was writing and editing the *Arminian Magazine*, first published in 1778.[8] His express design was "to publish some of the most remarkable tracts on the universal love of God, and His willingness to *save all men* from *all sin*" (*AM* 1:v). According to the preface, Wesley would not only defend this "grand Christian doctrine," he would also supply his readers with edifying extracts from the lives of holy men and women, letters and accounts of religious experience, and inspirational verse. In this regard, the magazine is of inestimable

value in the reconstruction of early Methodist history and spirituality, being, as it were, a repository of spiritual autobiography. While many of the early Methodist autobiographical accounts have survived independently, many more were published in the pages of Wesley's *Arminian Magazine*. Thomas Jackson collected thirty-seven of the *Lives of the Early Methodist Preachers* (that is, of the men) into three volumes in 1837–1838.[9]

But what about the women? In 1825 Zechariah Taft, the indefatigable advocate of women preachers within the Methodist tradition, wrote:

> A great deal of pains has [sic] been taken to preserve in printed records, some account of the labours and success of those *men*, whom God has honoured by putting them into the ministry; while many *females*, whose praise was in all the churches while they lived, have been suffered to drop into oblivion.[10]

In an effort to remedy this situation, Taft prepared *Biographical Sketches of the Lives and Public Ministry of Various Holy Women, Whose Eminent Usefulness and Successful Labours in the Church of Christ, have entitled them to be enrolled among the great benefactors of mankind*, a two-volume collection of spiritual biography and autobiography that has paralleled Jackson's compilation.[11] All other accounts of early Methodist women's religious experience, aside from the fuller autobiographies which were published and widely circulated in the early nineteenth century,[12] must be culled from the *Arminian Magazine* or various archival and manuscript collections.[13] To rediscover the lives of these and other women is critical to the life of the church today. We are all the poorer for not knowing them well. Our story is not complete without them, but reconstructing the portraits of these women—listening to their voices across the chasm of several centuries—is no simple task.

For one thing, in the recorded history of the church, it is men who have done most of the "talking." What might be described as a dialogue of the genders, especially on any official historical level, is a relatively new phenomenon in the life of the church. The voices of the few women we hear from the past are, almost by definition, exceptional because it was *men* who were entrusted with the sacrament of memory. And for this reason much of what might have been of

15

importance to women ("her-story" as opposed to "his-story") was simply ignored. This "lost history"—or to shift the image, the "muted voice"—of the early Methodist woman, is something that we must intentionally seek out, discover, and reconstruct.[14] Attending to the fragmentary sounds that remain—the echoes of the past—requires tremendous receptivity and sensitivity.

I can illustrate just one level of the challenge quite simply by extending the analogy of "sounds" to a specifically musical image. On the one hand, with the life and work of someone like Mary Fletcher, the listener encounters a fully orchestrated symphony—the journal, letters, and writings of a fully documented and well-known life. But that is extremely exceptional. On the other hand, in the one surviving letter of Ann Clemons to an unknown correspondent, you can faintly discern a note or two and cannot even be sure of the instrument that you have heard. Given such extremes, finding balance or establishing a sense of proportion is an arduous task. Who is speaking? What is she really trying to say? What is the story she yearns to tell, the song she has sung? What has the chorus of voices experienced, and what is it communicating in its song? At times, these are very difficult questions to answer, not only for women's history but also in all historical reflections. Regardless, they are well worth asking. It is to be hoped that heightened appreciation, perception, and understanding emerge out of the process of listening, which is, in itself, a powerful act of affirmation.

Of even greater concern, however, with regard to women's history in particular, is the way in which the voices of women have frequently been silenced, ignored, or intentionally distorted.[15] The draft of a virulent letter from Joseph Benson, most likely to Robert Empringham in October 1775, illustrates the depth of his feelings concerning the place of women in the church. "It is a shame, tis indecent, unbecoming the modesty of the sex for a woman to speak in the church. The actions of the women preachers place their very souls in peril! ... behold the sexes have changed places, the woman is become the head of the man, the men almost all, learn in subjection and the women teach with authority! These things ought not so to be!"[16] Fearful of the ever-widening sphere of women's influence within the movement, he spearheaded a campaign to silence them all.[17] How important it is, therefore, not to shut our ears to the great pathos in the words of someone like Mary Taft—words that represent a part of the

story of Methodist women. "All that I have suffered from the world in the way of reproach and slander is little in comparison with what I have suffered from some professors of religion, as well as even ministers of the gospel."[18] While the itinerant ministry of Diana Thomas (1759–1810) carried her thousands of miles on horseback throughout Wales—from Pembridge to Aberystwyth—the edited record of her life which was published in the *Methodist Magazine* makes no mention of her ministry whatsoever.[19] These are historical facts raising hermeneutical concerns that cannot be ignored.[20]

There is a final more subtle challenge that I can only broach here concerning the "quest for the historical woman" of early Methodism. To continue the musical analogy, is it possible that women muted their own voices, from time to time, in order to conform to a conventional male interpretation of the musical score? What sacrifices of the "authentic self" were required for them to even have a hearing? How is the record of their days shaped by their ambivalence toward or conformity to contemporary expectations concerning the life of a woman? These are difficult questions indeed.[21] In an astute and provocative study of English-language fiction, biography, and autobiography entitled *Writing a Woman's Life*, Carolyn Heilbrun attempted to tackle these very questions in the secular sphere.[22] With subtlety and eloquence, she demonstrates how those who have written about women's lives (both biographers and autobiographers) often suppressed the truth about their experience in order to conform to the "male script" of their time. My own working assumption is that there is some of this in the material you will encounter in this volume. Certainly, this is more true of edited or solicited material than it is of manuscripts and writings that were never intended for an external audience. While acknowledging these issues is critical, on the whole, I think you will be struck by what is, to all appearances, pretty blatant honesty. One of the keynotes of these narratives, in fact, is their authenticity and the desire of the women to afford transparent portraits of their lives.

Despite the presence of very typical misogynist attitudes of that day and the reality of this interpretive labyrinth, it is important to acknowledge that Wesleyan Methodism was, on the whole, a movement of profound liberation for women. From its very outset, men, as well as women, spoke up in defense of the place of women in the life of the church.[23] Wesley himself emerged as one of the greatest

allies of the women. Much of his appreciation for the place of women in the life of the church can be traced to his formative years in the Epworth rectory. Largely due to the influence of his mother, Susanna, Wesley seldom wavered from this fundamental principle: No one, including a woman, ought to be prohibited from doing God's work in obedience to the inner calling of her conscience. This conviction would later lead him not only to sanction but also to encourage the controversial practice of women's preaching. Wesley was an outspoken advocate for the rights of women in an era of tremendous social upheaval. Many statements from his sermons and treatises reflect his desire to translate spiritual equality into day-to-day reality in the lives of women. But women were not elevated within the movement by the sheer weight of Wesley's personality and power inside the movement; rather, the liberating ethos of the essential Christianity that he sought to revive supported them as well.

The Wesleyan Ethos

The Wesleyan Revival, under the direction of the Wesleys, arose, in fact, as a renewal movement within the Church of England. The Wesley brothers never intended to found a new denomination; rather, they organized small groups within the life of the church in order to rediscover a living faith rooted in love. These "religious" or "United Societies," as they were originally called, functioned as catalysts for renewal and provided a supportive environment within which new disciples could explore their calling as Christians. In these groups, which augmented the liturgical rhythms and normal worship life of the Anglican Church, the early Methodists shared the vision of the Christian life as a spiritual journey—a way of devotion in which faith working by love leads to holiness of heart and life. The heartbeat of the whole movement was personal religious experience and its power to transform both the individual and society. This revival of essential Christianity involved a rediscovery of the Bible, an emphasis on the experience of conversion, or saving faith, and a vision of activity in the life of the world as women and men together participated in God's mission.[24] All of these elements are reflected in the writings of the early Methodist women.

The Wesleyan Revival, like virtually all other authentic movements of Christian renewal, was quite simply a rediscovery of the Bible. The early Methodist people believed that "their book" was not simply a compilation of letters and histories, of prayers and biographies, of wise sayings and encouraging words; rather, they realized that these ancient "words" could become the "Living Word" for them as they encountered scripture anew through the inspiration of the Holy Spirit. They understood the Bible to be the supreme authority in matters of faith and practice. In both preaching and personal study, the scriptural text sprang to new life, forming, informing, and transforming their lives with immediate effect and lasting influence. For the women, scripture was liberating, but the freedom they discovered in Christ through the Word often demanded their prophetic witness to the truth in the face of opposition. Their defense of the ministry of women, for example, ran counter to the accepted social and ecclesiastical norms of their day and required great courage. The Bible was not only the source of their strength but also a book of promise that held the key to abundant life.

The experience of Hester Ann Rogers illustrates this biblical focus:

Reading the word of God in private this day was an unspeakable blessing. O! how precious are the promises. What a depth in these words: "For all the promises of God in him are yea, and in him, amen, unto the glory of God." Yes, my soul, they are so to thee! The Father delights to fulfil, and the Spirit to seal them on my heart. O that dear invaluable truth! . . . The Lord poured his love abundantly into my soul while worshiping before him. And I was enabled to renew my covenant, to be wholly and for ever his![25]

Encounter with the Word immediately draws God's children into community through shared experience. From the time of Christ there has always been an evangelical faith—a community of life rooted in a God who proclaims good news. There have always been men and women of faith who have experienced God's love in their lives through Jesus of Nazareth as a liberating experience of grace. In this sense Wesleyanism represents nothing distinctive; rather, it finds its rightful place in a lengthy doxological procession. One of the characteristic emphases in these writings, therefore, is the experience of conversion—a process involving a call to personal repentance, moral

transformation, and concomitant freedom to love. Sarah Ryan experienced this kind of liberation when she encountered Christ anew at the Sacrament of Holy Communion one Easter morning.[26] In a burst of ecstasy, Sarah Colston exclaimed, "I felt such a power and love of god in my soul that I did not know how to live. When I came home I was praying and singing all day long."[27] Mary Langston, in similar fashion, piles image upon image and bursts into song as she contemplates the joys of heaven begun here on earth:

> I see fountains upon fountains. O what rivers of pleasure are there! How shall I swim in those *oceans of love* to all eternity! I am overcome with love! Oh . . . how would I sing!

> No need of the sun in that day,
> Which never is followed by night,
> Where Jesus's beauties display,
> A pure, and a permanent light:
> The Lamb is their light and their sun,
> And lo! By reflection they shine,
> With Jesus ineffably one,
> And bright in effulgence divine.[28]

Those who encountered the good news of the gospel and were subsequently drawn into Christian communities of love were also propelled into the world with a mission of witness and service. This is an important third characteristic of the writings—that the Wesleyanism revealed here is essentially concern for social justice and mission rooted in evangelical faith.[29] The women of early Methodism were people of vision, and the image of the church they lived out was one of active social service, commitment to the poor, and advocacy for the spiritually, politically, and socially oppressed. For the women there could be no separation of their personal experience of God in Christ from their active role as agents of reconciliation and social transformation in the world. Their autobiographical portraits are bold images of people living in and for God's vision of shalom.[30] The women had learned from the Wesleys that authentic Christianity is mission, and sincere engagement in God's mission is true religion. The center of this missiological calling and identity, moreover, was simply their desire to share with others the good news they had experienced in

Christ. In other words, in their view, the heart of mission was evangelism. Mission and evangelism were not viewed as separate (or even, perhaps, optional) aspects of the Christian life; rather, they were the very essence of what it meant to be a Christian in the Wesleyan tradition.

Methodist women, therefore, sought out people in need—the poor, the hungry, the destitute, and the neglected. They preached the Word, visited prisons, established orphanages and schools, and practiced their servant-oriented faith as devoted mothers who discerned the presence of God in the most menial of chores. Hardly passive Christians for whom ministry was performed, these women were active, ministering servants who cared for one another and extended their ministry into the communities they served. Nearly one year into her Sunday school experiment in High Wycombe, Hannah Ball recorded this characteristic resolution in her diary:

> I desire to spend the remaining part of my life in a closer walking with God, and in labours of love to my fellow-creatures—feeding the hungry, clothing the naked, instructing a few of the rising generation in the principles of religion, and, in every possible way I am capable, ministering to them that shall be heirs of salvation.[31]

The advice of Wesley to a Methodist woman aspiring to "perfection" is a typical expression of this gospel alongside the poor: "Go and see the poor and sick in their own poor little hovels. Take up your cross, woman! Remember the faith! Jesus went before you, and will go with you. Put off the gentlewoman; you bear an higher character."[32]

Women were able to experience, live, and write about these critical matters of faith because of the liberating environment of the Wesleyan Society and the ethos of accountable discipleship that was part and parcel of the movement. The structure of the Society itself was a practical means to a spiritual end. One of the unique features of early Methodism, therefore, was its capacity to create its own leadership from within. Women pioneers who were responsible for the initiation of many of the new Societies naturally assumed positions of leadership. The large extent to which women functioned in this sphere was a major contributing factor to the inclusiveness and vitality of the movement. By allowing women to assume important positions of leadership within the structure of the Societies, Wesley

gave concrete expression to the freedom he proclaimed in his preaching.[33] The end result was that individuals who stood impotently on the periphery of British society were empowered and gifted for service in the world. Women, who were otherwise disenfranchised in a world dominated by men, began to develop a new sense of self-esteem and purpose.

The Methodist Societies were, themselves, *ecclesiolae in ecclesia* (little churches within the church) and functioned as catalysts of renewal inside the established church. These Societies were composed of still smaller groups known as classes and bands. All members of the Methodist Society were allocated to little companies or classes. But while the classes were heterogeneous groups of about twelve members, the smaller bands (of four to seven people) were divided between men and women and by marital status. These intimate circles of married and single women, under the leadership of women, were the primary locus of leadership development as well as spiritual accountability. Characterized by close fellowship and stricter obligations, the bands were potent in the empowerment of women and the development of their gifts for ministry and mission. There is no question that this cellular structure of the Methodist organism accounts in large measure for the growth and dynamism of Wesley's mission.[34] The selections in this volume provide an amazing glimpse into the meanings of these structures and their influence on the lives of these women. One of the most potent aspects of Methodist structure, moreover, was the way in which it both reflected and supported Wesleyan theology.

Certainly, the egalitarian impulse of the Wesleyan Revival was founded on certain fundamental theological principles that supported women. Among these cherished beliefs were the value of the individual soul, the possibility of direct communion with God, the present activity of the Holy Spirit in the life of the believer, and the importance of shared Christian experience within the family of faith. These views combined not only to create a theological environment conducive to the empowerment of women (like the structures we have just examined) but also to encourage a form of Christian faith and practice in which the fullest possible experience of God could be nurtured, realized, and tested. This synthesis of structure and theology, of form and Spirit, was one of the greatest strengths of early Methodism. Moreover, the Wesleyan conception of salvation, focused

as it was on liberation and empowerment, was responsive to the needs of those who yearned the most for such good news. Women, in particular, eagerly embraced Wesley's view of salvation and the Christian life, a dynamic relational process evoked by the gift of grace and anchored in the Pauline concept of faith working by love leading to holiness of heart and life.

Much of Wesley's concern did revolve around the doctrine of salvation itself, or what has been described as the Wesleyan *ordo salutis* (order of salvation).[35] When forced to define his view of salvation as succinctly as possible, Wesley responded by saying, "Our main doctrines, which include all the rest, are three—that of Repentance, of Faith, and of Holiness. The first of these we account, as it were, the porch of religion; the next, the door; the third, religion itself."[36] Each of these terms, and several others I will introduce to you, is important and needs to be clearly defined because the women use them so frequently throughout their narratives. Repentance is a true self-understanding elicited by our vision of who we are in comparison to what we were created to be.[37] Faith is the gift of trust in those things we cannot see, especially Christ's love for us. But the word "faith" often functions as a shorthand symbol among the Wesleyan writers for the more specific concept of "justification by grace through faith," which refers to the experience of having been accepted and pardoned by God through faith in Christ. Holiness is another shorthand term that refers to the whole process of becoming Christlike in our lives. It includes the idea of both sanctification (the process of growing in grace and love) and Christian perfection (the love of God and neighbor filling one's heart and life), which is, perhaps, the most important of all Wesleyan concepts. This, in fact, was the flying goal toward which all of the Methodist women aspired.

The foundation of this Wesleyan order of salvation is the redemptive work of Christ and the revelation that our whole existence is enveloped by the wooing activity of God. Preventing or prevenient grace (a divine response to the fallenness of humanity) is available to every person and functions to stir the sinner to repentance (convincing grace). The sinner who has thereby come to herself despairs of her own efforts to reach out to God and ceases to cling to her own ability to achieve the goodness that God demands. In that moment, justification (justifying grace) is experienced as pardon and a sure trust and confidence that "Christ died for me." It is the completion

of the work which God had initiated by the activity of the Spirit in the life of the believer. Regeneration or "new birth" (a real change in the person's life) is simultaneous with justification (a relative change in one's relationship to God). This new birth is the beginning of sanctification (sanctifying grace) or maturation into scriptural holiness. This holiness, for the Wesleyan, is always characterized by the twin dimensions of holiness of heart (internal holiness), or love of God, and holiness of life (external holiness), or love of neighbor. The goal of this process is perfect love, or entire sanctification, the Spirit's greatest gift. For the Wesleys, as is also reflected in the writings of the women, none of these "stages" is static; rather, their understanding of salvation is always dynamic and relational. You will be struck by the "realism" of the women's narratives, by their doubts and struggles honestly confronted, and by their triumphs in God's grace.

It is not surprising at all that Wesley should find some of the most profound examples of this theology of religious experience among the women.[38] For one thing, the women seem to have been more open to writing about and discussing these "matters of the heart."[39] In their writings, and particularly in correspondence, the women evinced a strong dedication to personal spirituality conjoined with practical religious service. It is also clear that, while obviously thoughtful and intelligent, they did not fear questioning and remained teachable with regard to their lives of faith.[40] Those aspects of Wesleyan theology that surface most frequently in the pages of these documents, and that call for special attention here, include the foundation of the Christian life in grace, the practical goal of happiness in Christ, and the necessity of growth in one's salvation through immersion in the means of grace.[41]

Wesleyan theology, as has been widely noted and as we have already seen, is rooted in grace.[42] When Wesley defined "grace" in his *Instructions for Children*, he simply described it as "the power of the Holy Ghost enabling us to believe and love and serve God."[43] The end of faith, as well as its beginning, is true self-knowledge, humility, and absolute trust in God. Christian discipleship—the arena of God's continuing activity in the life of the believer—is, first and foremost, a grace-filled response to God's all-sufficient grace. The women often articulated their experience of God's grace, therefore, in terms of total dependence on God. Ann Gilbert, the first Methodist woman

to preach in Cornwall, expressed her experience using these striking images: "My soul is humbled to the dust at the feet of the Lord, and I am as a little child on its mother's breast, always depending on the bounty of Heaven. I live but a moment at a time, and that moment,—for eternity. . . . I never wanted Christ more, than I do now. My strength is perfect weakness."[44] Perhaps no early Methodist woman was more widely acclaimed for her proclamation of grace than Grace Murray, the major prototype for female leadership within the movement. At the end of her life and many years of faithful service to the Methodist cause, she left this dying testimony: "I would have no encomiums passed on me; I AM A SINNER, SAVED FREELY BY GRACE: Grace, divine grace, is worthy to have all the glory. Some people I have heard speak much of our being faithful to the grace of God; as if they rested much on their *own* faithfulness: I never could bear this; it is GOD'S FAITHFULNESS *to his own word of promise*, that is my only security for salvation."[45]

Hannah Ball, in her understanding of the Christian life, drew a clear connection between God's grace and human happiness. "There is no state of life but needs much grace, and no real happiness but what comes from God. One day, meditating on what would constitute a person's happiness that had escaped the incidental allurements of youth, it was powerfully applied to my mind, 'The grace of God, and nothing else.' I have ever found it true."[46] Radical trust in the sufficiency of God's grace leads to love, of both God and neighbor and to a quality of happiness in life that can only be attributed to the indwelling of the Spirit in the life of the believer. For the Wesley brothers and their early Methodist followers, the words were simply interchangeable; "holiness is happiness."[47] For the women, as you will read, Jesus is conceived as friend, brother, husband, the source of their rejoicing, their hope of happiness in life, the joy of their souls. The phrase, "The Unspeakable Love of Jesus," is so frequently repeated by Isabella Wilson in her diary that it would serve as a suitable title for her biography. "This is love unspeakable!" she proclaims in wonder. "His delight is to make us happy. . . . We joy in his redeeming love. He is most precious, and altogether lovely."[48] On a somewhat humorous note, the transparent happiness of Hester Rogers troubled a Calvinist friend who thought it not proper for a Christian to appear so full of joy.[49]

25

While happiness in life does have its serendipitous moments, it is also something that can be cultivated. It is something that grows throughout the course of one's journey with Christ. A single phrase from the same pen of Hester Rogers succinctly expresses her whole Christian philosophy of life. "I desire nothing but to please him: to grow in inward conformity to [God's] will, and sink deeper into humble love."[50] The Wesleys always seemed to prefer the dynamic, biological, and therapeutic images of new birth, growth, and recovery to the static, albeit biblical images of acquittal, imputation, and satisfaction. Wesley found opportunities to speak at length about the necessity and reality of a relative change in one's forensic status before God. But the experience of justification by grace through faith was, for both John and Charles, a means to the greater end of a real change—a regenerative act, the beginning of a process of recovery that restored the image of God in the heart of the believer. "Ye know that the great end of religion is to renew our hearts in the image of God, to repair that total loss of righteousness and true holiness which we sustained by the sin of our first parent."[51] Wesley discovered, in the richness of Methodist religious experience and particularly the experience of women, a spiritual development that was analogous to birth, growth, and ultimate maturity. Here was an imagery with which the women could resonate quite readily.

Sarah Ryan, Wesley's faithful correspondent, had a vision one day of such growth and seized on it as the directing principle of her life: "[On Sunday] in Spitalfields Church, I saw the Lord Jesus standing, and a little child all in white before him: and he shewed me, he had made me as that child; but that I should grow up to the measure of his full stature. I came home full of light, joy, love, and holiness; and God daily confirmed what he had done for my soul. And, blessed be his name! I now know where my strength lieth, and my soul is continually sinking more and more into God."[52] Bathsheba Hall, one of the most diligent "seekers of holiness" in Bristol, went so far as to say, "I do not apprehend that we are fully converted, until we are restored to all that Adam lost."[53] She immediately confessed that she, like Paul, was far from attaining that fullness of restoration, but this was the goal, as she would say, toward which her "every wish aspires." But how were these women to grow in grace or "sink deeper into humble love"? Without question, their response was unequivocal: by immersing themselves in the classic means of grace that were so cen-

tral to the movement as a whole. The "means of grace," namely, prayer and fasting, Bible study, Christian fellowship, and participation in the Sacrament of Holy Communion not only nurtured and sustained their growth in grace but also provided the "energy" which fueled the Wesleyan movement as a powerful religious awakening.[54]

In a journal entry of February 18, 1775, Hannah Ball, in characteristic Wesleyan fashion, provided an outline of those means of grace she had found most helpful to her spiritual growth. "I have received, I trust, an increase of patience: my soul rests in God. To the end that I may improve in the knowledge of Him, I read, write, and pray; hear the word preached; converse with the people of God; fast, or use abstinence; together with every prudential help, as channels only, for receiving the grace of God; but private prayer is in general the most strengthening means of all."[55] Similarly, Ann Gilbert testified to the centrality of these "works of piety" in her life. "Before I conclude, there is one thing I wish to be particularly remembered; during the course of my pilgrimage, I have always found that the more diligent I was in using the means of Grace...the more happiness I have enjoyed in my soul."[56]

The Christian fellowship and intimacy provided through the class and band meetings, for the women in particular, were a potent means of grace. Frances Pawson, one of the guiding lights and a leading force in Yorkshire Methodism, never forgot the impact of the spiritual conversation she enjoyed within the context of these small groups: "I cannot repeat all the good things I heard from Mrs. Crosby, Mrs. Downes, and others. I can only add, that those little parties, and classes, and bands, are the beginning of the heavenly society in this lower world."[57] In the intimacy of these small groups, and particularly the bands, women learned what it meant to grow in Christ and, together, plumbed the depths of God's love for them all. When interest in these intimate circles of fellowship began to wane among some of her Methodist friends, Isabella Wilson sprang to their defense. "I am astonished to see this mean of grace so much neglected amongst God's people, which so *keeps up* his life in our souls. Close communion with God should always be with us the one thing needful."[58]

No means of grace, however, was as important to the Wesleys as the Sacrament of the Lord's Supper. The early Methodists sang, and the women bore witness to the testimony of the hymn:

> The prayer, the fast, the word conveys,
> When mix'd with faith, Thy life to me;
> In all the channels of Thy grace
> I still have fellowship with Thee:
> But chiefly here my soul is fed
> With fulness of immortal bread.[59]

These "feasts of love," as the women often described them, shaped their understanding of God's love for them and their reciprocal love for God, all powerfully symbolized for them in the sharing of a meal. "I have been much favoured this day with the means of grace, which were feasts of love to my soul. I have fed at the table of the Lord on rich grace with thanksgiving."[60] Hannah Harrison explicitly linked her experience of God's sanctifying grace with these instruments of restoration and wholeness of life: "From this time I began to seek for full sanctification; while receiving the Lord's-Supper, I felt the application of those words, 'Thou art sealed unto the day of redemption.' The Thursday morning following, when at private prayer, I was so overwhelmed with the divine presence, that I cried out, 'Lord, can what I feel proceed from any but thee?' "[61]

The Women and Their Writings

Who were these early Methodist women?[62] In a fascinating case study of women and their families in east Cheshire Methodism, Gail Malmgreen offers the following characterization that may be generalized with legitimacy to Methodist women throughout Britain during the eighteenth and early nineteenth centuries. The ordinary woman in early Methodism was more likely to be unmarried than her male counterpart. She often traveled widely, especially in the case of the more exceptional women who responded to a divine call to preach or to share the good news of the gospel specifically through evangelism and the work of mission. The women also frequently associated themselves with the Methodist movement in defiance of their par-

ents' wishes.[63] Coming from all levels of British society, they often lived their lives in a countercultural orientation and with a heavy emphasis on the formative role of the Wesleyan community in their Christian praxis. These women were serious about theology. They studied it, talked about it, and reflected on it constantly. Their formative role on the nascent movement of renewal was monumental.

What still remains to be fully appreciated is the major role that women played within the life of this movement, both historically and theologically. The fact of female preponderance in the Methodist network of Societies only serves to illustrate a much larger reality.[64] Anecdotal evidence concerning the formative influence of women abounds in journals, diaries, and some local history. Women were conspicuous as pioneers in the establishment and expansion of Methodism. They founded prayer groups and Societies and, in their attempts to bear witness to their newly discovered faith, often ventured into arenas that were traditionally confined to men. The story of Dorothy Fisher and her circle of Lincolnshire women is representative and illustrates the strategic position of women on the crest of the wave of revival.[65]

Converted under Wesley's preaching in London, Dorothy joined the Society there in 1779. She introduced Methodism to Great Gonerby in Lincolnshire in 1784 by inviting the itinerant preachers to hold services at her home after her move to the north. Two years later she purchased a small stone building, which, after renovation, served as a Methodist chapel. Learning of Dorothy's pioneering work, Sarah Parrot (having been told by God to do so) invited her to help establish a Methodist Society in Lincoln. Discerning that this was indeed a call from God, Dorothy consented, settled her affairs, moved to Lincoln, procured a suitable residence, and commenced her pioneering labors once again in Pauline fashion. In 1788 a small Society was formed in an old lumber room near Gowt's Bridge. This Society consisted of four women: Dorothy, Sarah Parrot, Hannah Calder, and Elizabeth Keyley. Dorothy built yet another chapel with an adjoining residence, all of which was deeded to the Methodist Conference in later years. This story is consistent, in much of its tone and detail, with the many accounts of Methodist origins throughout the British Isles.

The legacy of Mary Bosanquet's early life is also an amazing testimony to the place and influence of Wesleyan women. In 1763 a prop-

erty near her place of birth in Leytonstone, known locally as "The Cedars," became vacant. Mary and Sarah Ryan (the friend whom Wesley would later describe as her "twin soul") moved there on March 24 with the intention of establishing an orphanage and school on the basis of Wesley's own prototype at Kingswood.[66]

After much careful deliberation the women decided to take in none but the most destitute and hopeless. The children came, as Mary recalled, "naked, full of vermin, and some afflicted with distemper."[67] At first the family consisted of Mary; Sarah; a maid; and Sally Lawrence, Sarah's orphaned niece of about four years of age. With the addition of five more orphans and confronted with the problem of Sarah's declining health, Ann Tripp was secured as a governess for the children. They formed themselves into a tightly knit community, adopted a uniform dress of dark purple cotton, and ate together at a table five yards in length. Over the course of five years they sheltered and cared for thirty-five children and thirty-four adults.

While these two vignettes of Dorothy and Mary demonstrate the critical roles that women assumed as models and mentors within the Methodist Societies, there were other roles and even offices within the movement for women who were otherwise disenfranchised and subservient in the wider world of men. Certainly, the primary training ground for the women was in the area of band and class meeting leadership.[68] It was within this arena that women found the widest range of opportunity. These leaders also stood nearest to the rank and file of the movement, and for this reason occupied a strategic position within the Societies. The primary function of these leaders was to assist their Methodist brothers and sisters in a common quest for holiness. Appointment to such an office was based primarily on one's ability to empathize with the spiritual and temporal struggles of the members for whom they cared. Many of the women, some of whom are featured in this volume, were well suited by nature for this kind of nurturing role.[69]

Of the other offices in which women exerted tremendous influence, the most important (for the purposes of this volume) included those of housekeepers, visitors of the sick, preacher's wives, and local and traveling preachers.[70] Of much greater significance than might be inferred from the title, housekeeper was an office within the Methodist institutional structure which entailed serious managerial and spiritual responsibilities.[71] Sarah Ryan was one of the earliest

housekeepers and viewed her provision of hospitality and the maintenance of order among her appointed "family" to be serious aspects of her Christian vocation. Another office in which the early Methodist women excelled was that of visitor of the sick. Wesley first developed this office in London in 1741 but described this important role in his *Plain Account of the People Called Methodists*: "It is the business of a *Visitor* of the sick: To see every sick person within his district thrice a week. To inquire into the state of their souls, and advise them, as occasion may require. . . . What was Phebe the deaconess, but such a visitor of the sick?"[72]

Grace Murray, later Bennet, was an early example of this type of leadership in the early years of the Wesleyan Revival and stands out as the clear model of the Methodist woman. An important excerpt from her journal reveals the extent of her work in the newly established Society at Newcastle:

Mr. Wesley fixed me in that part of the work which he thought proper; and when the House was finished, I was appointed to be the Housekeeper. Soon also, the people were again divided into Bands, or small select Societies; women by themselves, and the men in like manner. I had full a hundred in Classes, whom I met in two separate meetings; and a Band for each day of the week. I likewise visited the Sick and Backsliders. . . . We had also several Societies in the country, which I regularly visited; meeting the women in the day time, and in the evening the whole society. And oh, what pourings out of the Spirit have I seen at those times![73]

Wesley was accustomed to speak of her as his "right hand."

According to Kent Brown, "the role of the preacher's wife as a leader in the society developed rather gradually."[74] This was because of their husbands not being parish priests of the Church of England with clearly defined roles (and restrictions!); rather, they were itinerant evangelists and catalytic agents of renewal. Zechariah Taft's description of Sarah Stevens, is an apt portrayal of the women in this volume who fulfilled the same role: "a peculiar helpmate in many important branches of his public calling—*she laboured with him in the gospel*, and sometimes laboured *for* him."[75] An autobiographical revelation from her journal reveals even greater detail. "At present my hands are full with two classes, three bands, a prayer-meeting every morning at six o'clock, and the public band on the Saturday

31

evening."[76] What Sarah does not reveal to us in that momentary glimpse of her life is the fact that she was a preacher as well.

It is not widely known that Wesley promoted and approved of the preaching ministry of women in his evolving movement as early as the 1760s. He had come to the affirmation of women preachers over time, though not without some personal struggle; but once he was convinced that God was working through a whole host of women called to preach, he embraced their work on behalf of his movement wholeheartedly.[77] A number of the women featured in this volume were key players in this amazing drama of female liberation and promotion. Primary among them are Sarah Crosby, the first authorized woman preacher; Margaret Davidson, blind evangelist and first woman preacher in Ireland; Hannah Harrison; Elizabeth Hurrell; Sarah Mallet; Dorothy Ripley; Mary Stokes; and Mary Taft, the greatest female evangelist of the nineteenth century; among others. Whether a member of this illustrious band or a simple class leader in a local Society, early Methodist women functioned as coworkers, pastors, and partners in God's renewal of the church. They felt free to express themselves and exercise their gifts. They led the Methodist family in their simple acts of worship and service. They were the glue that held Wesleyanism together on the most practical levels of its existence.

I will introduce you to the women whose writings you will encounter in this volume as we come to them, one by one. But it might be helpful for me to offer something of a "group photo" here at the outset. The first and most important thing to say about these women is that they are broadly representative of "the early Methodist woman." Here are the famous and the nearly anonymous. Some of the material you will encounter from their pens was published and widely circulated in their own day, while other writings are presented here for the very first time and drawn directly from manuscript sources. I have tried to strike a balance as much as I possibly can between these two extremes. But, while some names will be quite familiar to a student of early Methodism, you will be meeting most of these women for the very first time. They come from the bustling city of London and the sleepy villages of Cornwall. Some never wandered farther than twenty miles from their native home, while at least one, Dorothy Ripley, made more trans-Atlantic passages than you and I will in our age of jet travel. Some wrote without the slightest intention or realization whatsoever that someone would

be reading their words and peering into their souls some two hundred years later, while others wrote with an audience in mind, fully intending their self-portrait to be read by others and even emulated. The women came from all walks of life but with one common vision and purpose in life: to allow God's amazing love to fill their lives so as to become channels of that love to others.

As in all anthologies, questions regarding the selection and scope of materials are central. The principles of selection for this particular collection are simplified somewhat by the accidents (perhaps I should say intentionalities) of history. Inclusion of material has been determined to a large extent by the simple fact of survival. While this is more true of the women's theological writings (to be exhibited in a companion volume to this present work) and less true of spiritual autobiography, the male bias of the eighteenth and early nineteenth centuries which often excluded the concerns of and materials related to women must always be kept at the back of one's mind. Not wanting the "dates of John Wesley" to be determinative for the women, it seemed to me that those of Mary Fletcher (arguably the most important woman of Wesley's Methodism) were most fitting—namely, 1739–1815. This period sets a reasonable limit on what otherwise would be an impossibly large task. Beyond the 1815 terminus, changing currents in the British context, both theological and historical, led women's issues in very different directions. The whole context of Methodism changed radically. Termination by this date safeguards against a journey into the divisions within British Methodism in which the question of women is very central and complex. Beyond this point, the question of what to exclude or include becomes rather monumental. The writings included in this volume, therefore, with only several exceptions noted *in situ*, are those of Wesleyan Methodist women who were near contemporaries of Mary Fletcher. The basic test for those women whose life dates overlap the terminal dates revolves around the question: Would her significance after 1739 or before 1815 have been sufficient to justify her inclusion?

Limits obviously do force exclusions. Several beg for particular attention. The writings of the two most prominent women of Anglican Evangelicalism, for example, have been excluded. I have not included excerpts from the vast correspondence and writings of Selina Hastings, Countess of Huntingdon (1707–1791), close associate of the Wesleys, founder of Trevecka College in Wales and her own evangelical "Con-

nexion," because of her affiliation with "Calvinistic" as opposed to "Wesleyan" or "Arminian" Methodism. Likewise, nothing from the *Works* of Hannah More (1745–1833), well-known playwright and literary figure in London Society, has been included because of her vigorous disclaimer to any interest in either Methodism or Dissent. Similarly, Barbara Heck, justifiably described as the "mother of American and Canadian Methodism," is absent here as well because her primary work and influence was in the context of the North American frontier. The *Memoirs* of Anne Carr (1783–1841), one of the early women preachers of the Primitive Methodist Church, are excluded on the basis of her non-Wesleyan denominational identity, despite the close familial connection. Most noteworthy of all is the exclusion of Mary Fletcher herself because her more prodigious literary output merits a separate volume of its own. I am prepared to sympathize with every protest against almost any significant omission (a wonderful phrase coined by Outler). My greatest hope, however, is that what I have laid before you here opens a window to the real world of the early Methodist woman as *she* saw it and lived it. If these materials throw new light on important aspects of the Methodist heritage and serve as pointers to what has been left out, then the purpose has been fulfilled.

The most fundamental principle governing this volume is the desire to allow the woman of early Methodism to speak for herself. Introduction, commentary, and exposition, therefore, are intentionally limited and designed to provide a contextual backdrop with minimal distraction from the material itself. Some extracts are presented in their entirety; others have been necessarily abbreviated. If excerpts send the serious student back to the originals, all the better. There is no substitute to holding a fragile, original document in your hands, or reading the holograph of a letter that was once in the hands of its author. In general, punctuation, capitalization, and spelling have been modernized (which is not to say necessarily Americanized) in order to make the text more accessible to a contemporary reader. Original writings, therefore, are not presented in a "critical text" form; rather, the best tools of critical historical scholarship have been applied to them in order to enhance their transparency. In those cases where such modernization might diminish the impact of the original, it has been avoided. Individual items are presented chronologically in each major section (that is, on the basis of the life dates of the authors rather than the date of publication or actual writing, except for the

letters of part 4). While of particular interest to readers of the Methodist tradition, it is hoped that students of women's history, literature, and spirituality, as well as the story of Christian faith in general, will find this collection both stimulating and inspiring. It vividly illustrates the richness of women's perception of and contribution to life in all its fullness.

The writings of the women collected in this volume fall roughly into four categories represented by the four part division. First, you will be reading accounts of religious experience. What distinguishes these materials from the diaries, journals, and memoirs of part 2 is the clear intention of the author for them to be read by others. Most of these "account" examples were written specifically on request—perhaps, even that of John or Charles Wesley himself. They provide a succinct statement of God's work on their soul.

The second batch of material is drawn directly from the personal journals of the women. Some of these journals and diaries were published during the lifetime of the author as memoirs; others are manuscript transcripts. While the accounts tend to be brief and have a more clearly defined focus, these excerpts from much longer narratives often span many years, reveal various concerns (religious and otherwise), and reflect multiple contextual situations. Each is, essentially, the record of the journey of a soul. Many of these documents are not only rare but are also moving because the soul of the author is in these pages.

I have developed a separate section for the journals of women who were specifically involved in the ministries of evangelism and mission and defined their lives inside these categories. On one level they do not differ from the diaries and journals of part 2, but on another, they represent a specific vocational self-understanding that is not present to the same extent in the writings of their sisters in the faith. To make a somewhat dubious, albeit helpful, distinction, these portraits are more of the women's "work" than of their "lives." They reflect and re-present the incarnation of God's mission through these particular vocations in the Wesleyan Revival. These documents are not only records of selfless devotion to the service of others but also autobiographical portraits of mission and evangelism that enable us to see how the Wesleyan vision of ministry in the world reflects the inseparability of the person from the calling.

The only major exception to the paucity of surviving material related to women is that of correspondence. Early Methodism was born

and developed in the age of the epistle, a time in which the letter was one of the most important literary forms as well as the most intimate and revealing.[78] With regard to letters (twelve of which are included in part 4 of this volume), selection has been governed principally by an effort, once again, to strike balances. Here is a mixture of the familiar and the unknown, connectional and local concerns, everyday life and lofty theological reflection, and matters related to institutional development and Methodist spirituality. Part 4 has been, in fact, the most difficult of them all to construct, simply because of the monumental exclusion of material that it necessarily entails. The twelve letters are drawn from literally thousands of samples,[79] and the concluding "death statement" is part of a large body of material related to the "art of dying" in Methodist literature, still a widely unexplored terrain. This is, therefore, only the minutest of samples. But, my hope is that here is such a sample to make the importance of these women's lives and writings more evident and their critical role in spiritual direction, in particular, more widely appreciated.

To return here at the conclusion of this introduction to the musical metaphors with which I began, I have attempted to assemble a chorus of early Methodist women's voices in this collection of their writings. My hope is that by allowing them to speak for themselves, you will be able to discern each unique, individual voice while at the same time appreciating the distinctive, harmonious sound that their voices together create. I am convinced that the story of each of these women, and the more fully detailed depiction of early Methodism that they provide through the harmonization of their combined voices, can help us to understand the dynamics of Christian authenticity and renewal more fully. To move back to the primary metaphor, if these are autobiographical portraits at all, they are most certainly portraits of love. They are painted stroke by stroke with the winsome acts of kindness and compassion that made these women both distinctive in their own time and typical of all who seek to root their lives deeply in the love of God. Listen to their voices. Listen to God's voice through them. Seek to find your own voice, male or female, in the chorus of the faithful whose lives are a joyous doxology of praise and thanksgiving.

PART ONE
ACCOUNTS OF RELIGIOUS EXPERIENCE

Introduction to Part One

Testimony was one of the central features of early Methodism. While the Wesleys never made the sharing of one's personal testimony of faith a requirement of admission, as some other Christian communities had done, religious self-expression was essential to the vitality of the movement, especially its small, intimate group life. Such spiritual "sharing" is important to any Christian tradition that emphasizes accountable discipleship. In order to be accountable to one another, Methodist women needed a language to express their innermost feelings and "safe places" in which to tell their stories. The Wesleyan Revival fulfilled both of these needs. Not only was personal testimony a major aspect of the more private band and class meetings, but there were also public events at which the women were invited to share their stories of faith. The Love Feast, in particular, afforded women a unique opportunity to exercise their gifts and contributed to the development of their skills in communicating the gospel.[1] Patterned after the *agape* of the early church and contemporary Moravian services, these times of sacred fellowship functioned as an extension of the band and class meetings; they were places of open sharing and celebration. The movement from oral testimony to written religious account was both fluid and natural.

John Wesley and the early Methodists owed much to the English Puritans and the Continental Pietists for the specific form of their own religious accounts. Testimony concerning one's personal Christian experience had been a prominent feature of Puritan praxis during the English Civil War era as well. So there was an existing tradition on which to build. Many accounts, on the model of John Bunyan's classic *Grace Abounding to the Chief of Sinners* (1666), were published for the edification of a larger audience.[2] In Pietism, spiritual autobiography served the larger purpose of the movement, which was to rescue a vital faith from an arid orthodoxy. No figure was more decisive in this effort than August Hermann Francke (1663–1727). Conversion stories in this tradition reflected a specific "order" that generally included deep desire for God, penitential strug-

gle, breakthrough to illumination, and certainty of faith.[3] Both movements had a profound influence on the Wesleys' lives, shaping their own experience to some extent and providing both a language and a form to articulate their unique experiences of God in Christ.

In May 1738, Wesley prepared a religious account of his own Christian pilgrimage. It is a somewhat lengthy memorandum concerning the important events surrounding his experience at Aldersgate.[4] Shortly thereafter he induced others to engage in similar reflection as well, to reflect on their own journey of faith, and to write it into the form of an account. "Being desirous to know how the work of God went on among our brethren at London, I wrote to many of them concerning the state of their souls," and then he subjoined several of the accounts he received in his published *Journal*.[5] Whereas up to this point Wesley had read scripture, devotional writings, sermons, and some Christian biography in small fellowship groups to give definite and instructive direction to their conversation, he now began to interject contemporary accounts of Christian experience—this new *genre* of Christian literature—as a means of encouragement within the context of mutual accountability.[6]

One of the striking features of the religious accounts you will encounter in this section of the volume is their blatant realism. Seldom do you encounter a story of easy ascent; these are narratives of struggle. A spiritual breakthrough is, more often than not, the consequence of a series of ups and downs. The story is one of struggle, leading to transformation, leading to questioning, leading to restored assurance. The metaphor of light is frequently used to describe a journey from darkness to illumination, and of subsequent struggle with remaining darkness, doubts, fears within, and recurrent shining moments. Whatever the particular details may be, their stories are replete with the language of pilgrimage and of journey, the goal of which was to be filled with the light and love of God.

Another recurring refrain is the centrality of preaching or the encounter with the Word, especially at critical junctures in the journey. Scripture frequently functions as a catalyst in the experience of an instantaneous conversion or dramatic, transformative event. Immersing oneself in the means of grace figures prominently in the progression of the soul. More important than anything else, however, is how God's grace—whether encountered in Bible study, preaching, sacrament, or prayer—affects the heart. It is the heart, softened,

warmed, changed, filled, and renewed that stands at the center of all religious experience for the women.

The "Account of Ann Gilbert" illustrates yet another crucial element. Genuine encounter with God in Christ leads to concern for others. This imperative to service is often expressed, initially and primally, in the need to share the experience with others. To couch this in biblical language, whenever the individual encounters the good news *(euangelion)* of God's love, she is drawn immediately into a community *(koinonia)*, the purpose of which is service *(diakonia)* to others. Another way to describe this recurring dynamic is to say that the convert is propelled into mission and ministry.

This brings us full circle, in a sense, to the evangelistic or transformative purpose of the religious accounts themselves. Mary Stokes, in typical fashion, describes how she was moved by the hearing of another person's testimony. These accounts were not only a source of mutual encouragement but also potent catalysts for transformation as well, as personal testimony has always been.

The five excerpts which follow, therefore, are very special. They are characterized by the twin graces of artless simplicity and sincere conviction and are dominated by the central concern for growth in grace through Christian discipleship. As spiritual vignettes of the progress of the soul in relation to a saving and intimate God, they reflect the central aspects of the Wesleyan order of salvation—a dynamic process of faith working by love. The language of the women's accounts is that of repentance, faith, and holiness—the three grand pillars of the Wesleyan journey toward peace and happiness in life. They speak repeatedly of the necessity of sanctification and of their yearning for a maturity of faith that is realized in holiness of heart and life. The means of grace were the primary means to this end—prayer, immersion in the Word of God, fellowship in small groups, and faithful participation in the sacrament of Holy Communion figure prominently in the record of their lives. What makes these accounts so compelling is their blatant realism concerning human life coupled with a joyful optimism in the grace of God. These pieces serve as a deeply personal introduction of early Methodist women to the reader.

Manuscript Account of Sarah Colston

Editor's Introduction

Sarah (Sally) Colston (17??–1763?) was apparently an active member of the nascent Methodist Societies in Bristol. Nothing is known of her life except for the glimpses that can be garnered from this manuscript account of her spiritual experience. Charles Wesley visited her husband on his deathbed on September 2, 1739, and was commissioned to convey greetings to her in October 1745.[7] In a letter to Charles, dated February 8, 1763, Wesley leaves this cryptic memorial: "I should not wonder if a *dying* saint were to prophesy. Listen to Sally Colston's last words!"[8] But apart from these few references, the record is silent.

Charles Wesley requested Sarah to prepare an account of her religious experience which she forwarded to him in the Spring of 1742. By this time Bristol had become a major center of Methodist activity.[9] It was here that Wesley first preached in the open air in March 1739 and constructed the first Methodist chapel, the New Room in the Horsefair, in order to accommodate the amazing growth of the two largest Societies in Nicholas and Baldwin Streets. The "United Societies," as Wesley soon began referring to them, were composed of small groups for accountable discipleship known as bands. In early 1742 a new structure for spiritual accountability, known as the class or class-meeting, was conceived and implemented in Bristol. In this environment of dynamic growth and spiritual vitality, shared experience played a critical role in the evolution of the Methodist movement. The following extract from the epistolary account consisting of seven tightly written duodecimo pages (preserved in the *Meth. Arch.*) appears here in print for the first time.[10]

May 20, 1742

Reverend dear Sir:

According to your desire I have writen the particular works of God in my soul. I was brought up very strickt in my d—— till I was about nine years old. Then my father died and soon after I began to [leave off?] every thing that was good and live to the desire of my own will. Yet I was never happy. I have often felt the sweet heavenly drawing of the spirit of god, and I thought I could give all the world to be a Christian, but I did not seek after it. In the year 1737 I went to hear Mr. W[h]it[e]field and thought never was a speaker like this man.[11] Then I began to go to Church and [leave off?] my carnal company. Then I thought I began to be very good, and I was upheld in it by others. All this wile I knew nothing yet, as I ought to know. O how ready we are to believe the devil that we are good when our soul is on the brink of hell.

March 1739 I went to hear your dear Brother the second time of his preaching in Bristol and god shewed me that he had a great work to do for my soul by his wisdom.[12] I never mist one opportunity, night or day if I knew where he was to be. The first time of my being convinct of sin was in hearing Mr. Wesley expound the second Chapter of the Romans, at the Society in the Castle.[13] Then I knew I never kept one of the commands of god. Then I felt I was in my sins and in a state of damnation. And the more I heard your brother the more clearer it was to me. Yet I do not remember that I felt any sorrow of soul, to be afraid of God's wrath or damnation, for I did belive that god would give me faith to feel my sins were forgiven me through the Blood of Christ. Still I went on my way reioyceing, yet I knew I was in a lost state till I felt my sins were forgiven for the sake of Jesus Christ.

Tuesday, May the first, I went to the Society in Baldwin Street were your dear brother expounded the 6 of the Acts.[14] Then I felt a strange alteration in my heart. But the time was not fully come. Yet I did expect it every moment when the Lord would give me that forgiveness of sins.

The next day, Wensday the second of May, when the power of god was upon our brother Haydon,[15] he sent for me for he saw me the night before. And wile I was there, Mr. Wesley came and after he had sung [and] praied with him and I, he went to preach at Baptist Mills.[16] And wile he was away, I felt in one moment Christ died for

43

me. I knew my sins were forgiven me. I felt such a change in my soul which was unspeakeable. I then spoke with these words; now my soul is like a storm that is over. I felt such a peace and love in my heart wich no toungue can uter.

Soon after the enemie came, reasioning with me, telling me it was only a delusion, that I only thought my sins were forgiven. There was no such thing. It was all nature. It was because it was nice doctring or because I was high spirited that I felt such a love and power. It was all delusion; that I did only because my own soul.

Then I thought, do I not love god? Do I not hate sin? Do I not feel I have power over anger and other sins which before I had not? I found I had and I knew god did not love sin and I knew the devil did not love god. And I knew by the spirit of god, it was not his wish that I should commit sin and I knew the devil would not give me power over sin. But if Satan be devided against himself how should his kingdom stand [cf. Luke 11:18].

At last I gave way to reasoning and let go my shield. Then my soul was in heaviness through many temptations. Then I began to be surounded and very busy. Then I felt sin stiring; and unbelieving. But the Lord soon unveild his face and shewed that he loved me.

Then the devil brought another temptation before me. That all the glorious priveledges belongd only to the Jews and not to the gentiles. That they was the beloved people only. That held me some weeks. Then I searcht the scriptures night and day and the Lord shewed in the 40 Chapter of Isaiah and the Romans that he was no Respecter of persons [cf. Acts 10:34], but willing that all should believe and be saved. Yet I do not mind that ever I utterly lost the since of my Justification, tho sometimes it was as a spark midst the floods of some temptations.

The latter end of October in the year, I was very busy and the devil told me I should never hold out to the end. I should soon give up all and turn back into the world. November the first I had the happiness and pleasure to breakfast with you at Sister Turners[17] near Stevens Church after you had praised and were singing these words of the hymn:

> Jesus come thou serpent bruser:
> bruse his head womans seed:
> Cast down the acuser.[18]

I felt such a power and love of god in my soul that I did not know how to live. When I came home I was praying and singing all day long. I shall never forget that day and hour. This was the way I went on in general [. . .] till May the 28, 1740, Wensday, as I was with your dear brother and the leaders.[19] At the hour of prayer about two in the afternoon I felt in a moment such a witness in my heart that I was a child of god that I never had any douts or fears from that hour to this. Yet I am never easy for I do feel such hungering and thirstings and burning desires after god that is stronger than death. Yet I felt such a peace and love that all the world is nothing to me. Yet I w—— that I could praise god that I am alive in gospel days. And even in this hour my soul is waiting upon god so that I may allways learn to live but from hour to hour.

Dear Sir, pray for me that I may be faithful to improve my glorious talents every moment of my life and never rest till I am pure in heart. . . . And I hope I shalt never be wanting to offer up my weak prayers for you and your dear brother, that the Lord Jesus will bless you and lead you by his Holy Spirit and strengthen your faith to preach the everlasting gospel, faith alone in the Blood of Jesus Christ and free grace and love to every soul of man, and increasd holiness without wich no man can see the Lord [cf. Heb. 12:14]. And may your heart be filled with the love of god and may he give you that grace which passes knowledge every moment. So prayer from her heart though the least and unworthyest of all your flock.

But when I think what god has done for my soul and what he does dayle and hourly, it goes beyond my thought or tongue to utter. Yet I know I have an evil nature, but I have power over all sin and I find such desires and breathing after god that takes away my strength, wich makes me cry my Jesus, and my all. Whom have I in heaven but thee and there is nothing upon earth that I desire besides thee.

> Fulfill fulfill my large desires,
> Large as infinity;
> Give give me all my soul requires,
> All all that is in thee.[20]

Sarah Colston

45

The Experience of Ann Gilbert, of Gwinear

Editor's Introduction

Cornwall has a conspicuous place in the history of the Methodist movement. Some of the classic anecdotes of the revival are drawn from the thirty-two visits of Wesley to this "Methodist County" during the course of his ministry. In 1743, the same year as Wesley's first evangelistic journey into Cornwall, Ann Gilbert (d. 1790),[21] destined to become the first woman preacher of Cornish Methodism,[22] was converted under the preaching of a young lay preacher at Gwinear. In 1771 she began exhorting herself and, soon thereafter, preaching in the surrounding villages. On one occasion, perhaps during his visit to Cornwall in August 1773, she consulted Wesley on the subject of her speaking in public. After hearing her statement, he is reported to have tersely replied: "Sister do all the good you can."[23]

In a marginal notation to his brief sketch of her life in *Holy Women*, Zechariah Taft provides the following pertinent anecdote:

> I have been informed that however opposed to women's Preaching the preachers were who were appointed to that Circuit, they were soon convinced that *Ann Gilbert* was eminently *holy* and *useful*, but on one occasion a person informed her that the new preacher had given it out that he would silence her . . . & her answer on hearing this was "if Mr. ———, can produce more converts than I, I will give it up."[24]

An unidentified Wesleyan itinerant affords the following eyewitness account of an occasion when Ann was welcomed into one of the Methodist chapels of western Cornwall:

I had the pleasure of hearing Mrs. Ann Gilbert preach in the Chapel at Redruth, to about 1400 people. She had a torrent of softening eloquence, which occasioned a general weeping through the whole congregation. And what was more astonishing she was almost blind, and had been so for many years.[25]

She died on July 18, 1790, in Gwinear.

✳ ✳ ✳

From my infancy, so far as I recollect, I led what is called a moral and inoffensive life and was strictly educated in the doctrine and worship of our established church. My parents watched over me with an affectionate concern, and it is chiefly on that account, I was happily preserved from the grosser vanities and follies of the world.

In the year 1743, I was induced to go with the crowd to hear Mr. Williams, one of the first itinerant preachers that visited Cornwall.[26] His serious and earnest manner of praying and preaching were such as I never heard before, and his word was as a flame of fire, to soften and melt my heart. I shed many tears during the sermon, and was clearly convinced that the Methodists were a people going to heaven. O! how gladly would I, from that moment, have lived and died in the closest fellowship with them. But alas! having no religious connection, nor any one to take me by the hand, I suffered these convictions to die away. However, from that instant, I was always conscious I wanted something to make me happy.

In this state I continued till the year 1760 when the Lord, by a gracious providence, was pleased to establish the preaching in our parish. The first time I attended, he sent his word to my heart, and visited me again with my former convictions. As I returned home, I prayed very earnestly that I migh[t] not lose these divine impressions, through a worldly spirit, as I had lost the other thro' childish vanities. To avoid which, I embraced the first opportunity of joining the Society. O! it is a pity that so many thousands lose their good impressions, for want of laying themselves open to some experienced person, and helping each other in the ways and work of the Lord.

My distresses were exceeding great for the space of six weeks, for the Lord was shewing me the vileness of my heart, and the multitude

of my sins. It is true, I had not been what is called a five-hundred pence debtor, but I saw I owed him more than fifty pence, and that he might justly consign me over to everlasting misery. Frequently, indeed, I was afraid to close my eyes at night, lest I should awake in hell, to receive the reward of all my unrighteous deeds.

About this time I had occasion to visit my sister at Trucking-Mill,[27] and while I was riding, endeavoured to exercise my mind with the Lord, by repeating "the humble Suit of a sinner,"

> Thou seest the sorrows of my heart,
> My grief is known to thee, &c.[28]

All on a sudden I received such a manifestation of the power and presence of God, that I cried aloud, "Lord, if I should die this moment, I shall go to heaven." His anger was turned away, and he comforted me; and his love was shed abroad in my heart by the Holy Spirit.[29] As soon as I came in, I simply related the whole to my sister, but being in a carnal state,[30] she neither understood what I said, nor could rejoice on my account.

From this blessed moment, I walked in the light of God's countenance for several weeks. I had a feeling sense that heaven was opened in my heart, and that all my former sins were forgiven, through the merits of Christ. I now thought, that the heaven of love, joy, and peace, which I felt, would continue and increase for ever. Yea, I said in my heart, My mountain is so strong, I shall never be moved. Whether this thought grieved the Lord, or whether I was less grateful and attentive to his Spirit, I cannot say. But he hid his face from me, and left me to walk in darkness and distress. During the few days that this cloud was on my mind, I suffered much, and wandered from one mean[s] of grace to another, seeking rest and finding none.[31] However, on the ensuing Sabbath, I seemed to entertain a dawn of hope, and said in my heart, "I will go to the morning preaching; who can tell, but the Lord may meet me there." And, glory be to his Name, He again shone upon my mind, and shed abroad his love in my heart. After this, I was much more watchful, and filled with a holy fear of offending God. I was afraid lest I should again grieve his blessed Spirit, and cause him to withdraw his sacred comforts.

It was now that I became extremely jealous of my own heart, and began to watch it, as my most inveterate enemy. Many times I was

distressed by the motions of anger and pride, sins to which I had been peculiarly addicted from my infancy, and which frequently occasioned me the loss of my comfort. This led me to cry mightily to the Lord, that he would destroy them, or otherwise, I knew that they would destroy my soul. The sin of my nature was truly a burden to me, for I could not bear to find any thing in my heart contrary to love. Mean while I began to grow in grace. My faith and love increased, and I had frequently very affecting views of the emptiness and vanity of the world. The cry of my soul was, that I might learn of Jesus to be meek and lowly in heart [Matt. 11:29], and altogether devoted to do and suffer his righteous Will.

After my mind had been exercised in this manner about a year, I went one evening to the class, and while we were singing the first hymn, I found an uncommon hardness of heart, such as I had never found before. This induced me to cry mightily to the Lord, that he would soften and melt it into tenderness, by his dying love. In that same moment, the overwhelming power of God fell upon me, and his glory shone into my soul. I was brought into a blaze of light, and so filled with the divine presence, that for some moments, I scarce knew whether I was in the body, or out of the body. All within me was peace, and love, and filial reverence. It was

> The sacred awe that dares not move,
> And all the silent heaven of love.[32]

The whole of this blessed night was spent in praising and glorifying God, for I had neither wish nor inclination to sleep. And in the morning while in prayer the Lord answered me, "Thou art holy [cf. 1 Pet. 1:16],—thou art sanctified [1 Cor. 6:11],—thou art cleansed from sin [1 John 1:7]." For a little while my happiness and peace were undisturbed, but it was not long before Satan endeavoured to rob me of my confidence. He suggested, that it was impossible for me to be saved from sin, especially from the sin of anger. I went immediately, and cast my soul before the Lord, and he answered, "My grace is sufficient for thee" [2 Cor. 12:9]. My soul laid hold on the promise, and I went on my way rejoicing. My confidence increased in the belief of this farther work of grace which God had wrought in my soul, when I heard the great blessings of the new Covenant opened by the

49

preachers, for I do not remember at the time I first experienced it, to have heard a single sermon upon the subject of christian perfection.[33]

One blessed fruit of the work which God had wrought in me, was a more than usual concern for the salvation of poor sinners. I would have done or suffered any thing on their account, if I might have been the instrument of their conversion. Sometimes I have intreated for them in secret, and sometimes I have poured out my soul, both in public and private, on their behalf. In the year 1771 going one day to preaching in the adjoining village, the preacher happened not to come, I therefore gave out a hymn and went to prayer, according to my usual custom. I then told the people, they need not be disappointed, for the Lord was present to bless them. Immediately I received such a manifestation of the love and power of God, that I was constrained to intreat and beseech them to repent, and turn to the Lord.[34] All the people were melted into tears, and many were convinced of sin, some of whom continue steadfast to this day. I endeavoured to the utmost of my power to be diligent in every duty, both public and private, especially meeting my classes, visiting the sick, and attending the prayer-meetings.

One Sunday I found my mind much pressed to go and meet a few backsliders who had lately been joined in class at a neighboring village. When I got into the meeting, the leader was reproving some young people for indecent behavior. He desired me to give out a hymn and go to prayer, which having done, I admonished the young people. And while I was speaking to them, [I] was so filled with the peace and love of God, that I could not but exhort and intreat them to repent. Presently their laughter was turned into weeping, and one person who had been a backslider for twenty-three years, cried aloud for the disquietude of her soul, and the Lord healed her wounded mind, before the conclusion of the meeting. These tokens for good so encouraged me, that I promised the Lord, if he would give me strength, to use it to his glory. And blessed be his Name, he has enabled me to continue to the present day. The Lord gave me abundance of satisfaction, first, by restoring my health in a wonderful and unexpected manner; secondly, by deepening his work in my own soul; and thirdly, by owning my poor labors in the conversion of many sinners.

It is now about twenty-five years since I found the abiding Comforter. I do not know that I have lost the divine consolations for a single moment all this time. And although I have had abundance of

temptations and sufferings, being deprived of many of my children by death, and exercised with various worldly trials and losses, yet in all these I have been so preserved, that the enemy has never been able to rob me of my confidence or comfort. The light of God's countenance, indeed, has not shone so bright at some times as at others. But I have always enjoyed a constant heaven, being enabled to rejoice evermore, to pray without ceasing, and in every thing to give thanks [cf. 1 Thess. 5:16-18]. I have found a continual stream of happiness flowing from the Lord Jesus, and the emanations of his love attracting my affections heaven-ward.

For many years after I first received the abiding witness of the Spirit, I had no idea, that there was such a fulness of happiness to be enjoyed upon earth, as that which I have experienced for the last eight years. My soul is humbled to the dust at the feet of the Lord, and I am as a little child on its mother's breast, always depending on the bounty of Heaven. I live but a moment at a time, and that moment,—for eternity. But I cannot express in words what I enjoy, for there is only a thin vail between Heaven and my soul. Yet I never wanted Christ more, than I do now. My strength is perfect weakness [cf. 2 Cor. 12:9]; and, glory be to his Name, I find him covering my infirmities, and presenting me blameless to his Father, every moment. I would not offend him for all the world. The world, indeed, is under my feet, and heaven is opened to my view, and the constant desire of my heart.

Before I conclude, there is one thing I wish to be particularly remembered. During the course of my pilgrimage, I have always found that the more diligent I was in using the means of Grace, . . . the more happiness I have enjoyed in my soul. Besides attending public worship, it has been my constant practice to pray three times a day with my family, and four times in secret.[35] If any thing interrupted this order, I have spent the more time at night with the Lord. I know I do not merit any thing by this, but he has shewed me, that I must be as diligent in using the means, as tho' the whole of my salvation were merited thereby.

If all the particulars of my experience had been written, they would have filled many volumes. But I have been almost totally blind for the last thirty-five years, and consequently incapable of doing it. However I have embraced the present opportunity of procuring a friend to write these fragments for me, for the use of my family, and the dear people among whom I have lived.[36]

51

An Account of Hannah Harrison

Editor's Introduction

Hannah Harrison[37] (1734–1801) was a pioneer of Methodism in York.[38] A convert to Methodism in November 1750, an ambassador of reconciliation among the besieged Methodists in Beverley during periods of mob violence there,[39] and an aspiring member of the small conclave of women at Cross Hall, Hannah was particularly well-known for her preaching at the north Yorkshire village of Malton. It may have been there that John Atlay, one of Wesley's itinerants and later book steward for the Methodist Connection, was converted under her preaching.[40]

While no letters seem to have been exchanged between Hannah and either of the Wesley brothers, several references to her in John's correspondence offer some cryptic glimpses of this noteworthy woman. He reveals something of his esteem for her in a letter to Ann Foard, dated August 8, 1767. After discussing "some who have deep experience of the ways of God," he observes that "Hannah Harrison is a blessed woman. I am glad you had an opportunity of conversing with her."[41] In a subsequent letter to Sarah Crosby, however, dated March 18, 1769, from Chester, he cautions that aspiring preacher concerning the propriety of her actions (still struggling himself with the validity of a woman's call to preach), and after providing detailed advice concerning her activities, concludes: "If Hannah Harrison had followed these few directions, she might have been as useful now as ever."[42]

Ironically, the account of her life published in the *Arminian Magazine* in 1802 makes no reference whatsoever to her activities as a preacher. Joseph Benson,[43] editor of the publication at that time, was

a major antagonist to women's preaching, and the silence concerning her important contribution to the Methodist movement in this regard may have been due to his editorial pen. Benson's silence, however, is more than accommodated for in the testimony of the protagonist, Zechariah Taft, who described her as "a woman of an excellent spirit, of amiable manners, ardent piety, and burning zeal to promote the glory of God."[44]

<p align="center">❋ ❋ ❋</p>

As I consider myself to be near the end of my journey, I think it my duty to leave some memorial of the Lord's loving-kindness toward such an unworthy creature. I was born in the year 1734. At six years of age, I was very unhappy, because I could not be good. Both my parents were serious Dissenters.[45] But losing my pious mother when only eight years of age, I fell into the hands of those who took great pains to qualify me for being a useful member of Society in this world, but who knew very little of that which is to come. My school exercises, &c. left me neither time nor inclination to pray. At eleven I entirely omitted bowing my knees in secret, and strove to forget that I must one day be laid in the cold grave. At 13, by a violent pain in my head, I was entirely deprived of sight. Where then was my promised pleasure? My good father spared no expence in endeavouring to get my sight restored. Many doctors were consulted. At fifteen I was pronounced incurable. Had what I then felt been eternal, it would have been a hell indeed! I endeavoured to pray, but could not, and would have thanked any one to have told me, what I must do to be saved.

In the year 1750, I providentially heard Mr. Samuel Larwood,[46] at Accomb, near York, and was pleased with his deliberate manner of preaching, but could not understand his meaning. Soon after I heard brother T[homas] Mitchel[l],[47] but still was no wiser. In November 1750 I was convinced of sin because of *unbelief*, by the instrumentality of our late venerable brother Jonathan Maskew.[48] In May 1751 my dear father invited the preachers to his house, and in less than three days, I was enabled to believe on the Lord Jesus Christ with a living faith. I then hoped the design of Providence was fully answered, and repeatedly prayed for the restoration of my sight. But what was my distress when I was made sensible that my sight was taken away to

draw me out of common life, and would be with-held to prepare me for a sphere of greater usefulness. The rebellion of my will exceeded description. The Searcher of Hearts knows that, . . . the leader of two bands, and two classes, it was six years before I could say, (without a draw-back) "Thy Will be done [Matt. 26:42]." About this time, brother John Haime visited us,[49] and preached several awakening sermons, "proving the necessity of sanctification." Sister R. Hall[50] was deeply convinced of the necessity of what was then called, "A farther work of grace,"[51] which she received in a few months. Brother John Manners professed to have the same experience.[52] But such was my opposition to this doctrine, that I walked seven miles one frosty morning to convince Mr. Manners he was in a delusion. For ever adored be that wisdom which enabled him to convince me, that without the same experience, I could neither be comfortable here, nor meet for that degree of glory which then appeared my purchased privilege. From this time I began to seek for full sanctification. While receiving the Lord's-Supper, I felt the application of those words, "Thou art sealed unto the day of redemption" [Eph. 4:30]. The Thursday morning following, when at private prayer, I was so overwhelmed with the divine presence, that I cried out, "Lord, can what I feel proceed from any but thee?" and the language of my heart was,—

> [Nay, but]—I yield, I yield,
> I can hold out no more,
> I sink,—by dying love compell'd,
> And own Thee Conqueror.[53]

My next enquiry was, "Lord, how shall I glorify Thee, who hast done so much for me?" and was answered, "By keeping silence." But I asked, Must I hide this light under a bushel [cf. Matt. 5:15]? and it was again suggested, "Your light will shine most if you keep silence." I knew obedience was better than sacrifice, and upon that principle, concealed what I had received for more than five months. I then felt a desire to meet in the select band,[54] and was introduced by one of the preachers, but was sharply interrogated, and told by one, (who is, I doubt not, worshipping before the Throne,) that all I said appeared false. The consequence was, none of the good people were permitted to receive my testimony, till Mr. Wesley came to York, who entirely removed their objections.

My Jesus will never leave me, no, he will never forsake me, but will take me to himself.[55] I shall praise him to all eternity. I cannot sufficiently praise him now; but I thank him for this affliction, knowing it is for my good. He will spare me till I am fully ripe for glory. My Jesus bears me above all my afflictions. I find him very precious, and shall for ever sing of mercy unto him who hath bestowed it. Till then, it is my constant prayer that I may have a full sense of it. My heavenly Father does all things well. I have been much tempted since I last saw you; but I count it all joy, for it is profitable to my soul. I have gained more self-contempt. I love an empty spirit, because then there is more room for Jesus:

> O what are all our sufferings here,
> If, Lord, thou count us meet,
> With that enraptur'd host t' appear,
> And worship at thy feet![56]

I have been all this day in a disposition to cast my crown at his feet. I cannot express how I rejoice to give all the glory to Christ my Lord. All within me acknowledges he is worthy to receive all glory.

We shall shout free grace to all eternity.

The Experience of Mary Stokes

Editor's Introduction

Proselytizing between the Methodists and the Quakers, or Society of Friends, was common throughout the eighteenth century with notable conquests on both sides. One important defection from the Methodist side was that of a trusted Society leader in Bristol, Mary Stokes (1750–1823), later to become "one of the greatest and most influential of the women preachers of the eighteenth century."[57] Born to Joseph and Mary Stokes in Bristol on June 6, 1750, she joined the Methodist Society at the New Room only to become a Quaker after her marriage to Robert Dudley of Clonmel, Ireland. It is possible that she began her public ministry as early as 1771. John Wesley, being an intimate friend, had done everything in his power to keep her from succumbing to the "allurements of Barclay's *Apology*." In his last letter to her of August 10, 1772, he entreated her to read his *Letter to a Quaker*[58] and expressed his fear that she was unwittingly teetering "on the brink of a precipice."[59] In spite of her subsequent conversion, Wesley continued to greatly esteem her spiritual gifts.

The following extract is taken from her Bristol letter, requested by Thomas Rankin and dated October 12, 1771, later published in the *Arminian Magazine* in 1795 (18:99-101). Her account reflects her experience among the people called Methodist prior to her conversion to the Society of Friends.

❊ ❊ ❊

From the time you left Bristol, I think my distress increased. What I felt, none but those who have themselves groaned under the most

galling yoke, can express or understand. Sometimes ready to wish myself inanimate, and desiring to fly from the dreadful sight of a heart so totally depraved. Again praying to feel its utmost Fall. Frequently revived by the promises, my soul, as you express it, has soared in lively expectation, and seemed, from Pisgah's top, to behold the promised Land [cf. Deut. 34:1]. Then disappointed of her hope, she has, indeed flagged, and moved heavily along. The depth of the Fall was one time so discovered to me, that my very life seemed departing. O the unutterable sight! I seemed without a God, while darkness, worse than Egyptian, covered my soul. The struggles of my breast were past description. How often has every sinew seemed unstrung, and my heart rending to pieces. Yet in this agonizing state, I could depend and confide in my God for deliverance. But I sometimes sunk into such indifference and carelessness about the matter, that I seemed just on the brink of returning again to the beggarly elements of this world. O my gracious God! how high is thy hand! Had it not sustained me, where should I have been? Even in the depths of black despair. But thy thoughts were thoughts of love concerning me.

On the 25th of September, my soul was much depressed, and weighed down with corruption's burden; yet I seemed stript of all hope of deliverance. Truly miserable, I went with my dear sister Cantle, to Knowle.[60] While she was reading to me a part of her experience, I found my spirit's cry was, "Lord, help me!" The power of God so descended, that reading gave way for mighty prayer. My friend did indeed besiege the Throne of a *present Deliverer*. The agony my soul was brought into cannot be described. It was, indeed, the unutterable groan which it breathed. Language failed. My every power gasped for God, till spent, and entirely overcome, I felt, (what the Lord himself only can explain to my friend) a mighty, an all-conquering change. My misery was gone. I don't remember any particular promise being given me, nor did I find any rapturous emotion. But instead of crying, "Lord, cleanse thy temple;" these blessed memorable lines, were my whole prayer:

> Now thine inward Witness bear,
> Strong, and permanent, and clear?[61]

I cannot tell you, what a very fool I seemed to myself; having nothing, knowing nothing. I said, "I know not what the Lord hath done, but my spirit does wait upon him." The clog,—the hindrance, was gone; and my soul hung on its Beloved. With what transport did I often cry,

> Jesus! Thee alone I know,
> Monarch of my simple Heart.[62]

I found him, indeed, my King. Satan soon began and suggested, what a delusion I was in; but simply flying to my Lord, the enemy was conquered. Some friends said, "You are happy." Here the enemy closely pursued me to deny the work, but my Jesus was mightier, and constrained me to testify what he had done. While I have been speaking, I have felt such divine communications of his love, such rays of approbation, from him, that with ecstacy I have cried, "Jesus is precious! My GOD, and my ALL" [cf. John 20:28]! Such love to every soul, but to the children of my Father, what a divine cement, what an holy union, do I feel? My friend, I am lost in astonishment! Praise Him for me! I never found such buffetings from the enemy, in my life. How have I been obliged to fly to my Refuge? He gives me great and precious promises, and through all has yet kept me confident. I am sometimes favoured with much enjoyment, and seem almost out of the body; but this is not always. My dear Lord shews me, I must suffer, and blessed be his Name, I find my heart cries, "Thy will be done." I have many doubts and fears, and have lately thought that sin was going to revive, but my Beloved will disperse them, I fear not, and stablish the thing he hath wrought in me. I feel my dependance on him in a manner I cannot describe, and feel that I cannot do one moment without the Blood of Sprinkling [cf. Heb. 12:24]. I have wrote as freely as I can think, I have found no restraint, and hope our gracious Lord will bless our correspondence. I trust, my dear friend will advise, help, and direct me. O how weak, how poor I am! May our adorable Lord bless you with his continual smiles and love!

An Account of Isabella Wilson

Editor's Introduction

The only record of Isabella Wilson's life is that preserved in the excerpt of her diary prepared by John Pipe, "Memoir of Miss Isabella Wilson" (1765–1807), from which the following account is drawn.[63] We know only that she was born at Sinnethwaite in 1765, was an important instrument of revival in northern England, and died in 1807. Pipe notes that while Wesley's itinerants preached salvation by means of pulpit and publication, Isabella "strove to cast her mite into the sacred treasury, by meeting classes, holding meetings for prayer, visiting the sick, by epistolary correspondence, and spiritual conversation" (*WMM* 31:462). She is the unknown woman *par excellence* apart from this glimpse and those afforded by Mary Taft in her *Memoirs*.

※　　※　　※

The Lord so far enlightened my mind, that I saw clearly if his Word were true, the generality of the world were out of the way. From the little I saw and heard of the Methodists, I thought, if any knew their duty to God, they did, and that they were his people. And I was always ashamed before them for fear they should speak to me concerning my soul; yet I loved to hear them talk of the things of God.

Nothing pleased me now so much as going to hear the word, and attending the service of the church. I was, however, still in a state of darkness with regard to the way of accepting the offers of mercy. Surely no one ever took so much teaching as I did.

I prayed to the Lord and at that moment he gave me to see that I was wretched, miserable, poor, blind, and naked. I no sooner saw myself in this dreadful state, than I was directed to look to Jesus, and was enabled to cast myself upon him just as I was, fully believing he had died to save me. Now all my trouble was gone, I had calm peace and such resignation to God as I never before experienced. I felt such love to God, and his ways, that I thought nothing too much for me to suffer. At first, indeed, I saw myself to be so unworthy that I did not advert to my being justified, but a little while after, the same night, I saw clearly and felt that I was.

I set off with a glad heart. [My father and I] talked of religion. And when about half way to my father's, my mind was so carried above that I scarcely knew whether I was in the body or out of the body. The cry of my heart now was, "O Lord, make me as holy as it is possible for any one to be on earth." And I seemed as clay in his hands [cf. Jer. 18:2-6], waiting that all his will might be wrought in me, and the faith that bringeth full salvation.

I was sitting by the fire; and, in an instant, experienced such a change of heart as astonished me. I was so filled with the love of God that I could scarcely contain myself. I retired as soon as I could, to pour out my soul to God in praise for this unspeakable blessing. I now had the clear witness that God was reconciled to me, through the Son of his love. Light shone from his word into my mind, and I knew that Jesus was my beloved, and that I was his, and I longed to die and go to him. It was now my meat and drink to do the will of God, as far as I knew it. I was, indeed, ignorant of many things, but he bore with me, and blest me abundantly. To guard this sacred treasure in my soul, and to keep my evidence clear and bright for glory, seemed to me to be the one thing needful.

I was ready to say, continually, O Lord, what am I, or what is my father's house, that thou shouldest have such respect for me, as thus to feed me in green pastures, and lead me beside the still waters [cf. Ps. 23:2]. It was soon noised abroad that I was turned Methodist. Many of my friends were sorry for me; but, Oh! how I pitied and prayed for them. I had no difficulty in getting free from my careless companions; they were cut off at a stroke; for, if they said any thing about the pleasures of the world, I rejoiced at the opportunity of telling them that I had too long followed the shadow, but now had

found the substance, for which I never could sufficiently praise God, and I intreated them to seek the same happiness.

Oh, what blessed seasons were [times of Christian fellowship] to my soul! Here I fed upon Christ with thanksgiving. Oh! I thought how favoured are these people by the Almighty. . . . His Word and Spirit were my continual guides. All the precious promises were yea, and amen, to the joy and rejoicing of my soul [cf. 2 Cor. 1:20]. Truly, the Word was a light to my feet, and a lamp to my paths [cf. Ps. 119:105].

I felt much for [my father's] soul. Though I could say but little to him, I prayed much and fervently for him. The Lord blessed me abundantly in so doing, and gave me to believe he would save him. His heart was changed in this affliction. He became heavenly-minded, and so spoke of the things of God, that all my doubts and fears concerning him were gone. I think the Lord raised him again that we might see the change wrought in him. He seemed entirely disengaged from the world, and so easy and happy, that I could not doubt of his acceptance with God.

I was brought into closer communion with the God of my mercies, and I was more determined for heaven than ever. The language of my heart was,

> Oh, may I breathe no longer than I breathe
> My soul in praise to HIM, who gave my soul,
> And all her infinite of prospect fair.[64]

These words of our Saviour to his disciples, when he was about to leave them, were spirit and life to me. "If ye love me keep my commandments, and I will pray the Father for you, and he shall send you another Comforter who shall abide with you for ever" [cf. John 14:15-16]. This *for ever*, was glorious indeed. And, likewise, his words to Thomas, "Blessed are they who have not seen, and yet have believed" [John 20:29]. I was more and more thankful for a believing heart. It is not pleasing to our God to hear us cry, "My leanness! my leanness!" when there is so much laid up for all that believe and ask for it. Well might our Saviour say, "Ye will not come to me that ye might have life" [cf. John 10:10]. Oh! blessed be God, since I came to Jesus I have had life, and that abundantly.

We met in band, and the Lord blest us together. I am astonished to see this means of grace so much neglected amongst God's people, which so *keeps up* his life in our souls.[65] Close communion with God should always be with us the one thing needful.

The last winter, when the Lord's hand was upon me, I found great rejoicing. I always thought there was great pleasure to be found in religion, but the pleasure far surpasses what I believed. Indeed, it is unspeakable. I have never had any conversation with any one who has received the perfect love of God which casteth out fear, so that I am ignorant of many things, but the more I attend the meetings, the more I am surprised that so few are set at liberty in the Lord. I should count it a great blessing if I were favoured with an opportunity of (frequently) attending the meetings, but the Lord is not confined to time or place. As often as we pray for grace with a sincere heart, he is ready to help.

While I followed my own will I found nothing but trouble and sorrow, but since it has been resigned to thine I have daily found pleasures unspeakable, and full of glory. Oh, blessed change wrought in me by my God, to commune with him in the land of the living! This is boundless love indeed! Oh, may I never do any thing to cause thee to withdraw these blessings from me.

O my blessed Lord,[66] it is not my past experience of thy love and favour that can satisfy me, without a continual supply of thy rich grace to my soul. My whole dependance is upon thee both for present and future blessings. I cannot distrust my blessed Jesus, who has dealt so lovingly with me. I can never sufficiently praise thy holy Name for the consolations of thy Spirit, and favours renewed day by day. This is love unspeakable! His delight is to make us happy. O how does his love exceed all that fancy can form, or imagination paint. The favoured soul is ready to say, I have heard great and glorious things spoken of thee, but, oh, how little was said to what I find! O how unable are the tongues of mortals to set forth the pleasures of those who are united to this Jesus! We joy in his redeeming love. He is most precious, and altogether lovely.[67] Believers, when tempted, look to him and see the tempter flee; when under a cloud, they rest on their beloved, who disperseth the cloud, and causeth the brightness of his light to shine around them; when afflicted, he is their good physician, and lays no more upon them than they are able to bear. He doth all things well. He is the lover of our souls,[68] or

would he have left the glories of heaven to take our nature upon him, and become a man of sorrows, and acquainted with grief? He saw our condition, came to our relief, and shed his precious blood that we might be reconciled to God, and made meet to reign with him in glory.

> Amazing stoop of Majesty divine,
> Here love doth in its utmost lustre shine,
> O let it raise esteem in mortals higher,
> And my whole soul with holy raptures fire.[69]

And yet what multitudes reject this Lover of our souls, and choose the crooked paths which lead to destruction!

O blessed be the Lord God of Israel, who alone is our Protector in this land of banishment. Surrounded with the malice and insults of a world lying in wickedness, we march with courage through the midst of our enemies unhurt and undismayed. Following the Captain of our salvation, who cannot err, we shall be led to certain victory. Though the earth be moved, and the hills be carried into the midst of the sea, we will not fear. The God of Jacob is our God and Saviour; and when the earth is burnt up, and the heavens wrapped together as a scroll, then the redeemed of the Lord shall mount with holy triumph above the fiery void, [and] return to Zion with songs and everlasting joy upon their heads, while sorrow and sighing shall flee away for ever.[70]

O ALMIGHTY LORD AND SAVIOUR, it is with heart-felt joy that I renew my covenant with thee,[71] to be wholly thine for evermore. With the greatest humility I further implore thy heavenly grace and Holy Spirit to be my guide through this my pilgrimage to the heavenly Canaan. O my Lord, with what delight do I pass through the wilderness of this world! The light of thy countenance daily shines upon me. O my God, it is enough. I have mused, and the fire burneth; but, oh! in what language shall the flame break forth? What can I say but this, that my heart admires Thee, adores Thee, and loves Thee? My little vessel is as full as it can hold, and I would pour out all that fullness before Thee, that my heart may become capable of receiving more and more. Thou art my hope, and help, and salvation. When I set myself under the influence of thy good Spirit to converse with Thee, a thousand delightful thoughts spring up—a thousand sources

of pleasure are unsealed and flow in upon my soul, with such refreshment and joy, that I am, as it were, wrapped up into the third heaven. I bless Thee for this soul of mine which thou hast created. I bless Thee for the knowledge with which Thou hast endued it. I bless Thee for that grace with which I trust I may, not without humble wonder, say, Thou hast sanctified it; though, alas! the celestial plant is fixed in too barren a soil, and does not flourish as I could wish it; but, O blessed Lord, let the dew of thy heavenly grace fall upon it, then will it not fail to flourish as willows by the water courses. Unless thy heavenly grace distill on the Christian's soul, it will wither, droop, and die. Oh then let us live dependent on Thee our merciful God for the supply of every want. Oh! how humble ought we to be, who, of ourselves, can do nothing; and who find, in the Friend of sinners, we can do all things. May I walk humbly with Thee, my God, all the days of my life, that I may at last rise to the life immortal.

PART TWO
DIARIES, JOURNALS, AND MEMOIRS

Introduction to Part Two

Both John and Charles Wesley encouraged their followers—women and men alike—to record their experiences in journals and diaries.[1] The essential purpose of this discipline among the early Methodist people was to keep a finger on their spiritual pulse. There is no question that the women viewed this practice quite simply as another spiritual discipline, an important, if not absolutely essential, aspect of accountable discipleship. Their growth in grace and movement toward the full recovery of God's image in their lives was connected with full self-knowledge. Perhaps even more important still, in their understanding, was the way in which God's will, way, and presence in their lives could be most clearly discerned in retrospect. Diaries and journals became an important means of divine-human encounter.

These private and personal spiritual autobiographies are of a different order from the "artistic enjoyment of the inner life" raised to perfection in Rousseau's *Confessions*. They do not reflect the didactic ambiance of a Benjamin Franklin, the historical perspective of an Edward Gibbon, or the monumental craftsmanship of a Goethe, all near contemporary male autobiographers.[2] At their most basic level, the women's journals and diaries are characterized by their lack of such sophistication. Their power is in their transparency. But in the hands of a skillful editor (not excluding the author herself), these life stories not only provided prototypical models for those inside the Methodist movement but also functioned as a defense of Wesleyanism to its "cultured despisers." In her Preface to the *Memoirs of Mrs. Elizabeth Mortimer*, Agnes Bulmer made this apologetic intent quite explicit. "As a professor of the religion of the heart Mrs. Mortimer gave proof that spirituality is not necessarily enthusiastic or fanatical. . . . Neither for the world, nor for its literature, does Christian biography possess a charm. . . . The smile of superciliousness may mark the contempt of the worldling; but angels look down with intense interest on those who have entered the lists, and are strenuously pursuing the career of immortality."[3]

The selections which follow reflect both the shaping hand of editorial pens and the artless design of their authors. Three of the six extracts are drawn from published [auto]biographies, edited by close friends and relatives of their subjects. These include the *Memoirs* of Grace Bennet (edited by her son), the *Experience* of Frances Pawson (published by the early nineteenth-century biographer and Methodist preacher, Joseph Sutcliffe), and the *Memoirs* of Elizabeth [Ritchie] Mortimer (edited by the Methodist poet, Agnes Bulmer). In an effort to counterbalance this more widely circulated and crafted material with the unpolished diary of the early Methodist woman, I have alternated the published extracts with the unpublished diaries of Sarah Crosby, Bathsheba Hall, and Anna Reynalds.

Journals and diaries, of course, almost always reflect serious introspection, and this is the first impression to be gathered from these selections. The intentional self-analysis is sometimes brutal, sometimes humorous, but always with the clear intent of knowing God through the sacrament of the self more fully. The narratives slide quite fluidly from time to time into prayer. Such transitions are natural and reflect the Methodist understanding of the Christian life as a "way of devotion" in which ongoing conversation with God is the normal rhythm of the committed disciple. In fact, "conversation" itself is another striking theme throughout these writings. Frances Pawson wrote, "I have often entered in my journal the more striking remarks of conversation because it is food for my soul when I read it at a future day." In all of these areas, the women's journals reflect the piety of early Methodism as well as an understanding and experience of Christian praxis rooted in grace and animated by vigorous intentionality with regard to accountable discipleship.

One peculiar characteristic to note is the women's frequent allusion to hymns. Early Methodism was born in song; it is not too much to say that the followers of the Wesleys sang their faith before they preached it or reflected on it. In an earlier study of hymn quotations in the writings of early Methodist women, I discussed the frequent use of hymns in religious accounts, diaries, and journals.[4] The connection is natural. Hymns expressed the experience of the early Methodist women in terse, clear, and memorable ways. They articulated and shaped experience. But of particular interest is the way in which women apparently felt free to manipulate the texts of the hymns to suit their various circumstances. "O what are all my sufferings here"

becomes "all our sufferings" in a literary act of Christian solidarity.[5] Or the movement might be in the opposite direction, toward the more intimate first person singular. "For more we ask, we open then" becomes "For more I ask, I open now/My heart to embrace thy will."[6] Note how the women use the hymns of early Methodism, therefore, in the narrative to follow.

Multiple references are made in these selections to two distinctive Wesleyan services of worship: covenant renewal and the Love Feast. In early Methodism the Service of Covenant Renewal was a corporate reaffirmation of individual discipleship.[7] Culminating in a celebration of Holy Communion, these acts of renewal have usually been held on the first Sunday of the New Year since 1762. The rite itself, consisting of lengthy exhortations and prayers, came from Puritan sources in which the concept of covenant was central. The service was intended to mark a new turning back from sin to God and a fresh acceptance of God's purposes for the community of the faithful. Many of the women note the importance of the "covenant prayer"—the central act of rededication—in their lives and allude to it directly in their writings. Based on the Puritan text of Richard Alleine, John Wesley's prayer reads in part:

> I am no longer my own, but thine.
> Put me to what thou wilt, rank me with whom thou wilt.
> Put me to doing, put me to suffering.
>
> Let me be employed by thee or laid aside for thee,
> exalted for thee or brought low for thee.
> Let me be full, let me be empty.
> Let me have all things, let me have nothing.
> I freely and heartily yield all things
> to thy pleasure and disposal. . . .
> thou art mine, and I am thine. So be it.[8]

The Love Feast, or *agape,* was a symbolic meal, not to be confused with the Sacrament of the Lord's Supper in which bread is broken and water drank from a common cup.[9] Consisting essentially of testimony, prayer, and the singing of hymns, this fellowship meal, celebrated either by lay or clergy leaders, calls to mind the experiences of spiritual fellowship that Jesus shared with his disciples. Wesley rediscovered this ancient practice through the Moravian community

in Savannah, Georgia in 1737. Back in England, it very quickly became a central feature of the Evangelical revival and a regular part of the Methodist Society meetings. A natural extension of the class and band meetings in Methodism, the first Methodist Love Feast was apparently held by women of the Bristol Society on April 15, 1739. The supreme value of the Love Feast for the women lay in its open fellowship and its Christian expression of freedom and equality. It provided a public sphere for the exhibition of women's gifts and the open expression of their faith.

These excerpts from the diaries, journals, and edited memoirs of early Methodist women afford an important window into their souls.

Memoirs of Grace Bennet

Editor's Introduction

Grace Murray (1718–1803) was a prototype for female leadership in early Methodism. She first appears in connection with the Foundry Society in London[10] where she is listed as one of the early band leaders in 1742.[11] Her *Memoirs*, including the account of her religious experience, afford a glimpse of early Methodism in its London and Newcastle-upon-Tyne centers. In October 1742 Wesley appointed her one of the first class leaders of the newly established Society at Newcastle, soon to become the northern center for the Methodist movement, and then Housekeeper at his innovative Orphan-House headquarters. According to her son and biographer, Grace "traveled by Mr. Wesley's direction, through several of the northern counties, to meet and regulate the female societies; afterwards she went over into Ireland for the same purpose."[12] There seems to be little doubt that she was the principal person employed by Wesley to organize the women's classes of the Methodist connection and, as his frequent traveling companion quickly endeared herself to the itinerant evangelist.

The relationship between Grace and Wesley has long been a controversial subject, to say the least. Nehemiah Curnock, the earliest editor of Wesley's journal, first drew attention to their relationship in an article on "The Loves and Friendships of John Wesley" in 1902.[13] J. Augustin Leger attempted to provide a full and accurate reconstruction of the relationship based on all the pertinent documents and previous studies in his *John Wesley's Last Love* (London, 1910). The fact that Grace and John Wesley were formally betrothed by a contract *de praesenti* in Dublin in 1749 is beyond dispute.[14] They were

in final preparations for marriage when Charles Wesley intervened to alter their course irrevocably.

In the important document concerning his relationship with Grace, the manuscript of which is preserved in the British Library, Wesley highly commends her labor by his side. "I saw the work of God prosper in her hands. . . . she was to me both a servant and friend, as well as a fellow-labourer in the Gospel."[15] Band and class leader, visitor of the sick, housekeeper, and itinerant "regulator" of women's groups, she functioned, in effect, as a subpastor, leading the Methodist family in their simple acts of worship and service. Long after the death of her husband, Grace continued conducting prayer and fellowship meetings outside the circle of Wesley's Methodism; and, only once more, in old age, did Wesley and Grace Bennet meet.

❈ ❈ ❈

Feb. 19 [1792]. How sweet is it to enjoy communion with God! One drop of the Love of God makes full amends for all our trials. I had rather have a sense of this, by the Divine Spirit, than enjoy all the riches of both the Indies; yea, than all worlds.

> My Jesus to know, and feel his blood flow,
> Is life everlasting, and heaven below.[16]

Feb. 24. This has been a heavy day, yet a *good* one. It is good to wait on God. His ear attends the softest prayer, but oh, how backward do I find my heart to the improvement of this privilege!

March 5. If I was mistress of the universe, it could not yield me one moment's real comfort. No, nothing short of Christ, being formed in my heart, can make me happy, living or dying. Then, Lord Jesus, thou that seest and knowest my heart. Come quickly, and finish thy work in me. Make a speedy end of sin! I cannot deceive *thee*, let me not deceive myself!

> If rough and thorny be the way,
> My strength proportion to my day;
> Till toil and grief and pain shall cease,
> Where all is calm, and joy and peace.[17]

72

March 12. I bless my God, who has enabled me to trust in him, as a *widow*, these *three* and *thirty* years. He is a promise-fulfilling God. I have ever found him faithful.

May 27. Some authors I love to read, and have been profited by their works. But the word of God is my chief delight; this cannot err. If I know my heart, it is my desire that my whole life may be squared by the rule laid down therein. O Lord, give me understanding, that I may know the will of God and my duty towards all men; how to act in my sphere of life! for, surely we were not sent into the world for our own sakes alone, but for the good of others, as far as we have ability. We should therefore consider, what place we are in, whether an eye, or a hand, or a foot in the body of Christ [cf. 1 Cor. 12:12-26], and act as such.

September 26. It is hard to give up our *All* to Him who gave us all we enjoy, yet it must be done. Of myself I can do nothing, but through Christ strengthening me, I can do all things [cf. Phil. 4:13]. Then, O Lord, I beseech thee, make me able and willing to do, and to suffer thy will to be done in and by me! Oh, for such a heart as leaves the whole to God! Thus I can say with all my heart, I would with every breath praise my God. Oh, to grace how great a debtor![18] Blessed be God, who made me sensible that [it] is by grace alone I am saved, and enjoy all mercies.

November 30. It is good to wait upon God. The face of Moses shone when he came down from the mount after he had been conversing with the LORD of hosts. And is it not true of every Christian, when he has been conversing with God in meditation and prayer, (if the intercourse has been open between God and his soul) that he afterwards shines in humility, meekness, love, and spiritual mindedness? This moment I feel a little what this means. I am astonished to think that the Almighty should stoop to hear such a sinner as me! Oh, that I could extol him! Lord, increase my capacity of loving and serving thee!

[August 27, 1793.] When I came to live at C——, I promised myself great pleasure amongst the people of God. I proposed to several to set up private meetings amongst the *women* for prayer and religious conference,[19] but they all made excuses. This was a grief to me, yea, it hurt my spirit, and caused me to go mourning many days. The spirit that was amongst them was quite different to what I had been used to. There was such stiffness and shyness in their looks, as if they

would say, "*Stand by, we are holier than you.*" If I had not known in whom I had believed, and something of my own heart, I might have thought their religion all a delusion and been turned out of the way. But blessed be God, he kept me from taking offence. He knew my aim was right. Therefore I persevered in going amongst them to hear the gospel. Oh for the mind that was in Christ! If we are Christians, we must act according to the rule laid down in his word.

[September 2, 1793.] I am ashamed and confounded before God for what has happened this day. A woman with three children came to my door to ask for charity. I found my heart rise against her; but why, I could give no reason. I did relieve her, but I am sure much against my mind. *This cannot be charity.* But whatever it was, it drove me to God both for myself and the woman and her children. I am ashamed before God for the unchristian temper I felt in myself. I think I am farther from the mind of Christ than I was fifty years ago. O Lord, destroy all the works of the Devil in my soul, and make me pure in heart that I may see thee. Amen!

Oct. 19. To day, reading Mr. *John Wesley's* Journal,[20] how did I lament in calling to mind those happy days in the church he mentions! For I was an eye and ear-witness of those persons God was pleased to work upon in that extraordinary way. Oh, I am grieved to feel myself so low and dead, grovelling here below my privileges as a child of God! O Lord, quicken and raise my soul to things above, that I may have my conversation in heaven, and my fellowship with the Father and his Son Jesus Christ! My soul hath enjoyed that happy state in a degree, why not now? It is the Lord's will that I should *rejoice evermore* [1 Thess. 5:16]; but my unfaithfulness makes me many times hang my *harp upon the willows* [Ps. 137:2], crying out, *my leanness, my leanness* [Isa. 24:16]. O my God, when wilt thou return and restore the light of thy sweet countenance and that holy familiarity I have enjoyed with thee!

Jan. 6, 1794. It being *Lord's Supper-day,* and the first sabbath in the New Year, my soul longed to go once more to partake of that sweet ordinance of bread and wine, in commemoration of my Lord's death for me a sinner. *He brought me into his banqueting house, and his banner over me was love. I sat under his shadow with delight, and his fruit was sweet unto my taste* [Song of Sol. 2:3-4]. I had a precious view of my interest in the glorious Redeemer, in all he did and suffered for me.

Yonder is the fulness, but this is a taste. I shall be with him, ever to behold his glory.

Jan. 22. Last night my little company met. My heart was enlarged as I endeavoured to shew them in what manner I believed Christ to be the sinner's hope for salvation, and how we are accepted in him; that it is not for any thing wrought in us by the Divine Spirit, nor for all the works we have done or can do, but for the righteousness of Christ alone *imputed* to us, without any thing in or of ourselves.[21] Doubtless, what the blessed Spirit worketh in us is a qualification or meetness for heaven, but 'tis not this which gives us our title to it. God looks upon the believer *in* Jesus, as if he had not committed sin. But, *out of Christ*, if a soul were enriched with all grace, God would be to that soul a consuming fire. Our compleatness is in Christ Jesus alone. I fear some build upon their *comforts*, instead of Christ, for their salvation! Do not, however, mistake me, and think I am speaking against comforts; far from it. I delight to feel the comforts of the Holy Ghost, yea, there is no true Religion without them, less or more. And perhaps I, the least of all the family of heaven, not worthy to be called a child of God, have tasted, and could say, as much as most of these sweets of Paradise. But I forbear. Christ is All and in All to me.

June 2. The promises and faithfulness of God ought to be preached, to strengthen his children, that they may walk steadily on their way. The *everlasting* love of God will enable souls to endure hardship, if they believe the crown and prize are sure before them, *their anchor being cast within the veil, sure and steadfast.*[22] If Jesus be in the ship, it cannot be lost. He will awake and rebuke the storm. Christians of riper age ought to have *their* proper food, and not to be starved because of *babes*. Let these have their milk—they ought—and be content.

April 16 [1797]. Easter Sunday. This day my Lord rose from the dead, triumphing over all the powers of darkness, and this I feel he did for *me*. The Spirit of God beareth witness with my spirit that it is so [cf. Rom. 8:16]. Then, my soul, doubt no more. Thy ransom is paid to the full. God's law and justice are satisfied. Praise the Lord, O my soul. For Jesus' blood hath made me free from the law of sin and death [cf. Rom. 8:2]. O Lord, help me to walk worthy of my calling here, that I may walk hereafter with Christ in white. Amen!

May 13 [1799]. My happiest days were when I rose at 4 o'clock for prayer, and preaching at five. And I would say it to the praise and glory of God, I find it no cross at this day (being in my 84th year) to

rise early to wait upon God with his people, no more than when I was *thirty*. O Lord, keep my soul awake and athirst for thee! It has been my grief to see and feel such deadness and dulness amongst Christians. Jesus Christ was whole nights on the mountain in prayer.

June 23 [1800]. I was helped to go to hear Mr. M—— preach an awful[23] sermon from the mighty God speaking to Moses out of the burning bush [cf. Exod. 3:1-12]. It was good for me that I was there. I was struck with holy awe, which I want more and more to feel. Oh, I long for the time, when I shall cast my crown before his feet and sing *Worthy is the Lamb that was slain*, [Rev. 5:12] etc. Miss D—— is going, but I may be gone before her. I shall be glad to welcome her into the regions of bliss. We have talked together about the sweet name of *Jesus*; but, then we shall see him face to face [cf. 1 Cor. 13:12]. O transporting thought! Then *all gloom shall be fled!* [cf. Rev. 7:17].

[February 22, 1803.] I have had wonderful manifestations of God to my soul, far beyond many. But I have always been afraid of saying too much, rather than too little, wishing rather that my life and conversation should witness to the truth of my profession. So far as I know my own heart, it has been my desire and study to adorn the doctrine of God my Savior in all things. But I would have no encomiums passed on me. I AM A SINNER, SAVED FREELY BY GRACE. Grace, divine grace, is worthy to have all the glory. Some people I have heard speak much of our being faithful to the grace of God, as if they rested much on their *own* faithfulness. I never could bear this. It is *GOD'S FAITHFULNESS to his own word of promise*, that is my only security for salvation. [Grace died the following day, February 23, 1803.]

The Diaries of Sarah Crosby

Editor's Introduction

Sarah Crosby (1729–1804) was the first woman preacher of Methodism and, therefore, claims a very important place, in the history of the tradition.[24] Converted from Calvinistic inclinations under Wesley's preaching, she received her first membership ticket and joined the Foundery Society in London in February 1750. May 1757 marked a critical turning point in her life as she met Mary Bosanquet and became a part of her influential circle of women. Momentous events occurred in 1761 as well when Sarah accompanied Mrs. Dobinson to Derby, began holding class meetings there in February, and "preached" to an enlarged class of some two hundred on the eighth of that month. Uncertain as to whether she had overstepped her bounds as a woman, she wrote immediately to Wesley and thereinafter engaged in a lively correspondence with her mentor on the subject of women's preaching.[25] In March 1763 she moved with Mary Bosanquet and Sarah Ryan to the Leytonstone orphanage, and then again in 1768 to Yorkshire to assist in their resettlement at Cross Hall. In the summer of 1772 she traveled extensively with Wesley and another woman preacher, Elizabeth Hurrell,[26] throughout Yorkshire. She died at Leeds on October 29, 1804.

A number of manuscript sources related to the life and work of Sarah Crosby have survived. Most important among these are her manuscript Letterbook and her collected Papers (1760–1804), both of which are a part of the Perkins Library Collection of Duke University. While composed primarily of copied correspondence, the collections also include religious accounts, notes, and prayers. In his compilation of materials on early Methodist women, Zechariah Taft reported that Mrs. Crosby:

... left behind her three or four books in manuscript, each of them containing two or three hundred closely written pages; ... it evidently appears that she intended them for publication. After the death of Mrs. Crosby, these journals fell into the hands of her intimate friend and companion, Mrs. Tripp, and from thence to Mrs. Mortimer, who had made a few extracts for the Methodist Magazine, but she did this very sparingly. ... Having obtained the loan of part of these journals I have made some very considerable extract of this Memoir.[27]

These manuscripts must be extant, but their location is unknown. The text which follows is based on a collation of Taft's excerpt (*Holy Women* 2:23-115) and "An Account of Mrs. Crosby, of Leeds," *WMM* 29 (1806): 418-23, 465-73, 517-21, 563-68, 610-17. Sarah, upon the request of Wesley, prepared an account of her religious experience as well, dated August 17, 1757.

� � �

January 31, 1761. On the 7th I left London, and the 8th, reached Derby.[28] I met a few friends, and we were truly sensible of the preference of our divine Master. This is as yet a barren place, but my Lord has made it as the garden of Eden to my soul. I have had many blessed interviews with the King of kings, and have sat under his shadow with delight, while his fruit has been sweet to my taste. On the 17th, I had a profitable time in conversation with a friend, and was much blest in meeting a few who, I believe, desire to save their souls. Saturday the 24th I was much quickened in prayer. My soul was deeply sensible of the presence of God. I saw great perfection in him, and many imperfections in myself, which I desire to be saved from. I felt my soul humbled before him, and had also power given me to rejoice with joy unspeakable, and great liberty to pray for friends and all mankind. Praised be the Lord, who maketh this house an house of prayer. This morning I rose much refreshed at six, and humbled myself before the Lord for the unprofitableness of my dreams.[29] Found the presence of my Lord while reading, and all the day enjoyed calm and steady peace.

Sunday, Feb. 1. This morning I was poorly in body, but the Lord was present with me, especially in prayer. At church I found him near, and was truly thankful for the opportunity of going to his

table.[30] In the evening I was much assisted by a sense of the presence of my Lord, while I met twenty-seven people in class.

Sun. [Feb.] 8. This day my mind has been calmly stayed on God. In the evening I expected to meet about thirty persons in class, but to my great surprise there came near two hundred. I found an awful, loving sense of the Lord's presence, and much love to the people, but was much affected both in body and mind. I was not sure whether it was right for me to exhort in so public a manner, and yet I saw it impracticable to meet all these people by way of speaking particularly to each individual. I, therefore, gave out an hymn, and prayed, and told them part of what the Lord had done for myself, persuading them to flee from all sin.[31]

Friday [Feb.] 13. This day being appointed for a public Fast,[32] I humbled myself in prayer. In the evening I exhorted near two hundred people to forsake their sins, and shewed them the willingness of Christ to save. They flock as doves to the windows, tho' as yet we have no preacher. Surely, Lord, thou hast much people in this place! My soul was much comforted in speaking to the people, as my Lord has removed all my scruples respecting the propriety of my acting thus publickly.[33]

Wednesday [Feb.] 18. Yesterday I visited a dying person, met two classes, and was much engaged with friends. My Lord was with me.

> O how shall I thy goodness tell,
> Saviour, which thou to me hast shewn![34]

I have been all this day kept in perfect peace, and in the evening was much drawn out in prayer for myself and all my dear friends. O my Jesus, thou art my all in all!

> Sink me to perfection's height,
> The depth of humble love![35]

Good-Friday, March 20. I was very ill this morning, but enabled to go to Church and commemorate the death of my precious Lord. In the evening I read a sermon on the occasion to several persons who were met together and went to bed weary but happy in God.[36]

Sunday [March] 22. I was very weak this morning, but found the Lord near in family prayer. All the day my soul was happy. In the evening the Lord was very present while I prayed and exhorted

many sinners to turn to God. They were much affected. I found nearness to God in private prayer. My strength of body began to return, and has increased ever since.

> Praise the mighty Jesu's Name:
> Thee, the Friend of sinners, sing,
> Whose love is ever new.[37]

Sunday, May 22, 1763. This has been a good day to my soul. I could join with Mr. C[harles] Wesley in acknowledging the more grace a person has, the more he knows of his own meanness and poverty, distrusting himself while he trusts wholly in Christ. This mark I have, as Mr. C[harles] W[esley] explained it. I come to the Lord empty, not full; poor, not rich; and weak, not strong.[38] Alas! how poor and weak I am, who can tell but he that judgeth righteous judgment [cf. 1 Pet. 2:23]! I seem to myself to be all infirmity, and can truly say, "No good thing dwelleth in my flesh" [Rom. 7:18]. I am not, indeed, torn by wrong tempers, or sinful desires. In this respect I have rest, and not only in this, for my confidence in the Lord is strong and increaseth daily, as also my love to him and his dear children. But I have one want, one desire, which is yet unsatisfied, and that is, that I may always live in the spirit and mind of Jesus.[39] O who can conceive the degree of mildness his precious heart felt to poor sinners or the tenderness of love that melted his breast towards his own people, or that fervency of delight he enjoyed in communion with his heavenly Father? O Jesus, explain this to my heart!

Sunday, May 1, 1768. Full of faith and expectation, I met the band. Jesus made me his mouth unto the people, and poured the spirit of love, zeal, and wisdom upon me for their instruction. In the last prayer he so abundantly revealed his glory to the eye of my faith as melted my soul before him and them. They catched the holy flame, while tears of love overflowed my eyes. O! the great, the glorious love, wherewith the Father himself loveth us! A taste causeth my soul to melt in desire and love before him.

Monday [May] 14 [1768]. This was a day of fatigue in outward employment, but I had inward rest. In the night Sister [Sarah] R[yan] was taken very ill, but soon our Lord poured a spirit of prayer on us all. I believed before, but now I was assured we should go to live in Yorkshire. While I prayed the Spirit of faith rested on me. I felt the Lord very near, and in his light saw that he had already appointed

the place where we should pitch our tent, though as yet unknown to us.[40] And as I said, "Lord, guide us," he answered in my heart, "The Lord shall guide thee continually, and satisfy thy soul in drought, and make fat thy bones, and be unto us as a place of broad rivers and streams" [Isa. 58:11], while his light, as the brightness of the sun, "shall shine upon our path" [cf. Ps. 119:105]. O! that I may be ever thankful for this favour!

Thursday, July 14, 1769. I unfeignedly thank my Lord for all the fatigue of body and mind his powerful hand has helped me through since I last recorded his mercies. Before we left Laton-Stone, we had a time of suffering, and our journey into Yorkshire was trying to the flesh. But our Lord brought us safe hither at the appointed time. Since we came to this place it is impossible to describe our sorrows, or satan's assaults. Yet hitherto hath the Lord helped us, and our confidence in him is greatly increased. From the first I always believed it was the will of God we should come and settle in Yorkshire, but never did I discern satan oppose any thing with more violence and constancy than he has done this. My prayer has been that he might not be suffered to frustrate the Divine will, and I believe he shall not. But "that out of the eater shall come forth meat" [Judg. 14:14], and "when our Lord has tried us, we shall come forth as gold" [Job 23:10].

Monday [Nov. 1]. While conversing with some friends, I found a persuasion which has lately rested on my mind, much increased, viz. that though we had prayed much for blessings, we had not praised God as we ought to have done for those which he had conferred on us. And, in particular, we were all made sensible we had not borne testimony simply and plainly, at all proper times, to the great salvation God had wrought in us, nor praised him for it as it was our duty to do, and that therefore we had some times suffered loss in our souls. O! that the time past may suffice! Lord, help me to be thy witness in this also. A field of light opened before me, and by persuading every one I spoke to, to praise God for what he had done for them, my own soul was lost in wonder, love, and praise.[41]

Sunday [Jan.] 2. I rose before six and had a sweet morning. I opened upon the 8th verse of the 143d Psalm, which set my soul on fire with Divine Love. O! how good thou art! I had a comfortable ride to D——r, about ten miles, with a friend. It was the strongest frost I ever knew. We had a good meeting with many simple people and rode home in the evening. I was almost starved with the cold, but

sweetly happy. Our conversation was on the great love of Jesus, self-denial, and taking up the blessed cross.

> To the cross, thine altar, bind
> Me, with the cords of love.[42]

Thursday, Oct.14 [1776]. I had a blessed meeting at six, and afterwards a good time in band with the married women. I spent a comfortable afternoon with the loving people at ———, and met a house full at six: it was such a meeting as several of them never enjoyed before. I have not often had such a one. My Lord so poured on me the spirit of prayer, as I know not how to describe. I thought I could have died for sinners, my God put such a desire into my heart for their salvation. Most of them were much affected. Hundreds of tears were shed, and the cries of many ascended up before our Lord. Several were more deeply awakened than they had ever been before, and some filled with hope of his near approach. The powerful presence of Jehovah filled the house. O! how shall a worm adore thee? Thou hast taught me to give all the glory of thy grace to thee, my God, and my All.

Wednesday, Dec. 31, 1777. Glory be unto thee, my Lord, who hast brought thy poor helpless creature to the end of another year. How shall I thank thee for all thy multiplied mercies! I have not improved either my time, or talents, as I wish I had, nor profited by my mercies, as I ought to have done. Yet, blessed be my gracious Father, I have great cause to be thankful on many accounts. I have lived, (adored be my kind Saviour), a life of heaven upon earth, and made some use of my time and multiplied mercies. If I know myself, my one desire has been to glorify my Lord, in thought, word, and deed, and to serve his dear children, in doing which I have many times taken up my cross many ways, some of which can only be known to my Saviour. My strength I ascribe unto thee, my Lord God. Thou hast enabled me, from the first of last January to the fourth of this month, (December,) to ride 960 miles, to keep 220 public meetings, at many of which some hundreds of precious souls were present, about 600 private meetings, and to write an 116 letters, many of them long ones, besides many, many conversations with souls in private, the effect of which will, I trust, be "as bread cast on the waters" [Eccles. 11:1]. All glory be unto him who has strengthened his poor worm. Since the 4th I have employed myself chiefly in retirement and in assisting the little flock at Whitby.[43]

April 23, 1778. O! how good thou art, my Lord, thus to bless an helpless worm! While praying alone, my spirit was overpowered with the Divine presence. My soul melted within me with love to my Lord, and very fervent desires for the salvation of precious souls, especially the souls I had lately been called to speak to in five or six places. Sure I am that prayer, and those tears, cannot remain unanswered. It seemed as though I could not live if Jesus did not save sinners. Several very dear friends were much on my mind, for whom I poured out my very soul before God. I had a solemn, happy day, and in the evening a good meeting with many attentive people, to whom I spoke a little from the 23d Psalm.

Saturday, May 9. Glory be unto my Lord, who has taken me into his banqueting house, and his banner over me has been love [cf. Song of Sol. 2:4]. I abode on my knees an hour and half, and was penetrated with the Divine presence while all my soul seemed dissolved in love. O! how precious was my Jesus. I felt, I love him above all his creatures, though he poured much love into my heart for my friends also, and for all his creatures. How good is God! Words are too mean to speak thy worth. Let silence praise thee for the mercy this day manifested toward the most unworthy.

[September 1799.] I have neglected to record many of my journeys and labours; also the blessed manifestations of his love and divine communion, both day and night, which I have often been favoured with during these [p]ast 20 or more years, for various reasons. Let me never forget or neglect to be thankful to thee, the blessed Author of all my mercies, for the multiplied favours thou hast bestowed and art increasingly bestowing!

I am now near 70, and have lived near six years in this house (at Leeds).[44] I have found, and still find it, a peaceful habitation, a quiet resting-place, both to soul and body. I am often afflicted with painful infirmities of body, and am not altogether without temptations of different kinds, though I am assaulted with few, very few that interrupt my peace. Yet sometimes they hinder my joy in God; but my soul, in general, dwells in peace and love. I live by faith on Jesus, my precious Saviour, and find my last days are my best days, not one of all the good things the Lord hath promised, having failed.

Blessed be my Lord, he enables me to meet two classes of about 30 persons each, every week, and two or three bands. He inclines many to come who have long met with me, though they live at a distance.

May our Lord abundantly bless their precious souls and help us all to live in love, and in the will of God, and then in heaven for ever.

October 30 [1799]. This ought to be a day of prayer, humiliation, and thanksgiving, for the long-suffering of the Lord. It hath proved salvation to my soul. It is now 50 years since I first felt the love of God so shed abroad in my heart as to assure me of my interest in Jesus Christ. I then first beheld his smiling face and rejoiced in his salvation. What greater cause have I now to rejoice! The Lord is still my salvation. He hath helped me through various trials, through snares and temptations his hand has preserved me. He hath called me to prove a greater salvation, a fulness of love. O! how shall such a worm as I am give praise to thy glorious Majesty? I will take the cup of salvation, and call upon the Name of the Lord for more [cf. Ps. 116:13].

> For more I ask, I open now
> My heart to embrace thy will.[45]

Jan. 27, 1800. Blessed be God, I have had a good beginning of this New Year, the last, probably, I may ever begin in this world. O! that it may be the best I ever had! . . . I have lately felt much weakness of body, but my soul rests in God.

Jan. 21, 1801. . . . On the first day of this year, while praying in my class, the Lord gave me such a manifestation of his loving presence, and such an assurance of his favour, as melted my soul into love. My friends partook of the blessing, and we praised our Lord together. On the Sabbath-day, I was too ill to attend publicly to renew my covenant with my Lord among his people,[46] but being alone, I offered myself afresh to him who is the Leader of his people.—He graciously shewed me, my present call was patiently to suffer, with resignation, all the will of God, offering praise and thanksgiving to him who has poured a spirit of praise into my soul.

Sunday [Feb.] 21 [1802]. The sermon and last prayer were quickening seasons. Many were much blest. Mr. B. seems so very desirous in every sermon to stir the people up to more earnestness, that it often seems as if the glory was descending. Every time last week he agonized with God in prayer, in a very extraordinary manner, and spoke sometimes so plainly of the hindrances to salvation, as was much blest to many. It appeared as though the time drew near for the Lord to display his power and overwhelm our souls with his glory.

The Experience of Frances Pawson

Editor's Introduction

Like many of the early Methodist women, Frances Pawson (1736–1809) is known, if known at all, by virtue of connection with her husband. But this is unfortunate, because Frances has her own story to tell—a saga of spiritual doubt and searching which led her eventually to a depth and maturity of faith renowned to many of her contemporaries. Fortunately, her manuscript journals were edited and published by Joseph Sutcliffe under the title *The Experience of the Late Mrs. Frances Pawson, Widow of the Late Rev. John Pawson* (London: Printed at the Conference Office, by T. Cordeux) in 1813.[47] The following excerpts are taken from this publication, having been compared and collated with the originals.

Born into the wealthy and cultured Mortimer family of York on May 11, 1736, her education continued unabated despite her father's death when she was only sixteen years of age. Her brother, the Reverend Charles Mortimer, an Anglican priest and later Rector of Lincoln College, Oxford, attempted to dissuade her from "religious enthusiasm" when she was exposed to it in London in the early 1770s, but his efforts were to no avail. In York she continued to attend religious meetings in the home of an Anglican evangelical, Mrs. Carr, and was increasingly drawn to the Methodists who frequently participated in these gatherings as well. During the first half of the year 1774 she experienced continuous bouts of confusion, doubt, and intermittent depression. John Spence, a class leader in the Methodist Society in York, proved to be an important influence in resolving this spiritual turmoil. Important breakthroughs came for her in 1775, but it was not until 1780 that she formally joined the Methodists.

On September 4, 1782 she married the Reverend Wren, an ardent Calvinistic preacher of the Countess of Huntingdon's Connexion.[48] It was an unhappy marriage that was short-lived due to his early death in 1784. John Pawson, recently widowed himself and stationed in Manchester, commissioned a preacher's wife to discover how Frances might react to a proposal of marriage. He pressed forward his interests without delay and married her on August 14, 1785 just days before their move to his new appointment in Edinburgh. Returning from Scotland to Leeds in 1787 she discovered many kindred spirits in this burgeoning center of women's activity—soulmates such as Mrs. Downes, Miss Rhodes, and her friend, Elizabeth Ritchie (Mortimer) of Otley, names that fill the pages of her journal.

Frances exchanged correspondence with Wesley toward the close of his life, and these letters provide important insight into her character and the aged revivalist's esteem for her. In his letter of November 16, 1789 (*Letters* [Telford] 8:184), Wesley encourages her to continue to be useful and "particularly to those that either already enjoy or are earnestly seeking perfect love." He stresses the need for continual growth in love, a quality which he discerns in her life and seeks to emulate himself. Likewise, in a letter to Adam Clarke, dated November 26, 1789, referring to their exchange of letters, he observes, "Last week I had an excellent letter from Mrs. Pawson (a glorious witness of full salvation), showing how impossible it is to retain pure love without growing therein" (*Letters* [Telford] 8:188). Considered by many to be a winsome example of Wesley's doctrine of perfect love, Frances died as she had lived—in Christ—on June 2, 1809.

❉ ❉ ❉

July 22 [1772]. This evening I spent a most agreeable hour in a select party of Christian friends. Mr. William Richardson, a clergyman of Cumberland who had lately come to York,[49] expounded Luke iv. 17, 18. Mrs. Carr desired him to read the 54th chapter of Isaiah.[50] He seemed much struck with the promises which are there made to the church. And, as the less is always included in the greater, they seemed to have a peculiar reference to the enlargement of this little Society in York. Mrs. Carr then spoke of the comfort which, for some

time, those promises had afforded to her soul. Miss S.[51] then spoke her experience. It was simply the language of faith. She related the work of grace from the beginning till the time of her being justified, which shows the wonderful goodness of the Almighty, as she had no teacher but him, nor the least assistance from any experienced friend.

Sept. 6. On reading Mr. Law's *Serious Call to a Devout and Holy Life*,[52] I was very much struck with the force and novelty of his arguments. They seemed to proceed from the Spirit of God. That part where Miranda is mentioned, as never employing herself in work that contributes to vanity, was strikingly applicable to me. A Christian woman employing herself in the embroidery of dress has the appearance of one who wishes to please the fashionable world rather than Jesus Christ. Hence I entreated the Lord to enable me to sacrifice every part of my dress, which might in anywise contribute to flatter my vanity.[53]

Nov. 28 [1773]. Mrs. Carr having called yesterday, I told her all my trial about attending the Methodist chapel. She advised me to go if I felt my mind drawn to go. On that account my heart was sorely distressed all the morning, for I had an amazing weight on my spirits, lest the Lord should draw me to go in the evening. Satan sorely harassed me by injections of pride, and a cloud of darkness rested on my mind.

But whilst I remained in darkness, my mother was brought into light. It was but lately that she had embraced the idea of feeling her acceptance in the Beloved. It is impossible to describe the joy that she felt. Both in reading and in conversation she seemed to abound in spiritual improvements, and with amazing ease. A new song was put into her mouth, even of praises to our God, Psal. xl. 1, 2, 3.

Nov. 29. Mrs. Carr, on hearing the good news, seemed much pleased with the manifestation my mother had received, but wished her still to pray for a clearer evidence. At this interview I told Mrs. Carr the struggles I had felt respecting an occasional attendance on the Methodist preaching. She spoke well of the preacher, and said, if I chose to accompany her, I might put on a red cloak and bonnet, and no one would know me. The enemy tempted me to levity at the idea of my dress; but this good woman dropped me a gentle caution against levity, and advised me to pray against giving way to it. Notwithstanding the disposition I was in, the great truths delivered by the preacher made an impression on my mind, and they were

applicable to my state. The text was, "Behold, I stand at the door and knock" [Rev. 3:20] &c. On returning home my mother seemed no way displeased with me for going to the chapel, which I took as a proof of the grace she had received. For her prejudices against Methodism were very strong.

May 24 [1774]. This afternoon I attended the love-feast for the first time. The sight of so numerous a company of serious people affected me. The decency, propriety, and seriousness, with which the preachers conducted the meeting, was extremely pleasing.

I was two or three times brought to tears. . . . Satan tempted me not to think, as I ought, of the experience of some who spake, because the country people related it in so uncouth a manner. On coming home my mother said nothing amiss to me, though she knew I had been at the meeting.

June 15. My cousin Hopwood and I walked this morning to Dring-houses. I believe there is a work of grace begun in her heart. Miss Scott also, who was awakened under Mr. [William] Richardson, seems now to be brought into liberty. I had been, of late, deeply affected for my dear friend Mrs. Carr, who is severely afflicted with a cancer. Yet it is amazing with what composure and sweetness she speaks of death and of the things of God.

June 19. I met Mrs. Crosby, an eminently pious woman, of Leeds,[54] at Mrs. Buckle's.[55] She seemed much interested in my welfare, and gave me many instructions, and advised me particularly to pray with simplicity, and to request the Lord to teach me to come to him with all the simplicity of a little child. She desired my good, not only on my own account, but with a view to the good it would prove to others.

July 9. This evening I heard Mr. Wesley.[56] His venerable looks inspired me with a veneration for him I cannot express. Mrs. Hall invited me to breakfast with him.[57] I accepted the invitation, and was much pleased to see how this great minister of the gospel conducted himself among his preachers, with cheerfulness, ease, and simplicity.[58]

Aug. 21. Mrs. Carr, on knowing that I was reading Mr. Fletcher's *Checks to Antinomianism*,[59] advised me to use caution, and observed, that those who attended her meeting were led on, in many respects, different to the Methodists. I endeavoured to take her advice. But I seldom open his books without profit. His remarks, on the just living by faith were, at this time, made very useful to me. My soul began to

assume an easy cheerfulness. I had an agreeable conversation with Mr. Hunter.[60] He exhorted me not to rest where I was, but to go on for a clearer manifestation of God's love. Mrs. Carr and, in short, all my friends, advised me to hold fast every promise which the Lord brought to my mind. I find the preaching of Mr. Hunter and Mr. Story[61] of great benefit to my soul.

Oct. 23. Mrs. Crosby spent some hours with me today, and her conversation was more satisfactory than her letters. By reading JENKINS, MARSHALL, and HERVEY,[62] I had adopted all their expressions concerning justification by the imputation of Christ's active and of his passive righteousness (a form of speaking which ZUINGLIUS[63] had introduced into the church). She recommended me rather to keep to the old expressions in the Liturgy,[64] and to ask every thing "through the merits of our Lord and Saviour Jesus Christ."[65] Whatever blessing I wanted, she advised me to keep to praying—believing—waiting until the power descended into my soul. She said this with a view to Miss S[cott]. who was present, and not as yet fully clear in the sense of acceptance with God. In the afternoon, we drank tea with the Rev. Mr. James Stillingfleet,[66] at Mr. ——. His conversation was not less instructive than his exhortation. He made many precious remarks, and was quite of a catholic spirit. He united the gentleman and the Christian more completely than any person I had hitherto known. He is an ornament to his profession.

Dec. 1. This afternoon I attended a meeting of a few Christian friends. Mrs. Crosby expounded the 13th chapter of the first epistle to the Corinthians.[67] She explained the characters of divine charity, or love, with a simplicity I had never heard before. Her heart and words acted in concert. Every sentence was impressive, and carried conviction to the heart. The temptations under which I laboured were dissipated, and my soul panted for that love on which she so delightfully expatiated.

Jan. 7, 1775. This evening my spirits were very low and much depressed. I went to the chapel at seven o'clock, and on my return, "the love of God was shed abroad in my heart" [cf. Rom. 5:5], and in such a degree that my soul was humbled into the dust. The sentiment of my past ingratitude was so strong that I saw, if the Lord had sent me to hell for it, he would have done me no wrong. I had, indeed, read many Calvinistic books on justification, but I never saw the

fulness and freedom of God's pardoning grace in such a light as I now do.

Jan. 22. Mrs. Wilson[68] called to-day and gave me an account of Mrs. Carr's death and how she was supported in her last moments. Considering the edification and delight I used to receive from the conversation of this saint, I was less affected with the stroke than I expected. Her last moments were employed in praise and gratitude to God, and gratitude was the leading excellence of her character. My heart, however, was melted with love by the solemn intelligence, and in this way the Lord was pleased to sanctify it to my soul.

Jan. 26. I read Mr. Wesley's *Plain Account of Christian Perfection*.[69] Mr. R[ichardson]. at tea spoke well of holiness, but his strictures on the way in which the Methodists sought it had no weight with me. I was, at this time, much impressed with a dream I lately had, which apparently indicated that the Lord called me to join the Methodists, and at other times I thought that this was not his design.

[Jan. 31.] In the evening, my soul was filled with gratitude to God, and his love was shed abroad in my heart [cf. Rom. 5:5]. My sole wish was that God's will might be fully accomplished in me. Neither cloud nor doubt seemed to interpose between him and my soul. I now feel, if I am convinced it is his pleasure, that I should join the Methodists, that it is to me a matter of indifference and I do believe that he is able to give me the blessing of entire sanctification.

Sunday, Feb. 19. This morning at eight o'clock Mr. Hunter delivered an excellent sermon on sanctification. In the afternoon my soul was truly given up to God. I could freely and fully surrender all I had to him. I can truly say that I did not wish to retain one idol in my heart. Every thought I desired to be brought into obedience to Christ. I desired neither riches, nor friends, nor any enjoyment, but as they came from him. I have, indeed, experienced much of the love of God, yet I never felt the power so freely to surrender myself to him as this evening. And if I shall see it the will of God to place me among the Methodists, I feel ready to do his will, having no choice of my own. By reading Mr. Wesley's Sermons and Tracts,[70] I find that both his opinions and his views are quite different from what had been represented to me by others.

[Jan. 11, 1776.] I received a kind letter from Miss Bosanquet (now widow of the late Reverend Mr. Fletcher) chiefly on sanctification.[71] It proved exceedingly profitable. Every sentence seemed a portion of

meat for my soul and it enlarged my heart in prayer to obtain the blessing.

June 4. This evening I was much edified at Mrs. Hall's class. She said a Christian should always be receiving from the fulness of God and returning what he gave in praise and thanksgiving. If we did not return, she said, what he gave us in grateful acknowledgements, we should become offensive as the stagnant waters. She described the barren faith which did not produce the fruits of the Spirit and exhorted us to get every Christian temper and affection formed in the heart. She remarked, that it was quite a mistake to suppose, that we were growing in grace unless we had an increase of faith, and love, and meekness, and resignation.

June 14. Last evening I walked with my mother, and on passing the Methodist chapel it came into my mind to ask her to go in and look at the new gallery.[72] She did so and stayed and heard the sermon! Surely nothing less than the divine power could have prevailed on my mother to do a thing which she had long believed God had forbid her to do. I never had the smallest hope of seeing her in a Methodist chapel.

July 7. For the last week I have enjoyed many high and singular privileges in hearing Mr. Wesley, and in enjoying the conversation of many religious friends who are come to meet him in York.[73] They seem fully to answer our Lord's character of his disciples, "Ye are the salt of the earth" [Matt. 5:13]. Miss Ritchie's[74] conversation and manner were so truly Christian, that, while I was in her company, and for some time afterwards, I seemed to feel as though I had hardly any religion or had attained any experience. They ask a blessing at tea and do every thing with a simplicity and grace resembling heaven.

From conversations so instructive I can but select a few fragments, which may be of use to me at another day. And with that view I treasure them up in my journal.

In one conversation Mr. Wesley remarked that if we see the blessing we seek at a distance, it will always remain so unless we make continual efforts to attain it.

When we feel our faith weak and low we resemble the man with the withered hand, and then is the time to stretch it forth, for the Lord is always present to heal [cf. Mark 3:1-6].

It is wrong to expect the power before we believe. We should believe in order to receive the power, just as the little child keeps making efforts to walk till he can walk.

Love, joy, and peace are the fruits, not the foundation, of this faith [cf. Gal. 5:22].

Mr. Cornelius Caley[75] observed that when we are most tempted, that was often the time when the Lord was about to give us a blessing.

The Lord often grants us blessings in a way which we think the most likely to counteract them. In outward providences we often walk in darkness and have no light, but by trusting in the Lord, he often exceeds our expectations.

Instead of wasting our time in reasonings and in groundless scruples, we should direct all our efforts to believe, and look to the cross of Christ to be healed of every wound [cf. 1 Pet. 2:24].

While we are seeking after holiness, the evidences of our justification will become clearer and clearer, for the desire of holiness is a present blessing. Our constant prayer should be, Lord, enable me, this day, to embrace thy will.

After tea I went with Miss Ritchie to meet Mrs. Hall's class. It was, indeed, a very edifying opportunity. I was struck with the simplicity and grace with which she conducted herself through the whole of this exercise. The image of God formed in her soul seemed to shine forth in her prayer and conversation with the people. During all the time I have been with her I have never noticed any thing contrary to the sanctification she professes to enjoy. She excels in pressing the people to look for higher degrees of grace. Every person who was awakened she pressed to look for justification. And every one who is justified she exhorted to look for a clear evidence of sanctifying grace. She really is a very extraordinary person. The more I become acquainted with her, the more she rises in my affection and esteem. If Mr. R[ichardson]. with whom she has had frequent conversations would invite her to meet his people, she would be a great blessing both to him and to the souls of his people.

April 22 [1777]. On Tuesday last, having renewed my covenant, I formed the resolution to wrestle with God for sanctifying grace in the same manner as I had done for justification. I had, indeed, prayed for it, but I saw I had not been equally earnest in looking and in waiting for it. Not being in a state of bondage, I had regarded the blessing too

much at a distance, and had not hungered and thirsted for the whole image of God with a fervour becoming its excellence.

The first grand and essential step towards attaining it, I saw, was prayer, and looking and waiting for it every moment. Accordingly, I spent what time I could spare, from my afflicted mother and other domestic duties, in prayer. The Lord is still my salvation. He hath helped me through various trials, through snares and temptations his hand has preserved me. He hath called me to prove a greater salvation, a fulness of love. O! how shall such a worm as I am give praise to thy glorious Majesty? I will take the cup of salvation, and call upon the Name of the Lord for more [cf. Ps. 116:13].

> For more I ask, I open now
> My heart to embrace thy will.[76]

While thus led on, and seeking purity of heart, Mrs. Crosby took breakfast with me and dropped me many judicious hints. She disapproved of my spending so much time in prayer as it interfered with other duties of life. And though it was our duty to be ever reaching forth for more of God, yet believers found the blessing of sanctification at different periods of life. Her whole conversation was very instructive and profitable. She lives in the spirit of doing good.

May 17 [1778]. I had this day much communion with God. Reading the Scriptures has, of late, been very profitable to me. When they are read for devotion, God is set before us, and the spirit in which they were written imperceptibly steals upon us.

In the evening, I attended the select band, with a mind unhinged, from having talked too much in the day. Mr. C. after speaking his experience superadded several excellent things. He magnified the power of grace and said that it was impossible to live to God for a single moment, unless we were divinely kept by the power of God; that we are not sufficient of ourselves to think a gracious thought, and that our greatest hindrance in the attainment of sanctification is the not giving up our will in all things to the Lord. Mrs. Hall spoke next of the necessity of living to God for the present moment and of our constant need of fresh supplies of grace. She enlarged on the privileges of a clean heart, that we may run the ways of God's commandments. On this subject she felt at home and the simplicity and power with which she spake seemed to overshadow the whole of the

people. My soul was truly refreshed and overflowed with gratitude to God for permitting me to meet with his people. O, how great are their privileges!

March 3, 1779. Last night my dear friend and faithful adviser, Mrs. Bathsheba Hall,[77] died in the Lord. I did not know the time of her death, but about nine o'clock I found an out-pouring of the spirit in prayer for the whole family, and it occurred to me that she was probably dead, as it afterwards proved.

March 5. This day I have attended the remains of Mrs. Hall to the grave and heard her funeral sermon at the Methodist chapel, by Mr. Thomas Hanson.[78] His text was, "Then shall the righteous shine forth as the sun in the kingdom of their Father," Matt. xiii. 43. O, what solemnity! What tears! What power attended the word! I never heard such a funeral sermon before. But words cannot utter the unity and love which subsist among the children of God!

May 5. Mr. Wesley is now here and he has delivered three excellent sermons.[79] In illustrating our Saviour's words, "the blade, the ear, and the full corn" [cf. Mark 4:28], he associated them with St. John's three states of grace, distinguished by children, young men, and fathers [cf. 1 John 2:12-14]. In explaining Heb. xii. 1, he warned the people against what are called little things, such as a positive temper which affects to be always in the right, and its opposite, a weak and pliable temper; rudeness, sternness, and the needless indulgences of snuff and tobacco. In his first sermon, on 1 Cor. xiv. 20, he shewed what reason could do in religion, and what it could not do; how far it could carry Socrates, Adrian the emperor, &c., and how far their hope fell short of the Christian's hope, for reason is unable to produce the faith, the hope, and love of a Christian.[80]

This forenoon, Mr. Wesley met the select band. He permitted me to meet without asking me to join the society. On my return I felt great liberty in praying for him and felt my heart overflow with abundance of love to him and his people. But what shall I do! My mother is more hostile to my joining than ever. She says it will cause us to separate. The very idea injures her health. By waiting, and taking no hasty step, I believe the Lord will either make my way or give me grace to break through. I feel much satisfaction that it is now generally known to Mr. R[ichardson].'s people that my mother is the sole hindrance of my joining the Methodists.

94

April 7 [1780]. To-day, as in general, I enjoyed a sense of God's love and felt a cry in my heart that it might increase more and more. I felt a hungering and thirsting after righteousness and the abiding Comforter. I regarded my inordinate thirst after knowledge as hurtful to my growth in grace. I read too many books and often lay them aside before I have read them through. I have found no books better to my soul than the Bible, and Mr. Wesley's extract of the *Life of De Renty*,[81] and of Kempis on the *Imitation of Jesus Christ*.[82] Miss Raison[83] lately was so frank as to apprize me that the frequent hurry of my spirits was a hindrance of my growth in grace. How good is it to have a faithful friend to admonish us of our daily defects! The character of Martha, rather than of Mary, has been mine [cf. Luke 10:38-42]. I want the habits of holiness, to retain the good I receive.

Dec. 21. This day, after gaining my mother's consent, and spending some time with her in prayer, I went to Mr. Thomas Taylor,[84] and joined the Methodist society.

April 2 [1781]. Since my mother's death my mind has been much drawn to prayer, and whatever station in life his providence may call me to shall be for the best. I have been much profited by reading Miss Bosanquet's tract on "Jesus altogether Lovely; or, the Advantages of a Single Life."[85] At church and sacrament I found a great desire to be wholly given up to God. The sermons, also, of Mr. Thomas [Taylor] and Mr. Joseph Taylor,[86] are made a blessing to me whenever I hear them.[87]

Sept. 12 [1787]. Taking tea with Mrs. [Dorothy] Downe[s],[88] Sister of Rev. [Samuel] Furley,[89] a vicar near St. Austle, daughter of a turkey merchant in London, and a few friends, I greatly admired her method of speaking to a sister who was seeking full salvation. She recommended a continual looking to receive it by faith and, at the same time, to mortify every propensity and check every desire which would obstruct the progress of the work, cherishing also whatever was found to promote a growth in grace. Yet she would have people plead nothing that they have done, but only what Christ hath purchased. She liked persons to come into the liberty from a heart-felt sense of the want of it. She by no means approved of loose professors being exhorted to believe and believe. She thought the first concern of many should be to get restored to a justified state, and then to seek the perfect love of God.

May 4, 1788. Miss Ritchie has been in Leeds for some days. I find her conversation, as I have ever done, full of life and seasoned with salt. Our Saviour bids us to gather up the fragments that nothing be lost. Hence, after being in company with friends who so much surpass me in wisdom and grace, I have often entered in my journal the more striking remarks of conversation, because it is food for my soul when I read it at a future day.

The conversation at Mrs. Baines'[90] turned on several very edifying subjects. Miss Ritchie enlarged on the necessity of self-denial in order to a close and habitual walk with God. And this must extend, not only to our words and actions, but also to our thoughts and to whatever else has the least tendency to damp the vigour of the mind. There were, she observed, a number of things best known to ourselves, which, by renouncing, would lead us to a more enlarged and immediate intercourse with God. For every degree of self-denial was the acquisition of a degree of grace. By looking unto Jesus strength would be imparted for the duty, and by the constant exercise of this virtue one hardly knows the degree of sanctification to which we may attain.

I was not less edified by her method of leading the class. She recommended us to come to the Lord with our present power, which would increase by exercise. Of one who was thirsting for full redemption, she inquired whether the sister was willing to give up all for Christ? On being answered in the affirmative, she advised her to be constantly offering up her all in sacrifice, waiting for the Lord to accept the oblation of her heart by coming in the power of his Spirit, to cleanse and fill it with love. Another who complained of the obstinacy of her will and the warmth of her tempers, she advised to mortify every temper contrary to love, looking at the same time every moment for a full deliverance, as we must never rest in present attainments. A backslider who was present she advised to get properly sensible of her loss, and then not to be discouraged from coming immediately to God with a contrite heart. She advised me, a hurry of my natural spirits being always an impediment of my progress, to be still and to know God. On Mrs. Baines' complaining that whenever she had grieved the Spirit of God she sunk into discouragement and concluded that she must go through a long course of sorrow before she could find comfort. Miss R[itchie] rejoined, that much of those fears arose from the work of the law, and that, on feel-

ing a conviction of having grieved the Holy Spirit [cf. Eph. 4:30] in any way, we are called immediately to look to God for pardon. We must not allow the mirror to remain sullied, but continually endeavour to behold therein the glory of the Lord and it will become brighter as our faith increases.

Dec. 31 [1789]. I now sit down to review the mercies of the past year. They are great and many. I have a husband to whom I feel an increase of affection. Not one jarring string exists to occasion discord in our happiness, but, on the contrary, an increase of mutual affection. Another source of gratitude is the kindness of so many valuable friends in Leeds and the many marks of affection and esteem which they conferred upon me. My health, my temporal mercies, yea, mercies which I cannot count, all call upon me to devote my future life to God, which I hope to do without reserve.

Jan. 1, 1790. I desire to begin afresh in my spiritual progress and to be particularly guarded against every thing that has been a hinderance to me in the preceding year. I have had many conflicts of late and have often been but just saved. Now, in the strength of God, I will arise and take the kingdom of heaven by a holy violence. I have discovered several things of late in which I have been led by my own spirit and not by the Spirit of the Lord. This humbles me at the throne of grace and makes me desirous to have my whole heart subdued and my will swallowed up in the will of God.

Feb. 3. I have been happy, as usual, in my soul, lively in the class, and I see some little fruit of my labours. My husband and I this morning looked over our temporal affairs. How thankful should we be that we have enough and to spare. The language of my heart is, not to lay up treasure on earth [cf. Matt. 6:19]. I feel desirous to give more largely to the cause of God and to the poor; for it is more blessed to give than to receive [cf. Acts 20:35].

May 14[?]. I am just returned from Leeds where Mr. Wesley has been for some days.[91] My heart glowed with love on meeting my dear friends in the Lord, and I found them lively and affectionate as usual. The precious opportunities I enjoyed among them at tea and in the classes and bands were as the dew of Hermon [cf. Ps. 133:3] to my soul. Mr. Andrew Blair,[92] at Miss Rhodes's,[93] observed that as iron must abide in the fire to retain its heat, so we must abide in Christ to retain our warmth and affection. Christ being the soul of the believing soul, we must all abide in him [cf. John 15] that he may actuate

the whole and that we may derive life and influence from the head. He urged the necessity of having our understanding given up that the power of Christ may rest upon us. Miss Ritchie enlarged on the hint dropped by Mr. Blair concerning not only our understanding, but all our senses and affections given up to Christ. She observed that faith, in some sort, was [a] new sense and analogous to our natural senses. The soul has an eye, an ear, and a taste. . . . the grand point was to get all these senses hallowed and strengthened, then every other Christian temper would proportionably grow and increase.

But I cannot repeat all the good things I heard from Mrs. Crosby, Mrs. Downe[s], and others. I can only add that those little parties, and classes, and bands, are the beginning of the heavenly society in this lower world.

March 5 [1791]. We have just received the printed letter of Mr. Wesley's death, after a few days' illness, on the second of this month.[94] A prince, a great man is fallen in our Israel [cf. 2 Sam. 3:38]. It is a great stroke to the church, but Zion has still her God. The pillars fall and the house stands. The Lord, who called him to this work, has given him a life of almost uninterrupted health for nearly eighty-eight years. And the Lord has spared him till the foundation of Methodism is adequately laid. There are now many pious and able ministers to carry on the work that this revival of religion may spread to the uttermost parts of the earth. I believe it will be a time of fervent prayer for the preachers and the whole connexion.

[August] I have received a very consoling letter from my husband of the peace and union of the Conference.[95] Surely this is of God, for the preachers were left as children without a father.

Aug. 31. We have been at Halifax a week. Our house under the chapel seems but gloomy, and I was at first discouraged in seeing no openings to be useful. However, I have found here, as at Leeds, women to whom I feel united and hope that we shall be useful to one another. A class has been given me to lead, and I have opportunities of meeting a few friends who are athirst for a full salvation.

Jan. 1, 1793. After reading over my journal, I sit down to make a calm review of the past year. 1. My leading efforts have been to purify my affections from the earth. In this view, I sigh for a farther liberty. 2. I have been often favoured with the spirit of prayer for my husband, that the Lord would support him in all the cares of the min-

istry and give him wisdom when preachers write to him for advice. 3. Our temporal property having increased in the funds, I feel a desire to dispose of it as the Lord shall please. I desire no more of worldly riches than what I shall improve to the glory of God.[96] 4. I feel no thirsting after spiritual honour. 5. I see that the Lord has not taken me to the mount to be filled with unutterable joy; but he has led me in a humble path and through many conflicts, to be delivered from all undue attachment to every thing on earth. Yet, in all my weaknesses and conflicts I have never once disputed my having been delivered from indwelling sin. On the whole this has been a year of many trials and of many blessings to my soul. The Lord has taught my hands to war and my fingers to fight. My husband's sermons have often been very refreshing and encouraging.

May 30, 1794. For six years past I have had a daily cross which I have borne in much silence in obedience to my husband and to God. Mr. Pawson, with the most humane of motives, has taken under his patronage a desolate niece. We have put her to school and discharged our duty to her as a daughter; yet, from the peculiar obstinacy of her temper, I have discharged the duty as a cross not as a delight. I have looked upon her living with us as an exercise to my faith and patience and, on that account, I have borne it as from the Lord. This little task has been alleviated by the kindness of the best of husbands.

[July 2, 1795.] I have likewise wrestled much with God for the whole connexion, lest it should be torn to pieces about points of discipline—points which will subside of themselves, if the parties will have a little forbearance with one another.

[July 1796.] The Conference is just at hand, and the preachers are beginning to come. My heart is enlarged for the prosperity of Zion. It is a day of trouble to the connexion. Alexander Kilham has agitated the minds of the Methodists by the circulation of many anonymous printed letters, &c. His whole attack seems levelled at the old preachers. He seems to wish the Methodists to adopt, as far as possible, the laws of the French National Assembly.[97] But to insinuate that my husband and other venerable men have defrauded the connexion, after devoting our lives and fortune to the cause, is cruel in the extreme. Well, the church has often had to endure the contradiction and the sneers of restless men. The preachers have all been united in his expulsion, and if he do not retract his slanders, God will

inflict upon him a heavier punishment. Had he wept over our defects I would have joined him in spirit.

[Dec. 19, 1797.] I have lately heard an excellent sermon from the Rev. Mr. Eyres, of Hommerton.[98] He preached in the City-Road chapel. The object of his sermon was to promote a friendly union between the Methodists and the Dissenters. There was an uncommon degree of unction attendant on his word. I wept much and felt my affections expanded to all the children of God. The whole congregation was affected.

> Happy day of union sweet,
> O when shall it appear,
> When shall all Thy people meet
> In amity sincere,
> Tear each other's flesh no more,
> But kindly think and speak the same,
> All express the meekening power,
> The spirit of the Lamb?[99]

[August 1799.] No sooner have I returned from York to Leeds than I find myself at home. The kindness of my friends and relatives has humbled me much, and my intimacy and union of spirit seem to increase with Mrs. Crosby, Sister Tripp,[100] Miss Rhodes, and others. Miss Rhodes being oftener with me, I feel a particular union with her founded on a persuasion that we are mutually beneficial to each other.

Dec. 23. Mrs. Crosby gave me a profitable hint for meeting classes. She did not always approve of exhorting persons to believe and believe, but rather to find out the hinderances of their faith. They should then be exhorted to lay those hinderances all aside and pray the Holy Spirit so to shine on their mind that they may see the little foxes which spoil the vine [cf. Song of Sol. 2:15].

On being asked what was the best method for a soul to take which had lost the earnest either of justification or of sanctification, she replied that the soul, in this case, was to be compared to the body. When the latter is unhealthy we avoid whatever tends to keep it so, and, on the other hand, we use every endeavour to remove its indisposition. Thus the soul, whenever its fervent desires after God are abated, should lay aside whatever obstructs a return of the consola-

tions of the Holy Spirit, such as the indulgence of earthly comforts, and use the means of grace with more fervour. Thereby it would acquire a spiritual appetite and God would satisfy its hunger and thirst after righteousness [cf. Matt. 5:6].

Oct. 29 [1804]. I have just received a letter, apprizing me of the death of that valuable woman, Mrs. Crosby, of Leeds.[101] She has been to me a friend, dear as my own soul, and that from my first setting out in religion. Her memory will be dear to me for ever. Though dead she seems still talking to me, and a number of her sayings crowd on my remembrance. I hope never to be satisfied till the truths she used to enforce be fully written on my heart. Few excelled her in Christian simplicity. Mrs. Mortimer[102] used to say that she could descend to the capacity of a child, and then rise again to expatiate on the deep things of God with those that had attained the highest state of grace. But, in point of sympathy, she surpassed all I ever knew. She could so enter into the feelings and concerns of others as to fulfil the precept, "Bear ye one another's burdens, and so fulfil the law of Christ" [Gal. 6:2]. O, how my soul has been blessed under her addresses to the throne of grace, when wrestling with God for the flock! She used to begin prayer with the simplicity of a little child and then rise to the language of a mother in Israel. Thus she prayed with the Spirit and with the understanding. And the triumph of her death corresponded with the glory of her life. But she also, like me, was assailed with a precipitancy of spirit and with a zeal which was not always tempered with wisdom. Nevertheless, I can apply to her what I have often heard my husband say of Mr. Wesley, that he had the glory of God in view in all he did. In the early part of her pilgrimage she stood almost alone for God and evidenced her love to him by an uniform, warm, and active piety.[103]

The Diary of Bathsheba Hall

Editor's Introduction

Very little is known about the life of Bathsheba Hall (1745–1780).[104] A conscientious member of the Methodist Society in Bristol, she resided for some time in London as part of the Foundery community as either Housekeeper, servant, or guest. Upon return to her native Bristol, she married John Hall, about whom nothing is known. The extant portion of her diary covers the period between December 12, 1765, and April 24, 1775, crucial years in the development of early Methodism.[105] This journal, essentially a narrative account of her spiritual journey, is described as "artless and simple," providing an indelible portrait of "a soul renewed in love, and wholly devoted to God." Moreover, it often expresses the tensions which women felt at this period, torn between a sense of duty in discipleship and a fear of condemnation—especially from male counterparts in the movement. Bathsheba died in September 1780 with Wesley preaching her funeral sermon at Kingswood, October 1. Of this "blessed saint," he observed that she was "a pattern for many years of zealously doing and patiently suffering the will of God."[106]

❄ ❄ ❄

Aug. 17, 1768. It becometh well the just to be thankful! It is now about five years since the Lord spoke peace to my soul. From my infancy I have been a daughter of affliction. And I am so still. And nothing less than omnipotent grace could have brought me, young and unexperienced as I was, through all my trials. From the very first I was convinced, that I could not stand without constant and earnest

Prayer. And I never lost a sense of his pardoning Love, from the moment I received it. How does the Lord guide us in our infant days! The day of small things!

About a twelvemonth after I found peace, I saw there was a greater Salvation to be attained: but I was not much concerned about it: though I had many severe plunges of illness, which brought me near the gates of death: but in the latter end of the year 1767, God sent one of his dear people to see me, who had been long a witness of the Great Salvation.[107] May that sacred day never be forgotten! She gave me a clear and full account of what she experienced. God applied it strongly to my heart, and beamed forth on my soul in a wonderful manner. For some weeks I walked in great liberty, desiring nothing but to be wholly devoted to God. And herein I receive strength daily, to prepare me for the following light affliction: I knew not yet, that the Lord was about to sit upon my soul, as a refiner's fire [cf. Mal. 3:2]. I soon felt, that I had an evil heart of unbelief, continually departing from the living God. He now began to break up the fallowground, to shew me the mazes of sin in my heart. How did I now feel, Salvation is of the Lord alone! I could do nothing but look to him! I could find no consolation but in Prayer and reading the Scripture upon my knees. The more I prayed over it, the more I saw how dark and blind the natural understanding is. But O! how welcome are the second rays, that break in upon the mind! Indeed, in the depth of my distress, the Lord gave me such promises, that I could ever after rest on his faithfulness. I did not remember there was such a prophet as *Nahum*, till he directed me to ch. i. ver. 7, and 13, *The Lord is good, a strong-hold in the day of trouble; and he knows them that trust in him. Now will I break his yoke from off thee, and will burst thy bonds in sunder.*

I do not apprehend that we are fully converted, until we are restored to all that Adam lost.[108] Now, I had not yet attained this. I still frequently felt anger: and I wished to *feel* my enemies till they were destroyed. My soul is looking out for his sudden appearing; and to him my every wish aspires.

Monday [March] 4 [1771]. I feel a great pressure of mind, by reason of my many defects and infirmities. But still, O Lord, thou art the one thing which I desire in earth or heaven! O that thou wouldst invigorate my soul! All my strength is derived from thee! I long that all within me should be Holiness unto the Lord. I am sunk at the foot of Jesu's Cross, "balm of my grief and care" [cf. Jer. 51:8]!

103

Sunday [March] 10 [1771]. The Lord hath been more to me than I can express. This has been a day of joy and gladness. Rivers of salvation rise, and all that is in me adores my God and my all!

Monday 11. I find within this week a much deeper devotedness to God. How blessed a thing is Christian fellowship? It does indeed, as it were, open heaven. My friend S. F. and I offered up a particular thing to the Lord: I trust, not in vain. O Lord, do thou guard her youth! Let her be a devoted shrine! Make her as the polished corners of the temple, a habitation of God through the Spirit [cf. Eph. 2:22].

Tuesday 12. The Lord has been gracious to me this day.

> Thou art my King! And lo! I sit
> In willing bonds beneath thy feet![109]

I feel, that thou art still the Lord of every motion in my soul. I was sensible this night, of the great importance of wrestling with God for the souls of others. O what a great thing it is, to be all on the Lord's side! O thou that neither slumberest nor sleepest [cf. Ps. 121:4], preserve me this night! While all nature is hushed in solemn silence, how often do I find the vigilance of the Powers of Darkness?

Wednesday 13. This day I have felt deep concern for a dear friend. She has strong sense: but I fear this stands in the way of her salvation. When will she become a fool for Christ's sake [cf. 2 Cor. 12:11]! She is favoured with a clear sight of self-devotedness. But what will this avail, if she rests here, and does not follow on to attain it? I weep in secret places for many, Lord! I praise thee, thou hast taken all my soul and body's powers!

Thursday 14. When outward exercises are suspended for a season, God calls me to suffer for others, although frequently far distant in body. I have been in great agonies this day for one that I hope will be soon set at liberty. I am willing, if it were the will of God, to be offered up for her.

Friday 15. The face of creation animates my soul. When we have God we have every thing! As the natural sun chears the drooping plants, so do thy beams gladden my every power.

Saturday 16. This day I was much assaulted with wandering thoughts.[110] But Thou knowest, all my desire is unto thee!

GOOD-FRIDAY [March 29, 1771]. I feel to-day, a solemn spirit; a sacred awe broods over my soul. I seem to have a more realizing view than ever, of Jesus on the Cross. And

> Faith cries out, 'tis HE! 'tis HE!
> My God that suffers there.[111]

Saturday 30. I feel to-day a spirit of deep poverty, a kind of annihilation. But though in the dust, yet will I sing. O that my soul may be always as a well-tuned instrument! I thirst for a deeper conformity to thee, my suffering, triumphant, adorable Saviour!

Monday, April 1. I find an increase in the divine life, and a deeper measure of that love, which *is long-suffering and kind*, which *is not provoked*, which *hopeth and endureth all things* [cf. 1 Cor. 13:4-5, 7].

Tuesday 2. I felt much of his soul-reviving power. But O! what ignorance remains upon my mind? I feel a thirst for divine knowledge; a contending with the Lord for spiritual wisdom. I am waiting at Wisdom's gate! Speak, Lord; for thy servant heareth [cf. 1 Sam. 3:9-10].

Wednesday 3. Business called me to see one, that *was* serious, but is now deeply revolted. I went with much prayer. As soon as I entered the room, he seemed struck with a solemn awe. O how solemn should the deportment of a Christian be! that all who see him may take knowledge he has been with Jesus. After I came home, I felt such love as I cannot describe, and much power to wrestle with God for him.

Thursday 4. Passing through the town to-night, what exquisite pain did I feel! What disorder! What sin of every kind! How does *the whole world lie in the wicked one!* [1 John 5:19].

Wednesday [May] 13 [1772]. The Lord is reviving his work at *Bedminster*.[112] I feel my soul much engaged in it. And yet I tremble, lest I should not be diligent therein. I know, I must improve my Lord's talent [cf. Matt. 25:14-30]. I had rather be obscure. But I dare not. O my God, help me to fight thy battles!

Memoirs of Elizabeth Mortimer

Editor's Introduction

Elizabeth Ritchie (Mortimer)[113] (1754–1835) is one of the most celebrated women of early Methodism since she was the one who was privileged to care for Wesley in his dying days and, at the bequest of Dr. John Whitehead, prepared a narrative account of his death.[114] Considered by many to be like a daughter to the aged priest, she functioned as his "eyes" during the closing weeks of his life and, in fact, closed his eyes at death. A half century his junior, Elizabeth's correspondence with her spiritual director commenced in 1774, when she was just twenty years of age, and reflected the concerns and insights of the "mature" Wesley. Contrary to his general rule to write only in reply to letters he received, he initiated much correspondence with her related to "spiritual advice."

Elizabeth was born on February 2, 1754, the daughter of John and Beatrice (née Robinson) Ritchie. A native of Edinburgh, her father had served as a naval surgeon before his retirement to the Yorkshire Dales and then, after her older brother's birth, to Otley, near York.[115] Elizabeth was raised in affluent and cultured circumstances, but in a family with strong sympathy for religious reform. She came under the influence of a Mrs. H., however, a patroness and a strict moralist, whose prejudice against the Methodist practices of Elizabeth's parents drove her away from the Wesleyan Revival for some time. Through an interesting chain of events, including Wesley's visit to her parents' home in 1770, Elizabeth revised her attitude toward Methodism, experienced God's grace in her life, and committed herself to the Wesleyan way. On July 3, 1771, at eighteen years of age, she

began to keep a journal, strictly for private use and "a more close inspection of my own heart," as she observes.

❈ ❈ ❈

In the year 1770, my friend Mrs. H. took a journey to London. She said, were I to accompany her, it would introduce me more into life than would be proper at so early a period, and that I should, therefore, visit my parents during her absence. This was a gracious providence for me. Mr. Wesley came to Otley, and I was pleased with him in company; yet such were my prejudices at that time, that I would not go to hear him preach.[116] The Curate of Otley, the Rev. James Illingworth,[117] was a spiritual man; but although I had been accustomed to attend the services of the Establishment both on Sundays and on week-days very regularly, yet, to my shame I must confess, I was an utter stranger to the blessed doctrines which its Articles and Homilies contain.[118] Mr. Illingworth particularly insisted on the natural depravity of man, on justification by faith only, the new birth, and the influences of the Holy Spirit. These subjects were news to me, and when I first heard him, he greatly attracted my attention. But I heard from others, and often said to myself, "This is very necessary for persons that have been openly immoral;" but I still remained ignorant of my own deep interest in them, until it pleased the Holy Spirit to remove the veil from my heart.

From this time the light began to shine into my heart. I had a strong and constant hope, that God, who had disclosed to me my danger, and had also shown me that he had prepared a remedy, would give me faith to make me whole, that, by receiving Christ as my justifying righteousness, my troubled conscience might obtain peace. This I now sought in all the means of grace. My tastes were changed. I had lost all relish for the gaieties of life. Worldly company was a burden to me, and I no longer feared reproach. My one desire was to feel vital union with the sinner's Friend, and, to obtain this, I felt it easy to surrender all beside.

As a help to my spiritual progress, I thought I would regularly note down what passed in my mind, relative to this important subject, and on July 3d, 1771, began to execute my purpose. I wrote merely for private use, and found it led me to a more close inspection

of my own heart. Often has my diary afforded me cause for thankfulness, but more frequently for humiliation. Goodness and mercy have followed me all my days [cf. Ps. 23:6], but I have been unworthy and unfruitful. My Lord has dealt, and still deals, with me according to his abundant mercy. I owe all my blessings to the meritorious passion of my Saviour, Christ.

[July 20, 1771.] I went to B[atley]., and found liberty to speak on sacred subjects. And, as God enabled me, I declared the truths belonging to salvation to Mr. S.'s family. My mind was pained to see such sensible people so entirely ignorant of the things that make for their peace. God grant that they may know the day of their visitation, lest these things should be hidden from their eyes!

February 2d, 1773. This day I enter on my twentieth year. How little of my time have I devoted to the service of the Best of Beings! Even since I made a profession of religion, how many moments have I wasted! How little proficiency have I made in the divine life! I am not yet altogether spiritual, but have great need of humiliation before God, on account of my non-improvement of his many mercies. May I now begin to live! As I this day enter on another year of my natural life, let me begin my spiritual course afresh! Saviour, let me die to sin. Seal my peace, and take up thy abode in my heart!

[May 3, 1774.] On Monday we were favoured with the presence of the venerable saint, Mr. W[esley], at our house.[119] He engaged in prayer with me, and encouraged me much to go forward, by enlarging on the grace and love of the redeemer, and on his present readiness to save, warning me, at the same time, to beware of pride. This morning, before four o'clock, he left us. I feel my esteem for him much increased, and my regret at parting was alleviated by a hope that, should we meet no more on earth, we shall at last meet in heaven. His charge to me, on taking leave, was, "see that you become altogether a Christian."[120]

[In Nov. 1775 she became a Class Leader.] I have been led much to meditate on the perfection of the human character of Christ. My mind has dwelt particularly on his love, his meekness, his humility, his resignation, and all those heavenly dispositions which he manifested here below. My soul aspires to imitate this bright example. I hear the word which says, "Let that mind be in you which was also in Christ Jesus" [Phil. 2:5]. Therefore, in the exercise of faith and hope I wait for a more full conformity to him, my living Head. I bless His

name who has already shown me so much mercy, as to keep me from desiring any thing that is not in accordance with his will, and that does not centre in himself.

[March 1776.] I have been with Mr. Wesley to the various places he has visited in this country;[121] and have had, while travelling, many valuable opportunities for conversation. I thank God I feel my soul much strengthened and my bodily health improved. I have enjoyed uninterrupted sunshine.

November 12th, 1781. I can truly say, I have been at one Christian wedding.[122] Jesus was invited, and he was at our Cana [cf. John 2:1-12]. We reached Cross-Hall before family-prayer. Mr. Fletcher was dressed in his canonicals, and after giving out one of Mr. Charles Wesley's marriage-hymns, he read the 7th, 8th, and 9th verses of the 19th chapter of Revelations, and spoke from them in such a manner as greatly tended to spiritualize the solemnities of the day. On our way to the church, which was nearly two miles distant, he spoke of the mystery couched under marriage, namely, the union between Christ and the church. They were married in the face of the congregation, the doors were thrown open, and every one came in that would. We then returned home and spent considerable time in singing and prayer with their own family. Nearly twenty friends were present. The time after dinner, (which was a spiritual meal as well as a natural one,) was chiefly spent in prayer and conversation. Mr. Valton[123] preached in the evening from these most suitable words: "What shall I render unto the Lord for all his benefits" [cf. Ps. 116:12]? There seemed, after preaching, to be a pleasing contest among us, by whom the largest debt of praise was due. Mr. Fletcher, in the course of conversation some days afterwards, said, "Five-and-twenty years ago, when I first saw my dear wife, I thought if I ever married she would be the person of my choice, but her large fortune was in the way. She was too rich for me, and I therefore strove to banish every thought of the kind."

[August 1785.] I have received a few lines from Mrs. [Sarah] Crosby, who mentions that a report has reached Leeds of the death of Mr. Fletcher, which she hopes is not correct, and requests my prayers in behalf of dear Mrs. Fletcher.[124] If I may judge from my own feelings, it is but too true. I went to the Lord, but could only pray for her and the church. My spirit felt tender sympathy with my dear afflicted friend. But the Lord can support her, and raise up an Elisha to fill the

place, and catch the mantle of our translated Elijah [cf. 2 Kings 2:14]. Last night confirmed the doleful truth. That bright and shining light no longer illumines our hemisphere. He is gone to that glory which had so powerfully transformed his spirit into the image of his blessed Master. When I found it really was so, with David "I became dumb. I opened not my mouth, because God had done it" [cf. Ps. 39:9]. Infinite Wisdom cannot err, but when I think of what my dear friend will feel, of the church's and of my own loss, and also of my small improvement of the invaluable blessing of such a Christian friend, as well as of the grief it will occasion to dear Mr. Wesley, my tears freely flow. I think my Lord will not reprove my sorrow. It draws me upwards. I feel a new attraction towards heaven. While memory recalls the form of the departed, his words, his actions, his heavenly looks, all seem to say, "Follow me, as I have followed Christ; then shall you also behold that glory to which I have now attained."

I wrote, as well as I could, to my dear afflicted friend, and offered her any assistance it might be in my power to render. Lord, make me more fully ready for thine appearing! My spirit, I am deeply sensible, may take a much brighter polish, and thereby, as a purer mirror, reflect the glory of my Lord to all eternity.

September 9th. This morning's post brought me a letter from dear Mrs. Fletcher wherein she says, "God orders all. The great lesson I want to learn is perfect resignation, which he has taken the most effectual means to teach me, and I trust it will answer his wise design."[125]

March 31st, 1786. This day I received a letter from a gentleman I had seen at Birmingham, who writes to me on the subject of marriage. He is a sensible good man, and, as to outward things, much beyond what I have any right to expect. He was converted to God in the same year that I was, and has been steady from that time to the present. He is Gunsmith to His Majesty, is in very affluent circumstances, and freely tells me he wants me to help him to live to God. After laying the matter before the Lord in prayer, I saw it my duty to decline his offer. It is true that one talent, of which I often now feel the want, would be put into my hands, but my time would not be all at liberty for the Lord's service. Nor do I feel that particular conviction from God, without which I cannot act in an affair of this kind. What my Lord may call me to in future, I know not. I would move at

his beck, as the leaf before the wind, but at present I have no intimation that this is his will concerning me. I do not mean that I expect a particular revelation to be made to me on the subject (although this, I believe, is sometimes given), but I think that whenever I am called to change my situation, it will plainly appear to my understanding that by such a change I shall be likely to become more holy and more useful.

I am often greatly straitened for time. My engagements multiply so fast, as to be almost too much for my strength. But the Lord enables me to live under the shadow of his wing, and keep me in constant peace.

[July 10, 1788.] I left my dear Otley friends, and went to Kirkstall Forge,[126] in my way to London. While preparing for this journey, I have felt peculiar rest and composure of spirit. When at prayer with the family, that word was given me, "The very hairs of your head are numbered" [Matt. 10:30]. It inspired me with calm confidence in my Lord's preserving care. I was assured that they should have a further fulfilment than merely in relation to the body, if I would but trust in him. I felt not only the will, but the power, to do so. Armed with my Saviour's might, I left my dear people, and once more, Abraham-like, followed my Lord into an unknown part of the vineyard. At Leeds I took sweet counsel with a friend, and on the 17th, at five o'clock in the morning, took coach for London, where, after a journey of mercies, I arrived about twelve the next day. I was kindly received by my dear friends, Mr. and Mrs. Peard Dickenson,[127] and in the evening supped with Mr. Wesley.[128] I soon felt myself quite at home. The situation is airy, and Mr. and Mrs. Dickenson seem just such friends as I need. We had a profitable time during the Conference.[129] Prayer was heard and answered in behalf of our honoured father who was divinely assisted in the performance of his arduous duties. In the public ordinances I drank freely of the water of life, and while I heard the truth, I felt it in my heart.

[November 1790.] Believing it to be my providential path, I entered on my new engagement,[130] and found sufficient business on my hands. The preacher who had usually read to Mr. Wesley being absent, he said to me, "Betsey, you must be eyes to the blind." I therefore rose with pleasure about half-past five o'clock, and generally read to him from six till breakfast. Sometimes he would converse freely, and say, "How good is the Lord to bring you to me when I

want you most! I should wish you to be with me in my dying moments. I would have you to close my eyes." When the fulness of my heart did not prevent reply, I have said, "This, my dear Sir, I would willingly do. But you live such a flying life, I do not well see how it is to be accomplished." He would close the conversation by adding, "Our God does all things well. We will leave it in his hands." During the two months I passed under his roof, which proved to be the last he spent on earth, I derived much pleasure from his conversation. His spirit seemed all love. He breathed the air of Paradise, adverting often to the state of separate spirits. "Can we suppose," he would observe, "that this active mind which animates and moves the dull matter with which it is clogged, will be less active when set free? Surely, no; it will be all activity. But what will be its employments? Who can tell?" I was greatly profited during this season. My hands were full, but I felt the light of the divine approbation shining on my path, which rendered easy many painful things I met with. Indeed, I felt it quite a duty to let Mr. Wesley want no attention I could possibly pay him. I loved him with a grateful and affectionate regard, as given by God to be my guide, my spiritual father, and my dearest friend, and was truly thankful to be assured that those attentions were made comforts to him.[131]

September 11th [1791]. This visit [to Madeley] has been a real blessing to me. I have caught fervour from a kindred fire, and long to follow my Lord as closely as my friends here do. Dear Mrs. Fletcher's love, zeal, and humility make me feel most sensibly that I am far behind. May the Holy Spirit breathe upon me, and infuse more vigour into all my powers!

I feel the sweetness, the security, of dependence on my adorable Redeemer. I see, I feel, that infinite wisdom, power, and love, are engaged to direct, sustain, and comfort me. Jesus Christ has opened the way into "the holiest;" and by faith I am enabled to enter. O the riches of grace that open to my view! I feel the truth of that word: "Through him we have access by one Spirit unto the Father, and are no more strangers and foreigners, but fellow-citizens with the saints, and of the household of God" [Eph. 2:18-19]. The privileges of this citizenship, I now in part enjoy—light, life, and liberty. The intercourse I open, but I come to my Divine Instructor to teach me more fully the way of simple faith that I may learn more of God. I feel a degree of sacred attention. My soul is recollected, and sits, with

Mary, at the Master's feet [cf. Luke 10:39], waiting for those brighter manifestations of his glory which shall transform me more completely into the image of my Lord. I am permitted to hold sacred communion with the militant church, as well as something very like it with the church triumphant. Lord, keep me in the secret place of thy presence, and let all my powers be gathered into thee, who are my Saviour, Husband, Brother, Friend!

[January 1792.] I drank tea with Mrs. Crosby. There were a few persons present who seemed almost persuaded to be Christians [cf. Acts 26:28]. They are rather in the higher walks of life, but are quite at a stand, as they think they cannot yet give up the world. We dealt faithfully with them, and should they persist in trying to reconcile things in their nature irreconcilable, and so perish after all, we are clear of their blood. Alas! what a pity it is, that a dread of the reproach of the cross should hinder any from aspiring to the title and privileges of a child of God, and that the insipid, trifling conversation of those who are strangers to themselves should cut them off from intercourse with persons who are conversant with higher and better things! What thanks do I owe to Him who has brought me out of a soil which yielded no supply for my spiritual wants into the blessed fields of divine truth, and has cast my lot among those who are instructed so to feast on the precious fruits which grow there, as to obtain healthful nutriment for their souls!

[Spring 1792.] About ten days ago, I received a letter from Otley, which informed me, that my lovely niece, Betsey Ritchie, had had the measles and that she was still suffering seriously under the effects of the disorder. I immediately laid her case before the Lord. I saw infinite love in the affliction, and could only say, "Thy will be done" [Matt. 26:39]. I own I felt little expectation of her life. Yesterday, another letter informed me that this sweet child had breathed her last. For some hours after I received the intelligence, resignation, praise, natural affection, and sympathy with the suffering parents, were strangely mingled in my breast. I loved her tenderly, and, indeed, the peculiar affection she always manifested towards me was so great that it would have been strange if I had not. When I left home in August, my sweet Betsey accompanied me for a short distance on my way, and when we parted, said, "Come home soon, aunt, and me come and meet you." So thou most likely wilt, my angel-niece!—but it will be to welcome me to my everlasting home.

I deeply felt the distinction between my feelings as a Christian, and a mortal subjected to human ties. As a Christian, I thankfully acquiesced, for my heart adored the infinite love which I clearly saw in the dispensation. But as a mortal, my emotions expressed themselves in floods of tears, which Jesus did not disapprove. My spirit felt a new tie to the invisible world, and a hallowed nearness by faith to the triumphant church.

[November 1804.] This day's post brought me tidings of the translation of my very dear, my faithful, my beloved friend, Mrs. Crosby, to the kingdom of glory.[132] She was remarkably happy all last week, met her class as usual, was at chapel on the Sunday, and in glory before eight o'clock in the evening. I had a sweet letter from her about a fortnight ago. She said she thought it would be her last. So it has proved. I have lost a friend who, with more than a mother's care, watched over me from the time of my first setting out in the heavenly race. Our souls were knit together in bonds which death cannot dissolve. My loss is great. I loved her tenderly. Lord, help me to strive to follow my friend to glory! She was a burning and a shining light. Her life, and her death, glorified God.

The Diary of Anna Reynalds

Editor's Introduction

Anna was born to an ardent Methodist mother, Ann Poat, who was one of the earliest followers of Wesley in western Cornwall. Anna's father, John, held these "religious extremes" in utter contempt. The life of Anna Reynalds (1775–1840) reflects all of the critical developments and tensions within the tradition at the turn of the century.[133] Prior to her mother's death in 1789, Anna attended a school run by two elderly Methodist women, unidentified, who left an indelible mark on her life. Confirmed in the Church of England at age fifteen and subscribed as a communicant at Kenwyn, it was not until 1792 that she established anew her connections with Methodism. Her marriage to George Reynalds, a timber merchant in Truro, on March 29, 1795, was designed, in large measure, to fulfill her spiritual aspirations. Once established with her husband in Truro, her diary reveals the mundane and extraordinary events of that Cornish Methodist community.[134] In 1818 Anna helped to form the Truro Dorcas Society for the Relief of Indigent Women and Children for which she was long remembered. Her obituary notice of October 23, 1840, simply concludes: "Often did the blessing of those who were ready to perish come upon her, and she made the widow's heart to sing with joy. In her the poor have lost a valuable friend."[135]

Reverend Thomas Shaw transcribed Anna's diary during 1960–1961, of which the original manuscript sources are included among the collections of the County Record Office in Truro. The following modernization of the excerpted text is based on the manuscript material collated with the Shaw transcription.

✳ ✳ ✳

I was born the 18th of March 1775 in the Parish of Kenwyn.[136] My father was a rigid Church man. My mother was one of the first Methodists in the west, convinced of sin in early life, and lived and died a happy woman. As I was the only daughter every care and attention was paid me by both my parents, but my mother in particular watched over me with the greatest assiduity and laboured indefatigably to instill into my mind eternal truths. Her impressive admonitions have caused me many times to weep. And I believe from my infant days the Spirit of the Lord strove with me.

[On Easter morning 1792] the Lord uncovered my heart, drew back the vail from my eyes and discovered to me that all my almsgiving and strict attention to a round of external duties were but filthy rags [cf. Isa. 64:6], and without repentance and faith in a risen Saviour, I must perish for ever. The sight I had of my wretched state led me to cry for mercy. I became insensable to all around me and lay speechless and motionless for some time. But the blessed Lord passed by and proclaimed himself the Lord, the Lord gracious and merciful, at the sight of which my burden fell off like Bunyan's at the sight of the Cross.[137] I was enabled to exercise faith in Him and returned home rejoicing in a sin pardoning God, blessing the day I was born to participate in such happiness.

The word of God became my delight and was truly spirit and life to my soul more especially as I had no one to open my mind to for the space of three weeks but gave up myself to the Lord's direction and through grace enjoyed His presence from day to day accompanied with a divine peace and tranquility.

About that time I discovered the necessity of a deeper baptism.[138] I felt the rising of pride and self will, and which I thought could not exist in Heaven, and considered that if Christ came to the world to put away sin by the sacrifice of Himself, He was able, willing, and ready to save me from all sin. And on that day three weeks in which the Lord shed abroad in my heart His love, in the same room a flood of light, life, and love broke in on my soul so that I was enabled to rejoice with joy unspeakable and full of glory. Here I felt my heart, will, and affections swallowed up in the will of God. God became all in all, all my affections were from that time drawn from the creature and created good and fixed on God.

[January 6, 1817.] Bless the Lord O my soul. I want language to speak His praise. The remembrance of His name is precious; were I

to omit praising Him the stones would cry out [cf. Luke 19:40]. Since the commencement of the new year my peace has been uninterrupted, and my joy I cannot express. O who is a God like unto Thee. . . . A measure of this glory the Lord condescended to favor me with on the eve of the new year after I returned from the Watchnight[139] where I felt as if the Lord was preparing my heart for an increase of grace & whilst striving to renew my covenant with Him and wrestling like Jacob of old, I will not let Thee go except Thou bless me.[140] He descended in the power of His Spirit and imparted that power that enabled me to cast all my self with all my sins on the atoning blood. . . . I never so fully proved that God is a satisfying portion, and it was as if Jehovah was saying, eat O friend, drink abundantly O my beloved. Such enlarging and filling, enlarging and filling, thus I past the night while my family were in bed, sitting in heavenly places in Jesus Christ. Truly the men of earth have found glory begun below. The flame of divine love burned ardently on the altar of my heart. . . . While praying the Lord to keep me while in the world, I felt those words sweetly applied, "I will never leave thee, nor forsake thee [Heb. 13:5], *abide in Me*" [John 15:4]. Each day since I have had such a humbling sense of His loving presence as often crushes the animal frame beneath its weight. From morning to night I feel as if at the feet of my blessed Lord. O help me to preserve this abiding witness of Thy presence.

[January 12.] I know not what the Lord is about to do with me. The very powerful manifestations have so enfeebled my frame. I never felt such a sinking into my own primitive nothingness nor the power to cast myself with all I have and are on God day by day as I now do. I never had such views of the secret Three in One.[141] At times I seem encircled with the Deity, and with ministering spirits, those which are sent forth to minister to such as shall be heirs of salvation, and those perhaps of my own flesh and blood forms a part of the heavenly Quire.

[September 6] All devotional seasons or exercises are only so far good as they proceed from a mind rightly disposed towards God. The imitation of Jesus Christ is a sweet theme for the mind to be exercised on and though not called to the same manner of life or to the same kind of actions, yet what I am called to do must be done in the same Christlike spirit and disposition of mind, to act by the same rule, and to look towards the same end, and to live as He lived is the

sole way of living to purpose.[142] He is the way, the truth, and the life [cf. John 14:6]. O for grace to practise that humility and piety that is pleasing to the Lord that I may be steadfast, immoveable, always abounding in the works of the Lord, knowing that my labour will not be in vain in the Lord.

[October 19, 1818.] I trust gratitude is written on the tablet of my heart to that being who does not let me rest in past attainments but gives me an increasing love for His word which together with my own experience teaches me the great need I have: to come to Him day by day for the renewing of His love, for persevering grace and for perfecting grace, and by thus coming to Him I feel more and more His establishing grace[143] and a greater dominion over inward as well as outward sin, and my soul brought into a sweet calm and waiting frame listening to the teaching of His Spirit. The cry of my heart is Lord instruct me in the way to Thy Kingdom. I feel called to lay myself out more for God. Since the poor and the sick have been laid on my mind I have seen it my duty to visit the abodes of misery and feel thankful that the Lord does enable me to lessen in my measure the load of human woe.

PART THREE
AUTOBIOGRAPHICAL
PORTRAITS OF
MISSION AND EVANGELISM

Introduction to Part Three

The Wesleyan Revival was, first and foremost, a rediscovery of "the church as mission." Rather than focusing attention on the preservation of the status quo, Wesleyanism emphasized the necessity of transformation. In an "Age of Reason," with the state church preoccupied as it was with the intellectual and theoretical concerns of the few, the Methodists sought to rediscover a practical divinity that touched the hearts and lives of the masses in real situations of suffering and neglect. They stressed responsible discipleship and identification with those abandoned by the respectable people of the society; they preached solidarity with no separation from the poor.[1] At the very time when the institutional momentum of the church was centripetal, or inward looking, Methodism became a counter, or centrifugal, force spinning its followers out into the world in mission. The Wesleys had simply rediscovered the primary model of the New Testament church.

Virtually everything related to the lives of early Methodist women, therefore, was missional. No group within the movement symbolized this self-understanding more dramatically than Wesley's band of itinerant preacher/evangelists. Here were men *and women* sent out in the most literal sense as agents of transformation and renewal. Mission was their life, and the primary task of these zealous preachers was that of evangelism—to offer Jesus Christ to others in all his fullness. To use Jesus' own image, they were like the sowers of seed, spreading the good news wherever they traveled, in hope of a good harvest for the Lord. But the good news they preached was not only a word for the soul of their hearers, it also involved concrete acts that demonstrated the power of God's love in every aspect of life. It was an incarnational ministry that looked to the whole person and responded in a holistic way to the physical, educational, social, and relational needs of people as well as their spiritual aspirations.

Some women felt called in particular ways into the ministry of evangelism and mission. As revivalism swept across the land, they styled themselves (as their male counterparts had done) as evange-

lists, and as the Protestant missionary movement began to sweep the globe, they responded to God's call to go and tell others about the story of Jesus through word and action in far off corners of the world. The women featured in this section are drawn from this smaller circle of early Methodist disciples who embraced an apostolic vision and mission.

In the narratives of these special women that follow it is not surprising to find that God's call is central to their story. "Oh the exercises of mind I endured—travelling in birth for souls—the love of God was as a fire shut up in my bones," explains Elizabeth Evans, "and the thoughts of the blessed work of bringing sinners to Christ drank up my spirits so that I knew not how to live." Perhaps no call, however, is more dramatic than that of Dorothy Ripley. She describes how she was physically knocked to the ground, reminiscent of the Damascus road experience of Saul. Lying for several hours in this state, "The Lord commanded me to 'go ten thousand miles,' . . . Ethiopia's, or Africa's, children by oppressors were brought to till the ground for many of the American planters. Therefore was I led thither . . . that they might find redress from a gracious God, whose compassion fails not to any of the children of men." Her language related to God is of particular interest in this regard. "Did men consider that the very name and nature of God is love! love to all the fallen race," she explains, "this would prove an incitement to them to return to the great and glorious Parent." Her calling was nothing less than a mission to restore the family of God, to function as an ambassador of reconciliation for the loving Parent.

All of these women describe the struggles they endured in their various ministries and the resistance they encountered because they were women. Despite that her ministry was characterized by nothing other than compassion and hospitality, Margaret Davidson had to face the charge that she was a witch. In her efforts to speak out on behalf of the African slaves in America, Dorothy Ripley encountered the wrath of slave owners and the benign neglect of a U.S. president. She was even turned away from a Methodist pulpit to plead her cause because she was a woman. After the death of John Wesley, jealous male leaders threw up barriers in the way of Mary Taft, one of the greatest Methodist evangelists of her day. Nothing grieved her more deeply than the resistence to her ministry that she experienced from those she considered to be her colleagues in the work of God.

She was constantly on the defensive within a tradition that had, at one time, affirmed God's call of women and embraced their servant ministry.[2] Even the painful realities of inevitable separation from family for those in mission and the cost of faithful discipleship for those possessed by God's vision for the world figure into these stories of struggle, defense in the face of resistance, and triumph over amazing obstacles.

The portrait of mission and evangelism which emerges is essentially that of incarnational ministry. The keynotes are compassion (suffering with others) and hospitality (opening one's life to others so as to give them a place of sanctuary in all the circumstances of life). Davidson engaged in a house to house ministry that carried her into the homes of hundreds of families across Ireland. She was particularly drawn to the children of the poor and sought to meet their multiple needs. Ripley's mission was more specifically focused in her desire to liberate the African slave from the horrendous bondage of America's "peculiar institution." The methods she used to achieve that goal were multifaceted and ranged from creating schools for the children of slaves to securing the floor of the American Congress and personal audiences with the president himself in order to make her appeal. The ministries of Mary Taft and Elizabeth Evans were those of the itinerant evangelist, traveling, preaching, planting, praying, and in all, demonstrating God's love for all people.

These are portraits of courage. They are an amazing testimony to women under fire and their strength to persevere against all odds. They bear witness to the experience of many women, who, as Dorothy Ripley once confessed, felt "lost in God, my only friend."

Margaret Davidson

Editor's Introduction

Margaret was born into a poor Irish family. Blinded by smallpox, she educated herself by whatever means at her disposal. Converted under the preaching of Methodist itinerant preachers, her faith was bolstered by the preaching of John Wesley in 1765. Widespread revival in the 1770s gave her the opportunity to evangelize and her public appearances were said to have resulted in many conversions.

The Reverend Edward Smyth,[3] who had encouraged her public ministry of evangelization, compiled her memoirs, and published *The Extraordinary Life and Christian Experience of Margaret Davidson, (as dictated by herself) Who was a poor, blind woman among the People called Methodists, but rich towards God, and illuminated with the light of life* in Dublin in 1782. The following extracts are taken from this rare work.[4]

❊ ❊ ❊

They brought me to *Newtown*,[5] to hear the Rev. Mr. *Wesley*. He preached in the bowling green from these precious words, *"Truly, our fellowship is with the Father, and with his Son Jesus Christ."*[6] While he was speaking, my heart was inflamed with love to God and man; and, as I was placed very near this harbinger of heaven, I could just observe the waving of his hand betwixt me and the light. After preaching, being requested to look at my eyes and give his opinion, he said, "I believe there is little ground to imagine that she will recover her sight here: But (continued he, gently taking me by the hand) Faint not—go on—and you shall see in glory." These words left a

lasting impression on my mind. O my God, fulfil the prediction of thy Servant!

I was present when he met the Society, and at parting, he *commended us to God, and the word of his grace.* Upon this, I was melted into tears but could say in all things, "The will of the Lord be done."

[In the time of the revival] I did not acquaint [my family who opposed the Methodists] of the outward wants to which I had been so often exposed but related all the good that was done for me. The motive I had in view was that their prejudice might be removed from and their love exercised to those whom they hated, as being *the off-scouring of the earth* [Lam. 3:45]. And, (blessed be God!) my design was, in some measure, accomplished, for they began to speak well of my once despised companions and myself.

Multitudes came to [my] house, some anxiously inquiring after the doctrine and deportment of the *Methodists*, others solicitous to hear the hymns repeated and sung.[7] I gratified them all as far as I thought requisite, and, even above my natural power, labored to persuade them that they could not be *Christians* without regeneration. It was mightily impressed on my mind to pray with them when they assembled together, and I was likewise urged to it by my Father. But it appeared a heavy cross to me to perform this duty in his hearing. Sometimes I refused but found a secret check for it.

I was invited from house to house through all the Country, and the people told me their intention was sincere in doing so. "We would rather hear you (said they) than our teacher, for it is beyond all doubt that God has wrought a miracle for you as you never had the advantage of human instruction." I have labored, for hours together, to convince them, one by one, of the necessity of true repentance and a lively faith in Jesus Christ. And the method that I generally used was to draw inferences from their own catechism[8] and from the hymns with which they were affected but did not at all presume to stand up as an exhorter lest any should take an occasion to say that I assumed the character of a Preacher, which (I believe) might have hurt the cause of God. I was deeply sensible of my own insufficiency and knew that I could speak nothing good unless it was imparted by a good Spirit.

On the conclusion of the whole matter, there were some that appeared to be awakened—that testified their repentance by tears and refrained their tongues from their customary swearing. Many of them, also, begged of me to bring a Preacher among them if it were

possible. A rich man who asked me to his house said they should meet with a hospitable reception from him.[9]

The year following, I went there again and told them I was grieved that they had shown such disregard to Christ and his messenger and had slighted that gospel which might have proved *the power of God to their salvation* [cf. Rom. 1:16]. Some of them seemed to be ashamed and said he exhorted them privately, and they never heard such gracious words as he spoke nor saw such grace in the countenance of any man. But, like *Adam*, each was prone to put the blame upon another of not going to hear him in public, shuddering at what these two great men threatened to do.

One time, while I was there, two little girls about ten years old (of whom my sister was one) begged me often to go apart to pray with them, to which I readily consented, and found such melting of heart as could not be expressed. They told me they had agreed together to leave all, as I had done, and to go along with me, adding with tears and uncommon zeal, "We do not matter what game the world makes of us or what they shall call us, for we are resolved to serve God." While I was with them I strove to strengthen them, but according to my expectation, when I was gone, they were baffled out of all their seriousness.

The Lord having blessed some of my simple words to an affectionate Girl, whose heart was united to mine, she strenuously insisted on my living with her in *Newtown* upon the easy terms of paying a shilling a week for my maintenance. This proposal I thankfully embraced and, therefore, prepared to remove my little concerns from *Lisburn* but wished, before I left it, to be present at the quarterly-meeting at Christmas.[10] How to accomplish my desire I knew not. Darkness respecting outward things surrounded me. Therefore, I was just resolving, though with much reluctance, to leave that blessed means of grace when, one day in the street, my gracious God inclined the heart of a poor woman who lived in a cabin at *Derriaghy* to ask me to spend some days with her.[11] After returning her thanks, I told her that I was not able to walk so far, the road being bad and my body weak. She answered, "Perhaps Mrs. G[ayer] will bring you on the car next Sunday."

Leaving me . . . in the Cabin I had been invited to before I was out of bed the next morning, I was strangely surprised at the kind desire of Mr. G[ayer] that I should go to his house. I arose immediately, full

of gratitude to the considerate Gentleman for his unmerited favor and found Mrs. G[ayer] also thankful. After the first salutation was over, she said, "Certainly, the hand of Providence is in this affair. I was reflecting, early this morning, on your poor condition and inquiring of God what was best to be done. I opened the Bible, and the first passage that struck my eyes was *Be not forgetful to entertain strangers, for thereby some have entertained angels unawares* [Heb. 13:2]. From thence I concluded it was my duty to send for you but first mentioned your name to my husband saying, 'If you were here, you would teach us a particular tune, which he was very fond of.' And accordingly he gave me the liberty to send for you and to keep you till the Quarterly-meeting."

I could not but admire and adore the goodness of God manifested in this wonderful dispensation. My body was not only refreshed with the good things of this life, but my soul was strengthened by the converse of some religious visitants, who all rejoiced together. Among the rest was a gospel-minister and his wife, who requested me to spend a month with them after the quarterly meeting for which they meant to stay. I looked upon the favor to be from God himself, which was afterwards very evident. For I had not been long at their house when Mr. S[myth] went to exhort in a barn at *Dunsford*.[12] Having taken me along with him, after his exhortation he insisted on my publicly declaring *what the Lord had done for my soul*, judging that my experience might be of use to the simple hearers. This I complied with but with much confusion and reluctance fearing the effects would not be answerable to his expectations. But my fears were put to silence, and the wisdom of God magnified in my foolishness.

Mr. S[myth], having then an impression that I might be profitable to the people, spoke largely to them concerning me and concluded by observing that he thought it advisable to leave me among them for a while and that as many as pleased might come at any time to a certain house where I would speak with them concerning the things of the kingdom of heaven.

On his recommendation, multitudes came, the day following, where I was, and they all appeared to be humble and teachable. I was neither disposed nor qualified to exhort them at large. But if any particular person or persons inquired of me what they must do to be saved, I was enabled in a pressing manner to beseech them to fly to

the wounds of a Redeemer. Many, while I was speaking to them, both that day and at other times, roared aloud for anguish of spirit, and some continued agonizing in prayer till they found rest to their weary souls.

I was taken from house to house and desired to pray with them. To the glory of God be it spoken, there were many very extraordinary answers granted me. In short, nine at one time, six at another, and many more at various times and different places, were loosed from the bands of iniquity, raised from the grave of sin by the voice of the Son of God, and by the quickening Spirit that raised Christ from the dead. Such clear discoveries of the power of God as was in this land and among this people in general I never before had heard of. It ought to be, and shall be, I trust, *had in everlasting remembrance* [cf. Ps. 112:6].

Upon the whole, what shall I say? The Lord will work, and who shall hinder? He will perform his desire by using instruments wise or foolish as seemeth good in his sight. By sounding silver trumpets or rams-horns, the walls of *Jericho* shall fall [cf. Joshua 6], the bulwarks of sin shall be beaten down, and the kingdom of *Satan* shaken. I revere with trembling the Almighty hand that bears rule over all, that *brings down the mighty from their seats, and exalts them of low degree* [cf. Luke 1:52]. God will humble every proud heart and make every tongue confess [cf. Phil. 2:11] that *salvation belongeth unto him* [cf. Ps. 3:8] alone, that none may boast of self-sufficiency, neither be hindered by false diffidence from all the good that God puts in their power to do.

I need not say that there is a material change among this highly favored-people, for it is visible to all around them. Yet there are both despisers and blasphemers now, as well as when Christ was in the flesh, who call his work not only a delusion but witchcraft and what not. I praise God that I have had the honor of being called a witch for his name's sake—a sacred scandal, the very consideration of which should make me sink into nothing before him.[13] Certainly it is cause of a rejoicing when *all manner of evil* is *spoken falsely* concerning us [cf. Matt. 5:11], for the sake of him who bore our reproach as well as our sins and sorrows on the tree. *If they have called the Master of the house Beelzebub* [Matt. 10:25], let not any of his unworthy servants expect better treatment from the ungodly world.

It is certain that there are many in this happy country who have *passed from death unto life* [1 John 3:14], for they manifest their love to God and to the Brethren. In a very affectionate manner they have asked me, poor and indigent as I am, to spend my time among them. I think it may tend to the advantage of both soul and body, for they say I need do nothing in the world but only be employed in singing and prayer and other religious duties. I believe I could not have power to leave them were it not for the fulfilment of a promise I made to my friend in *Newtown*, whom I now intend to visit and to decide matters with her, hoping to be directed by divine Wisdom in all things, particularly in respect to my living with these new friends who have been so graciously raised up in a time of great necessity. For this blessing I cannot cease magnifying and adoring the wonders of unbounded love and unmerited pity towards me.

Dorothy Ripley

Dorothy Ripley (1769–1831), a native of Yorkshire, was strongly influenced by both Methodist and Quaker preachers.[14] She was so impressed by the teaching of the Methodists that she made a vow in her early years to "take God as her husband." She decided to spend her life wholly devoted to the love and service of her "gracious Parent," as she often referred to God. In 1801 she felt a special call to work among the slaves in the New World. In her efforts to improve the living conditions of slave communities and raise the consciousness of the American public concerning their plight, she traveled up and down the eastern seaboard pleading their cause. She secured an interview with President Thomas Jefferson and, in a subsequent visit to Washington in 1806, obtained permission to address Congress on the topic of social reform and the abolition of slavery in particular. Functioning as an ambassador of mercy for over thirty years, she made the Atlantic crossing some eight or nine times, expanding her work in America to include prison reform, after the model of John Howard, and Native American advocacy. In later years, she made Charleston, South Carolina—the stronghold of Southern slavery—her central base of activity.

She published a number of books, including two major autobiographical works. Her early years are chronicled in *An Account of the Extraordinary Conversion and Religious Experience of Dorothy Ripley*, the second edition of which was published in London in 1817 and from which the following excerpts are drawn. In *The Bank of Faith and Works United*, the first American edition of which was published in 1819 in Philadelphia, she sought to illustrate her lifelong philosophy

of trust in a God who would always provide. Throughout the course of many preaching and consciousness raising tours across the eastern seaboard of the United States, she never permitted a collection to be taken on her behalf. Often literally penniless herself, Dorothy's many friends—Methodist, Anglican, Congregationalist, Baptist, and Quaker—supplied her basic needs and supported her active ministry throughout the years. Dorothy died in her adopted homeland on December 23, 1831, and is buried in Mecklenburgh, Virginia.

❋ ❋ ❋

In my eighteenth year I had a severe trial to pass through, which was the death of a pious father.[15] He offered me to God before I was born to be a preacher of righteousness and trained me up in the "fear of the Lord" for his kingdom. His virtuous example was the most like Jesus Christ's that ever I saw. And could I describe his lamb-like nature, it would be a duty which I owe to an earthly parent whom I loved as revered next to my God. But alas! his life crowned with mercy, faith, love, and obedience cannot be much illustrated by a groveling worm.

From a youth of nineteen he was banished from his native place by Folds, Lord of Ingelby Manor, for going to hear John Wesley's preachers. But the hand of his God was with him and designed him to build him an house for his glory and to be a pastor to Jesus Christ's flock. In faith he laid the foundation of the first large Methodist meeting-house in Whitby[16] (where I was born) and brought "forth the headstone thereof with shoutings, crying, Grace, grace unto it" [Zech. 4:7]. Twenty years he preached a free gospel in it. For his Master, Jesus Christ, had taught him this lesson, "Freely thou hast received, freely give" [cf. Matt. 10:8]. His private house was a comfortable residence for strangers who were all at home with him if they served his God. Many years I marked his footsteps which were "holiness to the Lord," while his conversation adorned the gospel of Jesus Christ which he preached, being a savor of life unto many up and down wherever he came.

His family were favored beyond thousands, for they saw his zeal, wisdom, and universal benevolence from year to year, ever breathing prayer and praise to Israel's God. It was his custom to rise at four

every morning and to read the sacred scriptures of truth once through every year, which he had done seventeen times since I was born, having all his children by him to instruct in that solemn duty which he owed to his Maker. I never remember one day in my life in which my Father omitted calling his children and servants together to worship in Spirit the Creator of the Universe, if at home. Morning, noon, and evening were set times for our devotion, which appeared to be done in the fear and love of God, love being his peculiar characteristic whereby he was well known. Believing it his duty, he fed the hungry, clothed the naked, and so increased his treasure above [cf. Matt. 25:35-36] winning many souls to God by the merchandise of wisdom. His fortitude was great, and murmuring was never heard from his lips. Neither did I ever hear one unprofitable word proceed out of his mouth, for it was a mouth for God to speak through.

On 28th 2nd month, 1797, entering my room to worship God, the power of God struck me to the earth where I lay as covered with his glorious majesty beholding as through his Spirit the riches of his kingdom "which God hath prepared for them that love him" [1 Cor. 2:9]. For some hours I lay on the ground viewing the glory of the city where the Spirit assured me I should dwell for ever in bliss unutterable, which then I participated through the overshadowing glory of this visitation which filled me with rapturous joy and surprising awe so that I was lost in wonder, love, and praise.[17]

In this situation the Lord commanded me to "go ten thousand miles," to "provide neither gold nor silver, neither two coats, neither shoes, nor yet a staff" [Matt. 10:9-10], the omnipotent arm of Jehovah being my support, leaning on no arm of flesh. Ethiopia's, or Africa's, children by oppressors were brought to till the ground for many of the American planters. Therefore was I led thither by the unsearchable wisdom of their Creator and mine to exhort them with tears to "stretch out their hand unto the Lord" [cf. Ps. 68:31] that they might find redress from a gracious God, whose compassion fails not to any of the children of men. Ah! the solitary path that I took! who but a God of everlasting strength could have brought me safe through? Yea, who but Abraham's God could have delivered me from Satan's power? When I consider the impediments which were in the way to stop my progress, I am astonished that my natural life was not taken away, notwithstanding the extraordinary pity of my God manifested in sustaining me, an helpless worm, who was weaker than a "bruised reed"

[Matt. 12:20]? How then shall I begin to rehearse his goodness with my pen that others may obey the Light and not hesitate respecting the difficulties in the way. God is willing to assist all who will be assisted by his gracious Spirit, which is seeking to gather the lambs and sheep to his fold of love, where each one dwells securely under the care of Israel's Shepherd, even Jesus Christ, my Lawgiver Priest, and King!

Going from city to city, from one nation to another, I have discovered the iniquity that lurks under the various masks of professing godliness, each different denomination thinking themselves the most sincere. But alas! when I seek for pious souls redeemed from the maxims and fashions of the present day, I almost seek in vain and ask if there are any who live now as Jesus Christ taught his followers in the days of his flesh, both by his example and precept? . . . Before the Lord sent me forth to preach the gospel, he testified by his Spirit that he would keep me unto the day of redemption and gave me faith to believe that I should stand firm in Jesus Christ a new creature being clothed with his imparted righteousness, "the saints' pure white linen" [cf. Rev. 15:6]. He sealed my eyes that they might gaze on his uncreated beauty and sealed my ears that they might not regard a stranger's voice, ever open to hear the voice of the true Shepherd, yea, to set me as a seal upon his breast—as a seal upon his arm.

No words can express the eternal union which has taken place on earth, my heaven being already begun, and knowing I shall delight myself through millions of ages. Yea, and the excellent God will delight himself with the least of his saints who love him through choice and not of necessity. It is my choice to serve the eternal I AM because he is infinitely good and gracious, full of wisdom, and full of compassion to all nations without respect of persons if I believe "Jesus Christ tasted death for every man" [cf. Heb. 2:9]. Surely I must believe this if I believe he died at all or died for me the chief of sinners. Did men consider that the very name and nature of God is love! love to all the fallen race? This would prove an incitement to them to return to the great and glorious Parent. He feeds by his bounty from year to year, millions of all nations although the greatest part of mankind live as if there were no God observing their ways, neither any hope of immortality in the regions of glory. Mistaken is man in the first point that leads to God supposing it impossible to come up to the standard of righteousness to imitate the lowly pattern. Man, as man, cannot arrive to perfection in righteousness. But God in man

133

can effect wonderful works of purity in every age of the world to testify the power of the Highest. He uses either male or female for his own glory that the church, the bride, the Lamb's wife, may be complete. This church are all the redeemed by the precious blood of the "Lamb of God, which taketh away the sin of the world"[18] by virtue of his merit, illustrated in his appearance as a servant of no reputation fulfilling the law through his obedience even to the shameful death of the cross [cf. Phil. 2:5-8].

An Account of my setting off from my native place in Yorkshire, to America

I left Whitby, 29th 12th month, 1801, at three in the morning, leaving a beloved mother and two endeared sisters for the sake of Jesus Christ, who testified by his Spirit that I never should know the want of a mother or sister so long as I was in his vineyard. For he would raise me up dear friends every where, which I had faith to believe. After my indulgent parent washed and dressed me, she took me into her arms and kissed me with tears, saluting me with her voice thus: "I can trust thee the world over, for I know thou wilt be preserved, but I shall never see thee again." My reply to this affecting final sentence was, "Mother, we shall live together for ever," which through faith and hope I believed.

The tears I shed and bitterness of spirit which I felt for the African race and the heathen at large, God only knows. And it sufficeth me to believe that he will soon cause the oppressors to cease their oppression[19] and reward with peace such who travail in spirit for the spread of the gospel of our Lord Jesus Christ. . . . I told the company my movement was not an hasty one, for it had been contemplated by me from a child. I had seen it necessary to give up myself to the same for the last twelve years that my peace might be secured, knowing that the Lord required of me to instruct the heathen, or the African race, which I was willing to comply with to promote their happiness if I laid aside my own ease and present comfort.[20] When those friends had proved my concern by the light of the Lord, they sympathized with me and requested me to go again thither the next day. So in the morning I went with a determination to be open to conviction, and to receive their counsel as from God, he having already administered hope to me by their faithful dealing after their consolatory portions of love which came pure from the word within.

Since I left Whitby I have traveled five hundred miles by land, in faith, and am now surrounded with blessings, having a good Captain and a fine little vessel with this testimony that God will land us safe.[21] Oh! what a debtor am I to my never-failing Comforter, who has exceeded all my expectations in raising up so many friends for me who have been as father, mother, brother, and sister while I have passed from city to city. Surely the Lord will strengthen my faith by the continuation of so many proofs of his care extended to me through the medium of his stewards who have ministered to me from his abundance of temporal and spiritual riches. Never may I distrust in his ability, never grow languid in the cause of truth when he exerts himself to remove all impediments out of the way of my duty that I may record his goodness to a generation unborn who shall fear him with filial love when I have run my Christian race and have entered the saints' rest to magnify his power above.

Thou art worthy of praise, O Lord! most high God,[22] for it is thou who hast inclined thy people to help me along from place to place that I might tell of thy watchful care over thy little ones whom thou callest "blessed." Were I to withhold thanks from thee and present them to the creatures whom thou makest subservient unto thee, thou mightst deem me unworthy of thy future regard and leave me to perish on earth, unworthy of present help from thy servants who are called (by thee) to aid each one in the time of trouble. Gracious Father, accept my unfeigned gratitude for thy past and present favors and let thy bountiful goodness lead me to walk humbly with thee, my God. Thou hast signified thy love through every step which I have taken in obedience to thee, my Heavenly Guide, who I have chose to conduct me through life to the mansion of peace. Let me with watchful care extend help to the destitute when opportunity serves, that I may be entitled to thy blessing for ever, having, according to thy ability in me, afforded assistance to others whom thou hast placed in my way, by which to try my faithfulness, for thou provest all thy children through various means. Whatever thou requirest of me, enable me to do by thy power, and may I attend to thy Spirit at all times, that thy immediate help may be manifested when I seek thy assistance, either for myself or others, amongst whom thou wilt cast my lot.

If I know my heart, it desires no other glory on earth but thine, no other wisdom save that which proceeds from thee, the true source of

divine understanding, which will enable me acceptably to do thy will. Thou hast given me an ardent solicitude for oppression to cease and hast filled my soul with tenderness to all who are degraded by the tyrannical power of man. And why am I concerned thus for the wretched situation of thy creatures if thou wilt not aid me with ability to shew my hatred to sin and strife, which are contrary to thee, a God of purity and love. I know thou art well pleased with my compassionate regard for thy workmanship, who are despised and set at naught through the reigning power of individuals. Therefore, follow with thy blessing my earnest prayers for the speedy deliverance of such as thou hast made me groan in spirit for from my childhood. If thou art pleased to use me as an instrument to exalt the Redeemer, whose merit is infinite, "Thy will be done." Promote thine own glory by a worm whom thou hast influenced, to serve thee through thy universal love to all nations, displayed by the shameful death on the cross. Let me freely forget my former attachments to the creature and fix even that love which was finite on thee, the Father of all flesh, who art worthy of my affection as well as my soul and body for thy temple.

And now, O my God! my only portion, fill me with thy Spirit. May I find my heaven in thee when far from all those whom I have yielded up for thy sake. May I be at liberty to do such things as thou mayst appoint for the purpose of ripening my soul for those joys which shall neither diminish nor depart from me to an endless day. And if great suffering be my allotment to ally me to thee, never let me shrink from the bitter cup offered in mercy. Never permit me to turn from thee to the creature whom I relinquished for thy sake for ever that thou mightest be all in all to me while life or being lasts or immortality endures.[23] Sacred are my engagements to thee, my beneficent Advocate, therefore aid me to keep my vow, that it be not violated by the insinuation of men or devils who will seek to rob thee of a heart which is thy own by virtue of thy merit.

Wast thou to withhold from me thy divine assistance, this would be as a dream or as an idle tale, which might pass away unnoticed of men if to my eternal shame it were recorded by thee in the annals of thy self-existing power, which sees and hears all things from eternity. Thou seest me this moment implore thy assisting grace to perform what thou requirest, and methinks thou approvest thereof. Lend thy assistance in the hour of difficulty that I may set forth thy praise in

strains of grateful love to allure the babes to seek thy face when my flesh and bones are returned to dust and my spirit is gone home to see thee, my God, whom I shall for ever worship among the glorified host, who, with unwearied pleasure shall enjoy thy ineffable goodness so long as thou shalt continue to create new objects to afford delight. Amen.

I have had this day for my meditation on deck, the "mighty angel," who "set his right foot upon the sea and his left foot upon the earth, and cried with a loud voice, as when a lion roareth, that there should be time no longer" [cf. Rev. 10:1-6]. The sea raging while I contemplated the awful scene added grandeur to the prospect and aroused me to take my pen to warn others, with myself, to prepare for the decisive hour, feeling my heart enlarged unto all and the flame of holy fire burn purely on the altar within.

On board of the *Triton,* 20th 2d month, 1802. We have been twenty days on the deep, and we have had very rugged weather for eleven or twelve days. Hitherto my faith has not failed, and I suppose we have got nigh two-thirds of our passage. I feel quite comfortable in every respect, believing, in God's appointed time, we shall see all and no doubt find hearts prepared to accommodate me with necessary things according to the richness of his mercy. For in him all fulness dwells from which the faithful derive comfort in every time of necessity having the promise of this life and in the hour of death. The wonders of the deep have engrossed many hours since I have been on the ocean admiring the power of him that saith to the winds and waves, "be still," and lo! there is a calm [Mark 4:39].

Let me observe how the tempestuous ocean and the winds readily obey the God of the seas and learn by their subjection to comply with his design whether it be prosperous or adverse to do his will. All nature cries aloud to man to obey his Maker, yet how indolently does he move to answer the appointment of his God although he sees summer and winter, seed time and harvest, roll on in their steady course for the gratification and service of man, who lives to little or no good purpose [cf. Gen. 8:22]. Shall I live thus? Shall all things serve me in their progressive turn, and yet shall my soul possess the sordid propensities of fallen men? No, sooner let me cease to breathe than wallow in the yellow mire where thousands spend their years in shamefully counting over their golden ore, which will perish with them amidst the wreck of matter and the crush of worlds.

Thou, O my soul, be zealous for the glory of the Lord of hosts, whose love thou knowest to be eternal, whose riches increase in splendor when earthly gems are dim with age, and whose power will rule with vengeance over every man of sin that slights the day of grace, the day of visitation offered in rich mercy to every sordid mind enveloped in sin and darkness. Never leave thy post; watch the Master's voice every moment, every hour, with strict attention. So shalt thou have reason to bless the morn as it approaches with new blessings to pour upon thy head for thy watchful care to serve Israel's King of Kings. Hitherto he is my delight by a long established union which will increase from day to day as I am pursuing the way of life, the path of peace, dying to every object but himself, that I may at length be swallowed upon in his immensity and lost to all below, lost in God my only friend, my infant choice above every other good in earth or heaven.

The seas roar and the waves are as mountains while we are obliged to heave to till the wind abates. Yet I have been able to use my pen to the glory of my heavenly Father, whose preserving goodness alone I trust in. For he could dash our vessel to shivers although we think her sound and able to ride upon those proud waves. I have said during this heavy gale, the God of the boisterous seas is my God, my portion, and my guide, dwelling in my mortal body which he deigns to bless with his heavenly smile though all around shows forth his terrific voice and thunders forth his mighty power.

Sixth, 3d month. We have had another heavy gale and are obliged to heave to and lash down our helm. Our poor sailors have had hard work for their patience, all hands being called up every night for some time past. This day we have had no light below, having our shutters or dead lights in and being out of oil and almost out of candles, so I have been obliged to sit on deck viewing the grandest scene in nature obey God while I have been singing with my spirit:

> The God who reigns on high,
> And all the earth surveys:
> That rides upon the stormy sky,
> And calms the roaring seas.[24]

From the greatest storm this morning we now have a serene sky and calm sea, which is one of the greatest wonders in nature that I

have ever beheld. But how placid was my mind during the awful gale, which would have filled me with horror if the Lord had not been my father and my friend, making even the roughness of the sea a pleasure to me by his transporting joy. How can I praise him enough, who testified that he would make winter as pleasant as summer if I would but obey him and move by his direction in faith. Oh! I am happy, yea, exceeding happy in the love of Jesus, who condescends to abide with me, making hard and rugged paths smooth with his cheerful countenance. He gladdens my heart, stripped of all earthly friends that I may delight myself in the Lord my God alone telling to others the wonders of his love and power which hath won me to serve him while I have life or being.

O my mother! my beloved parent, could I but just step and tell thee the wonderful works of thy God which I have seen since I bid thee farewell in the Lord. I am certain thou wouldst acquiesce in his calling me away from thee. But what thou knowest not now, thou shalt know hereafter when we appear at the judgment seat together to have our work of faith and patience tried by one God. He is an equitable Judge making no distinction betwixt mother or daughter, kings or beggars. . . . Should I never meet my beloved mother again in time, the remembrance of having yielded her up for the sake of her God and mine will soften my sorrows and assuage my grief on her account. But ah me! how could I bear to hear the tidings of her death in a strange land where I cannot take one glance of her lovely frame.[25]

We set off at sun-rise and got into Washington just before night commenced, 4th 5th mo[nth]. I had a letter of recommendation to Dr. W[illia]m. Thornton[26] and went to deliver it as soon as we got into the city. . . . J[ames] M[adison], secretary of state,[27] had his wife present, who politely gave me an invitation to make my home with them, and General Dearborn, secretary of war,[28] offered to accompany me to the president[29] so that the Lord was gracious to me in preparing the way thus far. In the morning I went to visit the president, . . . introduced to him by the vice-president,[30] who conducted us to his sitting-room, where he received us with handsome conduct and listened to my tale of woe!

I said my concern was, at present, for the distressed Africans. I felt disposed to lay aside my own ease and happiness to put forth an effort to promote theirs, if possible, and also wish to have thy approbation before I move one step in the business, understanding thou art

a slave-holder. The president then rose from his seat, bowing his head and replying, "You have my approbation, and I wish you success, but I am afraid you will find it an arduous task to undertake." I said again, "Then I have thy approbation," to which he rose and performed the same ceremony over, repeating nearly the same sentence he had already done with this addition: "I do not think they are the same race, for their mental powers are not equal to the Indians."[31] I told him, God had made all nations of one blood and that ancient Britons were degraded very much once in their powers of reason and this people being neglected many centuries, their power of reason was dimmed from long abuse of the same. I was inclined to think, if the present generation of children were separated from their parents and educated by virtuous persons, who would teach them habits of industry and economy, they might then prove a blessing to the country.[32] To train them up with the view that they were not the same race would prove only a curse to the land, especially the females, whom I felt myself concerned for the most on account of their exposed situations to the vile passions of men. Gen. Dearborn and Dr. Thornton approved of what was advanced and seconded the same with their warm sentiments, which I felt thankful for. Yea, they added, that this plan would meet with the approbation of the well-disposed among all classes of people.

Enquiring how many slaves the president had, he informed me that some time since he had three hundred, but the number was decreased. It now appeared a seasonable time to signify how my nature was shocked to hear of the souls and bodies of men being exposed to sale like the brute creation, and I implored his pity and commiseration. Then we parted in peace.

It was my design to have a school fixed in Washington city for sixty females, about the age of seven years, and to have them abide a term of time suitable for their improvement. The school is to be supported by public contributions from the humane who are always willing to strengthen the hands of the diligent from a sense of duty to God, their great Creator, and love to all objects placed in misery through the oppressor's power. This design may be accomplished through the blessing of my God, who has the hearts of all in his hands and who can dispose whom he sees meet to forward such an undertaking. No doubt it will bring glory to the Universal Parent of all nations and be a praise to all who may throw in their mite, if it be

even as small as the "poor widow's" in our Lord's time, when he observed how much each gave and said, "She had cast in her whole living" [cf. Luke 21:1-4]. Although Jesus Christ has ascended up into heaven, he still marks what is cast into the treasury for the poor. It is lent unto the Lord till the judgment day, the time of general retribution when every one shall receive back again an hundred fold of what they gave to the poor with a view to have his approbation and alleviate the wretched situation of the miserable of every description of people who are the workmanship of his admirable skill, divine love, and power. It was to the credit of the president that he did not object to such a design but gave me his approbation and wished me success. This was, according to my faith, from this weighty testimony that awed my mind all the way previous to my visit, "Not by might, nor by power, but by my Spirit, saith the Lord of hosts. Who art thou, O great mountain? before Zerubbabel thou shalt become a plain: and he shall bring forth the headstone thereof with shoutings, crying, Grace, grace unto it" [Zech. 4:6-7].

[July 2, 1802.] On our way I had seen five or six little wretched children, naked, from the age of two years up to nine, who were boys and girls. And I was told that some were not clothed till they could work for themselves. This was a shocking sight to me and sufficient to affect my heart although many will say to me, "They are happier than you are, why do you distress yourself about them?" Why do I? Because a gracious God leads me to feel for them—weep for them—and pray in faith also for them that they may be blessed with the same blessings which are poured down upon my head and others, who groan in spirit with me for their redemption from sin and thraldom of the oppressors.

The 6th I heard of a young man who was willing to take me forty miles, but I felt very uneasy with it yet was obliged to join with it . . . and passed through Fredericksburgh.[33] On this side of it were four hundred and thirty-two acres of standing corn, just in flower, which was beautiful to the eye. And opposite it, on the other side of the road, were a number reaping wheat, well clothed, who appeared to have a good master. I counted thirty, men and women, who were all black. As we were riding along the road this morning I felt very sorrowful in contemplating how many thousands of the poor Africans were sorely oppressed in those southern states. And while I was weeping and silently groaning in spirit, my mind was covered with

awe, and I was fully persuaded of God that in due time they should become possessors of this state where I am now sowing tears in abundance. I was also cheered by this, and a hope was given me to believe that many in the midst of their afflictions would seek help at the hand of the Lord, there being some in every city praying to a gracious Lord in their behalf. . . . Many young Baptists were present when I supplicated the throne of mercy, and they also were melted into tears and wept much that they were born in a land of oppression, fearing the blood of their fathers would be on their heads as their parents were slave-holders. They all vowed in my presence that when they came to inherit their property of slaves that they would free them, that they might free themselves from the curse of their fathers.

What a favor that I was not born in a land where the souls and bodies of men are priced, and bought, and sold, like so many cattle who are driven by the whip. God only knows why my days should be lingered out in thus groaning for them, but certain I am that those tears I sow here shall water the seed sown by some whom God appointed to preach the gospel before I was a resident among mortals. Well, let it suffice me then that my labor shall not be in vain, and let me also remember how many years of sorrow my Lord and Savior Jesus Christ endured before he opened his gospel mission and proclaimed liberty to the captive souls. O that my faith may increase for this purpose! that my love to the indigent may not be suppressed, neither a weariness in the spirit or in the flesh impede the work of salvation that is even now completing by the eternal Spirit. He is secretly working in me and many others, whom he appointeth to work in this land for the redemption of his creatures. Hoping in my God I shall yet see better days. I shall see thousands flock to hear the sound of the gospel through a prepared instrument, set apart for God's peculiar service to eternity, that his name may be praised. And who hath greater reason to praise the Lord than I have, when he always defends, always assists in the hour of difficulty, and brings me off victoriously to adore his triumphant strength that crushes the enemies of a God of purity in an unexpected moment? Leaving myself in his hand, I will close this day with resignation, saying, "Thy will be done."

Virginia, 14th 7th mo[nth], 1802. We had a pleasant ride to Richmond,[34] which is twenty-five miles. . . . On the road we passed by the

work-shops of Solomon and Gabriel, who were the ringleaders of the blacks who determined to destroy Richmond.[35] Their shops are desolate and almost falling to the ground. I looked at their master's residence, who is a man that owns many hundreds of poor wretched slaves,[36] and I thought that he was like foolish Rehoboam, who made his father's yoke heavier [cf. 1 Kings 12:10]. I was told that eighteen were hung with Solomon and Gabriel on this occasion.

Richmond, Virginia, 17th 7th mo[nth]. Undisturbed I am this day amidst the wiles of the enemy of my soul, who seems bent on breaking my peace, if possible. But I am hedged around with truth on every side and shall be by it more than a match for the deceiver. Persecution will not affright me, neither any distress prevent me attending to my duty both to God and my fellow creatures who have a claim upon me. I am disposed to think persecutions will confirm my faith and establish me fully in the truth, which I desire to acknowledge with boldness. The world hath done its utmost; the flesh hath assiduously strove for victory; but the Spirit of the Lord will not be subjected by the world, the flesh, or the devil, since I am bent to love the Lord my God and to walk humbly before him all the days of my life [cf. Mic. 6:8]. For my help is in him, and all my strength is derived from thence. Yea, all my unbounded expectations are from this source of infinite good.

21st 7th mo[nth]. My feelings have been pained exceedingly from the cruel treatment of one of the slave-holders, who has lashed his slaves himself till they had scarcely any skin left on them and that by his severity they have died soon after. Yet he himself hath escaped the punishment of men thus far. It appears marvelous to me that the judgments of the Lord do not pursue such with unlimited vigor in this life, but he hath reserved them for his vengeance to be exercised on in the world to come when the wickedness and cruelty of every one shall be brought to light in order that the justice of the Almighty may conspicuously appear before all nations in that great day of his wrath. Christ shall sit Judge of quick and dead and render to every individual according to his works of mercy or cruelty, which have been manifested on those in his presence, when "all flesh shall see his glory together" [cf. Isa. 40:5], and all receive their eternal doom of him in a decisive manner not to be reversed. For there will be no pleading with him then to lessen our weight of punishment should

we be found guilty. And every crime committed will strike the mind with new horror when shuddering on the brink of ruin.

The African race will then witness against their hard and cruel tormentors who exercised, unduly, the scourging lash. It will be returned back by the scourge of a just God on such as had no feeling for them when under their despotic power. I wish then those miserable creatures may not avenge their wrongs, but patiently wait till the Lord returns vengeance on their unmerciful masters. For the Lord seeth all injustice and observeth the ruling hand of the oppressors every where. What a God is he that no one can escape his notice in any dark corner of the globe. O that all would learn to fear him whose judgments are so tremendous that I tremble for every oppressor! for every one who deals hardly to any of God's creatures. It will be repaid back again by him who hath a love for every thing which he hath made, that has any part of his Spirit, or breath of life in them naturally, by his divine communication through his extensive influence or mighty power.

The Spirit of the Lord groaned in me for the redemption of master and servants, which are all equal in his sight, and I do earnestly entreat the God of all grace to follow them each with his convicting love that their spirits may be made contrite and humble in his sight and clothed upon with the covering of Jesus Christ's righteousness, who cancels the debt of every enormous sinner that sincerely repents.

I am a free woman by the authority of our Lord Jesus Christ who sends me where and when he pleases and who has sent me here at this time to baptize my soul for the dead, or "dry bones of Israel" [cf. Ezek. 37], and to groan in secret for the poor Africans for whom my spirit is pressed this day seeing so many colored women in the cities who live for no better purpose than to gratify the passions of vile white men. How many purchase those young girls with no other motive than self-gratification, which is a horrible thing in the eyes of every chaste woman. I believe such will repent it to eternity if God is a pure being, which I know he is from what he requires of me. Some of those women are disposed to be virtuous, and yet are compelled, having no power to resist; for soul and body are not theirs but their master's, who can buy as many as he pleases and compel them, if it is by threatening to starve them, which has been done frequently. I

know those who have bewailed their shame to me when compelled to evil by wicked youths before they were sixteen years old.

Good and gracious God, I beseech thee to give those blessed privileges of nature back again to this race, which a country has unjustly taken from them. And yet the people cry out, "We are independent, yea, we will be so." I ask, "Who made you free? Who gained the victory for the country? Did not God?" Yes, verily, and as he has taken your yoke off, so he will do to those whom ye pollute and make hewers of wood and drawers of water. Some will abuse me for speaking the truth, I know, and others will love me for it; but as I am called to give up every tender endearment, I will hazard my life in the cause for the rights of the African nation for whom I have mourned secretly twenty years. I could no more avoid it than I could cease to breathe, unless I made use of improper means to stop the natural functions of life. The Spirit of the Lord has laid a necessity upon me to cry mightily to the Lord God that he may arise and make bare his omnipotent arm in defending them and freeing them from the thraldom which they are in.

17th 9th mo[nth]. The sweetness and calmness of mind that I have felt the last night is unspeakable. But it is the goodness of the Lord who has proportioned my strength for the severe trial which has just come upon me, even the tidings of my most indulgent mother having fallen by the hands of death. As I was at breakfast this morning a letter was brought to me, which has followed me from place to place till it found me here. I prepared to read it with a bleeding heart and weeping eyes. However, I thought that I would finish my breakfast and then go into my room and open the letter, which was fortitude given me in the time of distress. I was an hour in reading the letter and could not scarcely believe that the account was true, repeating many times over, "And is she dead indeed." And shall I never more see my mother? My beloved, indulgent mother? Yea, one of the tenderest and most virtuous mothers! Ah me! poor worm! Well, I forsook her for Christ's sake, who demanded my soul, body, time, and talents, and nothing short of this would suffice. My beloved sisters say that our honored mother's last words were, "I shall praise him for ever and ever," which "she repeated with a faltering voice nine or ten times over, until within five minutes of her death."

My pen I have taken to vent my grief, although I scarcely can forbear in the midst of sorrow rejoicing that the spirit of my valuable

mother is purified—is made white—is numbered with the redeemed through the precious blood of our Lord Jesus Christ. She is now exempt from the pressure of mortality, while I am paying the last tribute to her memory with my pen, which can faintly describe her real worth. For, if she had any crimes, her greatest fault was this, loving us too tenderly. And this she suffered for by the stripping power of Jehovah, who unloosed the strings of nature (that twisted fondly around her loving heart) and so separated her first from her dear sons and beloved husband and next her blooming daughters, whom she, no doubt, has met again in the kingdom of glory where each are celebrating the praise of the Lamb of God who suffered in our stead.

While I am employed with my pen I am surrounded with a ray of glorious light and see, by faith, my honored mother's spirit clothed upon with a celestial mold, fashioned like the blessed Lord's when he went up on high in an immortal glorified body. Well, we shall meet again. We shall live with each other for ever, where not a wave of trouble shall roll across our peaceful breasts made happy with the love and joy of God. I will then dry up my tears and keep them to weep for poor sinners, since my father, mother, brothers, and sisters are gone to be crowned with immortal honors, where I expect to go in a short season when made perfect by suffering grace and ripe for glory through the redeeming love of Jesus, who is all in all to me, being stripped of many earthly ties that I may win souls to God and the Lamb who bought them with his blood.

Never more shall I fear respecting my aged mother feeling woe for me! Never more indulge a fond hope of seeing her house of clay again! No. It is for me to turn from such a dark pensive scene, to the bright body of celestial light which shall rise from the incorruptible power of the Highest, who burst the grave of Jesus Christ and brake the chains of death asunder showing "life and immortality were brought to light" [cf. 2 Tim. 1:10] thereby, to all the children of God. Heavenly Father, how good art thou at this time to sustain the drooping spirits of thy handmaid who dares not think thou dealest hard to her by the removal of her best and dearest joys on earth, whom faintly she yielded up for the sake of him who has taught her by his life of submission to say to thee, "Thy will be done."

[Soon after, in Washington,] there happened to be one of the oldest Methodist preachers, a man of good repute and I believe a man of God, who was moved by the Spirit of the Lord to try the hearts of the

146

people assembled. The hymn being sung, an exercise of spirit imme-
diately seized me, and I thought of my honored father, how God
prospered him in the attempt of building a house for his glory, but
that I had no place where I could make mention of his name or com-
mand "Ethiopia to stretch out her hand unto the Lord" [cf. Ps. 68:31].
All the time of worship I sat weeping and groaning secretly unto the
everlasting Jehovah that he would be pleased to prepare my way in
this respect and give me the desire of my heart that I might free my
spirit from the heavy weight which I felt burthened with. But how
was I surprised before the preacher had concluded the meeting to
receive an invitation of him by a woman friend. He sent to ask me, if
"I would speak to the people as he was called elsewhere in the
evening?" I was struck dumb for a moment and then answered: "Tell
the preacher I will let him know against afternoon meeting." My tra-
vail of soul increased so much that I knew not what to do. I therefore
entreated the Lord to assist me that I might know and do his will and
not follow my own understanding, which I knew would not glorify
him unless influenced thereunto through his Holy Spirit. At last I
was fully convinced it was the will of the Lord that I should speak to
this people. I therefore took my pen and wrote the following sen-
tence:

> D. Ripley's respects to the preacher, and feels willing to comply with
> his request, if she may have the liberty to conduct the meeting accord-
> ing to her pleasure.

The note was approved of and the meeting given out, which was
large and attended by a number of respectable inhabitants both from
the city and Georgetown.[37] The passage of scripture which my mind
was instructed in to choose for the benefit of the assembly was suit-
able to my own state of poverty and contempt for the last six years.
"In his humiliation his judgment was taken away: and who shall
declare his generation? for his life is taken from the earth" [Acts 8:33].
The Lord opened the sentence by his Spirit in my heart, which cov-
ered the people with a degree of solemnity and raised gratitude in
the minds of his dear children present. Never may I lose sight of his
astonishing love which was revealed to me this day while standing
an advocate for God and his Son Jesus Christ. I gave out another
meeting also, by the permission of the stewards and leaders of the

classes, and intimated to the people my great concern and distress for the Africans, which had induced me to lay aside all my temporal interest. A number of goodly women were invited to spend an afternoon with me at my friend's hospitable house.

Baltimore, Maryland, 3d 4th mo[nth], 1803. The Methodists' Conference being held while I was in this city, I believed it my duty to attend all the meetings for worship which I could.[38] Therefore Henry Foxal[l][39] introduced me to the Bishops. My old friend is a preacher of righteousness but a cannon-maker for the government in the city of Washington, which I would persuade him from if I had influence over him, for I esteem him an excellent man and unfit for such an employ. Being left alone with the two Methodist Bishops, a solemn awe covered my mind while we remained silent for the space of five minutes. Then Bishop Asbury[40] asked me these important questions: "Were you ever justified?" Replying "yes," he said, "Are you justified now?" to which I again said "yes." Then he simply enquired, "Were you ever sanctified?" Answering as before, "yes," he brought the matter closer by adding, "Are you sanctified now?" Being called upon to make this confession in the presence of God and in the midst of two good judges of Israel, I said as follows: "My body is the temple of the Living God," which sufficed the good old veterans almost worn out in the vineyard of our Lord.

Bishop Asbury then said, "I suppose you travel without money?" Feeling thankful to my bountiful Father, I answered, "No, I never am without money." He then requested thus, "Will you stop and dine with us!" I signified, if it would not be deemed an encroachment upon them, that it would be pleasant to me to be indulged thus far, to which Bishop Whatcoat[41] replied with complaisance, "O no, sister, for we have all things common here!" I was melted with this sentence and silently whispered in my heart, "Thou art like a shock of corn, ripe for the Lord's garner" [cf. Job 5:26]. It was at Samuel Coat[e]s's[42] where we dined, the preacher then a resident in Baltimore, and I may add, we eat our bread with singleness of heart, giving glory to God. After dinner, Bishop Asbury committed me affectionately to the care of S. Coat[e]s's wife, desiring her to take care of me.

I went to all the evening meetings and have been there from seven to eleven without being the least wearied and felt much pleased to see such a number really affected with the thundering voice as from

"the top of Mount Sinai" [cf. Exodus 19]. I was struck with dread awe and felt of a truth, God was there. . . . During this week I have enjoyed many blessings, and the Methodists have been very civil to me by way of inviting me to their houses where I have testified of the goodness of the Lord and excited them to diligence in the service of truth.

Philadelphia, 1st 5th mo[nth], 1803. Naming my concern to some of my solid friends to have a meeting with the Africans, I influenced them to send for Absalom Jones,[43] the black bishop, and Richard Allen,[44] the Methodist episcopal preacher who also was a colored man and the principal person of that congregation. A. Jones complied with my request and appointed a meeting for me on first day evening, which was a solid time. Many were deeply affected with the softening power of the Lord who unloosed my tongue to proclaim of his love and goodness to the children of men without respect to person or nation. There was a respectable number of colored people, well dressed and very orderly, who conducted themselves as if they were desirous of knowing the mind of the Lord concerning them. The first and greatest commandment of Jesus Christ, the Lawgiver, came before me: "Thou shalt love the Lord thy God with all thy heart, and with all thy soul, and with all thy mind" [Matt. 22:37]. I endeavored to enforce this as their duty to their Creator who alone could make them happy by his blessing through their obedience to his lawful command. My own experience of thus loving him I thought would illustrate it, therefore added it to shew the possibility of pleasing him and obtaining his divine favor which was our interest and duty as soon as we were able to distinguish right from wrong. . . . My spirit was deeply humbled, and I felt power to plead with the Father on account of the Africans every where who were captivated by the oppressive power of men. When we had separated, my mind was much relieved from the weight which pressed my spirit while I had contemplated the matter, desiring to move by the special direction of God.

I cannot avoid commending the citizens of New York and Philadelphia for their help to those that have been greatly oppressed, driving slavery out of their states that they may have the peace of God and his blessing upon the heads of their children and children's children.[45] I trust also to see the efforts of individuals crowned with a blessing in the southern states, where barrenness of the land be-

149

speaks the poverty and wretchedness of thousands of its inhabitants, who might enjoy the smile of Heaven if they would learn to fear God and love their neighbor. When comparing those states one with the other, what a vast difference there is between them in the outward appearance of things. But I trust the minds of the people to the southward are not like the barren appearance of many parts I have already traveled or may yet have to do. For I perceive the Lord intends me to return back to discharge my duty to him and the people up and down.

The Methodists in this city [New York] were so obliging as to let me have their largest chapel and circulate the meeting for me.[46] When I was speaking of the awful day of the Lord, that the Mountains shall melt as wax before the fire, there came one of the loudest peals of thunder that I ever heard to confirm the truth as it dropped from my lips. Some afterwards affirmed to me that they verily thought it was the day of judgment, but I was not so afraid of the thundering power of my God as I was of Satan, when he brought I the poor drunkard to disturb our peace. Thomas Morrel[l],[47] the presiding elder, was kind enough to accompany me into the pulpit as I had no one with me whom I knew. The people were very solicitous about my going with them to different parts of the city, as several were inviting me at once. But a colored man had engaged to let me lodge at his house, so he claimed me as his lawful property amidst so many gay persons whom he contended with for his right. I indulged him, or rather myself, by performing my promise and found every thing comfortable that I stood in need of to refresh tired nature. I have dined seven times with the colored families and tell them they must let their women sit at table with them, which they do not in some families, because the women act as servants when there is company.[48]

No language can describe my gratitude to thee, my gracious Parent.[49] Thou seest my heart, and that thou art suffced with, knowing my delight is in thee, my God, my Life. And it shall remain for ever my employ to sound abroad thy joyful praise to all the redeemed on high after I have testified of thy love and goodness to all below and finished the work thou hast given me to do. Let thy Spirit, Holy Father, aid my endeavor in thus attempting to set forth thy love to the children of men. May they be allured with thy beatitudes as thou didst allure me when thou didst win my infant heart from all on

earth. O that I could but tell one hundredth part of thy love where-with thou hast loved the world. But they with me shall see the Glory of the Lamb, prepared for the Church, his lawful Bride, arrayed in purest innocence, his righteousness their royal robes. And seeing, then shall they believe him worthy of their praise for all his match-less love in the redemption of their souls and bodies, redeemed to serve him, their Maker, while endless ages roll round with new scenes of wonder.

I seek my own full and free salvation, accomplished by his reign-ing love dwelling in me without a rival. No other good I know. No other end had I ever in view but to serve my God and him alone by a dedicated life in search of sinners who are lost for lack of his true knowledge amidst the blaze of Gospel Light. If to the present thou hast been my chief delight, surely thou wilt not let me loiter, or turn aside for a moment, in hopes of finding any other bliss beyond that which I now possess.

Annapolis, 7th first month, 1806.[50] This morning I took my leave of a kind people. The stage I came in was full, and sorrow hath been my lot all the way, occasioned by the distress of a forlorn mother with her five children who were slaves and going to New-Orleans. I told her master (by whom her babes and she were purchased) that if he did not take her husband with him, whom she mourned for, they never would do him the least service. He answered, "I have bid four hundred dollars, but his master will not let me have him under six." Though it was painful to my feelings to have this poor miserable slave and her helpless children for companions, yet I do confess that I had rather be her consoler than have partook of the richest dainties the earth produces. She thanked me for my good advice. The young man whose property they were took all I said in good part, making no reply from moroseness. I observed he had brought her off with-out dinner. But providentially there were put into my hands a quan-tity of rich cakes, so I fed her and the five children with unspeakable pleasure out of the bountiful hand of my God who guided me safe back again to Washington City.

As I was riding and had parted with my sorrowful cargo of slaves, I much admired Pennsylvania's Avenue, planted with two rows of young poplars which will make a delightful shade on each side for the citizens when the sun sheds forth his burning rays. . . . My request was granted, which is to me the most important work I have ever

engaged with.[51] The Lord direct my tongue and open my mouth powerfully, that His Name (by a woman) may be extolled to the great astonishment of the hearers, who no doubt will be watching every word to criticize thereon.

Washington City, 12th first month, 1806. Unto thee, O Lord! do I give thanks. Thou hast not hitherto forsaken thy charge but favored me with thy consoling presence. When I sat down in the Speaker's noble chair, methought Wisdom adorned me with her spotless robe of innocence. I perceived her fetters had become a golden chain or ornament put around my neck. The solemnity of the assembly delighted my soul. But with awful reverence I felt God was in the midst when supplicating His Throne of Mercy for assisting power that He might be honored by those Rulers of the land who had the direction and government of all the United States of America at this period when they were convened together for the purpose. Thomas Jefferson, the president, appeared no more terror to me than if I were the queen of the nation and he one of my subjects, ruled by my authority. But it was *Wisdom* that adorned my mind, and through the condescension of so noble a mistress, I was empowered to speak to the honor of God and not regard the appearance of any man, high or low.

Mary Taft

Editor's Introduction

In his advanced years John Wesley preferred to believe that prejudice against women preachers had declined within the Methodist movement. His confidence was not well founded. In the decade following his death, misogynist sentiment focused increasingly on the ministry of one woman in particular, Mary Barritt (1772–1851). Born near Colne in the Lancashire village of Hay, she was unquestionably the most famous female evangelist of the early nineteenth century. In 1827 she published an extensive autobiographical account of her work as a revivalist.[52]

Soon after Mary joined the Methodist Society at Colne, prayer in class meetings as well as testimony and exhortation at the Love Feasts led to preaching, as had been the case among her female predecessors. Even though her actions aroused immediate hostility, invitations for her to preach were many and came from some of the most prominent ministers of Methodism: John Pawson, Alexander Mather, Thomas Vasey, Samuel Bradburn, William Bramwell, and Thomas Shaw, among others.[53] She traveled across the Connection extensively as invited and in 1794 began a series of preaching journeys that continued for many years. Revival erupted wherever she spoke. Her brand of evangelism, as revealed by this excerpt from her collected *Memoirs*, was not simply "revivalism." Like Wesley, her spiritual mentor, Mary provided meticulous care for her converts and made every attempt to see that they were established in classes and properly assimilated into the Methodist Societies.

Eyewitnesses to Mary Barritt's preaching were unequivocal in their praise of her theological depth and balance. Numbered among

her converts were prominent preachers such as Thomas Jackson and Robert Newton, D.D.[54] The revivalist William Bramwell was her most enthusiastic supporter among the itinerant preachers and defended the evangelist indefatigably when Mary became a "storm center of controversy" during the first decade of the nineteenth century. Marriage in 1802 to Zechariah Taft, soon to become the most published of the women protagonists,[55] led Mary into direct confrontation with the increasingly patriarchal leadership of Wesleyan Methodism. Joseph Benson, one of the outspoken critics of women preachers, was outraged by the shared ministry of the Tafts at Dover and Canterbury and expressed his anger in a caustic letter in which he claimed that the Conference was ignorant about Zechariah having taken "a female to assist him in the ministry."[56] At the ensuing Conference, held in Manchester in 1803, women preachers were officially restricted although not formally prohibited as was the case within Irish Methodism. In light of the restrictive resolution, increasing numbers of aspiring women preachers found it necessary to sever their ties with the parent body of Methodism and found sanction for their activities within the larger pale of the Methodist tradition, among the later Primitive Methodists and Bible Christians, or farther afield among the Quakers. Mary Taft's *Memoirs* afford an unparalleled portrait of commitment and courage.

<p style="text-align:center">❊ ❊ ❊</p>

I believe there never yet existed any, singularly useful in the Church of God, who have not been opposed by their fellow-creatures in their benevolent career of doing good. Some of these opposers have been professors of religion; others, such even as were sustaining important and useful offices in the Church. This appears mysterious—something for which we cannot account but on the supposition of their acting under the control of unhallowed dispositions—diabolical tempers—or (to judge as charitably as we possibly can) an erring judgment.

This has frequently been my greatest grief for all that I have suffered from the world in the way of reproach and slander is little in comparison with what I have suffered from some professors of religion as well as even ministers of the gospel. To their own Master I

leave them. . . . In the midst of all, God hath given me his approving smile and a blessed consciousness that I was acting under his divine sanction and influence and with purity of intention, designing *only* to promote his glory among men and the real good of my fellow-creatures. These have been my constant support under powerful temptation, fierce persecution, and severe affliction. In addition to this, the Lord has graciously raised me up numerous friends, the remembrance of whose kindness and attention is engraved on my heart in indelible characters, and he has given me very many living epistles of evangelical truth, "seen, and read, and known of all men." Many of these, God hath appointed to occupy very important offices in his church, several of whom are traveling preachers while others are laboring for God in a more limited sphere as local preachers, leaders, &c., and some have joined other religious bodies where they have been eminently useful. These are my letters of recommendation, written as with the finger of God, and these I expect to be my crown of rejoicing in the day of the Lord Jesus. Many of them have gone to their reward in heaven. O, that all they that remain may be found faithful unto death that not a hoof of them may be left behind [cf. Exod. 10:26]! May the Lord of his infinite mercy grant that when the sun has done shining—the marble tombs are burst asunder—and the graves give up their dead, I may with them be enabled to welcome the approaching Judge and stand with boldness before his throne.

My time was generally occupied in traveling from place to place, holding public meetings, praying with souls in distress, and keeping up an almost uninterrupted correspondence with preachers and others in various parts of the kingdom. . . . I also wish to observe that it has always been a rule with me never to go to any place to labor without a previous invitation from the traveling preacher as well as the friends of the circuit I visited.[57] As a member of the Methodist connexion I conceived this to be my bounden duty; more especially, as the superintendent preachers are responsible to the Conference for those whom they employ in any public way in the circuits over which they preside. I do not know that I have ever deviated from this rule, excepting in a few instances, when I have been so sensible of its being my duty and the will of God for me to go that I durst not at the peril of my soul neglect going. This line of conduct however, I confess, has in some few instances exceedingly grieved some of my best

155

friends, which has caused me to weep in secret before the Lord. It hath sometimes happened, that *a preacher would not consent for any female to exhort sinners to come to the gospel feast*—and though I had many friends in his circuit and some *spiritual children* whom I could have visited and the withstanding of whose solicitations gave me considerable pain—yet, I have waited *one* and sometimes *two* years before myself and friends could be gratified in this particular. The Lord only knows what I have felt on those occasions.[58]

The day I found peace with God, I had heard Mr. Samuel Bardsley[59] preach from Matt xvii. 20. *"If ye have faith as a grain of mustard seed, ye shall say unto this mountain, Remove hence to yonder place; and it shall remove: and nothing shall be impossible unto you."* I saw plainly this faith was what I wanted and felt determined not to rest without it. I wept and prayed much under the word, and as I returned home, I wept and looked up and thought the sky might justly come down upon me and I drop into hell. . . . Just when I was ready to despair of the mercy of God and about to give it up all for lost, in a moment these words were applied to my heart: *"Thy sins which are many are all forgiven thee"* [cf. Luke 7:47]. I said, ye[a] Lord, I know, I feel they are. My sorrow was fled; love and joy sprung up in my heart. I was ready to shout,

> Come all the world, come sinner thou,
> All things in Christ, are ready now.[60]

In the morning my mother saw the change though I had said nothing to her. She said, "Mary, what is the matter with thee this morning?" I answered, "Mother, God has pardoned all my sins." She wept, and we praised God together.

Very soon after I was converted to God; I felt much concern for the happiness of my neighbors and took every opportunity of talking to, and praying with, and for them. I not only attended all the means of grace and began to exhort the people from house to house and many times with tears told them the danger they were in and exhorted them to flee from the wrath to come,[61] but I began to pray in the prayer-meeting. The first time was one Sunday evening. After several had sung and prayed, one of the class-leaders called upon me to pray. I did so, and the Spirit of the Lord came upon me in an extraordinary manner so that I entered into the spirit of my duty, not of

praying merely but of exhortation. As we returned home, the same leader advised me when I felt disposed to give an exhortation again that I should stand and face the people.[62]

About this time (1791) I suffered from a quarter I did not expect. The superintendent preacher told some friends that unless I immediately gave over exhorting and praying in meetings, the next time he came he would put me out of the Society. . . . when he saw the arm of the Lord made bare [cf. Isa. 53:1] and sinners brought to God in every direction, he declared to some friends that he should ever think it an honor to sit behind me in the pulpit in order to snuff the candles for me, and he continued in this mind to the day of his death.

Soon after this, we had a love-feast at Colne,[63] in which I spoke at large my religious experience and my whole mind relative to what I had suffered and passed through on account of *my call to speak and act for God*. Such an unction from above rested upon me and such a divine influence accompanied what was said that nearly the whole congregation were in tears. After this, Mr. W[illiam]. Sagar,[64] of Southfield, went to Mr. Harrison[65] and said, *"it is at the peril of your soul that you meddle with Mary Barritt. God is with her; fruit is appearing wherever she goes."* From this time, Mr. Harrison became my firm friend and advocate.

In the latter end of August, 1795, I complied with an invitation to travel again . . . and had some good times. Souls were brought to God, and we rejoiced together. We saw many singular instances of the power and goodness of God in saving poor sinners. I was at one place, called Aysgarth,[66] and spoke in the afternoon and at night. There was a young man that had been playing at football in the afternoon, whose mother (as I learned afterwards) had much to do to prevail with him to come. However, he came in the evening and placed himself on the top of a chest of drawers, but the Lord found him out. He was powerfully convicted in his conscience and cried aloud for mercy, but returned home praising God. Many more were awakened at this time, particularly a young woman, Ann Thompson[67] by name. I loved her much when I saw her first. She slept with me that evening, or rather wrestled and prayed, for we slept very little, if at all. I prayed with her till near two o'clock. . . . About four o'clock, the Lord spoke peace to her soul. Then it was with much greater difficulty that I kept her from waking the family with shouting. Glory be to God! She has been one of the excellent of the earth ever since, has

labored for the Lord in a public way, and had her labors blessed to many. The young man has also been an ornament to the gospel.

In the Yorkshire Dales . . . the Lord enabled me, and others, to gather the harvest in handfuls, and every where he gave us fruit. For, at that time, those circuits had but little help from the traveling preachers compared with what they now have. I might add many things also with respect to my convictions, views, feelings, and conduct relative to my public work. Suffice it to say that the Almighty, in a most *extraordinary manner removed my scruples, answered my objections, and thrust me out into his vineyard.* Indeed, nothing but a powerful conviction that God required it at my hand, and that I should love my *own soul*, if I did not endeavor to save the souls of others, could have supported me in it. Added to this, the Lord gave me souls in almost every place and, in general, whenever I stood up in his name before the people and more especially at those times when so overwhelmed with a sense of the magnitude of the work that I was tempted to run away from it. This wonderful condescension and stupendous love of Christ to *me* deeply humbled *my* soul before him.

There was one preacher[68] [who] took an opportunity in a quarterly meeting held at Leeds, of expressing his dissatisfaction observing that a raw girl had come into the circuit, who had made a great hubbub. He supposed *she* had picked up, somewhere, a *text* or *two* that she talked from in her way all over the country, adding, they would soon see what it would all come to if she were allowed. He further gave it as his opinion that she should be put to silence at once. Providentially, Mr. Wade[69] was present, who, when he had heard this, stood up and said, "I have now heard *Miss Barrett*, twenty-seven or twenty-eight times and have never heard her speak twice from the same passage." The preachers were silent, upon which others rose up and expressed their gratitude to God on account of good done and good received through her instrumentality. Several hundreds were added to the Society in that circuit, some of whom became useful local preachers.

[June 10, 1798.] I was riding up a very steep hill. The good man who rode before me would not suffer me to get off but alighted himself, and I sat forward on the slaps saddle. As we rode along, one of the foremost horses struck backward, and my horse, to save itself, sharply threw itself down the hill. I was thrown off some yards down the hill, and on the wrong side, but alighted on my hip and hand. The

Lord saved me from going sick. My dear friends alighted and helped me on my feet. As soon as I was able to speak, I said, "praise God, the devil has not power to take away my life as yet." It was with some difficulty I rode to Edam,[70] and when I got thither, I could scarcely walk over the house floor. The people being strangers to me did not look on me with that tenderness which I knew some of my other dear friends would have done had they been there, but the best of all was God was with me,[71] and I said, in his strength I will have another stroke at the devil's kingdom for this if God spare me. It was with great difficulty by the help of one person I was able to walk to the chapel and into the pulpit. O how I thanked the Lord. My heart burned with love for the hundreds of precious souls. . . . I forgot my affliction till I had done speaking. Men and women were in tears on every side, but to my great sorrow, I could not get to the distressed so that after a few of my dear friends had prayed, I was obliged to conclude. . . . It was with much pain I got back again to my lodgings. I then rubbed the bruised places with spirits of wine and camphor, and I think it took a little of the pain away. After supper and prayer, it was with great difficulty and pain I was got up stairs and to bed. I slept but little but at the worst of times could say, *"thy will be done."*

My brother brought his family to Colne, and I supplied his place in the White-avens circuit.[72] The arm of the Lord was made bare in a wonderful manner, to wound and to heal, to kill and to make alive, so that when he came back there were *one hundred and eleven added to the society* and several more afterwards. At one village in the circuit there were three clergymen came to hear, the eldest of whom sat in the chair before me while I spoke and said Amen heartily. Another of them had been a persecutor of the Methodists in that part but said afterwards to one of our friends that if what he had heard was the Methodists' doctrine, he was sorry for what he had said and hoped no one should hear him speak against them for the future.

A man out of the country, being informed that I was to preach, was determined to come and hear for himself. His wife strove to prevent his coming and was much enraged. When she found he was determined, she was still more liberal in her hard speeches and breathed nothing but curses, threats, and slaughter. After he was gone, she went and locked all the doors, resolving that he should not come in that night. After she had done this, she went up stairs, kneeled down, and prayed fervently to Almighty God to damn me. She had but

prayed a little while when she saw the room full of devils or evil spirits. At this, her prayer was soon changed into "Lord have mercy on me; save my soul," &c. When her husband came back, it was with great difficulty she arose from her knees, but after some time she did, and let down, opened the door, and received him joyfully. They both kneeled down and prayed together, and as I remember, the Lord pardoned them both while on their knees. I have since seen and conversed with them, and the woman informed me herself, with tears, of the circumstances of her praying for my damnation. They have both joined the Methodists and got the local preachers to preach at their house. Some of their ungodly neighbors told them they would lose their farm. To secure this point, the good man went to his landlord and told him that his neighbors had said if he took in the preachers, *Sir Jon* would turn him off his farm. His landlord replied that if he turned him off for being a Methodist, he might turn off all his tenants, for he thought they were all going to be Methodists now. "No," added he, "if you and your wife can agree any better than you used to do, you may take in who you please. You shall not be turned off."

[September 1799.] On looking upon the congregation before me, the first person I saw was this poor beggar. He evidently felt much, for the tears flowed down his face when he looked up and saw me. He dropped down on the seat instantly. The power of God came down. I cannot describe what I felt. My soul was filled as with the fulness of God. He came next morning with grateful acknowledgments for what God had done for him, still continuing happy and entreating our prayers for him.

Sunday, September 22.[73] I spoke twice at Manchester from *"Is the Lord amongst us or not"* [Exod. 17:7] and from *"Stand still and see the salvation of God"* [Exod. 14:13]. Many were much affected, and my own soul was as a well-watered garden.

Monday the 30th. I spoke at Bury[74] from *"What meanest thou O sleeper"* [Jon. 1:6] and on Thursday evening at Salford chapel,[75] Manchester, and I trust my labor was not vain in the Lord.

Sunday, October 6. I spoke twice in Manchester, and several souls were snatched from the paw of the lion. Praise the name of our God! During the week I spoke twice more and visited many families, met many classes, and prayed with many sick and dying persons. O may I redeem or buy up ever portion of time for the best of purposes.

I then returned into Nottinghamshire [early Autumn 1800] and saw evident good done at Hathern, Farnsfield, Edenley, Oxon, and Hucknall. From the latter place, Mr. Taft accompanied me to Stanton, where I had a gracious season; as also at Eastwood, Normanton, Cotmanhay, Cossall, Ilkestone, Stapleford, Watnall, Radcliffe, Bridgford, Carlton, Mansfield, Sutton, Boulsover, Bulwell, and Baseford.

On the 12th of October I was at the opening of a chapel at Normanton.[76] It was a good time. Two or three found peace with God. I shall never forget speaking, at this time, in the afternoon from *"The Lord added to his church daily, such as should be saved"* [Acts 2:47]. The amens of the people were like claps of thunder. The subject was astonishingly exemplified. Souls were indeed *daily* added to the church, and that not a few, for upwards of *five hundred were added to the Methodist society in this circuit in one quarter*—and several hundreds afterwards! I returned from thence to Nottingham. . . . I usually visited my parents once a year; but it being a year and a half since I had seen them, I became very uneasy, which increased from my mother's earnest desire to see me. I mentioned this to Mr. Bramwell[77] frequently, but he kept putting me off, making other appointments for me. I therefore determined to take the first opportunity of going away privately. We set off about five in the morning and arrived in Doncaster[78] that evening, just as the people were going to the chapel. Though very weary and drowsy after my journey, having been up the whole of the preceding night, we went to chapel. I did not intend making myself known, as I wished to proceed on my journey next morning, but . . .

. . . friends insisted upon our stopping one evening. We did so, and it was a time of power and great glory.

The day following, we arrived at Mr. [Edward] Wade's, of Sturton. Here, for the first time, I met with that venerable man of God, Mr. John Pawson.[79] On my entering the room, he rose up and, turning to Mr. Wade, said, "Now, sir, you can dispense with my labors since Miss Barrett is come, and I am glad to see her. But it is your appointment, and I insist upon you keeping your place," upon which he sat down. Soon after, Mr. Wade began to make enquiries relative to the great work in Nottinghamshire. I related some particulars which had come under my own notice. Mr. Pawson listened, and soon, tears begun to steal down his venerable face. After tea, Mr. Wade proposed prayer, upon which, Mr. Pawson said, "Miss Barrett will pray with

us." I did so and felt my heart much enlarged and blessed. Mr. Pawson prayed afterwards, and we had a good season. *His prejudice against women's preaching melted away as snow before the mid-day sun, and from this time he became my firm advocate and friend.*[80]

The *poetic* effusion addressed to me by one of our traveling preachers is very grateful to my feelings and deserves my sincere thanks.[81] That *females* were employed in the apostolic age of the Christian church in preaching the gospel of Christ is, in my judgment, set at rest by Dr. Adam Clark[e], in his Commentary on the Holy Scriptures.[82] On Rom. xvi. 12, the doctor says, *"many have spent much useless labor in endeavouring to prove that these women did not preach. That there were some prophetesses, as well as prophets, in the Christian church, we learn; and that a woman might pray or prophesy, provided she had her head covered, we know; and that whoever prophesied, spoke unto others to edification, exhortation, and comfort, St. Paul declares - 1 Cor. xiv. 3. That no preacher can do more, every person must acknowledge; because to edify, exhort, and comfort are the prime ends of the gospel ministry. If women thus prophesied, then* women *preached."*

God has in all ages of the church called a few of his handmaids to eminent publicity and usefulness, and when the residue of the SPIRIT is poured out and the mellinium glory ushered in, the prophesy of Joel ii. 28, 29 being fully accomplished in all its glory, then probably, there will be such a sweet blending into one spirit—the spirit of *faith*, of *love*, and of a *sound mind*—such a *willingness* to receive profit by *any* instrument, such a spirit of *humility*—in honor preferring one another that the *wonder* will *then* be that the exertions of pious *females* to bring souls to Christ should ever have been *opposed* or *obstructed*. May the Lord hasten the time! That the great head of the church may render the reading of the record of my labors and efforts to do good a still further blessing to the church of the world, is the earnest prayer of the reader's friend and servant for Christ's sake.

February 7 [1801]. I rested that night and preached at Sturton Grange on the sabbath to a crowd of attentive hearers. . . . the Lord was present both to wound and to heal. On the Saturday, I came to Colne [and] spoke in our chapel, but it was so crowded that there was scarcely any getting in. Numbers were obliged to stand without. On rising up, after I had sung and prayed, the people became alarmed from an apprehension that the chapel was falling. This occasioned considerable confusion, and the more so, as the gallery had

formerly come down at one time when Mr. John Wesley was preaching there, on which occasion many were seriously injured.[83] At *this* time, numbers jumped out at the windows both above and below. Many were greatly bruised, and not a few lost some part of their garments. But thank God, no lives were lost. The alarm was occasioned by the crash of a form under the gallery. For the moment, I felt unutterable things, but as soon as I ascertained the cause of the disturbance, I gave out some verses, and sung with all my heart and strength. This produced attention and many returned that had gone away.

My brother Robert said to a neighbor, "I will go in again and hear my sister." The other replied, "how can you think of going in, when I saw one of the beams had given way more than half a yard from the wall." This bespeaks the power of an alarmed imagination. Painful as this circumstance was, it serves to show that those who knew me best and had been acquainted with me from my infancy, were ever ready to hear what I had to say for the Lord. After the people had become calm and settled, I proceeded—had a great liberty in speaking—and upon the whole it was a good time. Many were affected under the word. My soul was happy, and I felt very thankful for having had another opportunity of warning my neighbors and friends, for whom I have often shed tears in private. O, when will the time be, when God will make bare his arm! O Lord God, remove every hindrance for thy mercy's sake!

On Wednesday, July 29, 1801. I rode to Leeds, where the general Conference was about being held. I heard some precious sermons and spent many valuable hours in company with some of the preachers. My good friend, Mr. John Pawson, was the president of this Conference.[84] I found it a special good time while hearing Dr. Coke[85] read his letters on the work of God in America. Surely, the Lord is abundantly reviving his work!

On Friday, the 9th of July [1802], my dear Mr. Taft[86] told me his mind fully relative to the subject of our union, and on the Thursday forenoon, while at prayer, the Lord so fully convinced me that it was his will that I durst not say any thing against it. This never was the case with me before. Though I had never said, either directly or indirectly, to any one that I never would change my situation, yet, hitherto whenever I was written or spoken to upon that subject, I saw many things against it. But not one objection could I raise, nor any

reason could I bring in my own mind against my union with Mr. T[aft]. His person—his behavior—his employment—his friends—his property, &c. were altogether calculated to court my esteem. I felt a union with him which, though I did not fully acknowledge, yet I durst not, nay I could not resist. The prayer of my heart then was, "Lord, if this be thy will, let it be further proved by my mind never varying." It was so; I never felt a change, for a moment, from that day to this. I am sensible that this was the Lord's doing and very marvelous in my eyes. O, how shall I sufficiently praise my covenant-keeping God, who hath hitherto stood by, provided for, and led unworthy me by a right way!

I fell down on my knees and began to beg of Him who had the hearts of all in his keeping, that he would open our way and make us a blessing to the people his providence might design us to be among. As soon as I rose from my knees, there was a rap at the door. Thinking it was Mr. T[aft], I said, "walk in." The door opened, and an aged lady moved toward me with the door in her hand. I begged her to walk in. She said, "Dear madam, I am sorry to disturb you, but have you any one poorly or are you so yourself? Can I be of any assistance? If so, I should be glad." I thanked her for her kindness and told her I was not poorly, neither had I any one with me at present, adding, "I will tell you how it is. I am a perfect stranger in this place, and so is my husband too. He has left me here and gone to seek some friends which we hope we have in this town, though unknown to us at present. And as I wish to do nothing without acquainting the Lord, or asking counsel from him, I have been praying that he would direct us and abundantly bless our coming to this place." Tears immediately sparkled in her eyes, and she replied, "very good," wished me a very good night, and then withdrew.

In a few moments, I heard a rap at the door again. I said, as before, "walk in," thinking it to be Mr. Taft. But the same lady came forward with tears in her eyes, and after some apology, said, "will you have the goodness to step a moment or two into the next room, for I have a young lady with me, and we are going to France tomorrow. She heard you pray, as well as myself. I told her what you said, and she cannot rest satisfied without seeing you." I straightway followed her, and in her room, saw a young lady in bed, weeping. As soon as I went to the bedside she got her arms about my neck and prayed God to bless me. I spoke very freely to them both for some minutes con-

cerning the work of grace upon the soul, and what we might obtain and enjoy through Christ. I then kneeled down and prayed for them with all my heart. I shall not easily forget what love I felt for the souls of these two strangers. They both wept and prayed God Almighty to bless both them and us. They then saluted and thanked me, and I took my final leave of them. O that the Lord may bless them both, and may we meet in glory! Amen.

[September 18, 1802.] Mr. Taft preached at ten, at two, and at seven in the evening [at Dover[87]]. The Lord was eminently present and afforded the needful assistance. In the evening I prayed after the service, and Mr. Taft met the society, during which, I felt the Spirit of God like fire in my bones, but what to say I knew not. I felt such power from above, that I knew I must say something. I stood up therefore, entreating the people to bear with me. I was a perfect stranger to them, but not to God, and as fully believed that God, even our God, had as surely sent us to them as ever he sent Joseph into Egypt. I immediately felt relief and the Lord gave his blessing. Several were much affected. We went home that evening . . . to a room provided for a single preacher. During the religious services of this day, and indeed afterwards, I felt what it is utterly out of my power to describe. I must confess, I feared there was but little more than the form of religion among those who attended the house of God, and indeed I suspected there was something very defective even in this, so much looking at one another, moving the hand or nodding the head. There appeared but little reverence and devotion, and as to any Amen, not a whisper could be heard except at reading the prayers, which are regularly performed there twice on the sabbath. Mr. Wesley's abridgment[88] of that excellent form of words is read, generally, by a layman. . . . the whole service, when taken together, was so different to those I had left, that had I not known the fact, I should not have supposed we had been in a Methodist chapel. Surely, the Lord will answer his Spirit's cry in my heart, and give us some more zeal, and life, and feeling. The Lord grant it soon, for his name's sake!

On Monday evening, Mr. Taft preached again, after which the stewards and leaders met to determine whether he must be received as their preacher. They expressed a great deal of satisfaction. My husband had previously informed them that I should not be any additional expense to them. During this week we visited the people, and exhorted and prayed with them from house to house. On Wednes-

day, I exhorted a little in the prayer-meeting. On Friday evening Mr. Taft preached again; and on the sabbath-day three times. It was a good day to many. The congregations were considerably larger. But I felt much, and was constrained to weep, when I saw with what light and trifling countenances the people entered the house of God. They looked upon us at first in a strange way, particularly me, as though I had come out of another land, for it appeared very strange there to hear a woman pray to Almighty God. . . . I think one of the oldest members in the society told me he had never heard more than three prayers from all the women he had ever seen at Dover.

On Wednesday, September 1, I spoke again a little in the prayer-meeting, which was held in a private house. Very few, in general, attended; however, we had more this week, and a strong desire was expressed that I would speak more largely. The third sabbath was a good day indeed. My dear Mr. Taft labored with all his heart, and many appeared to feel under the word. On Wednesday I spoke again at the prayer-meeting. Many attended. The Lord was present. And I felt much for precious souls, insomuch, that I thought if my way was not soon opened to labor more for the Lord, I must go and speak to the people on the sea-shore. I thought I could not live without doing that which I was as sensible it was my duty to do as I was of my own existence. This week, a friend came from Deal,[89] to ask us to go there. We consented and went September 11, 1802. I spake twice on the sabbath. The Lord was with us of a truth. Many wept much. My husband preached at noon. I felt my soul truly thankful for this opportunity. We returned again to Dover on the Monday. Mr. T[aft]. preached at night, as usual. This week, a friend came to our lodgings and informed me that he had a large place which had been occupied as a chapel, but lately as a warehouse and, that if I chose, he would fit it up as a place in which I might labor for the Lord. I gladly accepted the offer, convinced that the circumstance was an answer to prayer.

On Saturday evening, September 18, I spoke at Dover for the first time in a public place of worship from that passage, Job xxi. 3. *"suffer me that I may speak; and after that I have spoken, mock on."* There was a large congregation and many appeared much affected with the word. On the sabbath-day following, I spake in the workhouse. Some of the poor people appeared concerned about their immortal souls. On the Wednesday following I spake again in the chapel, which the

gentleman before-mentioned had opened to me. He soon came more fully forward himself and joined our society. On the Saturday evening I spoke again. The Lord was with us to awaken many, and some felt the love of God shed abroad in their hearts [cf. Rom. 5:5]. And also on Wednesday evening, September 29th, when the Lord was present to bless our souls.

We had, by this time, received several invitations from Canterbury. We went on Saturday, October 2nd, Mr. Taft having engaged a traveling preacher to supply his place at Dover. I spoke three times in the chapel at Canterbury by invitation from the preacher and stewards, and Mr. Taft once.[90] We had very large, and in general, attentive congregations. Many appeared to feel the force of divine truth. We returned to Dover on Tuesday, and I spoke at the usual place on Wednesday. The congregations in both places much increased, and some began to meet in class. During our absence the friends at Dover had chosen new stewards. This week the following paragraph appeared in the Kentish Herald, published at Canterbury, October 7, 1802. "On Monday evening, a sermon was preached in King-Street chapel, in this city, by Mrs. Taft, a female preacher, in the connexion of the late Rev. John Wesley. The novelty of a female preacher naturally excited great curiosity; many hundreds of persons were present, and others were prevented from getting in for want of room. The text of her discourse was from the first epistle of St. John, the first chapter, and the ninth verse, *'If we confess our sins, he is faithful and just to forgive us our sins, and to cleanse us from all unrighteousness,'* which she supported with many judicious and well-grounded remarks; and being possessed with great fluency of speech, she attracted great attention from the whole congregation."

October 30, 1802. I went to Canterbury. Some got a real concern for their souls during this visit, whom I hope one day to meet before God. I returned to Dover, November 4, and spoke on the Wednesday, in my new place; and on Friday evening, for the first time, in our own chapel, by an invitation from the stewards and leaders. Indeed, I should have been invited to labor in it before this time but for one person, who stood opposed to female preaching. This same person, during Mr. Taft's absence from Dover, had chosen new stewards and hinted to one of our friends that he had proposed one on purpose because he believed he would oppose Mrs. Taft's laboring in our chapel. Mr. Taft submitted to this though it was contrary to our rules

and customs. At this, one of our stewards, and nearly the oldest member in the society, took himself out and positively refused to take a ticket[91] until I was invited to speak in our own chapel. He thought, as all the hearers and members wished it, except one person and a relation of his who had been appointed steward, that the Lord was grieved with them for not doing it. In this particular, our good friend and aged brother missed his way; he should not have refused to take his ticket, and thereby throw[n] himself out of society. Besides, this gave an advantage to *one* who was seeking an occasion against us.

Hence, he went to London and charged me with dividing the society, and I know not what. I committed my cause into the hand of God. I knew, and the Lord knew, that we were all peace and harmony, but for one person, and about another or two, whom he had influenced to oppose my speaking in the chapel. But he must have seen and felt, had he been possessed of spiritual sight and feeling, that God was among us of a truth. I prayed for him with all my heart, but I felt exceedingly, as I always do, when I am fully convinced that any person is *standing in God's way*. The Lord supported me and most assuredly gave *me an answer* to prayer, though not exactly in the way I wished. Surely, there is a retributive providence. Soon after we left, *his sins found him out*, and he was removed *out of God's way*. He has once or twice been restored to membership, but, if I am correctly informed, he has not been in society for many years.

About this time, Mr. T[aft] received a letter from the chairman of the London district[92] saying that he had been informed that there was much disturbance at Dover and that an actual division had taken place in the society on account of Mrs. Taft's preaching. He intimated at the same time that if this was not put a stop to he must be under the necessity of calling a district meeting, which he was loath to do, not only because of the expense but because of the unpleasant consequences which might follow.

I cannot be sufficiently thankful to the Lord, who knows all things, that he should just at this juncture of time put it into the heart of one of our oldest traveling preachers, Mr. John Pawson, to write to the stewards of Dover, in favor of my *character, labors,* and *usefulness*.[93] Another traveling preacher wrote to them in the same way. This, I have ever looked upon as a particular providence, that God should put it into the heart of this good old apostle to write to us and to the

stewards in the way and manner he did, and just at the very time when we stood in need of such encouragement. His letter was dated the same day as the letter Mr. T[aft]. received from the chairman of the London district. Truly, the Lord knew our situation and sent timely help.

One forenoon, having taken a walk to visit some of the people, I passed a house where a child was crying most pitifully. I stopped a moment to listen and then went into the house. I said to the mother, "What is the matter with your child?" The poor woman, with tears in her eyes, said, "I have little or no milk and believe it is crying for hunger." I said, "Let me give it some milk," which the child took with great eagerness. I then requested her to bring it to our house every day at a certain time, which she did. In about a fortnight it was so much altered that her husband said, "The preaching woman has cured my child. I will go to hear her; perhaps she will cure my soul." He came and got awakened. His wife also. And they both united with us in class and soon found peace with God. O may I meet them in heaven! What a vast variety of circumstances does God overrule and make subservient to the salvation of souls.

The great business of our life is to be daily preparing for eternity. This, to us, as accountable and immortal creatures, is of the utmost moment. Herein is involved *our all*, our present peace, and our future and endless well-being. In comparison with this, our weightiest temporal matters are lighter than vanity. May the Spirit of the Almighty so give us to feel the solemn weight of eternal things.

Mrs. Tatham,[94] of Nottingham, in a letter which lies before me, observes, "We have no doubt but a dispensation of the gospel is committed to you. If the Methodist Conference will, as assiduously, guard against the innovations of the stronger as well [as] of the weaker sex, it will be much to the credit of religion, the honor of the gospel, and the future advancement of divine truth amongst us as a people. Your cause is God's cause. He has hitherto been with you, and, I believe, he will never fail, nor forsake you. With respect to your future actions, you have nothing to do with the approbation, disapprobation of the Methodist Conference. One is your master, even Christ. Were they to forbid you preaching amongst us, they could not forbid you preaching *to us*. He that *called you* and *blessed you* will still stand by you and suffer no man to set on you to do you harm."

The reason why our friends wrote to us at this time in this encouraging way was as follows. A minute had been made in the Sheffield District requesting the Conference to put a stop to women's preaching. As this became known, we had a multitude of letters on the subject. The following letter, from an old and tried friend, shall be transcribed verbatim.

Sheffield, July 18th, 1809

DEAR BROTHER,

I have been informed that there is an intention at the approaching Conference to put a total and final stop to women's preaching among us. It may be so with some of the preachers, but I cannot believe that a majority of the brethren, who will compose the Conference, will be of that mind. The labors of Mrs. Taft have been so [uniquely] owned of God in the awakening of sinners and the conversion of mourners in every place where she has labored, and her conduct, both as a *Christian* and a *Christian Minister*, has been from the beginning so pure and irreproachable, and so many of the Itinerant preachers know this that if they, or a majority of them, pass a vote that she shall preach no more among us, I am at a loss to know to what cause to ascribe such a conduct. I feel unwilling to ascribe it to envy; and yet, if it be an absolute fact that God has, and still does, bless her preaching to the conversion of many, very many souls, I do not, cannot see what can influence the preachers to silence her. For certainly, if she was acting in opposition to the word and will of God, he would not crown her labors with such success. What I have seen of her as a public character at *Sheffield, Nottingham, Birstal, Leeds, York*, and elsewhere with what I have heard very many in all these places say of her exemplary life and successful labors, fully satisfied me that she has a special mission from God to preach the gospel. Yea, and that she is manifestly and indispensably the person whom our God delighteth to honor. That the Lord may preside in the Conference and abundantly bless you shall be the prayer of,

Your ever affectionate,

H[ENRY]. LONGDEN[95]

[July 1809, at the Manchester Conference.] This was a time of trial to me, but our God overruled.[96] Praise his holy name for ever! I felt and prayed much for myself, family, friends, and the church of God.

The Lord preserve me from shrinking from the Cross, but may we glory in it and live under it till we change it for a crown.

Sunday, April 29th, 1810. We received a long and valuable letter from my son in the gospel, Mr. George Thompson,[97] traveling preacher. I am happy to find that the Lord is with him and owns him in the conversion of sinners. It is also pleasing to find that he has not forgot the hole of the pit out of which he was dug or the rock from which he was hewn, nor is he yet ashamed of the instrument of his conversion. He says, "I am constrained to be favourable to the doctrine of *women's preaching,* for, by a *woman,* God sent the glad tidings to a rebel. I am sure I did not send for her, nor do I believe the devil could or would use her for the conversion of one of the vilest of men. I am fully satisfied she was a messenger sent from God to pluck me as a brand from the burning and to save multitudes besides." May the Lord keep him humble and faithful and make him abundantly more useful! Amen.

Monday [July 16, 1810]. I set off . . . for Madeley, in Shropshire, to see that extraordinary character for talent, piety, and usefulness, Mrs. Mary Fletcher, relict of the late Rev. Mr. [John] Fletcher and formerly Miss Bosanquet. We arrived at Madeley the next evening about five o'clock and found our honored friend, with whom we had corresponded about seven years, pretty well. Mr. Taft preached this evening, and I on the following, in Mrs. Fletcher's chapel.[98] Indeed, one of us preached every evening for a week or ten days at Madeley or in the neighborhood, and surely we spent the time as on the verge of heaven. Mrs. Fletcher entertained us much with the interesting history of her life and labors. She told us also many anecdotes of Mr. Fletcher.

On Monday evening, July 23rd. We had the pleasure to hear Mrs. Fletcher paraphrase on the 9th chapter of John. It was a sweet time to us, and many more. Mrs. F[letcher] though in her 71st year, keeps five public meetings every week and is received as an angel of God. Multitudes attended her ministry, among whom are many of the rich and great, and several Clergymen.

August 1st, 1816. *Truly God is good to Israel, even to such as are of a clean heart* [Ps. 73:1]. Blessed be God, I feel it so! O may I live to praise him more than ever! Thank the Lord all is well! My husband is at the London Conference. He went by sea and arrived safe. I was glad he preached on ship board and at the Conference since he

arrived. May the Lord bless his word! I felt much helped on Sabbath evening. Afterwards there came many fresh persons to our class. One came to inform us that the Lord had just set her soul at liberty in the chapel and that she was come to return public thanks to Almighty God. Three more came in before we concluded. We had between fifty and sixty in our house. I hear that my two butchers, on the South side, are made a great blessing by their living new lives. All who know them discover the wonderful change. One of our new neighbors has been into our house. We had some profitable conversation and prayer. She promises to meet in class with me. I am just now come in from the prayer meeting in which I gave the people some conference news and read part of Mr. Taft's letter, at which there was a general gust of *praise to God*. Bless the Lord, we are living next door to heaven!

Elizabeth Evans

Editor's Introduction

The name of Elizabeth Evans (1776–1849) is intimately connected with the famous novel *Adam Bede* by George Eliot, pseudonym of Mary Ann Evans (1819–1880), niece of the Methodist evangelist. This first Eliot novel, like most of her early works, sympathized with the religion of the increasingly marginalized elements of society, the separatist Methodist traditions in particular. The biography of Elizabeth Evans and the story of Eliot's fictional Dinah Morris, heroine of the novel, are so inextricably tied together that it is virtually impossible to separate them. The extent to which Eliot's aunt functioned as a model for her heroine has long been a matter of critical scholarly debate.[99] However conclusive the evidence for or against this connection, the equation between the two became a firm folk-belief,[100] testified to by a memorial tablet in the Methodist chapel at Wirksworth. It simply describes Elizabeth Evans as one "Known to the World as Dinah Bede, a mother in Israel." There is little doubt that "my aunt's story," as Eliot called it, namely, her aunt's visit of a young woman condemned to death in prison, functioned as the climax toward which the whole story line of the novel moved. Because of the intimacy between Elizabeth and Eliot's character, I have chosen to append four relevant excerpts from the novel, set just at the close of the eighteenth century, to the brief excerpt from Evans's journal.

Elizabeth, born in 1776 to Methodist parents named Tomlinson in Newbold, Leicestershire, was converted in 1797 while listening to a sermon by George Smith of Newfoundland, the spiritual upheaval of which threw her into extreme asceticism. The account of her spiritual journey which follows carries the reader through the agonies of

her struggle to be faithful to the call of God on her life. Exhortations in prayer meetings held in Derby eventually gave way to a preaching ministry that would carry her throughout the region of her birth. When Samuel Evans heard her preach in Ashbourne, he was not just impressed; he fell immediately in love. "Simplicity, love and sweetness are blended in her. Her whole heart is in the work. She is made instrumental in the conversion of many sinners."[101] The two were married in 1804 at Wirksworth, which remained their family home for years.

The team soon became legendary in the district. Crowds gathered eagerly to hear them. After a full week of work, it was not uncommon for them to walk fifteen or twenty miles on Sunday, preaching in the neighboring villages and homes along the way. According to Zechariah Taft, she was so valuable to her employer at the lace factory that he accommodated his own schedule to whatever outrageous terms her career as an itinerant evangelist demanded.[102] Despite the restrictions placed on women preachers at the Wesleyan Conference of 1803, Samuel and Elizabeth continued to conduct joint evangelistic tours as Methodist local preachers until 1832 at which time the Conference further objected to "female preaching." They associated for a while with the Primitive Methodists and then became active among the Arminian Methodists (also known as the Derby Faith Folk). This latter group, noted for their enthusiastic revivalism and employment of women preachers, welcomed the Evans couple warmly. A circuit was created with three preaching places in Derby and twenty-seven in the surrounding country. Their first annual assembly was held in Derby in June 1833. Eventually, however, both Elizabeth and Samuel returned to the Wesleyan Methodist tradition. Elizabeth died in 1849 and Samuel ten years later.

The following excerpt is drawn from Zechariah Taft's transcript of Elizabeth's journal in *Holy Women* (1:145-58).

✳ ✳ ✳

In a little time the Lord inclined me to read and pray much in private on my knees. Oh! the precious seasons I experienced in this exercise. In a little more than one year after this, the Lord convinced me of the necessity of being sanctified, more sensibly than ever I was

of being pardoned. I sought this blessing almost day and night, for even in sleep my mind was occupied with this subject. . . . under the prayer of that man of God, Mr. Bramwell,[103] I was enabled to lay hold on the blessing and to sink into the purple flood. I held this blessing with a trembling hand, and was enabled to grow in the Grace wherein I stood and to rejoice in hope of a greater glory still pressing after the fullness of God. For it is one thing to be emptied of sin and to feel nothing contrary to love and another to be filled with the fruits of righteousness.[104] I experienced many deep baptisms into the spirit of God. *I saw it my duty to be wholly devoted to God and to be set apart for the master's use. And after many struggles, thousands of tears, and much prayer with fastings, I did enter into a glorious liberty.* I could truly say I am crucified with Christ; I live, yet not I, but Christ liveth in me [cf. Gal. 2:20]. . . .

Mr. Bramwell observed in a sermon, "Why are there not more Women Preachers? Because they are not faithful to their call."[105] I concluded if ever the Lord called me I would be faithful, and almost immediately *I felt it my duty to call sinners to repentance.* I labored under this conviction for nearly two years. Oh the exercises of mind I endured—travelling in birth for souls—the love of God was as a fire shut up in my bones, and the thoughts of the blessed work of bringing sinners to Christ drank up my spirits so that I knew not how to live. I felt assured that if I did not preach I never could be happy, for I was sensible it was the will of God.[106] But how it must be brought about I could not tell; for I felt shut up, and could not tell my mind to any one but my band mate, for I was determined never to open the door myself. I gave myself to continual prayer and searching the Scriptures that I might not deceive myself. But the more I prayed, fasted, and read the word [of] God, the stronger my call was felt. . . . The language of my heart was—Oh that I had wings like a dove, then would I fly away and be at rest. . . .

. . . I went to Derby.[107] The dear people (Mrs. Dobinson[108] in particular) begged I would lead her class. We also had blessed prayer meetings. In these I spoke a little, and some good was done. This visit was the means of my becoming acquainted with the dear friends that first opened the door of usefulness unto me. I cannot help seeing the kind hand of a gracious God in these things, however others may *sneer* at them and call it *enthusiasm* or what they please. A second time happened in 1801 or 1802, which was made a great blessing to

175

my soul. A Mary Voce, a poor unhappy woman, who poisoned her child, was confined in the town gaol at Nottingham, and tried at the March Assizes, and condemned to suffer.

A Miss Richards (now in heaven), who was eminently pious and useful, was granted the favor of being with her night and day until the morning of her execution. I longed to be with her also, and how my heart rejoiced when I heard Miss Richards say, Betsey, go with me to the gaol directly. Accordingly I went, and a most mournful night we had. . . . At seven o'clock we all kneeled down to prayer, and ten minutes before eight o'clock, the Lord in mercy spoke peace to her soul. She cried out, "Oh how happy I am! The Lord has pardoned all my sins, and I am going to heaven." She never lost the evidence for one moment and always rejoiced in the hope of Glory.

Miss Richards and I attended her to the place of execution. Our feelings on this occasion were very acute. We rode with her in the cart to the awful place. Our people sang with her all the way, which I think was a mile and a half. We were enabled to lift up our hearts unto the Lord in prayer in her behalf, and she was enabled to bear a public testimony that God in mercy had pardoned all her sins. When the cap was drawn over her face, and she was about to be turned off, she cried, "Glory! Glory! Glory! The angels of God are waiting around me!!" And she died almost without a struggle. At this awful spot, I lost a great deal of the fear of man, which to me had been a great hindrance for a long time. I felt if God would send me to the uttermost parts of the earth I would go and at intervals felt I could embrace a martyr's flames. Oh! this burning love of God, what will it not endure? I could not think I had an enemy in the world. I am certain I enjoyed that salvation that if they had smote me on the one cheek, I could have turned to them the other also. . . .

I seemed to myself to live betwixt heaven and earth. I was not in heaven because of my body, nor upon earth because of my soul. Earth was a scale to heaven, and all I tasted was God. I could pray without ceasing and in every thing give thanks. . . .[109]

Now it may be asked, would the all wise God have done these things for me and in me, if he had not intended to accomplish some blessed design. If the person had been a male instead of a female, would it not have been concluded at once, he is called to preach; certainly these thing[s] testify the truth of it. But it is argued, "I suffer not a woman to speak in the church" [1 Tim. 2:11-12]. And is the

Apostle then alluding to preaching? I believe not. If he is, in other places he contradicts himself, which under inspiration he could not do. And does he not sanction women laboring in the Gospel? But is the Apostle alone in this matter? No, search but the old and new testaments, and you will find many daughters that did prophesy or were prophetesses. And Joel [2:28-29] says, in the latter days saith God, "I will pour out my spirit upon my servants and handmaids."

✳ ✳ ✳

Excerpts from George Eliot's *Adam Bede*[110]

(Dinah Morris Preaches on the Green at Hayslope)[111]

. . . Dinah began to speak.

"Dear friends," she said, in a clear but not loud voice, "let us pray for a blessing."

She closed her eyes, and hanging her head down a little, continued in the same moderate tone, as if speaking to some one quite near her:—

"Saviour of sinners! when a poor woman, laden with sins, went out to the well to draw water, she found Thee sitting at the well. She knew Thee not; she had not sought Thee; her mind was dark; her life was unholy. But Thou didst speak to her, Thou didst teach her, Thou didst show her that her life lay open before Thee, and yet Thou wast ready to give her that blessing which she had never sought. Jesus! Thou art in the midst of us, and Thou knowest all men: if there is any here like that poor woman—if their minds are dark, their lives unholy—if they have come out not seeking Thee, not desiring to be taught; deal with them according to the free mercy which Thou didst show to her. Speak to them, Lord; open their ears to my message; bring their sins to their minds, and make them thirst for that salvation which Thou art ready to give.

"Lord! Thou art with Thy people still: they see Thee in the night-watches, and their hearts burn within them as Thou talkest with them by the way. And Thou art near to those who have not known Thee: open their eyes that they may see Thee—see Thee weeping over them, and saying, 'Ye will not come unto me that ye might have

life'—see Thee hanging on the cross and saying, 'Father, forgive them, for they know not what they do'—see Thee as Thou wilt come again in Thy glory to judge them at the last. Amen."

Dinah opened her eyes again and paused, looking at the group of villagers, who were now gathered rather more closely on her right hand.

"Dear friends," she began, raising her voice a little, "you have all of you been to church, and I think you must have heard the clergyman read these words: 'The Spirit of the Lord is upon me, because he hath anointed me to preach the gospel to the poor.' Jesus Christ spoke those words—he said he came *to preach the Gospel to the poor*; I don't know whether you ever thought about those words much; but I will tell you when I remember first hearing them. It was on just such a sort of evening as this, when I was a little girl, and my aunt as brought me up, took me to hear a good man preach out of doors, just as we are here. I remember his face well: he was a very old man, and had very long white hair; his voice was very soft and beautiful, not like any voice I had ever heard before. I was a little girl, and scarcely knew anything, and this old man seemed to me such a different sort of a man from anybody I had ever seen before, that I thought he had perhaps come down from the sky to preach to us, and I said, 'Aunt, will he go back to the sky to-night, like the picture in the Bible?'

"That man of God was Mr. Wesley, who spent his life in doing what our blessed Lord did—preaching the Gospel to the poor—and he entered into his rest eight years ago. I came to know more about him years after, but I was a foolish thoughtless child then, and I remembered only one thing he told us in his sermon. He told us as 'Gospel' meant 'good news.' The Gospel, you know, is what the Bible tells us about God.

"Think of that now! Jesus Christ did really come down from heaven, as I, like a silly child, thought Mr. Wesley did; and what he came down for, was to tell good news about God to the poor. Why, you and me, dear friends, are poor. We have been brought up in poor cottages, and have been reared on oat-cake, and lived coarse; and we haven't been to school much, nor read books, and we don't know much about anything but what happens just around us. We are just the sort of people that want to hear good news. For when anybody's well off, they don't much mind about hearing news from distant parts; but if a poor man or woman's in trouble and has hard work to

make out a living, they like to have a letter to tell 'em they've got a friend as will help 'em. To be sure, we can't help knowing something about God, even if we've never heard the Gospel, the good news that our Saviour brought us. For we know everything comes from God: don't you say almost every day, 'This and that will happen, please God'; and 'We shall begin to cut the grass soon, please God to send us a little more sunshine?' We know very well we are altogether in the hands of God: we didn't bring ourselves into the world, we can't keep ourselves alive while we're sleeping; the daylight, and the wind, and the corn, and the cows to give us milk—everything we have comes from God. And he gave us our souls, and put love between parents and children, and husband and wife. But is that as much as we want to know about God? We see he is great and mighty, and can do what he will: we are lost, as if we was struggling in great waters, when we try to think of him.

"But perhaps doubts come into your mind like this: Can God take much notice of us poor people? Perhaps he only made the world for the great and the wise and the rich. It doesn't cost him much to give us our little handful of victual and bit of clothing; but how do we know he cares for us any more than we care for the worms and things in the garden, so as we rear our carrots and onions? Will God take care of us when we die? and has he any comfort for us when we are lame and sick and helpless? Perhaps, too, he is angry with us; else why does the blight come, and the bad harvests, and the fever, and all sorts of pain and trouble? For our life is full of trouble, and if God sends us good, he seems to send bad too. How is it? how is it?

"Ah! dear friends, we are in sad want of good news about God; and what does other good news signify if we haven't that? For everything else comes to an end, and when we die we leave it all. But God lasts when everything else is gone. What shall we do if He is not our friend?"

Then Dinah told how the good news had been brought, and how the mind of God towards the poor had been made manifest in the life of Jesus, dwelling on its lowliness and its acts of mercy.

"So you see, dear friends," she went on, "Jesus spent his time almost all in doing good to poor people; he preached out of doors to them, and he made friends of poor workmen, and taught them and took pains with them. Not but what he did good to the rich too, for he was full of love to all men, only he saw the poor were more in

want of his help. So he cured the lame and the sick and the blind, and he worked miracles, to feed the hungry, because, he said, he was sorry for them; and he was very kind to the little children, and comforted those who had lost their friends; and he spoke very tenderly to poor sinners that were sorry for their sins.

"Ah! wouldn't you love such a man if you saw him—if he was here in this village? What a kind heart he must have! What a friend he would be to go to in trouble! How pleasant it must be to be taught by him.

"Well, dear friends, who *was* this man? Was he only a good man— a very good man, and no more—like our dear Mr. Wesley, who has been taken from us? . . . He was the Son of God—'in the image of the Father,' the Bible says; that means, just like God, who is the beginning and end of all things—the God we want to know about. So then, all the love that Jesus showed to the poor is the same love that God has for us. We can understand what Jesus felt, because he came in a body like ours, and spoke words such as we speak to each other. We were afraid to think what God was before—the God who made the world and the sky and the thunder and lightning. We could never see him; we could only see the things he had made; and some of these things was very terrible, so as we might well tremble when we thought of him. But our blessed Saviour has showed us what God is in a way us poor ignorant people can understand; he has showed us what God's heart is, what are his feelings towards us.

"But let us see a little more about what Jesus came on earth for. Another time he said, 'I came to seek and save that which was lost'; and another time, 'I came not to call the righteous but sinner to repentance.'

"The *lost!* . . . *Sinners!* . . . Ah, dear friends, does that mean you and me?"

❋　❋　❋

"Dear friends," she said at last, "brothers and sisters, whom I love as those for whom my Lord has died, believe me I know what this great blessedness is; and because I know it, I want you to have it too. I am poor, like you: I have to get my living with my hands; but no lord nor lady can be so happy as me, if they haven't got the love of

God in their souls. Think what it is—not to hate anything but sin; to be full of love to every creature; to be frightened at nothing; to be sure that all things will turn to good; not to mind pain, because it is our Father's will; to know that nothing—no, not if the earth was to be burnt up, or the waters come and drown us—nothing could part us from God who loves us, and who fills our souls with peace and joy, because we are sure that whatever he wills is holy, just, and good.

"Dear friends, come and take this blessedness; it is offered to you; it is the good news that Jesus came to preach to the poor. It is not like the riches of this world, so that the more one gets the less the rest can have. God is without end; his love is without end—

> 'Its streams the whole creation reach,
> So plenteous is the store;
> Enough for all, enough for each,
> Enough for evermore.' "

Dinah had been speaking at least an hour, and the reddening light of the parting day seemed to give a solemn emphasis to her closing words. The stranger, who had been interested in the course of her sermon, as if it had been the development of a drama—for there is this sort of fascination in all sincere unpremeditated eloquence, which opens to one the inward drama of the speaker's emotions—now turned his horse aside, and pursued his way, while Dinah said, "Let us sing a little, dear friends;" and as he was still winding down the slope, the voices of the Methodists reached him, rising and falling in that strange blending of exultation and sadness which belongs to the cadence of a hymn.

✳ ✳ ✳

(Dinah Engages in Conversation with Mr. Irwine)[112]

"... you are a Methodist—a Wesleyan, I think?"

"Yes, my aunt at Snowfield belonged to the Society, and I have cause to be thankful for the privileges I have had thereby from my earliest childhood."

"And have you been long in the habit of preaching?—for I understand you preached at Hayslope last night."

"I first took to the work four years since, when I was twenty-one."

"Your Society sanctions women's preaching, then?"

"It doesn't forbid them, sir, when they've a clear call to the work, and when their ministry is owned by the conversion of sinners, and the strengthening of God's people. Mrs. Fletcher, as you may have heard about, was the first woman to preach in the Society, I believe, before she was married, when she was Miss Bosanquet; and Mr. Wesley approved of her undertaking the work. She had a great gift, and there are many others now living who are precious fellow-helpers in the work of the ministry. I understand there's been voices raised against it in the Society of late, but I cannot but think their counsel will come to nought. It isn't for men to make channels for God's Spirit, as they make channels for the water-courses, and say, 'Flow here, but flow not there.' "

�належ ✻ ✻

"But tell me—if I may ask, and I am really interested in knowing it—how you first came to think of preaching?"

"Indeed, sir, I didn't think of it at all—I'd been used from the time I was sixteen to talk to the little children and teach them, and sometimes I had had my heart enlarged to speak in class, and was much drawn out in prayer with the sick. But I had felt no call to preach; for when I'm not greatly wrought upon, I'm too much given to sit still and keep by myself: it seems as if I could sit silent all day long with the thought of God overflowing my soul—as the pebbles lie bathed in the Willow Brook. . . . I was called to preach quite suddenly, and since then I have never been left in doubt about the work that was laid upon me."

"But tell me the circumstances—just how it was, the very day you began to preach."

"It was one Sunday I walked with brother Marlowe, who was an aged man, one of the local preachers, all the way to Hetton-Deeps— that's a village where the people get their living by working in the lead-mines, and where there's no church nor preacher, but they live like sheep without a shepherd. It's better than twelve miles from Snowfield, so we set out early in the morning, for it was summertime; and I had a wonderful sense of the Divine love as we walked

over the hills, where there's no trees, you know, sir, as there is here, to make the sky look smaller, but you see the heavens stretched out like a tent, and you feel the everlasting arms around you. But before we got to Hetton, brother Marlowe was seized with a dizziness that made him afraid of falling, for he overworked himself sadly, at his years, in watching and praying, and walking so many miles to speak the Word, as well as carrying on his trade of linen-weaving. And when we got to the village, the people were expecting him, for he'd appointed the time and the place when he was there before, and such of them as cared to hear the Word of Life were assembled on a spot where the cottages was thickest, so as others might be drawn to come. But he felt as he couldn't stand up to preach, and he was forced to lie down in the first of the cottages we came to. So I went to tell the people, thinking we'd go into one of the houses, and I would read and pray with them. But as I passed along by the cottages and saw the aged trembling women at the doors, and the hard looks of the men, who seemed to have their eyes no more filled with the sight of the Sabbath morning than if they had been dumb oxen that never looked up to the sky, I felt a great movement in my soul, and I trembled as if I was shaken by a strong spirit entering into my weak body. And I went to where the little flock of people was gathered together, and stepped on a low wall that was built against the green hill-side, and I spoke the words that were given to me abundantly. And they all came round me out of all the cottages, and many wept over their sins, and have since been joined to the Lord. That was the beginning of my preaching, sir, and I've preached ever since."

※　　※　　※

(Dinah Visits a Woman Condemned to Death)[113]

"Hetty," she said, gently, "do you know who it is that sits by your side?"

"Yes," Hetty answered slowly, "it's Dinah."

"And do you remember the time when we were at the Hall Farm together, and that night when I told you to be sure and think of me as a friend in trouble?"

"Yes," said Hetty. Then, after a pause, she added, "But you can do nothing for me. You can't make 'em do anything. They'll hang me o' Monday—it's Friday now."

As Hetty said the last words, she clung closer to Dinah, shuddering.

"No, Hetty, I can't save you from that death. But isn't the suffering less hard when you have somebody with you, that feels for you— that you can speak to, and say what's in your heart? . . . Yes, Hetty: you lean on me: you are glad to have me with you."

"You won't leave me, Dinah? You'll keep close to me?"

"No, Hetty, I won't leave you. I'll stay with you to the last. . . . But, Hetty, there is some one else in this cell besides me, some one close to you?"

Hetty said, in a frightened whisper, "Who?"

"Some one who has been with you through all your hours of sin and trouble—who has known every thought you have had—has seen where you went, where you lay down and rose up again, and all the deeds you have tried to hide in darkness. And on Monday, when I can't follow you,—when my arms can't reach you,—when death has parted us,—He who is with us now, and knows all, will be with you then. It makes no difference—whether we live or die, we are in the presence of God."

"Oh, Dinah, won't nobody do anything for me? *Will* they hang me for certain? . . . I wouldn't mind if they'd let me live."

"My poor Hetty, death is very dreadful to you. I know it's dreadful. But if you had a friend to take care of you after death—in that other world—some one whose love is greater than mine—who can do everything? . . . If God our Father was your friend, and was willing to save you from sin and suffering, so as you should neither know wicked feelings nor pain again? If you could believe he loved you and would help you, as you believe I love you and will help you, it wouldn't be so hard to die on Monday, would it?"

"But I can't know anything about it," Hetty said, with sullen sadness.

"Because, Hetty, you are shutting up your soul against him, by trying to hide the truth. God's love and mercy can overcome all things—our ignorance, and weakness, and all the burthen of our past wickedness—all things but our wilful sin; sin that we cling to, and will not give up. You believe in my love and pity for you, Hetty; but

184

if you had not let me come near you, if you wouldn't have looked at me or spoken to me, you'd have shut me out from helping you: I couldn't have made you feel my love; I couldn't have told you what I felt for you. Don't shut God's love out in that way, by clinging to sin. . . . He can't bless you while you have one falsehood in your soul; his pardoning mercy can't reach you until you open your heart to him, and say, 'I have done this great wickedness; O God, save me, make me pure from sin.' While you cling to one sin and will not part with it, it must drag you down to misery after death, as it has dragged you to misery here in this world, my poor, poor Hetty. It is sin that brings dread, and darkness, and despair: there is light and blessedness for us as soon as we cast it off: God enters our souls then, and teaches us, and brings us strength and peace. Cast it off now, Hetty—now: confess the wickedness you have done—the sin you have been guilty of against your heavenly Father. Let us kneel down together, for we are in the presence of God."

Hetty obeyed Dinah's movement, and sank on her knees. They still held each other's hands, and there was long silence. Then Dinah said,

"Hetty, we are before God: he is waiting for you to tell the truth."

Still there was silence. At last Hetty spoke, in a tone of beseeching,

"Dinah . . . help me . . . I can't feel anything like you . . . my heart is hard."

Dinah held the clinging hand, and all her soul went forth in her voice:

"Jesus, thou present Saviour! Thou hast known the depths of all sorrow: thou hast entered that black darkness where God is not, and hast uttered the cry of the forsaken. Come, Lord, and gather of the fruits of thy travail and thy pleading: stretch forth thy hand, thou who art mighty to save to the uttermost, and rescue this lost one. She is clothed round with thick darkness: the fetters of her sin are upon her, and she cannot stir to come to thee: she can only feel her heart is hard, and she is helpless. She cries to me, thy weak creature . . . Saviour! it is a blind cry to thee. Hear it! Pierce the darkness! Look upon her with thy face of love and sorrow, that thou didst turn on him who denied thee; and melt her hard heart.

"See, Lord,—I bring her, as they of old brought the sick and helpless, and thou didst heal them: I bear her on my arms and carry her before thee. Fear and trembling have taken hold on her; but she

trembles only at the pain and death of the body: breathe upon her thy life-giving Spirit, and put a new fear within her—the fear of her sin. Make her dread to keep the accursed thing within her soul: make her feel the presence of the living God, who beholds all the past, to whom the darkness is as noonday; who is waiting now, at the eleventh hour, for her to turn to him, and confess her sin, and cry for mercy—now, before the night of death comes, and the moment of pardon is for ever fled, like yesterday that returneth not.

"Saviour! it is yet time—time to snatch this poor soul from everlasting darkness. I believe—I believe in thy infinite love. What is *my* love or *my* pleading? It is quenched in thine. I can only clasp her in my weak arms, and urge her with my weak pity. Thou—thou wilt breathe on the dead soul, and it shall arise from the unanswering sleep of death.

"Yea, Lord, I see thee, coming through the darkness, coming, like the morning, with healing on thy wings. The marks of thy agony are upon thee—I see, I see thou art able and willing to save—thou wilt not let her perish for ever.

"Come, mighty Saviour! let the dead hear thy voice; let the eyes of the blind be opened: let her see that God encompasses her; let her tremble at nothing but at the sin that cuts her off from him. Melt the hard heart; unseal the closed lips: make her cry with her whole soul, 'Father, I have sinned.'. . ."

"Dinah," Hetty sobbed out, throwing her arms round Dinah's neck, "I will speak . . . I will tell . . . I won't hide it any more."

❋ ❋ ❋

(Dinah accompanies condemned woman)[114]

It was a sight that some people remembered better even than their own sorrows—the sight in that grey clear morning, when the fatal cart with the two young women in it was described by the waiting watching multitude, cleaving its way towards the hideous symbol of a deliberately inflicted sudden death.

All Stoniton had heard of Dinah Morris, the young Methodist woman who had brought the obstinate criminal to confess, and there was as much eagerness to see her as to see the wretched Hetty.

186

But Dinah was hardly conscious of the multitude. When Hetty had caught sight of the vast crowd in the distance, she had clutched Dinah convulsively.

"Close your eyes, Hetty," Dinah said, "and let us pray without ceasing to God."

And in a low voice, as the cart went slowly along through the midst of the gazing crowd, she poured forth her soul with the wrestling intensity of a last pleading, for the trembling creature that clung to her and clutched her as the only visible sign of love and pity.

Dinah did not know that the crowd was silent, gazing at her with a sort of awe—she did not even know how near they were to the fatal spot, when the cart stopped, and she shrank appalled at a loud shout hideous to her ear, like a vast yell of demons. Hetty's shriek mingled with the sound, and they clasped each other in mutual horror.

But it was not a shout of execration—not a yell of exultant cruelty.

It was a shout of sudden excitement at the appearance of a horseman cleaving the crowd at full gallop. The horse is hot and distressed, but answers to the desperate spurring; the rider looks as if his eyes were glazed by madness, and he saw nothing but what was unseen by others. See, he has something in his hand—he is holding it up as if it were a signal.

The Sheriff knows him: it is Arthur Donnithorne, carrying in his hand a hard-won release from death.

PART FOUR
SELF-IMAGES IN LETTERS

Introduction to Part Four

Letter writing is an art. The major importance of any letter as a historical document is the personal self-revelation it affords. No other form of writing provides a more intimate image of the author than correspondence. Letters, therefore, are sacred, for they expose the most heartfelt emotions stirring within a person's soul. These particular selections give us a better understanding of Methodist life because they provide us with immediate and often striking insight into the human situations and experiences that were part and parcel of the Wesleyan Revival. In these letters we meet the women of early Methodism as known personally to their friends. Whereas it is now impossible for us to visualize the author or the recipient as the correspondents would have done—face to face, as it were—we can at least gather glimpses of life and thought and action related to the Methodist movement at closer range. The following twelve samples from a large, monumental, and essentially untouched collection were selected to illustrate the roles that women played in Wesleyan life, the depth of their commitment to Christ and to one another, and the range of spiritual insight they had to offer to fellow pilgrims in their own time.

During the eighteenth and nineteenth centuries the familiar letter flowered into a literary genre of major importance and popularity.[1] Letters, especially those the reader believed had not been intended for publication, had a particular appeal to the public and religious communities in particular. In addition, the letter genre, with its use of the familiar style, natural structural unity, and aura of authenticity, encompassed the type and variety of conversations the women desired to share.[2] Without question, it was this latter quality—the authenticity of correspondence—that created the greatest appeal, especially for those seeking models of a more authentic experience of life in Christ.[3] But the letters of these women, even the most private and intimate, are more complex than the reader might realize on initial reading. Throughout the course of this period, as feminist literary historians in particular have demonstrated, women were beginning to

develop rhetorical strategies that permitted self-revelation even by means of the tension between self-deprecation and self-assertion.[4] The letters, as is also the case with their other writings, could both reproduce and challenge the predominant male ideologies of the day. The portraits of the women that emerge are, to use Felicity Nussbaum's phrase, "alternative configurations of identity," that both challenge and inspire other women to achieve their fullest potential while confirming the contemporary conventions of womanhood.[5] They reflect on yet another level the liberating ethos of the tradition in which the women stood.

The letters collected here come from both published and manuscript sources. They are organized chronologically. Regardless of sender or circumstance, I have attempted to preserve the original spontaneity and emotive power of each letter. For the most part, therefore, the letters are printed in their entirety. It is important to remember, however, that letters, like people, defy easy categorization. They reflect varying styles and tones. They may be well formed responses to particular questions or letters of introduction—the initiation of a new relationship with someone virtually unknown. Some writers express themselves in lush, extravagant prose, while others use a few sharply worded sentences. Through all these unique characteristics and nuances we can gain a greater understanding not only of the personality of the sender but of the amazing versatility and variety of letters themselves, even with so small a sampling. There is something both captivating and fulfilling about a letter that reveals the author to us, as it were, from beginning to end. Great letters, moreover, like the people who write them, have a rhythm that is uniquely their own. I believe that the letters I have selected for this section represent spiritual friendship at its best—supportive, open, forgiving, thoughtful, and trusting.

It should be no surprise that theological and spiritual concerns are predominant in these letters. Here, we quickly discern the central themes of Wesleyanism afresh; namely, the centrality of grace, the role of faith in a personal relationship with God through Jesus Christ, the goal of holiness of heart and life, the place of the means of grace in the believer's life, and the need of a faith activated by love. It is the everyday world, however, that frames these more lofty concerns. For this reason, there is an intimate connection between the spiritual and the practical, a vision of God's presence and power in the midst of

life.[6] The most impressive aspect of the correspondence is the level of energy committed to accountable discipleship. Whether writing in response to specific questions about spiritual progress or encouraging a friend in the midst of persecution, the portrait of the women that emerges from these letters is one of mutuality and genuine concern for one another in every aspect of life.

The letters attest to a vision of the Christian life characterized by intentionality and perseverance. "Press forward to higher degrees of faith and love," writes Mrs. Lefevre; "Cleave to Jesus," admonishes Elizabeth Ritchie. "The will stands firm for God, and the intention is always single," writes Hester Rogers. Elizabeth Collett explains, "I had only one desire, one prayer, 'Lord, make me holy.' " What enabled these women to maintain their focus—their singleness of intention—was quite simply the support they felt from one another. "You must *too* pray for me, and we must both strive to increase and strengthen each other," enjoins Mrs. Lefevre.

In her response to Miss Hurrell's question about how to make progress in her spiritual life, the elder Mrs. Ray lays out a clear course of action that strikes to the heart of the Wesleyan way. This extremely articulate answer to the question of a tender soul demonstrates a maturity of faith that bears closer scrutiny. She points first to the essential centrality of faith. Next she makes clear that Jesus is our sanctification; there can be no holiness in life apart from Christ. But whatever our fullest possible experience of God is, if it is to have integrity it must be a trilogy of holiness, happiness, and heaven here on earth. The way forward is simply to practice the presence of God day by day. That spiritual discipline will reveal to us how fellowship with God is characterized by friendship more than anything else. Blessed by God in so many ways, the Spirit of Christ enables us to grow in our love of the Giver rather than becoming obsessed with the gifts we have received. She then ends on the high note of God's sovereign grace throughout the course of all our lives and the need, as other women will emphasize frequently, for God to be all in all.

These letters also describe events and experiences drawn from the concrete realities of the women's lives. Jane Cooper recalls her providential escape from temptation. Hannah Ball remembers an important breakthrough in her life while hearing John Wesley preach. Simplicity is the keynote of Sarah Crosby's important letter. Details

concerning the care of her recipient's children figure prominently in the letter of Margaret Davidson, in addition to her reassurance that the whole family remains constantly in the prayers of the people. The whole issue of preaching surfaces time and time again. Accounts of some of the women's preaching tours are here, such as those described by Sarah Crosby, Elizabeth Hurrell, and Mary Taft. The final letter of the collection, that of Sarah Boyce to an unknown correspondent, not only includes a description of her practice as an early Methodist preacher under Wesley's supervision, but also records one of the most famous notes of authorization in the history of the tradition: "We give the right hand of fellowship to Sarah Mallet, and have no objection to her being a preacher in our connection, so long as she preaches the Methodist doctrines, and attends to our discipline." I hope these selections represent a balance of the ordinary and the exceptional, the commonplace and the momentous experiences of early Methodist women. Whatever the case, you are sure to encounter, as Elizabeth Collett writes, "rooms filled with glory" and "hearts overflowing with love."

The first letter of Mrs. Lefevre was actually reprinted by Wesley from a previously published collection of her correspondence. While he also published a collection of *Letters Wrote by Jane Cooper*, his only other publication of this kind, the second selection by her here was originally printed in the *Arminian Magazine*, as is the case with letters three and ten. Most of the other letters are taken directly from published *Memoirs* of early Methodist women, specifically those of Hannah Ball, Elizabeth Ritchie, Margaret Davidson, and Mary Taft, their editors frequently including large blocks of correspondence both to and from the subject. Of special interest is the selection from Sarah Crosby to her potential colleague, Elizabeth Hurrell, which is transcribed here from Crosby's manuscript Letterbook. A number of "spiritual letters" were published as an appendix to Hester Ann Rogers's *Experience*. Her letter to Mrs. Condy is included here from that source. The two remaining items were printed in Zechariah Taft's two-volume *Holy Women*.

This volume concludes with the dying testimony of Mary Langston. It was frequently said of the Methodist people that they knew how to die well. The assumption was, of course, that it took a lifetime of living—truly living—to learn what it meant to die. Despite their unique nuances related to the doctrine of Christian perfection,

both Wesley brothers believed that the gift of perfect love—the goal of all authentic Christian living—was usually deferred until the moment of death. It is no surprise, therefore, to find such deep interest in the *ars moriendi* (art of dying) in these Wesleyan circles. John Wesley was particularly interested in accounts of triumphant death of all sorts.[7] One word characterizes this particular example of a unique genre, the word "glory." It is repeated no fewer than nine times in the few pages which draw these portraits of early Methodist women to its close. In all of these letters and in this account, the emerging portrait of the women's lives is ably summarized in the pithy statement of Hannah Ball: "Give your hands to the world, and your heart to God."

PORTRAITS OF THE CHRISTIAN LIFE

Letter 1

Mrs. Lefevre to Mr. ———

Editor's Introduction

Very little hard biographical data is available concerning Mrs. Lefevre (1723?–1756), a devout woman who was held in high esteem by the Methodist leaders. She appears to have been converted and to have become a Methodist only two or three years prior to her death. Her husband published ninety of her letters, *Letters upon Sacred Subjects, by a person lately deceased*, in London in 1757. Wesley abridged and reprinted the collection under the title *An Extract of Letters by Mrs. L——*, with one of his standard printers, William Pine. Mrs. Lefevre initiated the correspondence between Wesley and Rev. William Dodd on the subject of Christian perfection in February 1756. Charles Wesley's poem on her death (July 6, 1756) speaks of her as "A spotless soul, a sinless saint,/In perfect love renewed." She was also an important early influence on Mary Bosanquet who described her as "the greatest comfort" of her life.[8]

※ ※ ※

January 7, 1754

I return my dearest ——— thanks for his last letter. The satisfaction which it, and the conversation we had together on *Saturday*, gave me is inexpressible. Oh may you, by the assisting grace of God, continue in the happy way you are now in and still press forward to higher degrees of faith and love [cf. Phil. 3:14]. But, my dear, you must not think too highly of me. I am one of the most unworthy objects of the free mercy of God. I stand more, perhaps, in need of your prayers than you of mine. You must *too* pray for me, and we must both strive to increase and strengthen each other. I should be glad to know whether you, last night, notwithstanding the disagreeable manner of the preacher, received any comfort and satisfaction from what he said. I own I did. His words (under all these disadvantages) raised and strengthened *me* in a remarkable manner. I wish it had been the same

with you all, but your expectations were so highly raised by the name of ——— that an angel would hardly have satisfied them. And thus shall we be always disappointed if we look more at man than God. The most famous preacher—let his eloquence, his manner, his doctrine be ever so near perfection—can never make the soul taste the words of salvation unless the Spirit of God accompanies and inforces his preaching. And the same blessed Spirit can make the words of the meanest, the most despicable, the most disagreeable preacher of the gospel, effectual to awaken, to convince, and to comfort.[9] But in order to our reaping these benefits, we must hear with *sincerity* and with *singleness* of intention, not seeking to have our outward ears and eyes delighted, but desiring the *sincere* milk of the word to nourish and strengthen our souls [cf. 1 Pet. 2:2]. Would it not be the highest madness to throw away the *water* of *life* because it was brought to us in an earthen vessel? *Solomon* says, "To the *hungry soul* every bitter thing is *sweet*" [Prov. 27:7]. So to the soul which really *hungers* and *thirsts* after *Christ* and his righteousness [cf. Matt. 5:6], the sound of the *gospel* of *peace* (let the voice which proclaims it be *harsh* or *soft*) will be *sweet indeed*. Oh may you and I, my dear ——— always find it so to us! May that blessed Redeemer in whom we have *peace* be dearer to us than *light*, than *life*, than any thing we can form to our imagination either *here* or *hereafter*! In dangers, in difficulties, in temptations, may we still look to him as our defence, our deliverer, our strength. He is *all* in *all* throughout the oracles of God, both in the *Old* and *New Testament*. May he be *all* in *all* to our *souls*. May we walk by his *light* [cf. Ps. 89:15], conquer by his *strength* [cf. Rom. 8:37], and, in the end be joyful partakers of that everlasting felicity which he has prepared for those that love *him*. This is the constant wish and prayer of

Your affectionate [Mrs. LeFevre]

Letter 2

Jane Cooper to Miss Scott[10]

Editor's Introduction

John Wesley had a very high esteem of the character and writing of Jane Cooper (1738–1762). Born at Higham in Norfolk in 1738, she

died at a young age in November 1762. For other samples of her correspondence, see Wesley's anonymous publication of *Letters Wrote by Jane Cooper: To which is Prefixt, some Account of Her Life and Death* (London: Strahan, 1764). This collection includes twenty-one of her letters, written between August 29, 1757, and September 29, 1762, to at least four correspondents, including Wesley himself. Sarah Crosby copied out a portion of Cooper's diary into her manuscript Letterbook, covering the period between January 9 and March 13, 1762. No details of Miss Scott are known.

※ ※ ※

Dec. 25, 1760

My dear Friend,

Although our acquaintance was short, I trust the occasion of it was lasting. I have found that friendship founded upon the love of Jesus is not to be forgotten by distance of place or length of time. And therefore I take the liberty of enquiring how your soul prospers? As I call you my friend, I have a right to ask. I am persuaded the Lord has a peculiar favour towards you. Does this find you rejoicing in his love, or mourning for his consolations? In either case you will not rest. You will still be saying, "give, give," and that is the language the Lord approves. "Ask, and ye shall receive; yea ask, and your joy shall be full" [cf. John 16:24].

I think you found the book of letters useful to you. As they are not to be bought, I desire you'll accept them. I have one thing to require in return; that is, to lend it to all you can. I shall be glad to hear from you at any opportunity. I bless the Lord for dealing very graciously with me. Out of every temptation he makes a way to escape, and lays no more upon me than his own grace is sufficient for. I retain at most times a sense of his love, and when that is strongest, I am most abased. But I want it to continue and increase. I have opportunities of hearing most of the eminent preachers, but I find Mr. Wesley to be the most useful to me. Pray for me, that I may make a right use of my blessings. The more I hear Mr. Wesley, the more I am enabled to lay all prejudice aside, arising from any particular opinion. And daily [I] find more and more, 'tis not a set of right notions in the head will make a Christian, but the power of Christ experienced in the heart.[11] And this power is freely offered to you

and me. Let us only ask, and we shall have. May the spirit of supplication descend upon you, and give you to pray without ceasing, to rejoice evermore, and in every situation to be thankful [cf. 1 Thess. 5:16-18]. My love to your sister. I hope she persists in seeking Jesus. Tell her the kingdom of heaven suffereth violence, and the violent take it by force [cf. Matt. 11:12]. I wish her to imitate wrestling Jacob,[12] and then she will have the success of prevailing Israel. Only remind her it is by grace she must be saved [cf. Eph. 2:8]. God help her to renounce her own, and submit to the Saviour's righteousness. I am, for his sake,

Your affectionate Friend,
Jane Cooper

Letter 3

Mrs. [Ann] Ray to Miss [Elizabeth] Hurrell[13]

Editor's Introduction

This letter is a response to the inquiry of Elizabeth Hurrell (1740–1798), a noteworthy early Methodist woman preacher and close associate of Sarah Crosby and Mary Bosanquet, who was struggling at this time with questions related to progress along the "spiritual journey."[14] Three of the letters in this section deal with her. In later years, Elizabeth preached with Wesley's approval and sanction. Among those who were led to Christ under her preaching were William Warrener, the first Methodist missionary to the West Indies, and Henry Foster, a prominent itinerant preacher. The author here is not to be confused with the recipient of letter 4, although there may have been a familial tie between them. If only we knew more about this correspondent who reveals herself here to be both erudite and articulate in matters of theology and spiritual direction.

❋ ❋ ❋

Newington, Sept. 2, 1769

My Dear Friend,

By the tenour of your letter it appears to me that the greatest want you suffer at present is that of faith. Else why do you see holiness at

199

such a distance? Faith brings the promises near, realizes the substance of them to the soul, and capacitates it to feed upon the tree of life [cf. Gen. 3:22], and so to live *now* and *for ever*. It seems, also, that you have not sufficiently studied or been enlightened in the doctrine which Mr. Gilbert so sweetly enforces in his *Treatise of Christian Perfection;*[15] viz. that Jesus *himself* is our sanctification as well as our righteousness and, in truth, our *all;* that in proportion as we are united to him by faith, in the same measure we partake of his divine nature; that we cannot have the *least* degree of holiness, any more than the *greatest, from Christ,* but *with* him. "*With himself* he freely gives us all things" [cf. Rom. 8:32]—holiness, happiness, heaven.[16] All good things come with him and are his inseparable attendants, but none are separate from him. His intense love to our souls and, if I may so speak, his desire of complacency and union with us will not suffer him to let us be happy without the enjoyment of himself. He knows, indeed, that we cannot. Happiness cannot be found out of him even in his gifts either of nature or of grace. All falls short of the supreme good *itself;* and when the soul is truly tinctured with an esteem for, and love to, its great Original, its invariable language in the possession of all is, "*This is not my God.*" But I believe that, in general, we are a good while in the ways of religion before we know that *himself* is all we want to make us happy and holy and that he alone is our centre and place of rest. This is owing to the blindness of our understanding and our extreme distance from God in a state of nature.[17] This ignorance of our want of *him* to make us happy and the esteem we have of all his gifts rather than of *himself* discover a depth in the Fall which is inexpressible. I have long laboured in this labyrinth, and therefore I speak of what I do know and testify what I have seen and felt. And now, I can only answer my friend's important query, "How she shall make the swiftest progress in the heavenly road," by touching on my own experience in the above-mentioned lessons in which Jesus hath graciously instructed me.

You want holiness because you want God. You cannot apprehend him, you cannot possess him *here* but by faith. He is the eternal fulness that filleth heaven and earth [cf. Jer. 23:24], that surrounds you, that is in you by his Spirit. He tells you that he is the salvation of his people; that his presence is salvation; that the word of faith is *nigh* you, in your mouth, and in your heart [cf. Rom. 10:8]. You already know him as your reconciled God in Christ, your Friend and Saviour.

This word of faith *consequently* belongs *to you*, as it does to all believers, in a peculiar manner. Endeavour, therefore, with the utmost simplicity of faith, to advert to his presence in you, around you, wherever you are, at every time and place.[18] *Believe* him in you, near you. He is, you know, "bone of your bone, and flesh of your flesh" [cf. Judg. 9:2]; yea, nearer than that by far, for "he that is joined to the Lord, is one *spirit* with him" [cf. 1 Cor. 6:17]. Think of his immediate presence as often as you can. Speak to him in the simplest manner possible as frequently as you can. Tell him all you want, all you can do, or cannot do; but, tell it as to a *present God*, a *present* Friend who is able and willing to help you. Do not behold him afar off, in heaven, only. He is here upon earth, or rather earth and all things are in him. As Dr. [Edward] Young says,

> Praise I a distant Deity? He tunes
> My voice; (if tuned;) the nerve that writes sustains;
> Wrapp'd in his being, I resound his praise.[19]

Faith makes every place a *Bethel*; and you need not fear missing of holiness if you seek it by the practice of faith. For as Jesus is the spring and fountain of all purity, he will lead you by his life-inspiring presence to that perfect love of himself that shall cast out of your soul all fear [cf. 1 John 4:18]. By his loving presence, he will save you from the hand of all your enemies [cf. Ps. 138:7], and your heart, by this means, will be more endeared to his *person* than to his *gifts*. You will prize the Giver far beyond the gifts.

Study the scriptures much. Study them as being what they really are, a transcript of the divine majesty. There is matter for the various and continual exercises of faith delivered by Jehovah himself. Observe his loving commands for this end. "Doth God take care of oxen" [1 Cor. 9:9]? "Are not two sparrows sold for a farthing, and not one of them falls to the ground without" [Matt. 10:29] his knowledge? Does he that "toucheth his little ones, touch the apple of his eye" [cf. Zech. 2:8]? Do the guardian angels of such little ones, while they attend the feeble believer at the same time, "behold the face of God" [cf. Matt. 18:10]? How nearly, then, are heaven and earth connected! And does the Lord thus reign, and does he govern the world? Does he order all things in number, weight, and measure to each individual? Can no crosses, trials, or temptations happen to his people but by his order? If this is thor-

oughly *believed*, then we shall no longer repine at the contradictions of others, or blame them, but quietly yield and submit our will to the will of our heavenly Father. Thus his sovereignty will take place in us and over us, and we shall live in the experimental knowledge of our Saviour's kingly, as well as of his prophetic and priestly office.[20]

I could add much more on this delightful subject; but my paper will not permit. If your heart do not rise against this *simplicity* of faith, I should wonder; for mine has done so, many and many a time. I would rather have been *something to Jesus*, than have *him become thus all in all to me*.

I shall be pleased to hear from you whenever it is on your mind to write and am yours in Him,

Ann Ray.

Letter 4

Hannah Ball to Miss Ray[21]

Editor's Introduction

Hannah Ball (1733–1792) was one of the most industrious of the early Methodist women and a favored correspondent of Wesley. Converted in 1765, she became one of the leading figures in the Society of High Wycombe, near Oxford, and is most well remembered for her establishment of a Sunday school in that town in 1769, nearly fourteen years before Robert Raikes began his experimental schools in Gloucester and was later heralded (improperly) the founder of that movement. While it has been claimed that Hannah was the originator of Sunday schools, another woman, Catherine Warren of Haverfordwest, may have been the first to explore this new area of ministry to children. Hannah's practice was to meet with the children on Sundays and Mondays, "instructing a few of the rising generation in the principles of religion." This letter, evangelistic and self-revelatory in tone, is apparently the first piece of correspondence exchanged between Ball and an affluent friend.

September 29, 1769

My Dear Friend,

I feel honoured in the favour of your acquaintance. May the blessing of the Lord accompany these few lines. I rejoice to hear that you have found redemption in the blood of Jesus, and hope you can say, from heartfelt experience, "Jesus is mine, and I am His;" that He has pardoned all your sins, having the witness in yourself that you are born of God, that you are a child of God, and heir of the kingdom. If, however, this is not your experience, be not discouraged. Seek, and you shall assuredly find that faith which is the gift of God [cf. Eph. 2:8]. Do not be cast down for want of Christian friends. The Lord will find you friends, or be more than friends to you. He hears your every sigh, and every silent wish reaches Him, for He is a God of love and tender compassion who draws us with the sweet attractions of His Holy Spirit that we may run after Him. Dare you, my dear friend, forsake all and follow Christ, to be counted the off-scouring of all things for His sake who died for you? If so, I congratulate you on your noble resolution. O, to be a child of God and heir of eternal glory! But we must remember we cannot serve two masters [cf. Matt. 6:24]. If we serve God, we must forsake the world, its fashions, customs, and vanities, which I trust the Lord will enable you to do. After being convinced I was out of the way, it was more than two years before I made any one acquainted with my troubles, still living the ways of the world, striving to be inwardly religious and not letting any one know it. Sinning and repenting, making resolutions and breaking them. But I have been since brought to see that these resolutions were made in my own strength and that I had no strength but what I received from God.[22] At length, when almost driven to despair, my proud heart submitted to go and hear Mr. Wesley preach. His text was, "O woman, great is thy faith, be it unto thee even as thou wilt."[23] After hearing this sermon, I was under very strong convictions for five months, and then I found peace to my troubled soul.

I am your affectionate friend,
H[annah]. Ball

Letter 5

Sarah Crosby to Betsy Hurrell

Editor's Introduction

In this very significant letter to her friend and aspiring woman preacher, Elizabeth Hurrell, Sarah Crosby describes the essential interrelationship between her religious experience and her call to preach. The text is taken from Sarah's transcript in Crosby's manuscript Letterbook, 69-71.[24] Sarah Crosby had moved to Cross Hall, near Leeds, with Mary Bosanquet, Sarah Ryan, and Ann Tripp, to reestablish their community for destitute children in 1768. This farmhouse where they eventually settled soon became a vital center of Methodist worship and witness in the area.

❋ ❋ ❋

Cross Hall, July 2, 1774

I hope my dear friend will be glad to hear that our Lord continues to pour out His Spirit amongst us. . . . And what is astonishing even to ourselves is, that our Lord is doing this great work by the most *simple* means. Many are thirsting for full salvation in L[eeds?] and various other places. We have had some sweet meetings, and my Jesus often says, "Behold a [proof?] cometh."

As for myself my dear, I know not what to say, but that the immeasurable comfort swells my own transported breast! For He reneweth my strength as the eagle [cf. Isa. 40:31]. I live in a holy astonishment before my God, while He fills my soul with divine power and the *simplicity* of a little child, and never was so continually filled, yea overflowed, with love before. . . . I hearkened *too much* to the voice which said, hold thy peace, keep thy happiness to thyself. (Though not enough to please them neither.) But He now forbids me to hide the light He gives under a bushel [cf. Matt. 5:15-16]. And the more simply I witness for God, the more does He witness in my heart, and others too. Glory be to His dear name forever. "O let my mouth be fill'd with thy praise, while, all the day long I publish thy grace, &cc."

[Sarah Crosby]

204

Letter 6

Elizabeth Ritchie to John Wesley[25]

Editor's Introduction

Elizabeth Ritchie (Mortimer) (1754–1835), who hosted John Wesley on his many visits to her native Otley, faithfully attended him on his deathbed in 1791. This single item comes from a lengthy correspondence with her spiritual mentor that extended from 1774 to 1788. Contrary to his rule of writing only in reply to letters he received, he sent her many letters of spiritual advice. In response to this letter, he wrote in part: "My Dear Betsy, It gives me much pleasure to find that you stand fast in the liberty wherewith Christ hath made you free. Trials you will have; but they will only be means of uniting you to Him more closely. While your eye is singly fixed on Him your whole body will be full of light."[26]

Otley, July 19th, 1774

Rev. Sir,

How infinite is the Saviour's love! I am lost in wonder![27] What has He suffered for me! and yet how little do I love Him! How little am I capable of loving Him! O that my heart may be enlarged and filled with God! But I stand by faith [cf. 2 Cor. 1:24], and while I am looking unto Jesus, nothing can harm me. My short-comings and many weaknesses you are not unacquainted with, but blessed be God for that blood which cleanseth from all sin [cf. 1 John 1:7]!

I had a blessed time while at Miss Bosanquet's[28] and had intended staying longer, but on Sunday I was fetched away, my mother being but poorly. I have abundant cause to be thankful for this dispensation. Some time ago it would have tried me much, but love makes all things easy. I feel that Jesus enables me to sit calm on tumult's wheel. Since I came home, I have at times been in the fire, but this cannot

harm while God is near [cf. Daniel 3]. It cannot hurt the soul that cleaves to Jesus.

May the Lord abundantly bless you, dear Sir, and may every purchased and promised blessing be yours for ever. So prays

Your unworthy daughter,
E[lizabeth]. Ritchie

Letter 7

Margaret Davidson to [Mrs. Agnes Smyth?][29]

Editor's Introduction

For an introduction to Margaret Davidson's life and work, see part 3, selection 1. Margaret writes this strong letter of encouragement and support to those who had first supported her preaching in Ireland.

❋ ❋ ❋

Strangford, January 8th, 1777

Dear Madam,

Were it not in compliance with your humble request, I think I would not give you the trouble to release such an insignificant letter as you are likely to receive from me. Alas! I am barren of invention and have hardly any recollection to dictate a line to a friend since my late severe illness from which I am but just beginning to recover and that only since I came to *Strangford*. But sure I am, I want words to express my unfeigned gratitude to that gracious God who disposed your heart, my ever dear benefactor, to send for me in such a time of need. My ardent soul cleaves close to your nobler spirit, infolding it fast in its most eager embrace. Hail, you highly-favoured of the Lord! Blessed are you among women [cf. Luke 1:28], and that in a peculiar manner, being called to suffer reproaches and persecutions, yea, may I not say, *the loss of all things* [Phil. 3:8] for the sake of that lovely Jesus who freely laid down his life for you [cf. 1 John 3:16] and manifested the power of his first resurrection in your heart.

O my dearly beloved in the Lord Jesus, faint not, but continue to rejoice in tribulation. Endeavour to strengthen your much-valued head and dearest partner in the kingdom and patience of Jesus.[30] O may his face be set as a flint against all the opposition of a frowning world, and save him, O Lord, from the pernicious smiles thereof [cf. Isa. 50:7]. Grant them both armour to fortify themselves against *the fiery darts* of the Wicked-one [cf. Eph. 6:16]!

Oh that I could say any thing that might prove the smallest blessing to a beloved and persecuted Sister of my dear Lord Jesus! O my love, what a glory is it to be set at nought and despised, yea, even cast out of the synagogue for being the witness of Jesus in this degenerate age—for preaching salvation by faith—the forgiveness of sins through the blood of the Crucified [cf. Col. 1:14]! But oh! how awfully fulfilled are the words of an inspired Apostle concerning those unhappy wretches who are wise in their own eyes and too prudent in their own sight to be saved by the foolishness *of* high-way *preaching.*[31] No, they spurn *the cross of Christ,* and through their obstinate pride and accursed unbelief, it becomes to them a stumbling block; and, instead of falling upon the *Corner-stone* in order that their obdurate hearts might be broken for sin, they make it to themselves a *rock of offence* [Isa. 8:14]. And (oh dreadful threatening!) it shall at last fall upon them and *grind them to* eternal *powder* [cf. Luke 20:18]. But surely, *it shall be well with the righteous* [Eccles. 8:12], for the Lord hath promised to deliver him out of all his troubles. Amen. So be it, Lord Jesus! Redeem thy Servant and Handmaid from all evil! Pluck them *from the teeth of the lion and from the paw of the bear* [cf. 1 Sam. 17:37]. O Lord, let them never be ashamed to confess thee before kings and rulers if called by thy Providence to the same. Neither let them be afraid of vain man *who can only kill the body* [cf. Matt. 10:28], and when he has expended the blast of his fury, it proves but a kindly tempest to hasten the happy souls of the saints the sooner to glory.

I rejoice, my beloved, to think that you go on through evil and good report, following the contemned *Nazarene,* giving the right-hand of fellowship as well to a *Lazarus* in rags [cf. Luke 16:20-25] as to a *Solomon* in glittering robes [cf. Matt. 6:29]. May the Lord God Almighty *stablish, strengthen, and settle you* [1 Pet. 5:10], and after being made perfect in love and in suffering, oh may he translate you to behold the shining face of your suffering Saviour, who gives you

now to partake of the cup of his sorrow but mingles it with love and sweetens it with the joyful prospect of reigning with him for ever.

> Then shall you bathe your weary soul
> In seas of heav'nly rest,
> And not a wave of trouble roll
> Across your peaceful breast.[32]

O thou dear, dear lover of my Lord, my heart bleeds with sorrow yet leaps for joy concerning your painful but profitable trials. It cannot be wrote what I feel for you, but I trust shortly to be favoured with hearing you speak of the loving-kindness of the Lord to your soul. Then I think I shall truly unbosom myself to you, which, perhaps, would not be expedient now to do.

O Madam, it cannot be told how greatly I have longed and do long for Mr. S[myth] and you, expecting to be strengthened by your prayers and animated by your Christian example. You have the prayers of many of the faithful and also those of your Class, who cease not to pray for your speedy and safe return to them. I trust they are pressing after holiness and heaven. They are contented to join with me in prayer every morning and evening, and many strangers come together with us so that your kitchen is often full. And (glory be to God!) I know my unworthy soul has been refreshed in meeting with them, though I groan under a sense of my unprofitableness and proneness to wander from the God whom I fain would love with an undivided heart.

> Lord, when shall all my wand'ring end,
> And all my steps to thee-ward tend?[33]

Dear Madam, the Child *Samuel* appears to thrive well. I think he is already beginning to learn the language of heaven, for it is but a few moments since I heard him say, "Hallelujah." As this is his first, oh may it be his last triumphant note of praise! I also think that *Nancy* is very careful of the Child. She is observant to keep him clean, not neglecting his food and sleep in due season. She is careful of, and tender-hearted to me in my weak state. I can bless God above all that I can find comfort in her religious conversation. Oh that she and I may have the love-stamp impressed upon our

hearts so that nothing shall ever erase it. I pray God that our Religion may not be *like the morning cloud or early dew that passeth away* [cf. Hos. 13:3].

I am yours, dear Madam,
In the closest of bonds,
Margaret Davidson

Letter 8

Elizabeth Hurrel[l] to Sarah Crosby[34]

Derby, May 18, 1779

My dear Friend,

Your favours are generally the answer to prayer and very acceptable. I have not forgot former times and, therefore, feel a great attachment to my good, old, tried friend. And while Christianity has any seat in my heart, Mrs. Crosby will be deservedly dear to me. I rejoice to hear that the Lord your keeper stands omnipotently near. I trust He will ever give you to feel in all the changes of this fluctuating scene, beneath and around you, are spread the everlasting arms [cf. Deut. 33:27]. I hope you have found a good time at Scarborough and that you are much blest to the Whitby friends, to whom present my love.

At length my dear, the snail hath left its shell, and here I arrived with God's blessing on Saturday week, where I have *full employ*,[35] and here I believe it is the Lord's will I should be for a season but rest now satisfied, and wait the Lord's direction.

If nothing prevent, I intend going from hence to *Sheffield, Doncaster, York*, and stop a little at *Pocklington, Beverley, Driffeld*, and from thence to *Scarborough*, and then where the Lord pleases to appoint.[36] I wait His guiding eye to feel. If you think any of my London friends has been whispering in my ear to stay among them, I must fully acquit them. I have many there who are truly concerned for my welfare, yet they do advise me to go and be and do as the Lord points out. Here I am, and earnestly desire to be and do what, and as, God pleases. All I ask is that I may not disgrace the Gospel or cause the

good way to be evil spoken of. Mrs. Dobinson[37] joins in love to you. Pray for me,

Your affectionate friend,
Eliza. Hurrel[l]

Letter 9

Hester Ann Rogers to Mrs. Condy

Editor's Introduction

Hester Ann Rogers (1756–1794) was one of the most influential early Methodist women on both sides of the Atlantic Ocean, noted in particular for her life of holiness. Despite family opposition, "Hetty" Roe joined the Methodist Society in her native Macclesfield in 1774. She served there as a devoted class leader until her marriage in 1784 to one of Wesley's traveling preachers, James Rogers. Much of their itinerant life was spent in Ireland, where she was a prominent influence in the "Dublin Revival." After their move to Cork, Wesley wrote to her expressing his hope that they would "see a revival in Cork also" and admonishing her to "take particular care of the tender lambs."[38] James Rogers was stationed in London during the final years of Wesley's life, and both were present to witness his death in 1791.

Hester kept a journal from the time she became a Methodist, contributed significantly to the *Arminian Magazine*, wrote some verse, and engaged in extensive correspondence about religious matters. Many editions of her letters have been published. The first edition, from which this selection (Letter 27) is taken, *Spiritual Letters by Mrs. Hester Ann Rogers*, was printed in Bristol by R. Edwards in 1796. Other letters were subsequently added to the original twenty-nine of this collection. Extracts from her journal and autobiography (previously published in 1793 as her *Experience*); her funeral sermon, preached by Thomas Coke in 1794 and printed the following year; and the expanded collection of her letters were combined and gained considerable circulation under the title *The Experience and Spiritual Letters of Mrs. Hester Ann Rogers*.[39]

210

In this letter to Mrs. Condy, written from Ireland not long after James Rogers's appointment to Cork, Hester articulates her understanding of Christian perfection in the Wesleyan tradition. Little is known of the recipient other than she was the wife of Richard Condy, one of Wesley's itinerant preachers in Ireland.[40] He entered the ministry in 1776 and later served as the first master of a free school for boys. As is the case with many wives from this period, she remains elusive.

✳ ✳ ✳

Cork, Oct. 11, 1789

My Dear Friend and Sister,

I believe you are well able to answer your own questions. However, as you desire it, I will freely tell you my thoughts on what *we* call Christian perfection. We do not mean, hereby, the perfection of God, of angels, of disembodied spirits, or of Adam while innocent. But we mean that perfection of which *our* natures are capable through the grace of our Lord Jesus Christ, the second Adam [cf. 1 Cor. 15:45]. We are under the law to Christ; viz., the law of love—the law of liberty; or, in other words, the covenant of grace. Whosoever loveth the Lord his God with all his heart, and mind, and soul, and strength, and his neighbour as himself, fulfilleth this law [cf. Matt. 22:37]. The lowest degree of this salvation is to have all contrarieties to this love cast out of the soul.[41] We may be said thus to love him with a *pure heart* when proud *self* and great *I* are slain, and we feel only humility; when anger, fretfulness, and impatience, are no more, but we ever feel a meek and quiet spirit; when *I will* and *I will not* is all brought into subjection to the will of our heavenly Father, and our will is that *he* should reign over us;[42] when he really does regulate and govern our passions, affections, and desires inordinate desires and inordinate creature love being no more; and, lastly, unbelief (and consequently all tormenting fear and painful anxiety) is wholly cast out. But, after all this, it remains that we go forward, that we grow in grace [cf. 2 Pet. 3:18], till we be not only emptied of sin but filled with all the fulness of God [cf. Eph. 3:19].[43]

The moment any soul is justified, it is free from the power and dominion of outward and of inward sin and may hold fast that

blessed freedom to the end [cf. Gal. 5:1]. But, supposing a person does this, such a one will feel a mixture of evil propensities, tempers, affections, and desires, which defilement is so rooted in our nature that none but *Jehovah Jesus* can cast out "the strong man armed, and spoil all his armour wherein he trusted" [cf. Luke 11:21-22]. It is true, we may mortify, resist, and keep *under* those evils, but Jesus alone can pluck up and destroy every plant and root which his Father planted not. We may gradually grow in grace and holiness and hereby increase in victoriously subjecting the enemy within, but Jesus alone can *slay* the man of sin.

All salvation, too, is by faith alone, as the instrument. If, then, we must be saved by faith, it is in a moment, and the *present* moment, if not our own fault. For, what wait we for, who are the children and heirs of God, and therefore heirs of the promises, which are all to us, "yea and amen in Christ Jesus" [cf. 2 Cor. 1:20]? If we wait for more worthiness—to suffer more, to do more, to be more *fit*—then we are seeking to be sanctified by these things; viz., by works. But if we believe we can only obtain the blessing by grace through faith, and this salvation is the free gift of God [Eph. 2:8], then let us be consistent with ourselves. Let us expect it by faith; expect it in a moment; and expect it *now*, which are one and the same thing and are inseparable.[44] To be dying and to be dead indeed unto sin [cf. Rom. 6:11] are two things. Be not *you*, my sister, content with the former. "A man may be dying for some time," says Mr. Wesley, "yet, properly speaking, he does not die till the moment the soul is separated from his body, and in that instant he begins to live the life of eternity. In like manner, a man may be dying unto sin for some time, yet he is not 'dead indeed unto sin' [Rom. 6:11] till sin be separated from the soul, and in that instant, he begins to live the life of *pure love*."[45] O be you "dead indeed unto sin, and alive unto God, through Jesus Christ your Lord" [Rom. 6:11].

It is the blood of Jesus alone cleanseth from all sin [cf. 1 John 1:7]—not penal sufferings, not mortifications of any kind, not any thing *we have*, not grace already received, not any thing *we are* or *can be* nor death, nor purgatory, no, not the purgatory of all our doings, and sufferings, and strivings put together—no, no, Christ is the procuring, meritorious cause of all our salvation. He alone forgiveth sins [cf. Mark 2:7], and he alone cleanseth from all unrighteousness [cf. 1 John 1:9]. Faith is the only condition, and it shares in the Omnipotence it

dares to trust. *"All things are now ready"* [Luke 14:17] is the gospel message, and Jesus saveth all them to the uttermost that come unto God by him. "I will, be thou clean" [Matt. 8:3], is his language to every seeking leprous soul!—to you if not already cleansed.

Joy in the Holy Ghost is a blessed fruit of this salvation, but divine joy is not always rapturous. We may be sorrowful yet always rejoicing [cf. 2 Cor. 6:10]. And there is suffering love as well as exulting love. A person saved as above may experience a degree of heaviness or dulness for a season through bodily infirmities, close trials, or sundry temptations; but such a one cannot walk in darkness [1 John 1:6-7]. Likewise, many mistakes are consistent with this state,[46] I mean errors in judgment and failures in memory, yet the will stands firm for God, and the intention is always single. Involuntary sins, (as some call them,) or sins of ignorance (except the ignorance be wilful), are not breaches of the law of love.[47] For these things we have an Advocate with the Father, Jesus Christ the righteous, who is our propitiation [cf. 1 John 2:1-2] and washes our holiest duties in his own blood, to whom we will ever give honour and glory [cf. Rev. 5:13]. I am, my dear sister, yours in the bonds of pure love,

H[ester]. A[nn]. Rogers

Letter 10

E[lizabeth] C[ollett] to Mr. B[enjamin] Rhodes[48]

Editor's Introduction

Elizabeth Tonkin (1762–1825) was one of the most remarkable figures of Cornish Methodism.[49] After joining the Wesleyan Society of her native Gwinear, she came under the influence of the first Cornish woman preacher, Ann Gilbert, was pressed into preaching herself in 1782, and was involved in a regularized ministry under the superintendency of Joseph Taylor. She married a Mr. Collett in 1785, was the mother of eleven children, and preached in Roseland and Veryan for some years before resettlement in St. Erme where she preached her final sermon in 1804 in a chapel built by her husband.

Rhodes (1743–1815), the recipient, a noted preacher and hymn-writer, entered the Methodist ministry in 1766. His prominence in the

movement was acknowledged by his appointment as one of the Legal Hundred in Wesley's 1784 Deed of Declaration.

❊ ❊ ❊

Feb. 5, 1792

Dear Sir,

A day or two after you left my house, I was encouraged once more to set out again in the pursuit of holiness. My soul pressed hard to attain it. The inward flame was kindled, which I have found in seeking it for some years; except for a few months last part, in which I was ready to faint, and began to doubt of ever being cleansed from all sin. But a few words which you spoke concerning holiness revived me again; and gave me encouragement to believe that the Lord would hear my cry, and give me the desire of my heart. On the first of this month, in the evening, I shut myself up in my chamber. My soul was full of strong desire and vehement pantings after the whole image of God. All within me sunk at the feet of Jesus. I felt nothing, but what bowed to him. I had only one desire, one prayer. *"Lord make me holy."* My heart was fixed upon it, and upon *him* who alone could give it. Not upon ease, peace, joy, happiness. No; nor upon heaven! But that I might love God with all the powers of my soul [cf. Matt. 22:37]. At the same time I was stripped of all merit, and O! what a divine consolation I felt in this unfeigned poverty, having nothing to bring; and that if even I should be cleansed from all sin, and made holy, it would be entirely for the sake of Him, after whom my soul panted [cf. Ps. 42:1]. The patience, resignation, and self-abasement I felt at the same time, cannot be described.

While I was thus wrestling in mighty prayer, the Lord answered for himself. The room seemed filled with his glory, and my heart overflowed with his love. Never did I feel the like before. At the same time, it seemed, as if the Lord spoke to me and said, "From all thy idols will I cleanse thee. A new heart will I give thee [cf. Ezek. 36:25-26]. And thou shalt love the Lord thy God with all thy heart, with all thy mind, with all thy soul, and with all thy strength" [Mark 12:30]. His cheering presence, and the light of his countenance have shone bright upon me ever since. Nor has one cloud interposed. It now appears natural to me to watch in all things, that no idle, or unnecessary word may proceed out of my mouth. Yet I fear to affirm that the Lord hath given me a "Clean heart," lest I should lose

214

what I now enjoy. Although I have felt no evil arise since that time, but such a perpetual sense of the love of God as cannot be expressed, and I am so carried out with desire for the welfare and salvation of others, that the flame is almost, at times, too powerful for nature.

A few days ago, while I was in my closet, I had such views of Jesus, and was so filled with his love, that my powers seemed too scanty to contain it, and yet sweetly longing to love him more! I saw *his* worthiness so infinitely great, that it appeared to me, if my heart was as large as the whole world, and all its expanded powers filled with love to him, that it all seemed as no more than a drop to the ocean, or even as nothing, compared to the debt of love I owed to my Lord. I often groan under the burden I feel for the unconverted. My desires, my prayers on their behalf, can only be known to God. And what I feel daily for the cause of God, and his people, will not be made known on this side the world of Spirits.

I daily long to be dissolved, and to be with Christ, that I may behold his glory. Yet my soul calmly waits in pleasing hope, and perfect resignation [cf. Ps. 130:5-6]. The continual language of my heart is "Thy will be done" [Matt. 6:10]. I am much drawn out in prayer for the preachers, that they may be of one heart and one mind, still devoted to God and his cause, until the whole world be filled with his glory! And I trust that you, dear Sir, will continue a faithful follower of the Lord. Your word has often been truly profitable to me. And I am doubly bound to pray that the Lord may daily multiply blessings on you. Your reproof and instructions, will ever be esteemed as a peculiar favour by your affectionate Servant,

E[lizabeth] C[ollett]

Letter 11

Mary Taft to Zechariah Taft[50]

Editor's Introduction

What follows is a letter from Mary Taft to her new husband. See her autobiographical account in part 3 for a discussion of the circumstances surrounding their situation in Kent.

※　※　※

215

Margate, October 16, 1802

My Dear Mr. Taft,

I hope you got well and safe to Dover. God bless—be with—and every moment cause his face to shine upon you [cf. Num. 6:25]. We returned with Mr. R[ogers?] and Mr. Brewer, from Margate.[51] I was glad to see my dear, good old Lancashire friend. At Sandwich, the chapel was well filled;[52] there were more than could sit down. The Lord was truly present. Many tears were shed. I spoke from 2 Cor. v. 11. My own soul seldom felt more. I was surprised when coming down from the pulpit, a gentlemanly person was speaking to Mr. R[ogers?], and I could just hear him blessing God for sending me into this country. Mr. R[ogers?] looked amazed and confounded. The gentleman then turned to me, and said, "I have come from Canterbury, on purpose to hear you again." And he did this with all the affection of a Yorkshire Methodist. Praise the Lord, my dear, that ever we were at Canterbury! He followed us to Mr. B[rewer]'s, and informed me, that his dear wife had got much good with us. Before he left us, I found that he was a *Baptist* minister, at Canterbury. He prayed with us, and said, "*I was with several ministers last Thursday, when you and your's were much prayed for.*" O, my dear, what kindness from entire strangers, and persons too, of another persuasion! But the Lord is the same, and those who have much of his Spirit, it may easily be known and felt. I heard Mr. Sykes[53] last night, from "*No weapon that is formed against thee shall prosper*" [Isa. 54:17]. The Lord has given me that promise, over and over. We have breakfasted with one local preacher, and we are going to dine with another, Mr. Pyke (I think) they call him. He and his wife were here last evening, and seemed very friendly. Many enquire after you. Lord help me, and teach me what to do and say, that may be most for his glory. The Lord is good and precious, and keeps my soul in perfect peace. I long to see you, my dear, best friend, whom I *most* love in all this world. Be mindful of yourself, for my sake. Mr. Sykes, and Mr. Brewer's love.

I am your's,
Mary Taft.

Letter 12

Sarah Boyce to ———

Editor's Introduction

One of the most celebrated of the female preachers, Sarah Mallet (b. 1764), is noteworthy because of the formal authorization she received from Wesley and the Manchester Conference of 1787. Born on February 18, 1764, in Norfolk, she received her first Methodist ticket in 1780. She experienced a call to preach in 1785 against which she resisted vehemently only to succumb in 1786 by preaching in her uncle's house and the Methodist chapel in Long Stratton. Unfortunately, very little is known about her life and work subsequent to her marriage to a local preacher by the name of Boyce, in spite of the fact that she was included with him in the preachers' plan for many years. She carried on a lengthy correspondence with Wesley, but whereas a number of his letters to her have survived, apparently none of hers remains extant.

Zechariah Taft possessed a number of important manuscripts related to her, some of which he published in *Holy Women*, from which the following excerpt comes (1:83-85). This document, in fact, is one of the most important and fascinating pieces of evidence related to the ministry of women in the Methodist tradition. There is no other document of its nature for any woman well into the twentieth century when "preaching licenses" were first issued to women as formal authorization of their preaching ministry.

Taft simply identifies this larger document, which contains the authorization as a "manuscript containing the experience of Mrs. Boyce." The content and style seem to indicate an epistolary document rather than diary or journal materials, so this undated item will close this section on the correspondence of early Methodist women.[54]

❋ ❋ ❋

But the more deeply was it impressed on my mind *"Woe is me if I preach not the gospel"* [1 Cor. 9:16]. Till my distress of soul almost destroyed my body. In my twentieth year the Lord answered my

217

prayer in a great affliction and made known to others as well as to myself the work he would have me to do and fitted me in the furnace for his use. From that time I began my public work. Mr. Wesley was to me a father and a faithful friend.[55] The same Lord that opened my mouth, and endued me with power [cf. Luke 24:49], and gave me courage to speak his word has through his grace enabled me to continue to the present day. Neither earth nor hell has been able to stop my mouth. The Lord has been, and is now, the comfort and support of my soul in all trials. I have not, nor do I seek, either ease, or wealth, or honour but God's glory and the good of souls. And thank God I have not run in vain, nor laboured in vain [cf. Phil. 2:16]. There are some witnesses in heaven, and some on earth [cf. Deut. 4:26].

When I first travelled I followed Mr. Wesley's counsel, which was to let the voice of the people be to me the voice of God and where I was sent for, to go, for the Lord had called me thither. To this counsel I have attended to this day. But the voice of the people was not the voice of some preachers. But Mr. Wesley soon made this easy by sending me a note from the Conference, by Mr. Joseph Harper,[56] who was that year appointed for Norwich. The note was as follows: "*We give the right hand of fellowship to Sarah Mallet, and have no objection to her being a preacher in our connection, so long as she preaches the Methodist doctrines, and attends to our discipline.*"[57] This was by the order of Mr. Wesley and the Conference of 1787 (Manchester). From that day to this I have been but little opposed by preachers. The greatest part of my labors have been in *Norfolk* and *Suffolk*. My way of preaching from the first is to take a text and divide it and speak from the different heads.[58] For many years when we had but few Chapels in this Country, I preached in the open air and in barns and in wagons. After I was married I was with my husband in the preachers plan for many years. He was a Local Preacher thirty-two years and finished his work and his life well.

I am glad some of our preachers see it right to encourage female preaching. I hope they will all, both Local and Travelling Preachers, think more on these words, "*quench not the Spirit*" [1 Thess. 5:19] neither in themselves nor others. "*Despise not prophesyings*" [1 Thess. 5:20], no, not out of the mouth of a child [cf. Ps. 8:2], then would they be more like Mr. Wesley, and I think more like Christ.

<div align="right">Sarah [Mallet] Boyce</div>

MARY LANGSTON'S *DYING TESTIMONY*

Editor's Introduction

Born in 1749, Mary Langston was awakened by Methodist preaching at fourteen years of age and proved herself to be extremely diligent in using the means of grace and meeting in class. She contracted small-pox and died in her twentieth year. While her life as a Methodist was short, her victorious death struck Wesley as so exemplary that he anonymously published *A Short Account of the Death of Mary Langs[t]on* from which the following extract is drawn.[59]

✳ ✳ ✳

I find my heart loose from every creature, and all created good, and wholly fixed on God. This is the desire of my soul,

> O that I might walk with God,
> Jesus, my companion be;
> Lead me to the blest abode,
> Through the fire, and thro' the sea:
> Then I shall no more complain,
> Never at my lot repine,
> Welcome toil, or grief, or pain,
> All is well, if Christ's mine.[60]

Glory is every moment open to my soul. There is nothing between me and eternal glory, but a few moments more of light affliction. Dear father, you have had many trials and difficulties in the world, and you have many more before you; but fear not, you are in the *way*, the *right* way. Continue in it and God will bring you thro' all.

O lovely Jesus! Blessed Jesus! Adorable Jesus! Glory! Glory! Glory! Glory! To God in the highest! On earth peace; good-will towards men [cf. Luke 2:14]. O how willing is Christ to save all that come to him! ... Surely he desireth not the death of a sinner, and therefore hath given his well-beloved Son, *that* whosoever *believeth on him should not perish* [John 3:16], though it is certain, that those who believe not,

219

shall be eternally miserable. . . . A goodly company![61] And I shall be *one*, and all that have died in the Lord, and all the preachers whom I have loved, and I shall see them there; and all the *Methodists*, that are *such indeed*; *they* shall be there.

O precious Jesus! My beloved is mine, and I am his! He is the *fairest* of ten thousand, yea *altogether lovely*.[62] O what glory do I see! And all for *me*! How does my soul burn with love to Jesus, who has provided it for me! I wonder, that *that* happiness could have no higher title than heaven.

Lord hasten thy work. Do more now in my soul in a day, than thou wast wont to do in many days. [After repeating Rev. xxii. 1, she said] I see fountains upon fountains. O what rivers of pleasure are there! How shall I swim in those *oceans of love* to all eternity! I am overcome with love! Oh if I were loose from this affliction how would I sing!

> No need of the sun in that day,
> Which never is followed by night,
> Where Jesus's beauties display,
> A pure, and a permanent light:
> The Lamb is their light and their sun,
> And lo! By reflection they shine,
> With Jesus ineffably one,
> And bright in effulgence divine.[63]

You [father] have many difficulties in the world, and I will tell you what you must do; give your hands to the world, and your heart to God, and *he* will make a way for you [cf. Ps. 5:8]. You may look for glorious times to come; for the Lord has a great work to do on earth, before the church militant can join the church triumphant. God has given you the *means of grace*, in order to bring you safe to glory; see that you do not slight neglect any of them; use them constantly, and look through them all to Jesus.

Weak in body, but happy in soul; I long to be gone to heaven. Some may think that I have a *heavy* affliction. No. I have none that I can spare. Oh! it's a *happy* affliction! Others may say of me, she was once *blooming*; how is she *altered* now? But I was never so *beautiful* in all my life; I am as the King's daughter, all-glorious within, and my raiment is of wrought gold [cf. Ps. 45:13].

I am going safe to glory . . . O little children! Love one another [cf. 1 John 4]. I cannot tell; but the will of the Lord be done. Only this I know, that neither life or death shall separate me from the love of Jesus [cf. Rom. 8:38-39], who has redeemed me from the foundation of the world. If I die, as soon as you see me depart, sing *Happy soul, thy days are ended.*[64] And when you carry me to the grave, sing the same hymn. When you return, do not let your hearts be filled with grief, but praise God, as I shall be rejoicing with him in glory.

Abbreviations

AM	*The Arminian Magazine: Consisting of Extracts and Original Treatises on Universal Redemption.* Edited by John Wesley. London: Fry et al., 1778–1797 (continued as *WMM*).
AM (BC)	*The Arminian Magazine: Consisting of Extracts and Original Treatises on Universal Redemption.* Edited by James Thorne. Devon: Arminian Bible Christians, 1822–??.
BCP	*The Book of Common Prayer.* London, 1662.
Funeral Hymns*	[Charles Wesley]. *Funeral Hymns.* 2d Series. n.p., n.d. [1759].
HLS*	John and Charles Wesley. *Hymns on the Lord's Supper.* Bristol: Farley, 1745.
HSP (1739)*	John and Charles Wesley. *Hymns and Sacred Poems.* London: Strahan, 1739.
HSP (1740)*	John and Charles Wesley. *Hymns and Sacred Poems.* London: Strahan, 1740.
HSP (1742)*	John and Charles Wesley. *Hymns and Sacred Poems.* Bristol: Farley, 1742.
HSP (1749)*	John and Charles Wesley. *Hymns and Sacred Poems.* Bristol: Farley, 1749.
John Wesley	*John Wesley.* Edited by Albert C. Outler. New York: Oxford University Press, 1964.

Journal (Curnock)	*The Journal of the Rev. John Wesley, A. M.* Edited by Nehemiah Curnock. 8 vols. London: Epworth Press, 1909–1916.
Letters (Telford)	*The Letters of the Rev. John Wesley, A. M.* Edited by John Telford. 8 vols. London: Epworth Press, 1931.
Meth. Arch.	The Methodist Archives and Research Centre, John Rylands University Library of Manchester.
MethH	*Methodist History.*
Poet. Works	*The Poetical Works of John and Charles Wesley.* Edited by George Osborn. 13 vols. London: Wesleyan Methodist Conference Office, 1868–1872.
*Psalms and Hymns**	John Wesley. *A Collection of Psalms and Hymns.* London: Strahan, 1741.
PWHS	*Proceedings of the Wesley Historical Society.*
Redemption Hymns	[John? and Charles Wesley]. *Hymns for those that seek, and those that have Redemption in the Blood of Jesus Christ.* London: Strahan, 1747.
*Scripture Hymns**	Charles Wesley. *Short Hymns on Select Passages of the Holy Scriptures.* 2 vols. Bristol: Farley, 1762.
WMM	Refers to quarterly theological journal of the (British) Wesleyan Methodist Church published as *The Methodist Magazine* (1798–1821) and *The Wesleyan Methodist Magazine* (1822–1913).
Works	*The Bicentennial Edition of the Works of John Wesley.* 35 volumes projected. Eds., Frank

Baker and Richard P. Heitzenrater. Nashville: Abingdon Press, 1984–. (Volumes 7, 11, 25, and 26 originally appeared as the *Oxford Edition of the Works of John Wesley*. Oxford: Clarendon Press, 1975–1983).

Works (Jackson) *The Works of John Wesley*. Edited by Thomas Jackson. 14 vols. 3d edition. London: Wesleyan Methodist Book Room, 1872; reprinted, Grand Rapids, Mich.: Baker, 1979.

* The quotations from these works are contained in *Poet. Works*.

Notes

Introduction

1. Most anthologies of eighteenth-century women are related to the important social and literary figures of the century. Typical among these are *Eighteenth-Century Women: An Anthology,* ed. Bridget Hill (London: Allen and Unwin, 1984); and *Women in the Eighteenth Century: Constructions of Femininity (World and Word Series),* ed. Vivien Jones (London: Routledge, 1990). The only exception to this general rule is *Women in English Religion, 1700–1925,* ed. Dale A. Johnson (New York: The Edwin Mellen Press, 1983), which contains sixty selections but is limited with regard to material about Methodist women. Cf. Cheryl Cline, *Women's Diaries, Journals, and Letters: An Annotated Bibliography* (New York: Garland Press, 1989). For material specifically related to women and religion of the period, see Dale A. Johnson, *Women and Religion in Britain and Ireland: An Annotated Bibliography from the Reformation to 1993* (Lanham, Md.: Scarecrow Press, 1995). For bibliographical information related to women in Methodism, see Kenneth E. Rowe, *Methodist Women: A Guide to the Literature* (Lake Junaluska, N.C.: General Commission on Archives and History, 1980); and *Women in the Wesleyan and United Methodist Traditions: A Bibliography,* ed. Susan M. Eltscher (Madison, N.J.: General Commission on Archives and History, 1992).

2. Paul Wesley Chilcote, *John Wesley and the Women Preachers of Early Methodism* (Metuchen, N.J.: Scarecrow Press, 1991), 48; cf. Paul W. Chilcote, "The Women Pioneers of Early Methodism," in *Wesleyan Theology Today,* ed. Theodore Runyon (Nashville: Kingswood Books, 1985), 180-84.

3. It is tragic that no critical edition of any of the early Methodist women's writings exists. The writings of Susanna Wesley, long celebrated in Methodist theology as mother of the movement's founders, have just recently been published in a critical edition: *Susanna Wesley: The Complete Writings,* ed. Charles Wallace Jr. (New York: Oxford University Press, 1997). But no critical edition has ever been prepared for the *Experience* of Hester Ann Rogers, the *Life* of Mary Fletcher, the *Memoirs* of Elizabeth Mortimer, or the two-volume *Life* of Mary Taft, all of which exerted tremendous influence on the development of early Methodism. What has been said of Mary Fletcher in particular could be said of all the women in general: "she has been largely ignored by scholars" (Johnson, *Women and Religion,* 132).

4. The Methodist women's writings also include biblical commentary, sermons, theological treatises, poetry, prayers, and other devotional materials, all of which I hope to explore in subsequent volumes. It should be noted, in particular, that none of the writings of Mary Fletcher (née Bosanquet)—without question the most prolific of all early Methodist women—are in-

cluded in this volume, as a separate collection of her writings is also in preparation. Gareth Lloyd, *Meth. Arch.* Research Assistant, has compiled a guide entitled *Sources for Women's Studies in the Methodist Archives,* which, while not comprehensive, is a helpful introduction to relevant materials deposited in the *Meth. Arch.* in Manchester, England (Manchester: John Rylands Library, 1996).

5. See the magisterial treatment of this theme prior to the time of Wesley in the introduction to the definitive edition of John Wesley's *Journal,* in *Works,* 18:1-36. With regard to women's autobiography, see Felicity A. Nussbaum, *The Autobiographical Subject: Gender and Ideology in Eighteenth-Century England* (Baltimore: Johns Hopkins University Press, 1990) where the author explores the ideologies of self-biography from John Bunyan to Hester Thrale with special attention devoted to the developing genre of spiritual autobiography among women and the emergence of gendered subjectivity; cf. Nussbaum's article, "Eighteenth-Century Women's Autobiographical Commonplaces," in *The Private Self: Theory and Practice of Women's Autobiographical Writings,* ed. Shari Bentock (Chapel Hill: University of North Carolina Press, 1988), 147-71, where she first broached the issue of "alternative identity" and called for an effort to map the territory of eighteenth-century "female autobiographical subjectivity." Cf. Cynthia S. Pomerleau, "The Emergence of Women's Autobiography in England," in *Women's Autobiography: Essays in Criticism,* ed. Estelle C. Jelinek (Bloomington: Indiana University Press, 1980), 21-38. Despite their limited reference to the writings of Methodist women, see one of the standard bibliographical guides, *British Autobiographies: An Annotated Bibliography of British Autobiographies Published or Written Before 1951,* comp. William Matthews (Berkeley: University of California Press, 1955).

6. See the theological writings of Robert E. Cushman, in particular, *Faith Seeking Understanding* (Durham, N.C.: Duke University Press, 1981), 181-97; cf. James Wm. McClendon Jr., *Biography as Theology* (Nashville: Abingdon Press, 1974).

7. Ward and Heitzenrater observe that "the sheer bulk of the surviving evangelical self-representation and confession is a broad hint of the huge volume of class-meeting testimony and the like, which never moved from oral to literary form" (*Works,* 18:24).

8. *Arminian Magazine: Consisting of Extracts and Original Treatises on Universal Redemption* (1778–1797); succeeded by the *Methodist Magazine* in 1798, the *Wesleyan Methodist Magazine* in 1822, and the *Magazine of the Wesleyan Methodist Church* in 1914. This monthly periodical review, esteemed as the earliest proper religious magazine in Britain, arose out of the renewed Arminian-Calvinist controversy which flared up in the 1770s. In the *AM,* Wesley countered Calvinistic doctrines of predestination and perseverance

with his own conception of "conditional salvation within the universal redemption wrought by Christ" (*AM* 1 [1778]).

9. The fourth edition in six volumes with a helpful index was published by the Wesleyan Conference Office in London in 1871. John Telford, editor of Wesley's *Letters*, produced an expanded edition of Jackson's work, entitled *Wesley's Veterans: Lives of Early Methodist Preachers Told by Themselves*, 7 vols. (London: Robert Culley, 1912–1914).

10. Zechariah Taft, *Biographical Sketches of the Lives and Public Ministry of Various Holy Women*, 2 vols. (London: Mr. Kershaw, 1825, vol. 1; Leeds: H. Cullingworth, 1828, vol. 2), 1:i.

11. Not all of the 78 women portrayed in this collection were Methodists, a sizable number being Quaker. A facsimile reproduction of the two volumes was produced by The Methodist Publishing House in 1992. For an incisive analysis of the ministries of women as exhibited in this set, see Jacqueline Field-Bibb, "The Worst of Heresies," *Modern Churchman* 33.4 (1992): 13-22.

12. The most stellar examples, namely, Hester Ann Rogers, Hannah Ball, Frances Pawson, Mary Fletcher, and Elizabeth (Ritchie) Mortimer, exerted a monumental influence on early Methodist people on both sides of the Atlantic Ocean. Cf. "Wesleyan Biographical Publications," *WMM* 63 (1840): 64-71, 744-50, 822-28.

13. On the difficulty of working with and identifying some of these materials, see Chilcote, *Wesley and Women*, 3, 26. Wesley published a number of accounts of early Methodist women, including the "Short Accounts" of Hannah Richardson (1741), E[lizabeth] J[ackson?] (1770), Ann Rogers (1770), Ann Johnson (1771), and Alice Gilbert (1773). He also published several extracts of letters and journals, such as those related to Jane Cooper (1764), Mary Bosanquet (1764), Mary Gilbert (1768), Elizabeth Harper (1769), and Mrs. Lefevre (1769). He published the death accounts of both Mary Langston (1770) and Elizabeth Hindmarsh (1777).

14. See the excellent introduction by Deirdre Beddoe, *Discovering Women's History: A Practical Manual* (London: Pandora, 1983); cf. Ruth Rosen, "Sexism in History or, Writing Women's History Is a Tricky Business," *Journal of Marriage and the Family* 33 (1971): 541; and "The Invisible Woman: The Historian as Professional Magician" in *Liberating Women's History: Theoretical and Critical Essays*, ed. Berenice A. Carroll (Urbana: University of Illinois Press, 1976), 42-54.

15. On the methodological problems associated with this dynamic, see Chilcote, *Wesley and Women*, 1-4.

16. MS letter, W. L. Watkinson Collection, The New Room, Bristol.

17. See Chilcote, *Wesley and Women*, 157-59, 305-8.

18. Mary Taft, *Memoirs of the Life of Mrs. Mary Taft: Formerly Miss Barritt*, 2 vols., 2d ed., enlarged (York: Printed for and sold by the author, 1828; Devon: Published and sold by S. Thorpe, 1831), 1:vi.

19. See William Parlby, "Diana Thomas, of Kington, lay Preacher in the Hereford Circuit, 1759–1821," *PWHS* 14.5 (1924): 110-11; cf. Leslie F. Church, *More About the Early Methodist People* (London: Epworth Press, 1949), 172.

20. In an incisive doctoral dissertation, Vicki Collins provides a publishing history of *The Account of Hester Ann Rogers* that demonstrates how this popular autobiography, as edited by male publishers, reshaped her memory in terms of her domestic virtues, emphasizing that she did not preach. See "Perfecting a Woman's Life: Methodist Rhetoric and Politics in *The Account of Hester Ann Rogers*" (Ph.D. diss., Auburn University, 1993). In similar fashion Margaret Jones examines twenty biographies in the *AM* between 1798 and 1821 to show how the public characterization of women remained firmly under male control. "Whose Characterisation? Which Perfection? Women's History and Christian Reflection," *Epworth Review* 20.2 (1993): 96-103.

21. The purpose of this introduction is to broach these issues without plumbing them to their depths. Concerns that revolve around these interpretive dilemmas will be raised throughout this volume but should always be in the mind of the reader. See the introduction to part 4, in particular, which identifies some of the more important scholarly works around these questions as it relates to epistolary material.

22. First published in 1988 by W. W. Norton, the study became an immediate national bestseller and was critically acclaimed as a modern classic. Scholars such as Bentock, Collins, Nussbaum, and Spacks, noted elsewhere in this volume, have been greatly influenced by this watershed study.

23. It is important to note that forces within European societies were cultivating a spirit of "feminism," defending the rights of women and challenging the old conventions of "feminine behaviour." See Barbara B. Schnorrenberg, "The Eighteenth-Century English-woman," in *The Women of England from Anglo-Saxon Times to the Present: Interpretive Bibliographical Essays.* ed. Barbara Kanner (London: Mansell, 1980), 190. Cf. *Women in the Eighteenth Century and Other Essays*, eds. Paul Fritz and Richard Morton (Toronto: Samuel Stevens, Hakkert and Co., 1976), 87; and Chilcote, *Wesley and Women*, 11-17.

24. My discussion of the early Methodist revival corresponds roughly with characteristics of "evangelicalism" articulated in the classic study by David Bebbington, *Evangelicalism in Modern Britain: A History from the 1730s to the 1980s* (Grand Rapids, Mich.: Baker Book House, 1989). He provides a four-fold definition of "evangelical," which includes concomitant emphases on conversion, Christ's redemptive work on the cross, the centrality of Scrip-

ture, and activism related to the Christian life. In these paragraphs I have conflated the first two points.

25. Hester Ann Rogers, *An Account of the Experience of Hester Ann Rogers* (New York: Hunt & Eaton, 1893), 128.

26. "An Account of Mrs. Sarah Ryan," *AM* 2 (1779): 304.

27. Sarah Colston, MS Account of Religious Experience, *Meth. Arch.*, 4.

28. [John Wesley], *A Short Account of the Death of Mary Langs[t]on* (London: J. Paramore, 1795), 8. The hymn allusion is to *Funeral Hymns*, "Hymn 8," v. 4, 6:198. Unless otherwise noted, all references to hymns are taken from the *Poet. Works* collection.

29. For a contemporary Methodist expression of this theme, see *Spirituality and Social Responsibility: The Vocational Vision of Women in the United Methodist Tradition*, ed. Rosemary Skinner Keller (Nashville: Abingdon Press, 1993).

30. Andrew Walls, noted missiologist and historian, has argued quite persuasively that the inevitable consequence of this vision was the rise of the modern missionary movement. See his *The Missionary Movement in Christian History: Studies in Transmission of Faith* (Maryknoll, N.Y.: Orbis Books, 1996). Bebbington has linked this feature of evangelicalism more broadly with a strong commitment to doing—an activism rooted in a moral radicalism and a strong sense of personal responsibility. See Bebbington, *Evangelicalism*, 10-12.

31. Joseph Cole, ed., *Memorials of Hannah Ball*, 3d rev. ed. (London: Wesleyan Conference Office, 1880), 57. Entry dated June 3, 1770.

32. Letter to Miss March (June 9, 1775), *Letters* (Telford), 6:153-54. For an excellent discussion of Wesley's "preferential option for the poor," see Theodore W. Jennings, *Good News to the Poor* (Nashville: Abingdon Press, 1990), 47-69.

33. See, in particular, Wesley's sermon "On Visiting the Sick" (*Works*, 3:395-96, §3.7), where he not only affirms the radical working equality of women in the life of the church but also defends their legitimate and noble place within the order of creation.

34. For a full account of the rise and development of the Methodist Societies, see Rupert Davies's introduction to *Works*, 9:1-29. Cf. Frank Baker's chapter on "The People Called Methodists, 3. Polity" in eds. Rupert Davies, A. Raymond George, and Gordon Rupp, *A History of the Methodist Church in Great Britain*, 4 vols. (London: Epworth Press, 1965–1988), 1:213-55.

35. First articulated most fully in the Edinburgh dissertation of Paul W. Hoon entitled "The Soteriology of John Wesley" in 1936, Wesley's *ordo salutis* (order of salvation) was popularized in the writings of Albert C. Outler, most notably in *Theology in the Wesleyan Spirit* (Nashville: Tidings Press, 1975) and his magisterial edition of the Wesleyan sermon corpus (*Works*, 1-

4); cf. *The Wesleyan Theological Heritage,* ed. Thomas C. Oden and Leicester R. Longden (Grand Rapids, Mich.: Zondervan Publishing House, 1991). Outler attributes Wesley's (and early Methodism's) conception of salvation as a process—as an articulated continuum of stages of both "moments" and processes—to the Eastern tradition of the early church fathers. For Wesley's most successful summary of this understanding of salvation, see his Sermon 43, "The Scripture Way of Salvation," *Works,* 2:153-69; cf. Paul W. Chilcote, *Wesley Speaks on Christian Vocation* (Nashville: Discipleship Resources, 1986), 17-31.

36. Letter to Thomas Church (June 17, 1746), *Letters* (Telford), 2:268.

37. When the women write about this experience and use language that seems to be deprecating to the self (e.g., the typical "worm language" of the day), it is important to remember that they are describing life *coram deo* (before God), their creature-feeling in the presence of an awesome Creator. In essence, they are reflecting the same experience of Isaiah in the temple (Isa. 6:1-6) or Peter in the boat (Luke 5:8-9). It is dangerous to impose contemporary, psychological concepts related to "self-esteem" on these statements. While there were some early Methodist women who did, in fact, suffer from dangerously low self-esteem, there were others, who used this same language, whose view of self was healthy and balanced.

38. When Wesley preached Ann Stead's funeral sermon on October 28, 1762, he identified her as the first witness of "the great salvation," or sanctification, in Bristol (cf. *Works,* 21:392). In his published *Journal* Wesley juxtaposes John Johnson's account of Judith Beresford's death with that of a man who "died as stupid as an ox" (*Journal* [May 5, 1757], *Works,* 21:101) and pointed to her as a primary example of his doctrine of perfect love. He described Elizabeth Longmore as the "first witness of Christian Perfection" in the strife-ridden community of Wednesbury, whose "whole life was answerable to her profession, every way holy and unblamable" (*Journal* [March 18, 1770], *Works,* 22:218). Cf. *Journal* (March 6, 1760), *Works,* 21:243-45 for an account of her religious experience.

39. Two recent studies on "sensibility" have drawn attention to this issue. G. J. Barker-Benfield, in *The Culture of Sensibility: Sex and Society in Eighteenth-Century Britain* (Chicago: University of Chicago Press, 1992) has demonstrated the high price paid for the identification of sensibility with women, while the earlier work by Janet Todd, *Sensibility: An Introduction* (London: Methuen, 1986), describes the intentional cultivation of the faculty of feeling in the mid-eighteenth century. She demonstrates how dynamic social changes contributed to this development and, more particularly for our interest here, how the language of evangelicalism supported and encouraged "sensibility" in religion.

40. See the analysis of Wesley's correspondence with women in *Works*, 25:86-88.

41. The following paragraphs are drawn in part from my discussion of these aspects of Wesleyan theology elsewhere. See Paul W. Chilcote, "Sanctification as Lived by Women in Early Methodism," *MethH.* 34 (1996): 90-103; and "The Blessed Way of Holiness," *Journal of Theology* 100 (Summer 1996): 29-51.

42. See Thomas A. Langford, *Practical Divinity: Theology in the Wesleyan Tradition* (Nashville: Abingdon Press, 1983), 24-48.

43. One of Wesley's few catechetical publications, this small tract was a revised English "extract" from an early eighteenth-century French work by the prominent mystic, disciple, and biographer of Antoinette Bourignon, Pierre Poiret, entitled *Les Principes solides de la Religion et de la Vie Chretienne* (1705). In Wesley's Works, it appears with the altered title, *Instructions for Children*, 8th ed. (Bristol: William Pine, 1767), 10.

44. "The Experience of Mrs. Ann Gilbert, of Gwinear, in Cornwall," *AM* 18 (1795): 45.

45. William Bennet, *Memoirs of Mrs. Grace Bennet* (Macclesfield: Printed and sold by E. Bayley, 1803), 83.

46. Cole, *Memorials of Hannah Ball*, 118.

47. Perhaps the first to draw major attention to this fundamental understanding of the Wesleys was Martin Schmidt in his classic study, *John Wesley: A Theological Biography*, 2 vols., trans. Norman Goldhawk and Denis Inman (New York and Nashville: Abingdon Press, 1962), vol. 1. So central is this concept to Wesleyan theology, in the view of Professor Schmidt, that it finds ready reference in his index, "Wesley, John, Holiness and Happiness." In one note he writes: "The formula 'holiness is happiness' belongs to the fundamental data of Wesley's theological thinking and constitutes the root of his later 'perfectionism' " (101). Elsewhere he traces the lineage of this eudaemonism back to Scougal via Susanna, the mother of the Wesleys. Indeed, a close study of her own prayers bears out the close relationship between holiness and happiness in her thinking. See in particular, Prayers 4, 6, 10, 16, and 23 in *The Prayers of Susanna Wesley*, ed. W. L. Doughty (London: Epworth Press, 1956).

48. John Pipe, "Memoir of Miss Isabella Wilson," *WMM* 31 (1808): 465. A journal entry from the final year of her life (January 5, 1807) is a fitting testimony to her happy life in Christ. "It is with gratitude of heart I recount the mercies of the last year. Upon the whole, it has been one of the best years of my life. Glory be to God for preserving grace. I feel my heart more united to Jesus than ever. With joy I draw water from the wells of salvation" (601).

49. See the interesting account drawn from her manuscript journal in Earl Kent Brown, *Women of Mr. Wesley's Methodism* (New York: The Edwin Mellen Press, 1983), 206.

50. Rogers, *Account*, 128-29.

51. Wesley's Sermon 44, "Original Sin," *Works*, 2:185, §3.5. The quotation continues: "Ye know that all religion which does not answer this end, all that stops short of this, the renewal of our soul in the image of God, after the likeness of him that created it, is no other than a poor farce and a mere mockery of God, to the destruction of our own soul. O beware of all those teachers of lies who would palm this upon you for Christianity! . . . Keep to the plain, old 'faith, once delivered to the saints,' and delivered by the Spirit of God to your hearts. Know your disease! Know your cure! . . . Now 'go on' 'from faith to faith', until your whole sickness be healed, and all that 'mind be in you which was also in Christ'!" Cf. Sermon 12, "The Witness of Our Own Spirit"; Sermon 45, "The New Birth"; Sermon 85, "On Working Out Our Own Salvation"; and Sermon 129, "Heavenly Treasures in Earthen Vessels." Outler has described the "recovery of the defaced image of God" as the "axial theme of Wesley's soteriology."

52. "Account of Sarah Ryan," *AM* 2 (1779): 309-10.

53. "An Extract from the Diary of Mrs. Bathsheba Hall," *AM* 4 (1781): 37.

54. John Wesley's sermon on "The Means of Grace" (*Works*, 1:376-97) was an effort to clarify the difference between the proper use and possible abuse of prayer (and fasting), Bible study, Christian fellowship, and the Sacrament of Holy Communion in faithful discipleship. These "means" were, in fact, the very foundation of Wesleyan spirituality and their rediscovery of a powerful reappropriation of ancient Christian practice for a people whose sacramental sense had atrophied and whose experience of grace was greatly biased toward spontaneity and immediacy. In a letter to William Law, dated January 6, 1756, Wesley argues that "All the externals of religion are in order to the renewal of our soul in righteousness and true holiness. But it is not true that the external way is one and the internal way another. There is but one scriptural way wherein we receive inward grace—through the outward means which God hath appointed" (*Letters* [Telford], 3:366-67). It is noteworthy that, during the so-called "Stillness Controversy" in 1741, when Wesley encountered criticism from Moravian colleagues because of his emphasis on the "means of grace," it was a woman, Jane Muncy, who came to his strong defense. In his *Journal* he records: "She was [in] one of the first women['s] bands at Fetter Lane, and when the controversy concerning the *means of grace* began, stood in the gap and contended earnestly for the ordinances once delivered to the saints. . . . From the time that she was made leader of one or two bands she was more eminently a pattern to the flock: in self-denial of every kind, in openness of behaviour, in simplicity and

godly sincerity, in steadfast faith, in constant attendance on all the public and all the private ordinances of God" (*Journal* [July 31, 1741], *Works*, 19:206-7). See also Chilcote, *Wesley Speaks*, 33-49. The most important recent work on this topic is Henry H. Knight, *The Presence of God in the Christian Life: John Wesley and the Means of Grace* (Lanham, Md.: Scarecrow Press, 1992).

55. Cole, *Memoir of Hannah Ball*, 97-98.

56. "Experience of Ann Gilbert," *AM* 18 (1795): 45-46. The fact that this statement concludes her account of her experience adds weight to its importance. The testimony of Grace Bennet is also noteworthy: "My happiest days were when I rose at 4 o'clock for prayer, and preaching at five. And I would say it to the praise and glory of God, I find it no cross at this day (being in my 84th year) to rise early to wait upon God with his people, no more than when I was thirty. O Lord, keep my soul awake, and athirst for thee! It has been my grief to see and feel such deadness and dulness amongst Christians; Jesus Christ was whole nights on the mountain in prayer" (Bennet, *Memoirs of Grace Bennet*, 78).

57. Joseph Sutcliffe, *The Experience of Mrs. Frances Pawson* (London: Printed at the Conference Office, by Thomas Cordeux, 1813), 84.

58. Pipe, "Memoir of Isabella Wilson," *WMM* 31 (1808): 411.

59. *HLS*, "Hymn 54," v. 4, 3:254. Cf. J. Ernest Rattenbury, *The Eucharistic Hymns of John and Charles Wesley* (London: Epworth Press, 1948), 176-249. For a discussion of the sacrament as an "effective means of grace," see in particular Ole E. Borgen, *John Wesley on the Sacraments: A Theological Study* (New York: Abingdon Press, 1962), 183-217.

60. Pipe, "Memoir of Isabella Wilson," *WMM* 31 (1808): 564.

61. "An Account of Mrs. Hannah Harrison," *WMM* 25 (1802): 321.

62. In addition to my writings on the subject, and those of Earl Kent Brown, already noted, see the extensive bibliography in Chilcote, *Wesley and Women*, 329-57. Cf. Thomas M. Morrow, *Early Methodist Women* (London: Epworth Press, 1967), which provides vignettes of Sarah Crosby, Hannah Ball, Frances Pawson, Mary Fletcher, and Sarah Bentley; Leslie Church's two-volume set, *The Early Methodist People* (London: Epworth Press, 1948) and the previously mentioned *More About Methodist People*; and the terse discussion of Methodist women's roles in David J. Boulton, "Women and Early Methodism," *PWHS* 43 (1981): 13-17.

63. Gail Malmgreen, "Domestic Discords," in *Disciplines of Faith: Studies in Religion, Politics, and Patriarchy*, ed. Jim Obelkevich, et al. (London: Routledge & Kegan Paul, 1987), 55-70. Cf. the volume of essays Malmgreen edited, *Religion in the Lives of English Women, 1760–1930* (Bloomington: Indiana University Press, 1986).

64. For a full discussion of the evidence related to female initiative in the formation and establishment of Methodist Societies, see Chilcote, *Wesley and Women*, 49-54.

65. See Abraham Watmough, *A History of Methodism in the Neighbourhood and City of Lincoln* (Lincoln: Printed by R. E. Leary; sold by J. Mason, 1829), 21-25. Cf. Journal entry (July 4, 1788), *Journal* (Curnock), 7:412-13; and Letter to Thomas Carlill (April 30, 1786), *Letters* (Telford), 7:326-27.

66. A part of Sarah's responsibilities as housekeeper at the New Room in Bristol was the management of Wesley's school from 1757 to 1761. For background information concerning the design and implementation of this project, see A. G. Ives, *Kingswood School in Wesley's Day and Since* (London: Epworth Press, 1970), 7-51.

67. See Chilcote, *Wesley and Women*, 126.

68. There is no need for me to repeat the evidence here that I have presented in *Wesley and Women* concerning the development of their leadership roles within the context of the Methodist Societies. See, in particular, part 1, "The Training Ground for Women Preachers," 45-113.

69. Eliza Bennis, an Irish Methodist band leader, exercised her office with such sensitivity, discernment, and effectiveness that the preachers responsible for her supervision refused to allow her to resign. See C. H. Crookshank, *Memorable Women of Irish Methodism in the Last Century* (London: Wesleyan Methodist Book Room, 1882), 24.

70. This only represents a small portion of the many roles women assumed in the movement. For a full discussion of these multiple roles, see Brown, *Women of Methodism*, which is essentially organized around leadership roles of women including speakers of the Word, advisors and counselors, group leaders, school leaders, visitors (to the sick, backslid, and imprisoned), ministers' wives, support group leaders, itinerant preachers, patrons, and Christian models. Brown also provides vignettes of the lives of Darcy, Lady Maxwell; Mary Fletcher; Elizabeth (Ritchie) Mortimer; Sarah Crosby; Selina, Countess of Huntingdon; and Hester Ann Rogers. Cf. his articles, "Standing in the Shadow: Women in Early Methodism," *Nexus* 17:2 (1974): 22-31; "Women of the Word: Selected Leadership Roles of Women in Mr. Wesley's Methodism," in *Women in New Worlds: Historical Perspectives on the Wesleyan Tradition*, eds. Hilah F. Thomas and Rosemary Skinner Keller, 2 vols. (Nashville: Abingdon Press, 1981–1982), 1:69-87, 384-86; and Earl Kent Brown, "Feminist Theology and the Women of Mr. Wesley's Methodism," in Runyon, *Wesleyan Theology*, 143-50.

71. See Chilcote, *Wesley and Women*, 68, 74-75, 125. Cf. William W. Stamp, *The Orphan-House of·Wesley; With Notices of Early Methodism in Newcastle-upon-Tyne* (London: J. Mason, 1863), 42-53.

72. "A Plain Account of the People Called Methodists," *Works* 9:274, §11.4; cf. Letter to Charles Wesley (April 21, 1741), *Works*, 26:55-56; *Journal* (May 7, 1741), *Works*, 19:193-94. Wesley published Sermon 98, "On Visiting the Sick," in 1786, *Works*, 3:384-98.

73. Bennet, *Memoirs of Grace Bennet*, 13-14. Cf. Chilcote, *Wesley and Women*, 74-75.

74. Brown, *Women of Methodism*, 75. See his discussion of "ministers' wives" in *Women of Methodism*, 74-83. Cf. the discussion of this theme in Thomas, *Women in New Worlds*, 1:97-131.

75. Taft, *Holy Women*, 1:59.

76. Ibid., 164-65.

77. My book, *Wesley and Women*, analyzes the evolution of this office in Wesleyanism from the training ground of lay leadership to the suppression of female preachers after Wesley's death in the early nineteenth century. Appendices provide biographical outlines of forty-two women preachers, sermon registers, and other relevant documents. A briefer version has been published under the title *She Offered Them Christ* (Nashville: Abingdon Press, 1993).

78. For a nearly encyclopedic discussion of "the letter" during this period, see Frank Baker's introduction to *Works*, 25:11-28.

79. Just to illustrate the magnitude of the problem, the Fletcher-Tooth Collection of the *Meth. Arch.*, just to mention one of its kind, rivals the entire Wesley collection in terms of its size. It remains essentially untouched.

Part 1. Accounts of Religious Experience

1. For a detailed study of testimony and the Love Feast, see Frank Baker, *Methodism and the Love-Feast* (London: Epworth Press, 1957), esp. 25-31. Cf. Paul Wesley Chilcote, *John Wesley and the Women Preachers of Early Methodism* (Metuchen, N.J.: Scarecrow Press, 1991), 96-100.

2. Concerning the proliferation of these autobiographical reflections see L. D. Lerner, "Puritanism and the Spiritual Autobiography," *Hibbert Journal* 54 (1956–1957): 37-86. In 1746 Jonathan Edwards (1703–1758), the great American evangelist and premier theologian, published his *Treatise on Religious Affections*, one of the most profound analyses of religious experience of that time and a work known well by Wesley. One of the most important early collections of Puritan autobiographical accounts was that of Samuel Clarke entitled *Lives of Sundry Eminent Persons in this Later Age*, published in 1683 but adapted and included by Wesley in two volumes of his fifty-volume *Christian Library*, completed in 1755. For a particularly helpful descriptive analysis of this genre, see Owen C. Watkins, *The Puritan Experience* (London: Routledge & Kegan Paul, 1972), chaps. 1–2.

3. On the schematic design of these conversion narratives, see *Works*, 18:14.

4. Ibid., 242-52.

5. *Works*, 19:23-26.

6. See the lengthy and instructive note by Nehemiah Curnock on this critical development in *Journal* (Curnock), 2:111-13.

7. See *Journal* (August 12, 1745), *Works*, 20:82-83; Thomas Jackson, *The Life of the Rev. Charles Wesley, M.A.*, 2 vols. (London: John Mason, 1841), 1:559. Cf. *AM* 5 (1782): 21-22.

8. *Letters* (Telford), 4:202.

9. See Richard P. Heitzenrater, *Wesley and the People Called Methodists* (Nashville: Abingdon Press, 1995), 98-119.

10. The manuscript is transcribed here with original spellings but with modernized punctuation and capitalization.

11. George Whitefield (1714–1770) was the most widely venerated orator of the Methodist revival. An impoverished native of Gloucester, he became a servitor at Pembroke College, Oxford, in 1732, where he later came under the influence of John and Charles Wesley. Befriended by Charles, he was introduced to the older brother in 1734, became a member of the Oxford Holy Club, and was ordained a deacon in 1736. The same year, he followed the Wesleys to Georgia where he founded an orphanage. In 1739 he began the publication of his journal leaving a remarkable account of his evangelistic tours and mission endeavors. In 1741 he established a chapel in Bristol and later, through the patronage of Selina, Countess of Huntingdon, opened a Tabernacle in London, which became a center for the proclamation of his Calvinistic brand of evangelical Christianity for many years. In spite of later serious theological differences with the Wesleys, Whitefield exerted a formative influence on both brothers early in the Methodist revival. Most particularly, he was the means of leading John to begin field-preaching at Bristol in 1739. See Wesley's account in *Journal* (March 10–April 8, 1739), *Works*, 19:36-48.

12. This was, in fact, April 1739. John Wesley reached Bristol on Friday evening, March 31, met Whitefield there, and learned of his colleague's *"strange way* of preaching in the fields." Wesley's *Journal* reveals the veritable whirlwind of activity which ensued. On April 1 he began expounding the Sermon on the Mount "to a little society which was accustomed to meet once or twice a week in Nicholas Street." The following day, as he records: "At four in the afternoon I submitted to 'be more vile', and proclaimed in the highways the glad tidings of salvation, speaking from a little eminence in a ground adjoining to the city, to about three thousand people." This marked the beginning of his field-preaching, taking as his initiatory text, Luke 4:18-19. Later that evening he preached on Acts at the Baldwin Street Society and

on the Gospel of John at the Newgate chapel the following morning. Wednesday, April 4, marked a critical development in Bristol Methodism. After preaching at Baptist Mills, Wesley records the important events of the day: "In the evening three women agreed to meet together weekly, with the same intention as those at London, viz., 'To confess their faults one to another and pray one for another, that they may be healed.' " The Methodist Societies under his direction at Bristol were born. Ibid., 46-47.

13. Most certainly Thursday, April 5, 1739. "At five in the evening I began at a society in Castle Street expounding the Epistle to the Romans" (Ibid., 47).

14. Wesley affords the following observations in the *Journal*: "Tuesday, May 1, many were offended again and, indeed, much more than before. For at Baldwin Street my voice could scarce be heard amidst the groanings of some and the cries of others, calling aloud to 'him that is mighty to save'. I desired all that were sincere of heart to beseech with me 'the Prince exalted for us' that he would 'proclaim deliverance to the captive'. And he soon showed that he heard our voice. Many of those who had been long in darkness saw the dawn of a great light, and ten persons (I afterwards found) then began to say in faith, 'My Lord and my God' " (Ibid., 53)!

15. John Haydon, possibly the Bristolian baptized at the church of St. Augustine the Less on November 5, 1694, was a weaver whose home later became a center for Methodist leaders and preaching. See Wesley's account of him in *Journal* (May 2, 1739). Ibid., 53-55.

16. Wesley first preached at this suburb of Bristol on April 4, 1739. His text for preaching on this subsequent occasion was Acts 5:31. Cf. Ibid., 55.

17. This is undoubtedly Mrs. Turner, John Bray's sister, who was instrumental in Charles's conversion of the previous year, May 21, 1738. For an account of these events, see Frederick C. Gill, *Charles Wesley: The First Methodist* (Nashville: Abingdon Press, 1964), 70-72.

18. *Psalms and Hymns*; "A Prayer for One that is Lunatic and Sore Vexed," v. 4, 2:29. Original:

> Jesu, help, Thou serpent-bruiser;
> Bruise his head, woman's seed,
> Cast down the accuser.

19. While Wesley published no journal account of the day, his diary indicates that he spent about one and a half hours (1:30–3:00 P.M.) praying and conversing with the Leaders. Cf. *Works*, 19:421.

20. *HSP* (1742), part 2, "The Spirit and the Bride Say, Come!" v. 22, 2:366.

21. "Experience of Ann Gilbert," *AM* 18 (1795): 42-46. Her account had been recommended by Rev. Joseph Taylor, August 1, 1794. The "Experi-

ence" is reproduced here in its entirety, with modernized punctuation and capitalization.

22. See Chilcote, *Wesley and Women*, 145-46; cf. 186-89 concerning the life and work of another Cornish woman preacher, Elizabeth Tonkin. Apparently unfamiliar with the pioneering work of Ann Gilbert, Thomas Shaw mistakenly asserted that Elizabeth was the first woman preacher in Cornwall. See *A History of Cornish Methodism* (Truro: D. Bradford Barton, 1967), 58.

23. Reported in Zechariah Taft, *Biographical Sketches of the Lives and Public Ministry of Various Holy Women*, 2 vols. (London: Mr. Kershaw, 1825, vol. 1; Leeds: H. Cullingworth, 1828, vol. 2), 1:49.

24. Ibid.

25. Ibid., 51, from a letter to Mary Barritt, dated 1798. She was apparently blinded in or about the year 1754. It is impossible to determine exactly when this event of preaching at Redruth took place.

26. Richard "Captain Dick" Williams was still actively involved in the movement in the 1780s, as the only two existing pieces of correspondence from John Wesley to him confirm; cf. Letter of December 10, 1783 in *Letters* (Telford), 7:201-2; and letter of February 15, 1785 in *Letters* (Telford), 7:257.

27. Never mentioned in the *Journal* or *Letters* of John Wesley, this small Cornish village lay in close proximity to Ann's native Gwinear.

28. Searches through the Wesleyan hymn corpus have been unsuccessful in identifying this hymn text.

29. Romans 5:5. Note the personal application of the text.

30. Wesley also described this "carnal state" as the "natural state," following Thomas Boston's familiar scheme of the "fourfold states" of the soul's progress in faith. In this view the soul passes through "natural," "legal," and "evangelical" stages before arriving at the final and ultimate "eternal state." In the carnal state, the individual "neither fears nor loves God" and having "no light in the things of God. . .walks in utter darkness." For a discussion of these stages of faith, see Wesley's Sermon 9, "The Spirit of Bondage and of Adoption," *Works*, 1:263-66.

31. See Editor's introduction to this section and note 52 in particular.

32. *HSP* (1749), vol. 1, part 2, "Hymn 43," 5:64. Orig. "The speechless awe that dares not move."

33. Ann's statement concerning the "grand depositum" of Methodism simply illustrates the uniqueness of this doctrine in the religious culture of the day.

34. For a discussion of the role of women in the practice of "exhortation" in the early Methodist revival see Chilcote, *Wesley and Women*, 100-107.

35. Note the "monastic" pattern of prayer described here. While Hippolytus, a presbyter of the church in Rome during the third century, was the

first to describe seven daily hours of private prayer, St. Benedict, in the early sixth century, established the definitive Western pattern which dominated the monastic setting until shortly after Vatican II. See *The Daily Office*, ed. R. C. C. Jasper (London: SPCK, 1968).

36. She lived about 18 months after composing the "experience," dying on July 18, 1790. Her last recorded words were, "O the glory! the glory! the glory!"

37. This excerpt is taken from "Account of Hannah Harrison," *WMM* 25 (1802): 318-23, 363-68. It is introduced by Joseph Benson and a letter from John Pawson, which relates primary data about her life. Mrs. Harrison presumably dictated the account to a friend on September 1, 1799. There is some confusion over her identity, Taft noting in the margin of his personal copy of *Holy Women* (1:203): "Is this the person whose life is published in the Method. Mag. for 1802?" John Telford, editor of John Wesley's *Letters*, identified her as the wife of Lancelot Harrison, but there is no conclusive evidence to this effect or even to the conjecture of her having been married. The "Account," in fact, asserts that Harrison was her maiden name, and if so, her father may have been Ebeneezer Harrison, a brewer of York. Cf. Chilcote, *Wesley and Women*, 130-40.

38. See John Lyth, *Glimpses of Early Methodism in York and the Surrounding District* (York: Williams Sessions, 1885), 64-68.

39. On November 26, 1768, John Wesley referred to her ministries there in a letter to Jane Hilton: "There seems to have been a particular providence in Hannah Harrison's coming to Beverley, especially at that very time when a peace-maker was so much wanting; and it was a pledge that God will withhold from you no manner of thing that is good" (*Letters* [Telford], 5:113).

40. See J. E. Hellier, "Some Methodist Women Preachers," *Methodist Recorder*, Winter no. 36 (Christmas 1895): 67.

41. *Letters* (Telford), 5:60.

42. Ibid., 5:130. Unfortunately, none of the details concerning this cryptic reference can be reconstructed.

43. A scholar, educator, and conservative Wesleyan bureaucrat, Joseph Benson (1748–1821) was appointed classical tutor at Kingswood School by Wesley in 1766, entered the itinerant ministry in 1771, and served as Conference president on two occasions during the tumultuous decades following Wesley's death. An even greater irony, he preached Hannah's funeral sermon in London on December 27, 1801. For a thorough discussion of his antagonism to the women preachers and a caustic defense of his position, see Chilcote, *Wesley and Women*, 139-40, 157-59.

44. Taft, *Holy Women*, 1:203.

45. In the British context, referred to those who had separated themselves from the Church of England, originally including Roman Catholics but by

the eighteenth century usually restricted to Protestant traditions. It is of interest to note that the Wesley brothers had a strong Dissenter heritage on both maternal and paternal sides of their family, the spirit of which was retained by Samuel and Susanna Wesley in spite of their conversion back to the Anglican tradition.

46. Samuel Larwood was a Methodist itinerant preacher for about ten years, traveled with Wesley in Lincolnshire in 1747, was added to the Conference in 1748, accompanied Wesley to the Irish Conference in 1752 and the English Conference the following year, but left the Methodist Connection to become an independent minister at Zoar Chapel in Southwark some time around 1753. Wesley officiated at his funeral there on November 5, 1755; see Charles Atmore, *The Methodist Memorial; being an Impartial Sketch of the Preachers* (Bristol: Edwards, 1801), 239-40; *Journal* (February 23, 1747), *Works*, 20:158; and Letter to Robert Gillespie (November 9, 1753), *Works*, 26:530.

47. Thomas Mitchell (1726–1785) joined the ranks of Wesley's itinerant preachers in 1748 and nearly lost his life at Wrangle in 1751 when the mob attempted to drown him. See Wesley's discussion of these events in his Letter to the vicar of Wrangle (August 15, 1751), *Works*, 26:474-75.

48. A Yorkshireman, Maskew (1718–1793) distinguished himself as one of early Methodism's most able itinerant preachers. He was born in Otley—not near Bingley in 1713 as is often reported—and was known as "Mr. Grimshaw's man" because of his close association with the evangelical vicar of Haworth and close friend of the Wesleys, William Grimshaw. Wesley is recorded to have said of him: "Ten such preachers as Jonathan Maskew would carry the world before them" (see note 17, *Works*, 26:502). He continued to preach widely throughout northern England even after his marriage.

49. One of Wesley's preachers from Shaftesbury, Haime (1710–1784), a professional soldier, first heard Charles Wesley preach at Brentford but soon thereafter embarked for Flanders. Following the Battle of Dettingen in 1743 he organized a religious society of soldiers. Wesley published his amazing autobiography in the *AM*. A full account of his life stands as the first biographical account in John Telford, *Wesley's Veterans: Lives of Early Methodist Preachers Told by Themselves*, 7 vols. (London: Robert Culley, 1912–1914), 1:1-59.

50. Could this be Ruth Hall (b. 1732), another pioneer of Methodism in York, born at Woolley near Barnsley? See Lyth, *Methodism in York*, 64, 69-71; *AM* 4 (1781): 477; *AM* 12 (1789): 303; and Letter to William Alwood (March 29, 1759), *Letters* (Telford), 4:61.

51. The gift of perfect love or "entire sanctification," which was a consistent theme in the preaching of the Wesleys and their itinerants. For a discussion of the Wesleyan insistence on Christian Perfection as a work of grace, see William Sangster, *The Path to Perfection: An Examination and*

Restatement of John Wesley's Doctrine of Christian Perfection (London: Epworth Press, 1943), 82-86.

52. John Manners (1731–1764), born at Sledmore near Malton, converted under Methodist preaching some time around 1754, but remembered primarily for his important role in the Dublin revival of 1762. John Wesley described him as "a plain man of middling sense, and not eloquent but rather rude in speech—one who had never before been remarkably useful but seemed to be raised up for this single work"; see Wesley's account of this spectacular episode in *Journal* (July 26, 1762), *Works*, 21:375-79; cf. *AM* 3 (1780): 275-76.

53. *HSP* (1740), part 1, "The Resignation," v. 16, 1:268. Cf. *Scripture Hymns*, "Hymn 1313," v. 1, 10:24. The opening lines of this hymn read: "Now, ev'n now, I yield, I yield,/With all my sins to part."

54. Or "select society," a new adaptation to the Methodist Society for those who had received remission of sins and were leading an exemplary life, probably introduced at the London Foundery in 1743. Wesley's purpose in establishing these groups was not only to direct the more earnest seekers how to "press after perfection," but also to "incite them to love one another more, and to watch more carefully over each other." He also looked upon them as "a select company, to whom I might unbosom myself on all occasions, without reserve; and whom I could propose to all their brethren as a pattern of love, of holiness, and of good works." Wesley described this innovation in 1749 in "A Plain Account of the People Called Methodists," *Works*, 9:270, §8); see also Davies's introduction in *Works*, 9:13; and David Lowes Watson, *The Early Methodist Class Meeting* (Nashville: Discipleship Resources, 1985), 120-21.

55. The remainder of this account, while not written by Hannah, purports to be an eyewitness account of her final words and, therefore, is included here.

56. *Funeral Hymns* (1759), 2d Ser., "Hymn 3," v. 9, 6:220. Orig. "O what are all my sufferings here."

57. Rufus M. Jones, *The Later Periods of Quakerism*, 2 vols. (London: Macmillan, 1921), 1:198. On her life, see *The Life of Mary Dudley*, ed. Elizabeth Dudley (London: J. and A. Arch, 1825); Taft, *Holy Women*, 2:149-77; Jones, *Quakerism*, 1:237-42, 274-78; and Chilcote, *Wesley and Women*, 161-63, 179-84.

58. The letter of February 1748, written apparently to Stephen Plummer of Paulton near Bristol, outlined the essentials of the Christian faith in fifteen propositions according to Robert Barclay's *Apology for the True Christian Divinity* and pointed out the differences between Quakerism and Christianity. It was soon published and passed through no fewer than three editions that same year.

59. *Letters* (Telford), 5:335; cf. *Journal* (April 22, 1778), *Works*, 23:81. From 1820 she resided in London, where she died at her home at Peackham on September 24, 1823, and was interred in the Friends' Cemetery near Bunhill Fields in the shadow of Wesley's City Road Chapel.

60. The neighboring community to Bristol.

61. *HSP* (1739), "John 16:24," 1:194. The middle of verse 12 reads in its entirety:

> Holy Ghost, no more delay!
> Come, and in thy temple stay!
> Now thine inward witness bear,
> Strong, and permanent, and clear;
> Spring of life, thyself impart,
> Rise eternal in my heart!

62. *HSP* (1749), vol. 2, part 1, "On the Loss of His Friends," v. 5, 5:185.

63. *WMM* 31 (1808): 372-75, 410-15, 461-69, 516-18, 562-67, 595-97.

64. Edward Young, *The Complaint: or Night Thoughts on Life, Death, and Immortality* (1742–1746), Night 4, in *Complete Works* (n.p., 1854), 378-80. Edward Young (1683–1776), a popular poet of the mid-eighteenth century, is remembered primarily for this work. One of Charles Wesley's favorite poets, the hymn-writer transcribed *Night Thoughts* during the summer of 1754 and incorporated many of its lines into his own poetic expression. Cf. Henry Bett, *The Hymns of Methodism* (London: Charles H. Kelly, 1913), 104-8.

65. It proved to be a constant challenge to keep interest alive in this central Methodist institution. After the death of Wesley at the close of the eighteenth century and as the Methodist movement evolved into an institutional church (especially by the mid-nineteenth century), the dissolution of the classes and bands was fairly rapid. See the interesting discussion provided by J. Artley Leatherman in "The Decline of the Class Meeting," in *Spiritual Renewal for Methodism*, ed. Samuel Emerick (Nashville: Methodist Evangelistic Materials, 1958), 38-49.

66. As an act of devotion Isabella often wrote out her prayers to God. Several examples of these follow.

67. Drawn from the courtship imagery of the Song of Solomon, and the particular verse which reads, "His speech is most sweet, and he is altogether lovely. This is my beloved and this is my friend, O daughters of Jerusalem" (5:16), this is a pervasive phrase in the writings of early Methodist women. Mary Bosanquet's small tract, *Jesus, Altogether Lovely*, published in Bristol in 1766, undoubtedly increased its popularity and general Methodist usage.

68. See the Charles Wesley hymn, "Jesus, Lover of My Soul," perhaps the most famous of all his hymns, first published in the 1739 collection of *HSP*. A hymn rooted essentially in the Psalmist's cry (17:8; 27:5), the description of Jesus as the "lover of souls" (Wisd. of Sol. 11:26) rests ultimately in the remembrance of his promise of eternal life.

69. Searches through the Wesleyan hymn corpus have been unsuccessful in identifying this hymn text.

70. This entire paragraph is little more than a catena of scriptural passages drawn from many different parts of the biblical corpus. The paragraph opens with the repeated refrain of the ancient historians (cf. 1 Sam. 25:32; 2 Sam. 18:28; 1 Kings 1:48; etc.). The "wickedness" references are drawn from 1 John 5, while the "Captain of salvation" imagery is taken directly from Heb. 2:10. Psalm 46:2 follows with its earthquakes and shaken mountains, and the deliverance of the God of Jacob in verse 11. She then turns to the apocalyptic imagery of Revelation 6 and 8, the paragraph concluding with a paraphrase of Isa. 35:10: "And the ransomed of the Lord shall return, and come to Zion with singing; everlasting joy shall be upon their heads; they shall obtain joy and gladness, and sorrow and sighing shall flee away."

71. The annual practice of most Methodists, using the well established Service of Covenant Renewal, urged on all of Wesley's followers as early as 1747 but held formally for the first time at the French Church in Spitalfields on August 11, 1755. Cf. David Tripp, *The Renewal of the Covenant in the Methodist Tradition* (London: Epworth Press, 1969).

Part 2. Diaries, Journals, and Memoirs

1. Having broached the issue of priestly ordination with his parents, John Wesley received a reply from his mother, including these words: "I heartily wish you would now enter upon a serious examination of yourself, that you may know whether you have a reasonable hope of salvation by Jesus Christ" (*Works*, 25:160). Shortly thereafter he began to keep a diary (a daily practice he would continue for the rest of his life), the entries of which are best characterized by the phrase, "meditative piety." Diaries and journals such as these often provided the raw material for the more reflective accounts of religious experience frequently requested by the Wesleys. These resources make the lives of some of the early Methodists, and certainly that of Wesley, the most fully documented of any age. See Richard P. Heitzenrater, "The Careful Diarist," in *The Elusive Mr. Wesley*, 2 vols. (Nashville: Abingdon Press, 1984), 1:51-55.

2. For developments related to autobiography as a literary genre during this period, see in particular, "Autobiography in Wesley's Later Years and After," *Works*, 18:105-19.

3. *Memoirs of Mrs. Elizabeth Mortimer*, ed. Agnes Bulmer, 2d ed. (London: J. Mason, 1836), 10-11.

4. Paul W. Chilcote, "Songs of the Heart: Hymn Allusions in the Writings of Early Methodist Women," *Proceedings of the Charles Wesley Society* 5 (1998): 99-114.

5. "Account of Hannah Harrison," *WMM* 25 (1802): 367; *Funeral Hymns* (1759), 2d Ser., "Hymn 3," v. 9, 6:220.

6. "An Account of Mrs. Crosby, of Leeds," *WMM* 29 (1806): 611; *HSP* (1739), part 1, "Grace After Meat," v. 4, 1:34.

7. The most thorough study of this service is David Tripp, *The Renewal of the Covenant in the Methodist Tradition* (London: Epworth Press, 1969). Cf. John Bishop, *Methodist Worship in Relation to Free Church Worship* (n.p.: Scholars Studies Press, 1975); and Paul W. Chilcote, "Renewing Our Covenant with God," *The Methodist*, 3 (1990): 2, 14.

8. The modern text of "A Covenant Prayer in the Wesleyan Tradition," *The United Methodist Hymnal* (Nashville: The United Methodist Publishing House, 1989), 607.

9. The definitive study of this distinctive Methodist service of worship is Frank Baker, *Methodism and the Love-Feast* (London: Epworth Press, 1957); cf. Paul Wesley Chilcote, *John Wesley and the Women Preachers of Early Methodism* (Metuchen, N.J.: Scarecrow Press, 1991), 97-99.

10. This was the first solely Methodist Society organized in London by Wesley toward the end of 1739. He later withdrew to this Society with his supporters from the Moravian Fetter Lane Society when the "Stillness Controversy" divided that fledgling community. Derelict and requiring extensive repairs (but soon to become the headquarters of Wesleyan Methodism in London), the former royal foundry for cannon in Moorfields provided rooms for small group fellowship, a school, Wesley's living quarters, and a spacious room accommodating as many as fifteen hundred people. The first Wesleyan preaching house in London, the Foundery Society held regular services daily: early morning and early evening. See Curnock's extended note, *Journal* (Curnock), 2:316-19.

11. In 1749 Grace married one of Wesley's itinerant preachers, John Bennet, through the intervention of Charles Wesley. On the life and work of Grace Murray Bennet, see William Bennet, *Memoirs of Mrs. Grace Bennet* (Macclesfield: Printed and sold by E. Bayley, 1803), from which the following account is drawn.

12. Ibid., 19; cf. William Bennet, *A Treatise on the Gospel Constitution* (London: Sold by B. I. Holdsworth, 1822), 8; notes to Journal entry (March 2, 1747), *Journal* (Curnock), 3:284; and the following from *Works*, 20: (August 16, 1748), 239; (August 26, 1748), 243; (September 6-24, 1749), 297-301; and (February 2, 1751), 378.

13. *Methodist Recorder,* Winter no. 43 (Christmas 1902): 21-32. This account, which sympathized greatly with Grace, was modified somewhat in his discussion of relevant portions of Wesley's *Journal* (See *Journal* [Curnock], 3:284, 367, 371, 395, 416-40). At best, it is difficult to harmonize some of his statements with those more sympathetic to Wesley in Luke Tyerman, *The Life and Times of the Rev. John Wesley, M.A.,* 3 vols. (London: Hodder and Stoughton, 1870–1871), 2:42-57, who is followed by Abel Stevens, in both *The Women of Methodism: Its Three Foundresses—Susanna Wesley, the Countess of Huntingdon, and Barbara Heck* (New York: Carlton and Porter, 1886), 114-28, and *The History of the Religious Movement of the Eighteenth Century Called Methodism,* 3 vols. (London: Wesleyan Methodist Book Room, 1878), 3:406-12.

14. See the definitive presentation of the evidence for their *de praesenti* marriage in Frank Baker, "John Wesley's First Marriage," *London Quarterly and Holborn Review,* 192 (1967): 305-15.

15. See the accurate reproduction with narrative and notes in Augustin Leger, *Wesley's Last Love* (London: J. M. Dent and Sons, 1910), 118.

16. *HSP* (1749), vol. 1, part 2, "Hymns for Believers—In the Work," v. 4, 5:24.

17. *HSP* (1739), part 2, "The Believer's Support," v. 6, 1:138. Translated by John Wesley from the German hymn of the Herrnhut Collection.

18. The opening line of the concluding verse of the famous hymn, "Come, Thou Fount of Every Blessing," written by Robert Robinson (1735–1790) as an exuberant act of praise in 1758, and based on 1 Sam. 7:12. Converted under the preaching of George Whitefield in 1752 and influenced by the ministry of Wesley, Robinson felt called to a preaching ministry himself and devoted the major portion of his life to a large Baptist church in Cambridge where he was well known as an able minister and scholar.

19. According to her son, Grace "was the principal person employed by [Wesley] to organize the female classes of his connection" (Bennet, *Gospel Constitution,* 8).

20. Grace refers here to Wesley's published *Journal,* the first extract of which appeared to the public in 1740. For a full discussion of the *Journal,* see *Works,* 18:1-119.

21. The "imputation of righteousness" refers to God's action for the believer in Jesus Christ by which the sinner is declared righteous in the experience of justification by grace through faith. Wesley's lifelong concern for the doctrine of salvation led him into many complex discussions of both imputed and imparted righteousness. According to Albert C. Outler, "His goal was an alternative to both of the older polarizations that had separated the notions of Christ's *imputed* righteousness in justification from an actual *imparted* righteousness" (*Works,* 1:63). To put it simply, he was con-

cerned that his followers actually become righteous and that God declare them righteous in Christ. For a thorough discussion of these issues, see Randy L. Maddox, *Responsible Grace: John Wesley's Practical Theology* (Nashville: Kingswood Books, 1994), 101-6.

22. Cf. Acts 27:29. This is the biblical text on which the only extant sermon preached by a woman during the eighteenth century was based, namely, that of Mary Fletcher. For a full text of the sermon, see Chilcote, *Wesley and Women*, 321-27.

23. Meaning worthy of awe, awe-full.

24. The most thorough account of her life and work is that of Chilcote, *Wesley and Women*, 118-34, 149-71, 200-207, 243-59. Cf. Frank Baker, "John Wesley and Sarah Crosby," *PWHS*, 27 (1949): 76-82; Earl Kent Brown, *Women of Mr. Wesley's Methodism* (New York: The Edwin Mellen Press, 1983), 166-75; Paul Wesley Chilcote, *She Offered Them Christ* (Nashville: Abingdon Press, 1993), 62-93; and Thomas M. Morrow, *Early Methodist Women* (London: Epworth Press, 1967), 9-26. For an extensive bibliography, consult Chilcote, *Wesley and Women*, 256-59.

25. They carried on a lengthy correspondence of some thirty-two years (1757–1789). No fewer than twenty-four of Wesley's letters to her are extant, the earliest letter dated June 14, 1757, his response to her inquiries here noted. The full text of these letters is available in *Letters* (Telford), 3:216-17; 4:132-33; 5:46, 130-31, 257-58; 6:184-85, 192, 290-91; 7:329, 331, 383; 8:105 (twenty-one letters in all); *PWHS*, 19 (1934): 173-74 (one letter); and MS Letterbook, 1760–1774, Crosby Papers, Perkins Library, Duke University (two letters). These will eventually all appear in *Works* 27 and later volumes.

26. Born in 1740 and awakened under the preaching of Rev. J. Berridge, Elizabeth became one of the most noteworthy women preachers of the north, traveling extensively throughout Yorkshire, Lancashire, and Derbyshire. Subsequent to her preaching in the Methodist Chapel at Sunderland on October 22, 1775, she became embroiled in a controversy over the propriety of her actions, and exchanged letters with Joseph Benson (emerging antagonist to the women preachers), Wesley, and Robert Empringham concerning her work. For an account of this incident, see Chilcote, *Wesley and Women*, 156-59. For unknown reasons, Elizabeth discontinued preaching in 1780, died in London on March 13, 1798, and was interred at the City Road Chapel.

27. Taft, *Holy Women*, 1:23-24. According to Mary Taft, Sarah Crosby wrote "upwards of 5000 pages, filled several octavo books, and intended *her life and labours* to be given to the religious world. Her intimate friends, now living *still* wish it, but, I am told, they were lent to a person who will neither give them up nor publish them himself." Mary Taft, *Memoirs of the Life of Mrs. Mary Taft: Formerly Miss Barritt*, 2 vols., 2d ed., enlarged (York: Printed

for and sold by the author, 1828; Devon: Published and sold by S. Thorpe, 1831), part 3, 116.

28. For an extended discussion of the introduction of Methodism to this northern city, see Chilcote, *Wesley and Women*, 118-23. The Dobinsons were London Methodists who had come under the influence of William Romaine and Wesley. They had moved to Derby in 1761 and carried their faith with them into this new area with the help of Sarah Crosby. Wesley's visit to Derby the following year, on August 15, was his effort to consolidate their labor in the face of "many threatenings from some of the magistrates and much opposition and discouragement in various ways." His next visit was not until March 27, 1764. Cf. *Works* 21: *Journal* (August 15, 1752), 385-86; and *Journal* (March 27, 1764), 447-48.

29. Dreams and visions figured prominently in the writings of early Methodist people—the women in particular. They were often woven into narrative reflection on important religious experiences. Wesley offered guidance concerning these phenomena but, while recognizing their validity and importance, also raised frequent caution concerning the "enthusiasm" they entailed. In June 1739, in the midst of an outbreak of supernatural phenomena including dreams, visions, and paroxisms of various sorts, he laid down what would become a guiding principle: "they *might* be from God and they *might not*, and were therefore not simply to be relied on (any more than simply to be condemned) but to be tried by a farther rule, to be brought to the only certain test, 'the law and the testimony' " (*Journal* [June 22, 1739], *Works*, 19:73). Cf. Henry D. Rack, *Reasonable Enthusiast: John Wesley and the Rise of Methodism* (London: Epworth Press, 1989), 424-25, 434-35; *PWHS*, 46 (1987): 38-44, 57-69; and for references to dreams in the Wesleyan sermon corpus, see *Works*, 2:54, 130, 134, 289, 577; 3:12, 27, 165; 4:17, 108, 110-12.

30. She refers here to her participation in the sacrament of Holy Communion.

31. This account, very reminiscent in both general impression and detail of Susanna Wesley's Epworth experiences, has worked its way into early Methodist lore through constant repetition. Cf. Chilcote, *Wesley and Women*, 135-36 for expanded reference. Sarah knew that she had come perilously close to preaching and immediately wrote to Wesley seeking his advice concerning this unconventional course of events. Frank Baker points out that he "does not seem to have been unduly worried, for his answer was not despatched until three days after he had received her letter, on February 14" (Baker, "John Wesley and Sarah Crosby," 78).

32. Fasting was one of the "means of grace" which Wesley highly commended to his followers. Not only a private "work of piety," he also established periods of time within the life of particular Societies, or within the

Connection as a whole, for the purpose of prayer and fasting. The so-called "Tables and Rules" of the *BCP* established basic guidelines for this practice, which the Wesleys were resolute in following. Their asceticism was moderate by comparison with rigorists and ascetics, both historical and contemporary. Wesley deals extensively with the matter of fasting in Sermons 5 and 7 of the "Sermon on the Mount," *Works*, 1:550-71, 592-611. Cf. Henry H. Knight, *The Presence of God in the Christian Life: John Wesley and the Means of Grace* (Lanham, Md.: Scarecrow Press, 1992), 116-22; and Steve Harper, *Devotional Life in the Wesleyan Tradition* (Nashville: Upper Room Books, 1983), 47-52.

33. This inner conviction was strengthened by Wesley's reassuring letter of February 14, which reads in part: "I think you have not gone too far. You could not well do less. . . . Go on calmly and steadily. If you have time, you may read to them the *Notes* on any chapter before you speak a few words, or one of the most awakening sermons, as other women have done long ago" (quoted in Chilcote, *Wesley and Women*, 122). This event, and Wesley's qualified approval of Sarah's actions, marks the beginning of his acceptance of women preachers! On Sarah's continuing work as a preacher, see Chilcote, *Wesley and Women*, 118-34, 142, 149, 151-62, 169-71, 198-201.

34. *HSP* (1739), part 2, Charles Wesley's conversion hymn, "Christ the Friend of Sinners," v. 2, 1:91.

35. *HSP* (1749), vol. 1, part 1, "After a recovery," v. 18, 4:447. Note the paradoxical imagery reminiscent of the radical reversals in the writings of St. Augustine.

36. It is clear that Sarah took the advice of Wesley's February letter, with its unmistakable reference to his mother's activities in the Epworth rectory, in her reading a sermon to the gathered assembly.

37. *HLS* (1745), "Hymn 21," 3:229.

38. The great hymn of Charles Wesley, "Wrestling Jacob," provides a lyrical explication of this central Christian, and particularly Pauline, paradox based on 1 Cor. 15:10, 2 Cor. 12:10, and Gal. 2:20 (among other texts) with its constant refrain, "Not I, but Christ/grace." Select verses read: "When I am weak, then I am strong;/And when my all of strength shall fail/I shall with the God-man prevail." "Yield to me now—for I am weak,/But confident in self-despair!" "All helplessness, all weakness, I/On thee alone for strength depend." *Works*, 7:250-52.

39. Here is Sarah's simple articulation of the Wesleyan principle of "singularity," what Wesley sometimes described as the "infallible rule," the desire and intention to be conformed to the *imago Christi*. His sermon "On a Single Eye" opens with reference to Thomas à Kempis's *Imitation of Christ*: " 'Simplicity and purity', says a devout man, 'are the two wings that lift the soul up to heaven; simplicity, which is in the intention, and purity, which is

in the affections' " (*Works*, 4:120). On the recurring theme of singularity and purity of intention based on the imagery of Matt. 6:22-23, see *Works*, 1:339, 573-76, 608-9, 672-73; 4:120-25, 371-77.

40. The Leytonstone circle of women, with Mary Bosanquet at their head, had been advised frequently to move to some part of Yorkshire and resettle their community on a farm. Such a move, it was argued, would relieve some of the financial pressures, which were a constant burden, and would also provide a more conducive environment for the raising of the orphans under their care. The arrival of Richard Taylor from Yorkshire, and his offer to assist them in such a resettlement, seemed to be a sign of providence. The entire community, including Mary, Sarah Ryan, Ann Tripp, Sarah Crosby, and their family of dependents and orphans, began their arduous journey north on June 7, 1768. They eventually settled at Cross Hall, a farmhouse near Morley in the general vicinity of Leeds. Unfortunately, Sarah Ryan died on August 17, 1768 and was buried in the Leeds Old Churchyard. The bodies of Sarah Crosby and Ann Tripp were subsequently laid to rest along with this aspiring woman preacher. See Hellier, "Some Methodist Women Preachers," 66; cf. Chilcote, *Wesley and Women*, 129-31; and Baker, "John Wesley and Sarah Crosby," 82.

41. Cf. the concluding lines of the famous Charles Wesley hymn, "Love Divine, All Loves Excelling," *Redemption Hymns* (*Works*, 7:545).

42. *HSP* (1742), part 1, "After a Recovery," 2:125-26. The stanza in its entirety reads:

> To thy cross, thine altar, bind
> Me with the cords of love;
> Freedom let me never find
> From my dear Lord to move:
> That I never, never more
> May with my much-loved Master part,
> To the posts of mercy's door,
> O, nail my willing heart.

For an interesting allegory, see Exod. 21:2-6.

43. A major fishing center on the northeast coast of England, site for the famous Synod of Whitby (A.D. 664) which severed the British Church connection with the old Irish (Celtic) Church in favor of Rome and ended the so-called Paschal Controversy in the West.

44. It is not possible to identify this residence with certainty. In 1781, when Mary Bosanquet married John Fletcher and the Cross Hall circle of women dissolved, Sarah moved to Leeds with Ann Tripp, where, according to J. E. Hellier, they took up residence in the historic "Old Boggard House"

(J. E. Hellier, "The Mother Chapel of Leeds," *Methodist Recorder*, winter no. 35 [Christmas 1894]: 62-67). This was a small house adjoining the parent chapel of the original Methodist Society in Leeds. On April 3, 1785, Wesley wrote to Sarah from Manchester and expressed his pleasure regarding her full employment in the circuit. Together with Ann, she assumed leadership of a strong and influential band of women preachers styled, with unconscious humor, as the "Female Brethren." Cf. Chilcote, *Wesley and Women*, 198-201. After this period, it is difficult to follow her movement.

45. *HSP* (1739), part 1, "Grace After Meat," v. 4, 1:34. Note the change from plural to singular, and from past to present, in the original: "For more we ask, we open then."

46. See part 1, note 71 and part 2, introduction on the Methodist service of covenant renewal.

47. Very little research has been done on her life beyond summary biographical sketches based on the *Experience*. The most concise and helpful of such sketches is that of Morrow in *Early Methodist Women*, 40-63. Cf. *AM* (1793): 93-100, 155-60; and *WMM* (1840): 823-25. Her journals are preserved in the *Meth. Arch.* The text has been modernized with regard to punctuation and capitalization.

48. Selina Hastings, Countess of Huntingdon (1707–1791), joined the Wesleys' Methodist Society in 1739 at the very outset of the Evangelical revival and, after her husband's death in 1746, devoted herself exclusively to social and religious work, becoming one of the chief means of introducing Methodism to the upper classes. After 1779, as a consequence of legal decisions that opposed her appointment of "Anglican chaplains," she registered her chapels as dissenting places of worship and in the theological disputes between Wesley and George Whitefield defended the Calvinistic evangelicalism of the latter. Despite this theological rift, Wesley continued to carry on a rather voluminous correspondence with her, one of his favorite correspondents. While no adequate biography of the Countess has been produced, consult A. C. H. Seymour, *The Life and Times of Selina, Countess of Huntingdon*, 2 vols. (London: Painter, 1840); and F. F. Bretherton, *The Countess of Huntingdon*, Wesley Historical Society Lecture, no. 6, 1940.

49. William Richardson (1745–1821) was ordained to the Curacy at Kirby Moorside near Pickering in 1768. It was in 1771 that he began a fifty-year ministry in York where he was incumbent of St. Michael-le-Belfrey and St. Sampson. He died in York on May 17, 1821.

50. Unfortunately, nothing is known of this devout Anglican laywoman other than what can be gleaned from Frances's journal. There are no references to her in either Wesley's *Journal* or *Letters*. There would seem to be no apparent relationship between her and the famous female revivalist of Leeds, Ann Carr, of the next generation. See D. Colin Dews, "Ann Carr and

the Female Revivalists of Leeds," in Gail Malmgreen, ed., *Religion in the Lives of English Women, 1760–1930* (Bloomington: Indiana University Press, 1986), 68-87.

51. Her identity remains elusive.

52. An Anglican nonjuror and Christian devotional writer, William Law (1686–1761) exerted a critical influence on Wesley, especially through his writings on Christian Perfection, the first of which was published in 1726. Law's *Serious Call*, the most famous of all his writings, was equally influential on many within the Methodist movement and was inspired by the practical mysticism of the Christian devotional heritage represented, in particular, by Thomas à Kempis. The central emphasis of the work is on the virtues practiced in every day life, namely, temperance, humility, and self-denial. It remains one of the most influential post-Reformation spiritual classics, second only, perhaps, to John Bunyan's *Pilgrim's Progress*. For Wesley's introduction to the Law material, see *PWHS*, 37 (1969–1970): 78-82, 143-50, 173-77. Wesley published his own extract of this work in 1744, which may be the edition referred to here. For a discussion of the relationship between Law and the Wesleys, see William Green, *John Wesley and William Law* (London: Epworth Press, 1945).

53. In 1760 Wesley published a small tract entitled "Advice to the People called Methodists with regard to Dress" (*Works* [Jackson], 11:466-77), which he appended to his fourth volume of *Sermons on Several Occasions* and in which he admonished his followers to frugality and plainness. Cf. his later sermon, a sequel to "The Danger of Riches," titled simply "On Dress," which appeared in installments in the *AM* 10 (1787) (*Works*, 3:247-61).

54. Her initial encounter with this first woman preacher of early Methodism.

55. Active member of the Methodist Society in York.

56. This would appear to be Frances's first encounter with Wesley. On the ninth, he simply records in his *Journal*, "I preached at Pocklington and York." He spent several days in York and the surrounding area noting that he was "in the morning and evening at York" (*Works*, 22:420).

57. Curnock identifies this Yorkshire Methodist as Mrs. Bathsheba Hall, not to be confused with her namesake of Bristol. She died at York several years later, on March 2, 1779, and was buried March 5 by the Methodist preacher, Thomas Hanson, who preached her funeral sermon. See Journal entry (July 10, 1774), *Journal* (Curnock), 6:31; and Journal entry (July 2, 1776), *Journal* (Curnock), 6:114. Cf. Taft, *Holy Women*, 1:52.

58. According to Frances's journal, this meeting took place on July 12, and her comments are consistent with Wesley's record of a quarterly meeting held on that day.

59. John Fletcher [Jean Guillaume de la Fléchère] (1729–1785), born in Nyon, Switzerland, became tutor to a family in English Shropshire in 1752

through a series of accidents. He was converted under Methodist preaching in 1755 and ordained an Anglican Deacon and Priest on successive Sundays in 1757. In 1760 he became vicar of Madeley, the pastoral position he retained to the end of his life. It was Wesley's desire that Fletcher succeed him as principal leader of the Methodist Societies at his own death, but Wesley's longevity precluded that hope. On November 12, 1781 he married Mary Bosanquet at Batley Church, near her Cross Hall orphanage in Yorkshire. While Fletcher is remembered, more than anything else, for his sanctity, he stands out as the first truly significant theologian in the Methodist tradition. During the tempestuous Calvinistic Controversy of the early 1770s, he argued Wesley's Arminian position with regard to faith and works in a clear, balanced, and compelling manner. In his *Checks to Antinomianism* (the first installment of which was published in 1771) he carefully lays out the Arminian arguments against the prevailing Calvinistic interpretation of predestination. His emphasis, as was Wesley's, is on the fusion and balance of God's sovereign grace and human moral responsibility. For a modern edition of his "First Check to Antinomianism," see *The Works of the Reverend John Fletcher* (New York: B. Waugh and T. Mason, 1935), 1:11-39; cf. Thomas A. Langford, *Wesleyan Theology: A Sourcebook* (Durham, N.C.: Labyrinth Press, 1984), 23-34; David C. Shipley, "Methodist Arminianism in the Theology of John Fletcher" (Ph.D. diss., Yale University, 1942); and Luke Tyerman, *Wesley's Designated Successor* (London: Hodder and Stoughton, 1882).

60. William Hunter (1728–1797), a Methodist preacher native to Northumberland, was taken into full connection in 1767 and included in Wesley's "Deed of Declaration" in 1784. Methodist leaders drew up an account of his preaching for Wesley which he published in *Journal* (June 4, 1772), *Works*, 22:331-33.

61. George Story (1738–1818), of Hasthill, West Riding, Yorkshire, is said to have been the first preacher admitted to the Methodist Connection on trial in 1762. He served as editor and superintendent of the printing office and was named by Wesley in the 1784 "Deed." See Thomas Jackson, *Lives of the Early Methodist Preachers* (n.p., 1837–1838), 5:218-40.

62. By reference to these authors Frances demonstrates her familiarity with a formidable literature and the difficult controversies that revolved around the question of the "imputation of Christ's righteousness," a central concern fueling the Calvinistic controversy of the decade. The most critical of the Calvinistic apologists to whom she refers here, James Hervey (1714–1758), had been a member of the Wesleys' Holy Club in Oxford but shifted to the Calvinist wing of the Evangelical revival to become one of Wesley's theological critics. In 1755 he published a major three-volume defense of Calvinism, *Theron and Aspasio*, in which he articulates a doctrine of "imputed righteousness" that aroused Wesley's concern. As Henry Rack

has observed: "Wesley saw the doctrine as unscriptural, unnecessary and in fact misleading and dangerous. It implied, he thought, that sinners were viewed by God as being still sinners but clothed by a kind of legal fiction in the protective righteousness of Christ" (Rack, *Reasonable Enthusiast*, 452-53). In this doctrine, in other words, were sown the seed of Wesley's greatest fear, namely, antinomianism. A pamphlet warfare ensued (See *Works* [Jackson], 10:298-306, 317-57). This painful controversy may also be traced in Luke Tyerman, *The Oxford Methodists* (New York: Harper & Brothers, 1873), 285-333. On the broader dynamics of this episode, see Rack's treatment of "Methodism in the 1770s and the Calvinistic Controversy" in *Reasonable Enthusiast*, 450-70.

63. Ulrich Zwingli (1484–1531), famed Swiss humanist reformer of Zurich and author of *Eine kurze christliche Inleitung* (1523), which explicated the relation between law and gospel.

64. That is, the Liturgy of the *BCP*.

65. See *BCP*, "The Second Collect at Evening Prayer."

66. James Stillingfleet (1729–1817), Anglican clergyman, was fellow of Merton College and, in association with Thomas Haweis, a leader of the Oxford Evangelicals. He is not to be confused with Edward Stillingfleet of the previous century whose Latitudinarian churchmanship was so influential on Wesley and his decision for the ordinations of 1784.

67. Frances's future husband, John Pawson, learned of Sarah's work at this time and dined with her on May 2, 1775. "He told me that he had heard that I had meetings at the preaching house at Halifax and Bradford and that they were filled with people, and said I was very welcome to have my meetings at the preaching house in Leeds if I pleased, for which I thanked him" (Taft, *Holy Women*, 2:84).

68. Identity uncertain.

69. There is no question that Wesley considered the "doctrine of Christian Perfection" one of his most important contributions to the development of Christian thought. In a letter of 1790, at the close of his life, he described this doctrine as "the grand depositum which God has lodged with the people called Methodist" (Letter to Robert Carr Brackenbury [September 15, 1790], *Letters* [Telford], 8:238). This doctrine, however, was extremely controversial and called for his defense on many occasions. In 1766 he responded to charges of theological inconsistency with *A Plain Account of Christian Perfection*, in which he quotes extensively from earlier works in an effort to demonstrate the consistency of his thinking and practice with regard to this "flying goal" of the Christian life. It is considered by many to be Wesley's magnum opus.

70. Undoubtedly speaking here of his many writings on sanctification and Christian Perfection, as she had been struggling with these questions for some time.

71. It was very common for Methodist women to conduct spiritual direction through correspondence. It has not been possible for me to consult this letter, if it is in fact extant. It is not mentioned in Mary Fletcher's journal but could very well be among her many letters in the Fletcher-Tooth Collection of the *Meth. Arch.*

72. See John Lyth's discussion in *Glimpses of Early Methodism in York and the Surrounding District* (York: Williams Sessions, 1885), 122-25.

73. Wesley arrived in York on July 2. Frances would have heard Wesley preach on one of his favorite texts, Ephesians 2:8, that evening. On Wednesday he preached on "the fashionable religion vulgarly called *morality*," and he demonstrated by his own account that "it is neither better nor worse than *atheism*." On Thursday, July 4 (while other critical developments were afoot in the American colonies) they met with him in the class meetings and shared other religious exercises (*Works*, 23:22).

74. Elizabeth Ritchie (later Mortimer).

75. Apparently husband of the Mrs. Caley associated with one of Wesley's favorite correspondents, Miss J. C. March, from whom John Pawson had "derived great benefit from their conversation and experience in the deep things of God" (see the introduction to Letter to Miss J. C. March [January 30, 1762], *Letters* [Telford], 4:170).

76. See note 45.

77. Not to be confused with the Bathsheba Hall of selection 4.

78. Born in Horbury, Yorkshire, Thomas Hanson (1734–1804) was converted to Methodism by his brother, Joseph. At that time, apprenticed to a clothier, he set himself to learn Greek and Latin and to read Wesley's Works as well as the *Christian Library*. He was admitted to full connection in 1760. His biographer described him as a "plain, honest, faithful, zealous man" (*WMM* 1805).

79. Wesley simply opens his *Journal* entry for May 7, 1779 with the cryptic remark, "After having visited the intermediate societies," making no mention of his preaching at York (*Works*, 23:130).

80. See part 2 of Wesley's sermon on the limitations of reason entitled "The Case of Reason Impartially Considered," based on the same Pauline text (*Works*, 2:593-600). Cf. similar references in *Works*, 1:60, 258; 2:172.

81. In 1741 Wesley published *An Extract of the Life of Monsieur de Renty*, which was, in fact, an abridgment of the Sheldon translation of Jean Baptiste de Saint-Jure's *Life of De Renty* (London, 1658). Gaston Jean Baptiste de Renty (1611–1649) was a Roman Catholic whom Wesley considered to be a kindred spirit, often referring to his life as a standard of perfect love. Cf.

David Butler, *Methodists and Papists: John Wesley and the Catholic Church in the Eighteenth Century* (London: Darton, Longman & Todd, 1995), 137-63.

82. Thomas à Kempis (ca. 1380–1471), Roman Catholic spiritual writer and practical mystic, was one of the most influential forces in Wesley's early life and continued to be one of the most frequently quoted authors in Wesley's own works throughout his life. Wesley was dissatisfied with the 1698 Stanhope translation of *The Imitation of Christ* and prepared his own edition which was published under the title *The Christian Pattern* in 1735, Wesley's third publication. It is certainly this edition to which Frances refers.

83. An active York Methodist; identity otherwise uncertain.

84. Thomas Taylor (1738–1816), one of the most widely traveled itinerants in Wesley's day, served after 1761 in Wales, Ireland, Scotland, and no fewer than twenty-two circuits in England. Ordained by Wesley in 1791, he was elected Conference president in 1796 and 1809.

85. Published by Mary Bosanquet in 1766, this tract was actually a letter written from Hoxton on March 10, 1763, on the eve of her creation of the Leytonstone Orphanage and School. This tract exerted tremendous influence on the women of the Methodist movement and was remarkable in its advocacy of semi-monastic communities for women and its exposition of the monastic vows of chastity, poverty, and obedience. See Paul W. Chilcote, "An Early Methodist Community of Women," *Church History* 38 (2000): 219-30.

86. Joseph Taylor (1752–1830) was born in Driffield near Derby and was taken into the itinerancy on trial in 1777. In 1785, along with John Pawson and Thomas Hanby, he was ordained by Wesley for ministry in Scotland. He was elected to the Conference presidency in 1802. Cf. *WMM* 53 (1830): 642-43.

87. She married Rev. John Pawson on August 14, 1785, just two weeks after Wesley had ordained him for ministry in Scotland. They went immediately to Edinburgh where they stayed for two years. It was here that she developed a relationship with Lady Maxwell.

88. Frequent correspondent of Wesley's between 1756 and 1783, Dorothy Furley was married to John Downes, one of Wesley's most trusted and admired preachers, around 1763 or 1764. It was Dorothy who first introduced Sarah Crosby to Mary Bosanquet at her home in London (where she had been an active member of the Foundery Society) prior to her marriage to Downes. Cf. *Letters* (Telford), 3:208, 214, 217-20, 228, 230; 4:5, 14, 70, 97, 132, 188, 220, 225, 245; 6:226, 233, 365; 7:94, 96, 197.

89. Samuel Furley (1732–1795), a Cambridge-trained Anglican clergyman, was appointed by Henry Venn as Perpetual Curate of Slaithwaite in 1762 but after 1766 served as vicar of Roche near St. Austle, where he joined the evangelical incumbents in Cornwall.

90. An active Leeds Methodist; identity otherwise uncertain.

91. Wesley's diary places him in Leeds on Friday, April 30, having arrived there shortly prior to dinner (*Journal* [Curnock], 8:62). It is probable that Sutcliffe improperly transcribed May 14 for 4. There is no journal account to fill in the detail of this visit. Wesley does note preaching on his favored text, Eph. 2:8, in the evening service.

92. Andrew Blair (ca. 1748–1793), noted Irish revivalist preacher, who first heard Methodists in 1768, was central to the Irish revival which broke out in the 1770s and was admitted on trial into the Methodist itinerancy in 1778. While serving in the Sligo Circuit, he became a good friend of Rev. James Creighton, curate of Swanlinbar, and from 1784 assisted James Rogers in his Irish ministry.

93. Another important Leeds Methodist who remains essentially anonymous.

94. Without doubt the narrative account of Wesley's death by Elizabeth Ritchie (Mortimer). The Conference of 1790 had appointed James Rogers to London with the intention of his accompanying the elderly itinerant on his daily journeys. Due to Hester Ann Rogers's declining health and her inability to care for Wesley, Elizabeth assumed that responsibility in November 1790. Dr. John Whitehead, Wesley's medical advisor and fellow itinerant, requested Elizabeth to prepare a narrative describing the Methodist founder's final days. Whitehead read a condensed form of this account at Wesley's Chapel, City Road, London, and then arranged for the publication of the whole document as the authentic narrative of Wesley's death. Elizabeth's full account is reprinted in the *Journal* (Curnock), 8:133-44. John Pawson, Frances's husband, preached Wesley's funeral sermon on March 20.

95. This momentous Conference of the Methodist Preachers following Wesley's death was held in Manchester in July 1791. Samuel Bradburn, one of the senior itinerants, read a letter that Wesley had written in 1785, the intention of which was to smooth the transition of leadership from Wesley to the Legal Hundred, the legally appointed body of the 1784 Deed of Declaration. The Conference resolved to follow and imitate their "esteemed Father and Friend" in doctrine, discipline, and life and "to follow strictly the plan which Mr. Wesley left us at his death" (*Minutes of the Methodist Conferences* [London: Mason, 1862], 1:243). Cf. Richard P. Heitzenrater, *Wesley and the People Called Methodists* (Nashville: Abingdon Press, 1995), 311-17.

96. See Wesley's Sermon 87, "The Danger of Riches," *Works*, 3:228-46; and Sermon 131, "The Danger of Increasing Riches," *Works*, 4:177-86.

97. Following the death of Wesley, many forces conjoined to threaten the unity of the Methodist movement. Primary among these concerns were issues of democracy and local power. The prominent figure in these disputes among the so-called "Church," "Conference," and "Dissent Metho-

dists" was Alexander Kilham (1762–1798). Born in Wesley's native Epworth, Kilham first met the aged evangelist at Nottingham in 1783, having been just one year in circuit as an assistant to Wesley's close friend and advisor, Robert Carr Brackenbury. Kilham always maintained a strong advocacy for lay representation at Conference, which concern he pressed vehemently in the Conferences after Wesley's death. His views were not accepted by the majority of the Conference of 1795 held in Manchester, which adopted a compromise document known generally as the "Plan of Pacification." Kilham countered with his "Progress of Liberty Among the People Called Methodists." He was expelled from this, the London Conference of 1796, and founded the Methodist New Connection the following year. Frances's views reflect her strong defense of her husband who was a major voice within the "Church Methodist" party. Cf. J. Blackwell, *The Life of the Rev. Alexander Kilham* (London, 1838); and W. J. Townsend, *Alexander Kilham: The First Methodist Reformer* (London, 1889).

98. Unable to identify.

99. *Scripture Hymns*, "Hymn 1096," v. 1, 9:388.

100. Ann Tripp (1745–1823), governess of the Leytonstone Orphanage, member of the Bosanquet circle, and, later, part of the nucleus of the "Female Brethren" of Leeds. A central figure in Leeds Methodism at the turn of the century, she is buried with her sisters in the faith at Old Parish Church. Cf. Chilcote, *Wesley and Women*, 126, 129, 135, 139, 200-201, 285-86.

101. The letter was dispatched to her immediately, as Sarah died at Leeds on the same day.

102. Elizabeth Ritchie, who married Harvey Walklake Mortimer, Esq. on November 1, 1801.

103. Frances died on June 2, 1808 and was interred with her husband at Thorner.

104. Not to be confused with her namesake of York, the close friend of Frances Mortimer, this Bathsheba Hall belonged only to Bristol, the London Foundery, Bath, and Kingswood. See Nehemiah Curnock's note and the identity questions raised by Henry Foster, in Journal entry (September 23, 1779), *Journal* (Curnock), 6:254-55.

105. The source of the following extract is *AM* 4 (1781): 35-40, 94-97, 148-52, 195-98, 256-59, 309-11, 372-75.

106. *Journal* (October 1, 1780), *Works*, 23:187.

107. A fairly common phrase referring to Wesley's doctrine of Christian perfection, but seldom used in the Wesleyan corpus itself. The term may have been drawn from Charles Wesley's well-known text, "Love divine, all loves excelling," the final stanza of which reads:

> Finish then thy new creation,
> Pure and spotless let us be;
> Let us see thy great salvation
> Perfectly restored in thee.

alluding to verse 12 of Psalm 51, a prayer for cleansing and pardon.

108. The essentially Wesleyan idea of salvation as a process of restoration of the image of God, as Outler has demonstrated, is deeply rooted in patristic sources, in particular, Irenaeus's doctrine of "recapitulation." According to Wesley, the therapeutic restoration of our disabled "image" to its original capacity is the goal of the entire process of salvation. For pervasive references to this divine *therapeia* in the sermon corpus, see *Works*, 1:143, 206, 432, 496; 2:482-83; 3:256; 4:161, 164, 239, 299-301, 354-55, 358.

109. It has not been possible to identify these lines of hymnic verse.

110. See Wesley's Sermon 41, "Wandering Thoughts," *Works*, 2:125-37.

111. *HLS*, "Hymn 21," v. 3. These lines conclude a verse that J. E. Rattenbury described as Charles Wesley's "Protestant Crucifix." His rich devotional imagery pictures the scene and draws the singer into the event itself. Cf. J. Ernest Rattenbury, *The Eucharistic Hymns of John and Charles Wesley* (London: Epworth Press, 1948), 20-30.

112. A suburb or small village outside of Bristol.

113. The following excerpt is taken from Bulmer, *Memoirs of Elizabeth Mortimer*.

114. For a discussion of this account, see *Journal* (Curnock), 8:131-44. Elizabeth, in fact, recorded in minute detail the events leading up to the very moment of his death. Cf. Heitzenrater, *The Elusive Mr. Wesley*, 2:143-50.

115. A village near York, Otley became a center of Methodist activity. Wesley preached there for the first time on July 17, 1759, at the foot of Otley Chevin, a high neighboring mountain, when Elizabeth was just five years old. By the summer of 1772 a new preaching house had been constructed there for the Methodist Society. Cf. *Journal* (July 17, 1759), *Works*, 21:209; and *Journal* (June 23, 1772), *Works*, 22:339.

116. Wesley preached at Otley to "a numerous congregation" on Tuesday, June 26, 1770. He reported that "they drank in the words of life, just as the thirsty earth the shower" (*Journal* [June 26, 1770], *Works*, 22:236).

117. Unable to fully identify at this time.

118. Taken alongside the *BCP*, the *Thirty-nine Articles of Religion* and the *Books of Homilies* are the repository of Anglican doctrine. It is noteworthy that during his lifetime, Wesley published abridged versions of both. The *Articles*, the edition of which is referred to here, was first published in 1563 and the *Homilies* formally authorized by Convocation under Edward VI in 1547, both the work in large measure of Thomas Cranmer. In 1738 Wesley

assembled and published the first five Edwardian Homilies, his very first published doctrinal manifesto. For the text, see *John Wesley*, 121-33. Wesley's 1784 *Sunday Service for the Methodists in North America* included his revision of the *Articles*, reducing the thirty-nine to twenty-four in number. See the facsimile edition of the same name by James White (Nashville: Abingdon Press, 1984), 306-14.

119. Elizabeth had accompanied Wesley to Birstall on April 30. He simply notes in his *Journal*, "On Monday and Tuesday, I preached at Otley and Pateley Bridge" (*Works*, 22:406-7).

120. Wesley reinforced this encouragement with a letter, which he initiated on May 8; see *Letters* (Telford), 6:84-85. On March 17, 1775, he wrote: "I trust you will find more and more opportunity of using whatever strength you have, even at Otley. Wherever the Lord revives his work, we are more particularly called to work together with him. Now, be instant in season, and out of season. Redeem the time. Buy up every opportunity" (Bulmer, *Memoirs of Elizabeth Mortimer*, 61).

121. His notation for March 24 reads: "I went on to Otley, where the word of God has free course and brings forth much fruit. This is chiefly owing to the spirit and behaviour of those whom God has *perfected in love*. Their zeal stirs up many, and their steady and uniform conversation has a language almost irresistable" (*Works*, 23:10).

122. Mary Bosanquet married the Reverend John William Fletcher, originally Jean Guillaume de la Fléchère (1729–1785), at Batley Church. The couple remained at Cross Hall, in Yorkshire, until January 2, 1782, when they set out for the vicarage of Madeley in Shropshire. Concerning their marriage, Samuel Bradburn said that "such a pair, I am inclined to think there never was a holier or happier couple since Adam ate the forbidden fruit," as quoted in Maldwyn Edwards, *My Dear Sister: The Story of John Wesley and the Women in His Life* (Manchester: Penwork [Leeds], n.d.), 95. For an account of their wedding and the remarkable ministry of this couple, see Chilcote, *Wesley and Women*, 182-86, 206-8.

123. John Valton (1740–1794), army ordnance officer turned Methodist preacher, while rejoicing in the union, confided to his journal: "Mr. Fletcher stole hallowed fire from my people, by taking away Miss Bosanquet to Madeley." On this day in his manuscript journal he wrote: "O what a blessed day we had! Nothing but the voice of prayer and praise was heard. . . . Jesus was at the marriage feast indeed and turned our water into wine and, I believe, filled all the water-pots" (J. C. Nattras, "Excerpts from John Valton's MS Journal," *PWHS* 8 [1912]: 22).

124. The untimely death of John Fletcher, the well-loved vicar and Wesley's "designated successor," occurred on Sunday evening, August 14, 1785. See Henry Moore, *The Life of Mrs. Mary Fletcher, and Relict of the Rev. John*

Fletcher, Vicar of Madeley, Salop: Compiled from her Journal and Other Authentic Documents, 6th ed. (London: published and sold by J. Kershaw, 1824), 158-60. After his death, Mary published a treatise entitled *Thoughts on Communion with Happy Spirits,* printed in Birmingham.

125. The transcript of this letter is not to be found in Moore, *Fletcher.*

126. A neighboring Yorkshire village.

127. Anglican clergyman and reader at Wesley's Chapel in London, Peard Dickinson (1758–1802) served as curate to Vincent Perronet at Shoreham, Kent. In 1788 he assisted Wesley in the ordination of Mather, Moore, and Rankin.

128. According to Wesley's diary, this supper engagement was on Friday, July 18. He reports conversation with her and the transaction of business on both Saturday, July 19 and Monday, July 21 (*Journal* [Curnock] 7:417-19).

129. Throughout the course of the London Conference of 1788, two issues, both divisive, dominated the conversations: separation from the Church of England and the secessionist spirit of the Dewsbury Methodists under the leadership of John Atlay. Despite these tensions, the Conference concluded on August 6 in a spirit of unity and renewed evangelical zeal. See Tyerman, *Life and Times,* 3:547-59.

130. Wesley appointed her Housekeeper of the City Road Chapel in London, a prestigious position of tremendous responsibility. For a description of this office, see Frank Baker's chapter, "The People Called Methodists, 3. Polity" in eds. Rupert Davies, A. Raymond George, and Gordon Rupp, *A History of the Methodist Church in Great Britain* (London: Epworth Press, 1965) 1:213-55.

131. For her account of his death, see *Journal* (Curnock), 8:131-44, where it is reproduced in its entirety.

132. Sarah Crosby died at Leeds on October 29, 1804. Taft included the account of her death prepared by Anne Tripp in his sketch of her life (*Holy Women,* 2:112-15). Her funeral sermon was preached on the text of her choice (Rev. 21:4) by Thomas Taylor (1738–1816), protagonist of the women preachers of the north and one of the most famous of Wesley's itinerant ordinands, twice elected Conference president.

133. For a fascinating glimpse into her journal, see Thomas R. Albin, *Full Salvation: A Descriptive Analysis of the Diary of Anna Reynalds of Truro, 1775–1840,* Cornish Historical Association Occasional Publication No. 17 (St. Columb, Cornwall: J. Edyvean & Son, Printers, 1981). I am much indebted to Rev. Albin for introducing me to this material. It is most probable that Anna's mother met Wesley during one of his three visits to Penryn in 1757, 1760, or 1762.

134. One particular incident is noteworthy. In 1815, when a "perfectionist" controversy erupted, daily readings in the Society of excerpts from Wes-

ley's *Plain Account of Christian Perfection* by the itinerant were not even enough to avert a schism.

135. Quoted from the *West Briton* in Albin, *Full Salvation*, 27.

136. An estate, not a town name, about a half mile at that time from Truro in Cornwall. When Anna was a child an elegant home was constructed there which Wesley described as "a house fit for a nobleman." This house later became the episcopal residence of the Bishop of Truro, renamed Lis Escop by Bishop Benson. See *Journal* (Curnock), 7:326.

137. The allusion is, of course, to John Bunyan's classic work, *The Pilgrim's Progress*, first published in 1678 and to the climactic spiritual liberation experienced by the central character of his allegorical tale.

138. Referring here to a second, or subsequent, work of grace, namely, the experience of perfect love. Sometimes described in Wesleyan parlance as a "second blessing" or "second baptism," this experience is distinguished from justification and is described by some as being "filled with the Spirit." For a discussion of these terms and their significance, see William Sangster, *The Path to Perfection: An Examination and Restatement of John Wesley's Doctrine of Christian Perfection* (London: Epworth Press, 1943), 83.

139. A distinctive service of Methodist worship modeled on the nocturnal vigils of the early church and similar gatherings attended by Wesley among the Moravians during his visit to the Herrnhut community in 1738. The first Methodist Watchnight Service was held in 1742 (although the specific date is disputed) and, in spite of its original monthly observance, evolved into an annual pattern. See Bishop, *Methodist Worship*, 92-94.

140. See the famous Wesley hymn, "Wrestling Jacob," based on Genesis 32:24-32, *Works*, 7:250-52.

141. Wesley was particularly interested in manifestations of the Trinity in prayer. On August 8, 1788, he wrote to Lady Maxwell: "Mr. Charles Perronet was the first person I was acquainted with who was favoured with the same experience as the Marquis De Renty with regard to the ever-blessed Trinity, Miss Ritchie was the second, Miss Roe (now Mrs. Rogers) the third. I have as yet found but a few instances; so that this is not, as I was at first apt to suppose, the common privilege of all that are 'perfect in love' " (*Letters* [Telford], 8:83). Likewise on October 6, 1787, he wrote to Sarah Mallet, also featured in this volume, saying: "I have lately see a young woman in the Isle of Jersey [Jeannie Bisson] whose experience is as extraordinary as yours; in one thing it seems to be more clear than yours—namely, in her communion with the blessed Trinity" (*Letters* [Telford], 8:15). In 1741, Wesley published an extract of De Renty's *Life* in which he quotes the Marquis as having said: "I bear in me ordinarily an experimental verity and a plenitude of the most Holy Trinity, which exalts me to a simple view of God." Cf.

Chilcote, "Sanctification in Early Methodism," 90-103 and Frances Pawson's allusion to this work in note 76.

142. Wesley's indebtedness to Thomas à Kempis's *Imitation of Christ* is well known. Anna reflects here the Wesleyan principle of "singularity," or purity of intention—aspects of spirituality central to the Anglican tradition as a whole.

143. Wesleyan theology is first and foremost a theology of grace, and in this theology, grace is always viewed within the context of the redeeming activity of divine love. The Methodist people, therefore, will frequently speak of prevenient, convincing, justifying, sanctifying, or here, of God's "persevering," "perfecting," and "establishing" grace as respective aspects of the way of salvation. Their language throughout is the language of grace. For one of the best discussions of this theology of grace, see Thomas A. Langford, *Practical Divinity: Theology in the Wesleyan Tradition* (Nashville: Abingdon Press, 1983), 24-48.

Part 3. Autobiographical Portraits of Mission and Evangelism

1. The entirety of the 1992 Oxford Institute of Methodist Theological Studies was devoted to the theme "Good News to the Poor in the Wesleyan Tradition." The premise of the Institute was threefold: "(1) that in some sense God's relation to the poor is constitutive of the gospel as conveyed by John Wesley and the Wesleyan tradition; (2) that honestly facing the deformation of the Wesleyan tradition away from the poor would be a hard but necessary task requisite to its more faithful practice; and (3) that regaining an evangelical relationship to the poor would be decisive for the transformation and renewal of Methodist/Wesleyan churches across the world." The addresses from the conference are gathered in a volume edited by M. Douglas Meeks, entitled *The Portion of the Poor: Good News to the Poor in the Wesleyan Tradition* (Nashville: Kingswood Books, 1995), 9; cf. Theodore W. Jennings, *Good News to the Poor* (Nashville: Abingdon Press, 1990).

2. See Paul Wesley Chilcote, *John Wesley and the Women Preachers of Early Methodism* (Metuchen, N.J.: Scarecrow Press, 1991), chap. 7, "From Recognition to Repression After Wesley," 221-52; in particular, 228-32, on Mary Taft.

3. Edward Smyth (1747/48–1823), of Dublin, was educated at Trinity College, appointed a curate in 1773, but expelled from the Established Church in northern Ireland for "cottage preaching and criticism of a neighboring nobleman" in 1777. He subsequently entered into connection with the Methodists, preaching irregularly in Ireland and assisting Wesley, whom he had first met at Derriaghy in January 1775. He was the younger brother of William Smyth, founder of the Bethesda Chapel in Dublin, and became his brother's regular chapel preacher in 1786. Wesley heard him "read prayers and give out hymns" there on Easter Day, April 8, 1787. In later years, Rev.

Smyth developed a strong anti-Church of England sentiment and a separationist spirit that led Wesley to submit a letter to the *Dublin Chronicle* in an effort to disassociate himself from Smyth and vindicate his own loyal churchmanship. After Wesley's death, Smyth built two proprietary chapels in Manchester, in 1793 and 1804, exemplifying the process of irregular Anglican evangelicals moving into settled urban ministries. Cf. *Journal* (Curnock), 7:258-59.

4. Cf. C. H. Crookshank, *Memorable Women of Irish Methodism in the Last Century* (London: Wesleyan Methodist Book Room, 1882).

5. Newtown (Newton or Newtownards) was approximately six miles from Limerick and is known today as Tervoe. Wesley first mentions this Irish village in his *Journal* (May 24, 1749), *Works*, 20:274.

6. First John 1:3. The date of this encounter was May 2, 1765. Wesley's *Journal* entry for May 1, 1765, reads: "I did not reach Newtownards till past eight. I spent the next day here, endeavouring to lift up the hands of a poor, scattered, dejected people. In the evening, I preached on the green. Though it was exceeding cold, none of the congregation seemed to regard it. And a few of them do 'remember from whence they are fallen and' resolve to 'do the first works' " (*Works*, 21:506).

7. On the importance of hymns in evangelism and the communication of Wesleyan theology, see the introduction to "A Collection of Hymns for the Use of the People called Methodists," *Works*, 7:1-22. Cf. Teresa Berger, *Theology in Hymns? A Study of the Relationship of Doxology and Theology*, trans. Timothy E. Kimbrough (Nashville: Kingswood Books, 1995). In typical fashion, the hymns were "lined out," with a hymn leader singing line by line and the congregation repeating.

8. That is, the basic catechism of the *BCP*.

9. Here follows a lengthy discussion of many appeals she received from a number of villages for Methodist preachers to be sent. When she was successful in securing preachers for the area, the magistrate and area ministers placed insurmountable obstacles in their way.

10. In the early years of the Methodist revival Wesley took every opportunity to unite Societies in close proximity to one another for the purposes of mutual encouragement and consultation. The first of these quarterly meetings, actually the brain child of John Bennet, was held at Todmorden Edge in 1748. The Conference of the following year made such meetings obligatory. While having no legislative authority within the movement, these gatherings became important means of spiritual accountability in the Methodist circuits. See Davies, introduction, *Works*, 9:19-20.

11. Derriaghy was the seat of Edward Gayer, clerk to the Irish House of Lords. His wife, Henrietta Gayer, had been converted under Wesley's preaching in 1773 and "The Prophet's Chamber" was set up in their home shortly

thereafter, with the consent of her husband, as a regular preaching station for the Methodist itinerants. Wesley was nursed back to health here from an illness that seriously threatened his life in June 1775. Cf. note 40, *Journal* (June 14, 1773), *Works*, 22:376-77; and *Journal* (June 17-22, 1775), *Works*, 22:456-57.

12. Or Dunsfort, a neighboring village to the ancient city of Downpatrick, in Ulster.

13. "Witch hunting" was a common occurrence well into the eighteenth century, especially in Scotland and northern England. There were many civil court and diocesan investigations of such charges throughout the century. One case in particular, at the beginning of the century, was highly publicized and gathered considerable attention. Two studies focus attention on the religious beliefs and the role of the clergy in this case study: Phyllis J. Guskin, "The Context of Witchcraft: The Case of Jane Wenham (1712)," *Eighteenth-Century Studies* 15 (1981): 48-71; and J. B. Kingsbury, "The Last Witch of England," *Folk-lore* 61 (September 1950): 134-45.

14. Very little has been written on the life and work of Dorothy. See the two articles, Arthur Mounfield, "Dorothy Ripley," *PWHS* 7 (1910): 31-33; "Dorothy Ripley, Unaccredited Missionary," *Journal of the Friends Historical Society* 22 (1925): 33-51; and 23 (1926): 12-21, 77-79.

15. William Ripley (1739–1784), stonemason and builder, was a mainstay of the Methodist Society in Whitby and served as a local preacher throughout the area. When plagued with ill health in 1784, "Billy," as John Wesley called him, traveled with the Methodist founder from the middle of June until the Conference in early August in hopes of an improvement but died the following December. See *PWHS* 4 (1904): 127-32; 6 (1907): 37-42; note 72, *Journal* (June 15, 1784), *Works*, 23:317; and *Journal* (June 12, 1786), *Works*, 23:397.

16. John Wesley first mentions Whitby in his *Journal* account of Tuesday, June 23, 1761, when he "preached on the top of the hill" near the old church and abbey (see *Works*, 21:331). On Good Friday, April 20, 1764, he preached in this "new house at Whitby," which, despite its size, could hardly contain the congregation (*Works*, 21:461). In later years, in his own journal account, Ripley summarized the importance of Wesley's preaching: "My soul was much blessed with hearing that ancient servant of Jesus Christ. His sermons were so encouraging and so filled with gospel simplicity that he appeared to aim at nothing but God's glory and the soul's welfare" (*PWHS* 6 [1907]: 37).

17. The concluding line of the Wesleyan hymn, "Love Divine, All Loves Excelling," *Redemption Hymns, Works*, 7:545.

18. John 1:29. This verse, of course, is also embedded in the daily round of prayers in the *BCP*.

19. Within six years, the British Parliament was prevailed upon finally to pass a law in 1807 which made the slave trade illegal in the Empire. Another quarter century would pass before the institution of slavery itself would be abolished. John Wesley and his Methodist followers played a significant role in these developments by laying the groundwork for such social changes in the previous century. In 1774 Wesley published a tract entitled *Thoughts Upon Slavery* (*Works* [Jackson], 11:59-79) in which he described this peculiar institution as the "sum of all villainies." It was, in fact, an abridgment of an earlier work by an American Quaker, see Anthony Benezet, *Some Historical Accounts of Guinea* (Philadelphia: n.p., 1771). Wesley's celebrated letter of encouragement to the British social reformer, William Wilberforce, written just a week prior to Wesley's death, echoes his vigorous anti-slavery sentiments. Cf. *Letters* (Telford), 8:264-65.

20. William Carey is considered the "Father of the Missionary Movement" or "Protestant Mission." In 1792 he published a book and began to disseminate his vision of global missions. His work led to the creation of the first missionary society of the late eighteenth century and greatly influenced mission theology for another century. The "heathen" language of the title was conventional in his day. It was used indiscriminately to refer to all in the non-Christian world and was quickly adopted by Western Christians as "cross and crown" were increasingly linked in the expansion of the European Empires around the world. See William Carey, *An Enquiry into the Obligations of Christians to Use Means for the Conversion of the Heathens* (London: The Carey Kingsgate Press, 1961). Cf. Mary Drewery, *William Carey* (Grand Rapids, Mich.: Zondervan Publishing House, 1979); A. Christopher Smith, "The Legacy of William Carey," *International Bulletin of Missionary Research* 16 (1992): 2-8; and R. Pierce Beaver, *All Love Excelling: American Protestant Women in World Mission* (Grand Rapids, Mich.: William B. Eerdmans Publishing Co., 1968).

21. Dorothy left Whitby in December 1801, walking and traveling by wagon to London. Failing to secure a vessel there or at Portsmouth, she finally embarked for America from Bristol on February 13, 1802, aboard the brig *Triton* with Gilbert Howland as Captain.

22. Here begins a lengthy prayer incorporated into the narrative of Dorothy's journey.

23. Concluding line of the famous hymn by Isaac Watts, "I'll Praise My Maker While I've Breath," quoted repeatedly by John Wesley prior to his death. See Isaac Watts, *Hymns and Spiritual Songs* (author used 1707 version housed at Trinity College in Bristol).

24. Watts, "Come, we that love the Lord" in *Hymns and Spiritual Songs* (1707). Included in the Wesleys' Charleston *Collection* (1737), the original of

the first two lines reads: "The God that rules on high,/That all the earth surveys," employing one of Watts's favorite metaphors.

25. Dorothy arrived in Rhode Island on April 1, 1802, after a sea journey of about six weeks, and set her sights on Washington.

26. William Thornton (1759–1828), an American architect, furnished the original design for the U.S. Capitol in Washington. After winning the competition for the design in 1793, he served as a Commissioner of the Federal District (later the District of Columbia) from 1794 to 1802, relinquishing that office not long after Dorothy's arrival.

27. James Madison (1751–1836), often described as "Father of the Constitution," served as fourth president of the United States of America from 1809 to 1817. Madison had worked tirelessly to secure the election of Thomas Jefferson as president in 1800, who then appointed him secretary of state the following year upon his inauguration. Together with the new Secretary of the Treasury, Albert Gallatin, this Republican triumvirate guided the young nation for eight years.

28. Henry Dearborn (1751–1829), an American army officer and congressman, served as secretary of war (1801–1809) in Jefferson's administration.

29. Thomas Jefferson (1743–1826) served as third president of the United States from 1801 to 1809. As author of the Declaration of Independence and the Virginia Statute of Religious Freedom, he was a conspicuous champion of political and religious liberty. Hailed as the "Man of the People," who sought to govern on the basis of popular interest and will, Jefferson heard Dorothy's appeal to this side of his character in her efforts to reveal the moral inconsistencies of slavery.

30. Aaron Burr (1756–1836), a dynamic and ambitious American politician and adventurer, served as Thomas Jefferson's first vice president from 1801 to 1805, but is remembered more for his duel with Alexander Hamilton, which resulted in the latter's death. His imperial schemes later resulted in his trial and acquittal on charges of treason in 1807.

31. In 1792, Benjamin Banneker, a freedman from Maryland, wrote to Thomas Jefferson complaining that it was time to eradicate false racial stereotypes. While expressing doubts regarding the merits of slavery in his "Notes on Virginia," Jefferson had expressed his belief in the inferiority of the African. See Joseph J. Ellis, *American Sphinx: The Character of Thomas Jefferson* (New York: Random House, 1998), 157-59; and Willard S. Randall, *Thomas Jefferson: A Life* (New York: HarperCollins, 1994), 213-15.

32. The legacy of early nineteenth-century educational theory is ambiguous at best but with two opposing views on the subject, the progressive and the conservative. Jane McDermid, in "Conservative Feminism and Female Education in the Eighteenth Century," *History of Education* 18 (1989): 309-22, argues that the conservative advocates for the education of women at the

end of the century sought to develop the reasoning power of women and placed a high value on women's domestic and religious roles. While Dorothy would fall clearly toward the conservative end of this debate, she was also a strong liberationist, unconsciously providing something of a synthesis of the two schools of thought in contemporary analysis. Barry Turner examines the role of the church in the early education of girls and the promotion of a Christian ideal of womanhood (*Equality for Some: The Story of Girls' Education* [London: Ward Lock Educational, 1974]). On the controversial issues of the educational debate, see Veena P. Kasbekar, "Power Over Themselves: The Controversy about Female Education in England, 1660–1820" (Ph.D. diss., University of Cincinnati, 1980). Of particular interest with regard to evangelical schemes of education is Paul Sangster's *Pity My Simplicity: The Evangelical Revival and the Religious Education of Children, 1738–1800* (London: Epworth Press, 1963), which provides the broad contextual background within which Dorothy's plan of education for slave children must be understood.

33. An independent city in eastern Virginia about 50 miles south of the city of Washington.

34. Capital of the Commonwealth of Virginia, the city was chartered in 1782 with a population of 1,031, half of whom were African slaves.

35. The southern United States, with slaves comprising about 40 percent of the population, had good reason to fear slave uprisings. Organized revolts in the West Indies, in particular, led to the wholesale slaughter of the white masters and their families and the burning of the great plantations. The most famous of the revolts, in St. Domingue, was successful in freeing the slaves, who then formed the independent country of Haiti. In spite of its long history of slavery, slave rebellions in North America had been few and relatively bloodless. The so-called Gabriel Plot or Rebellion of 1800 in Richmond, which is referred to here, was one of the most serious early insurrections. Inspired by St. Domingue, Gabriel, a Virginia slave, felt it was time for American slaves to revolt. He recruited an army of conspirators from Richmond and other Virginia towns, preparing the most far-reaching slave revolt ever planned in the United States. They chose the night of August 30, 1800, to strike. Torrential rains, however, delayed their attack, and the plot was discovered. Apprehended slaves were granted immunity for providing testimony about the conspiracy. The trial of at least 65 slaves began on September 11, 1800, and lasted two months. Twenty-six slaves were executed by hanging, including Gabriel, and their owners were reimbursed over $8,900 by the state for their value. See Herbert C. Aptheker, *American Negro Slave Revolts* (New York: International Publishers Co., 1989); and Eugene D. Genovese, *From Rebellion to Revolution: Afro-American Slave Revolts in the Making of the Modern World* (Baton Rouge: Louisiana State University Press, 1992).

36. Thomas Henry Prosser of Brookfield Plantation in Henrico County, Virginia.

37. A neighborhood in the western part of the city of Washington, established in 1751 and incorporated in 1789.

38. The Conference met in Light Street Church with fifty preachers attending. Preaching services were held daily in Philip Otterbein's church. At this annual event, Christian Newcomer presented a "plan of operation" in order to further unify the German Methodists and the General Conference. See Elmer T. Clarke, ed., *The Journal and Letters of Francis Asbury,* 3 vols. (Nashville: Abingdon Press, 1958), 2:387-88.

39. Henry Foxall (1760–1823), a native of West Bromwich, the birthplace of Francis Asbury, became a rich iron merchant in America, building and naming the famous Foundry Church in the city of Washington. In 1800 he moved from Philadelphia to Georgetown in order to be nearer to his primary foundry, the Eagle Iron Works. He served as mayor of Georgetown from 1819–1821. Asbury was a frequent guest at the Foxall home, which had become a major Methodist center. Foxall served as a local preacher at St. George's Church, and later, in the greater Washington area. See Clarke, *Journal of Asbury,* 2:195, 331.

40. Francis Asbury (1745–1816) was the first general superintendent or bishop of American Methodism. Born at West Bromwich near Birmingham in England, he came under Methodist influence at an early age, was accepted as a local preacher at age eighteen, and joined the itinerancy four years later. At the 1771 Conference, he was one of five volunteers to go to the American colonies. Asbury was the only British Methodist preacher to remain in the colonies during the Revolutionary War period, and his preeminent position was confirmed by John Wesley in 1784 through the "Christmas Conference," when he was consecrated general superintendent, a position which he held jointly with Dr. Thomas Coke. For thirty years Asbury made annual tours of the eastern United States, preaching sermons and administering to the far-flung Methodist congregations. During his lifetime and at least partly due to his influence and leadership, the Methodist Episcopal Church grew to become one of the most important Protestant denominations in the United States. No record of these exchanges with Dorothy are to be found in Asbury's *Journal,* there being a gap between March 29 and April 12, 1803.

41. Richard Whatcoat (1736–1806), second elected bishop of American Methodism, was born in Gloucestershire, England, began attending Methodist meetings in 1758, and entered the itinerant ministry in 1769. In 1784 he accompanied Thomas Coke and Thomas Vasey to America where they, together with Francis Asbury, organized the Methodists there into a church. Recommended for the position of American General Superintendent by

John Wesley in 1786, the American preachers failed to elect Whatcoat at their annual gathering in 1787, only to elevate him to that position thirteen years later at the General Conference of 1800. The hardships of the office proved too harsh for the elderly preacher who survived only six years after his election.

42. Samuel Coate, a native of New Jersey, had come to Baltimore where he was stationed as a traveling preacher at Baltimore and Fells Point in 1802 and 1803 after four years of work in Canada. Soon after this encounter, he returned to Canada to resume his ministry there, serving as presiding elder of the Lower Canada District in 1809. Cf. Clarke, *Journal of Asbury*, 2:357.

43. Absalom Jones (1746–1818) founded St. Thomas African Episcopal Church, the first Episcopal Church for blacks in the United States and also became the first black Episcopal priest, ordained to the ministry in 1804. Jones was born a slave in Sussex County, Delaware, bought his freedom in 1784, and became a lay preacher at St. George's Methodist Episcopal Church in Philadelphia. In 1787, Jones and Richard Allen, another lay preacher at St. George's, established the Free African Society and led black members of the church in a walkout protesting a new church policy that required blacks to sit at the back of the balcony.

44. Richard Allen (1760–1831) founded the African Methodist Episcopal Church (AME), the first African American denomination in the United States. Born into slavery in Philadelphia, he grew up on a plantation in Delaware, bought his freedom, and moved back to Philadelphia in 1786. He soon came to believe that blacks should have their own churches, founded Bethel African Methodist Episcopal Church in 1794, was ordained in 1799, and, in 1816, severed Bethel's links with the Methodist Episcopal Church, helping to establish the African Methodist Episcopal Church, which united Bethel with 15 other African Methodist congregations. He was elected the first bishop of the new denomination at their convention in Philadelphia in 1816.

45. By 1800 most of the northern states, including New York and Pennsylvania, had either eradicated slavery or had made provision for its gradual abolition. This action did not necessarily change the status of the slaves but gave hope to many that their children would be born free. While northerners were willing to free slaves, most continued to view the African as inferior and treated them as such. It was not until 1831 that Arthur and Lewis Tappan established the first Anti-Slavery Society in New York. See Linda J. Altman, *Slavery and Abolition: In American History* (Berkeley, N.J.: Enslow Publishers, 1999); and David Richardson, ed., *Abolition and Its Aftermath: The Historical Context, 1790–1916* (Portland, Ore.: Frank Cass Publishers, 1985).

46. She is referring, without question, to John Street Church, the first permanent home of the oldest continuous congregation in the United States, formally dedicated on October 30, 1768. In 1817 the chapel was torn down to make way for a larger structure which was dedicated the following year. See *The Story of Old John Street Church* (New York: Raynor R. Rogers, 1984); cf. Russell E. Richey, *Early American Methodism* (Bloomington: Indiana University Press, 1991).

47. Major Thomas Morrell (1747–1838), a noteworthy figure in early American Methodism, was an army officer under Washington in the Revolution. Converted under the preaching of John Hagerty in 1786, he became an itinerant preacher in 1787, was ordained at the New York Conference of 1788, and served in New Jersey and New York until his retirement in 1804. In 1789 he was appointed to build Forsyth Street Church, the second Methodist chapel in New York.

48. Dorothy left New York on June 28, 1803, bound for England on the ship, *Young Factor*, piloted by Captain Laban Gardner at the cost of 20 guineas.

49. Here begins a lengthy prayer of gratitude to God.

50. Dorothy had arrived back in England in August 1803 and spent the next 18 months building her network of connections with the Quakers in particular. On March 7, 1805, she set sail on her second transatlantic voyage to the United States and made landfall on May 4, 1805. Her immediate dual concerns were to establish contact with and become an advocate for Native American peoples and to visit the prisons of the United States so as to know how best to seek their reform. But she was soon compelled to pick up her struggle against the American institution of slavery. The following concluding paragraphs of the excerpt are taken from the second edition of Dorothy Ripley's *The Bank of Faith and Works United* (Whitby: G. Clark, 1822).

51. Arrangements had been made through the Speaker in the House of Delegates, T. E. Stansbury of Annapolis, for Dorothy to address Congress on the issue of slavery.

52. A second edition of her *Memoirs of the Life of Mrs. Mary Taft: Compiled from Her Journals, and Other Authentic Documents* was considerably enlarged in 1828, and a third part added to this two-part volume in 1831 extended her life story to the year 1827. These two volumes were bound together in a single volume in the possession of Dr. Frank Baker. The text which follows is based on this, the final edition, published and sold by S. Thorpe in Devon.

53. A sampling of such invitations may be consulted in Chilcote, *Wesley and Women*, 309-11.

54. Ibid., 228-32. Cf. J. Ward, *Methodism in the Thirsk Circuit* (Thirsk: David Peat, 1860), 29-30; and Gordon Rupp, *Thomas Jackson: Methodist Patriarch* (London: Epworth Press, 1954), 11.

55. Taft published his views on the validity of female preaching in several tracts including *Thoughts on Female Preaching* (1803) and *Scripture Doctrine of Women's Preaching* (1809). His two-volume *Holy Women*, as we have seen throughout, provided biographical sketches of women preachers within the Methodist and Quaker traditions. Zechariah Taft, *Biographical Sketches of the Lives and Public Ministry of Various Holy Women*, 2 vols. (London: Mr. Kershaw, 1825, vol. 1; Leeds: H. Cullingworth, 1828, vol. 2).

56. See the discussion of this explosive situation in Chilcote, *Wesley and Women*, 234-35.

57. Mary's self-description here is virtually identical to that of any itinerant preacher within the Methodist Connection. Indeed, her own labors often carried her beyond the expectations laid upon those who were full members of the Conference.

58. The preceding paragraphs are taken from the preface to part 1 of her *Memoirs*.

59. Samuel Bardsley (d. 1818) entered the itinerant ministry in 1768 and was a faithful correspondent with Wesley. He cared for his frail mother over the course of many years, and when the opportunity for marriage arose, his suit for Mary Charlton was opposed by John Pawson. Wesley named him n the Deed of Declaration in 1784. He died a bachelor and the oldest preacher in the Methodist Connection after many years of faithful service on August 19, 1818. Letter to Samuel Bardsley (November 24, 1770), *Letters* (Telford), 5:209; Letter to Samuel Bardsley (October 29, 1790), *Letters* (Telford), 8:244.

60. *Redemption Hymns*, "Hymn 50," v. 2, *Works*, 7:81.

61. Matthew 3:7. The singular requirement for admission to the Methodist Society as stipulated by *The Nature, Design, and General Rules of the United Societies*, published by Wesley in 1743: "There is one only condition previously required in those who desire admission into these societies, 'a desire to flee from the wrath to come, to be saved from their sins' " (*Works*, 9:70).

62. Mary treasured words of encouragement such as these. See sample formal letters of encouragement in Chilcote, *Wesley and Women*, 312-16.

63. Colne, the market town where Mary was born, is 35 miles south-east of Lancaster in Lancashire County.

64. William Sagar, like Mary, was a native of Colne and, by all accounts, a man of remarkable energy and faith. He was responsible for the construction of the Methodist chapel in Colne, the gallery collapse of which Wesley recorded in his *Journal* on June 11, 1777 (*Works*, 23:54).

65. In all likelihood, Lancelot Harrison, who was named to the Legal Hundred in the 1784 Deed of Declaration, and who died on November 17, 1806, after 39 years in the itinerant ministry. When first appointed to this circuit, his prejudice against women's preaching was very strong. As a conse-

quence of this event, his attitude was changed dramatically. See Chilcote, *Wesley and Women*, 228-29. Note here the similarity to Susanna Wesley's words of advice to her son concerning the ministry of Thomas Maxfield, Wesley's first "son in the gospel" (*Susanna Wesley: The Complete Writings*, ed. Charles Wallace Jr. [New York: Oxford University Press, 1997], 16).

66. A village in the Yorkshire Dales noted for its magnificent waterfall.

67. Ann Thompson (later Mrs. Thomas Coates) was born at Aysgarth. After this encounter with Mary, she, herself, preached throughout the Dales, especially at Reeth. See Chilcote, *Wesley and Women*, 102, 229, 284; and John Ward, *Methodism in Swaledale and the Neighbourhood* (Bingley: Harrison and Son, Printers, 1865), 63-64.

68. Alexander Suter, whom John Wesley had ordained in 1787 for the Methodist work in Scotland where he had spent most of his ministry. Journal entry (August 3, 1787), *Journal* (Curnock), 7:307.

69. Edward Wade, a perennial source of encouragement and support to Mary, wrote to her in March 1799: "I rejoice to hear that the Lord is carrying on His blessed work at Whitehaven and that you keep so happy and valiant. O! how am I ashamed that I have been such a coward that I have not been more valiant for my Master. . . . The Lord bless you Mary, and make you as happy as an Angel, and keep you in the very dust, and loosen your tongue, and enlarge your heart." *AM* (BC) 6.11 (November 1827): 395.

70. A small village midway between Sheffield and Buxton on the road to Macclesfield, famous in its day for the heroic conduct of its vicar during the plague. John Wesley had preached there on March 27, 1766 (*Works*, 22:34).

71. A clear echo of John Wesley's final statement in death, "The best of all is God is with us."

72. See note 69.

73. The following paragraphs provide a typical sample of the extent of Mary's activities and ministry at that time.

74. Mary probably preached at the Methodist chapel of this Lancashire town, a building completed in the 1770s after many difficulties and much persecution. It was replaced by a new structure more central to the expanding community in 1815. See *Journal* (April 15, 1774), *Works*, 22:403.

75. The Methodist chapel constructed after Wesley's death, as opposed to the Anglican church, Holy Trinity, of which John Clayton of the Holy Club became perpetual curate in 1733. This was in addition to his responsibilities as rector of Redmire in Wensleydale where Wesley had preached in earlier years when in Manchester. See *Journal* (May 7, 1747), *Works*, 20:173.

76. That is, the new chapel of this well-established circuit.

77. William Bramwell (1759–1818), noted revivalist and advocate for women preachers, became a traveling preacher in 1785, serving primarily in northern England. In association with Ann Cutler (1759–1795, whose *Account*

he later published) he enjoyed particular success during the Yorkshire revival of 1792–1796. In one of his sermons, in an effort to convict potential female colleagues, he observed, "Why are there not more Women Preachers? Because they are not faithful to their call" (Leslie F. Church, *More About the Early Methodist People* [London: Epworth Press, 1949], 161). His failure to rise through the ranks of the preachers after Wesley's death was due primarily to acts of disloyalty to the established leadership of Wesleyan Methodism, his 1803 resignation from the ministry in order to unite with dissident revivalist elements in Leeds, and certain divisive elements in his theology. Described by some as a precursor of the great revivalist, Charles Finney, he died at Leeds on August 13, 1818.

78. A major center of evangelical influence because of its associations with William Holmes of Sykehouse, a legendary figure in the history of early Methodism. One of Wesley's earliest local preachers, this farmer opened his home to his preachers for public worship and the establishment of a Society that met in the house for over a century. By this time a proper chapel had been constructed for the use of the Methodist people. See *Journal* (October 28, 1743), *Works*, 20:2.

79. See the introduction to part 2, selection 3, the experience of his wife, Frances Pawson.

80. Concerning his support of women preachers, see Chilcote, *Wesley and Women*, 155, 229.

81. The following two paragraphs are drawn from the "Preface to Part the Second" of the *Memoirs*.

82. Adam Clarke (ca. 1760–1832), Irish by birth, was a preeminent Wesleyan preacher, biblical commentator, theologian, linguist, and scholar. He became a Methodist in 1778, preached his first sermon in 1782, was received into full connection the following year after a unique probation of less than a year, and served as Conference president three times in the nineteenth century—1806, 1814, and 1822. He was appointed to London in 1795 in order to cultivate his scholarly interests and, over the years, mastered Hebrew, Syriac, Arabic, Persian, Sanscrit, Armenian, Coptic, and Ethiopic in addition to Latin and Greek. He obtained his M.A. from Kings College, Aberdeen, in 1807 and was awarded an LL.D. in 1808. His magnum opus, an eight-volume *Commentary on the Bible* referred to here, was the product of his labor from May 1798 to March 1825. It remained the standard work in this field for many years. See Adam Clarke, et al., *An Account of the Infancy, Religious and Literary Life of Adam Clarke, LL.D., F.A.S.*, 3 vols. (New York: B. Waugh & T. Mason, 1833). Cf. Maldwyn Edwards, "Adam Clarke: The Man," *MethH* 9.4 (July 1971): 50-56. Clarke's prohibitive attitude concerning women preachers was reversed through an encounter with Mary Sewell when he witnessed her preaching on April 28, 1784. From that day, he

became a strong advocate for women called into this ministry. See Chilcote, *Wesley and Women*, 190-203.

83. Wesley recorded the mishap, which occurred on Wednesday, June 11, 1777, in his *Journal*, "I had appointed to preach in the new preaching-house at Colne. Supposing it would be sufficiently crowded, I went a little before the time, so that the galleries were but half full when I came into the pulpit. Two minutes after, the whole left-hand gallery fell at once with a hundred and fifty or two hundred persons. Considering the height and the weight of people, one would have supposed many lives would have been lost. But I did not hear of one" (*Works*, 23:54-55).

84. Pawson had served previously in this capacity in 1795.

85. Thomas Coke (1747–1814), Anglican priest, American Methodist Bishop alongside Francis Asbury, and pioneer of overseas mission, was born in Wales and died at sea on one of his many missionary journeys. He was awarded a B.A. at Jesus College, Oxford in 1768, an M.A. in 1770, and a D.CL. in 1775. In 1784 he was dispatched to the United States by Wesley with the commission to co-superintend the work of Methodism in the newly established United States of America. Meeting together with the American Methodist preachers at the Christmas Conference of that year, he helped to found The Methodist Episcopal Church. He served as British Methodist Conference president on two occasions, 1797 and 1805. See John A. Vickers, *Thomas Coke: Apostle of Methodism* (New York: Abingdon Press, 1969).

86. Zechariah Taft (1772–1848), famous protagonist of women preachers within Methodism, entered the Wesleyan ministry in 1801. He published several tracts defending the ministry of women, most notably *The Scripture Doctrine of Women's Preaching* (1820), a revised and enlarged version of his previous *Thoughts* (1803) on the subject. He dedicated this latter revision to Mary, who, as we have seen, was one of the best examples of the practice he sought to defend. A second edition of this work was published in 1826. For his useful collection of the lives of nearly fifty women preachers in Methodism, see the Editor's introduction to this section. Taft obtained supernumerary status in 1828. He was arraigned before the Wesleyan Conference of 1835 for his sympathies with the Wesleyan Methodist Association but was exonerated fully with the dismissal of the charges. He died on January 7, 1848.

87. Taft was appointed to Dover, the southeastern coastal town in Kent noted for its cliffs, about 20 miles southeast of the cathedral city of Canterbury. Several preaching sites were established in the area during the early years of the Wesleyan revival. He took his bride of just one month into this appointment having married Mary Barritt on August 17, 1802. See *Journal* (January 28, 1756), *Works*, 21:40 and the note on early preaching there in *Methodist Recorder* (August 16, 1906).

88. In 1784 Wesley prepared an abridgment of the *BCP*, the standard book of worship for the Church of England, for the newly established Methodist Episcopal Church in the United States. It was adopted for use in the new church by the Christmas Conference held in Baltimore. Two years later, a new edition was prepared with only slight alterations, for use throughout "His Majesty's Dominions." In that same year, 1786, an edition appeared with the title, *The Sunday Service of the Methodists, with other occasional Services,* and under this name, it continued in use through over 30 editions until its final appearance in 1910. The *Service* includes set forms of Morning and Evening Prayer. See John Bishop, *Methodist Worship in Relation to Free Church Worship* (n.p.: Scholars Studies Press, 1975), 73-75.

89. Another coastal port, the one in fact where Wesley disembarked after his return journey from the colony of Georgia in 1738.

90. Note the disproportionate use of Mary's preaching in this situation. Word of their evangelistic activities had spread throughout the district, and much curiosity was raised by their presence.

91. That is, a class ticket which showed him to be a member of the Methodist Society in good standing.

92. Joseph Benson (1748–1821), an outspoken critic of women preachers and distinguished leader within the Methodist Conference, was outraged by these developments and fired the caustic letter, dated October 25, 1802, to Taft. It reads in part: "What the District Meeting or the Conference may say to you for deceiving them in this manner, I am not certain. . . . Mrs. Taft should decline ascending the pulpits of the chapels unless Mr. Sykes, Mr. Rogers, and you be *less sufficient* for your work than the Conference supposed you to be" (Joseph Benson to Zechariah Taft, *Meth. Arch.*). George Sykes, the newly appointed superintendent of the circuit, countered with a strong letter of defense. "We find two Mary Apostlesses to the Apostles. I have had a personal acquaintance with Mary Barrett for more than eight years. I *dare* not oppose her. . . . More than a year and a half ago, Mary Barrett was strongly pressed by our Hull friends to visit them; the elders of the Society sat in counsel . . . the conclusion was *not to admit her into the pulpit* but allow her to stand by the little desk in the chapel. But after once hearing this ram's horn, prejudices fell down like the walls of Jericho, the pulpit-door gave way, and this King's daughter entered, the chapel could not contain the people, and hundreds stood in the street. She then preached abroad to thousands, and solemn reverence sat on their countenances to the very skirts of the huge assembly" (George Sykes to Joseph Benson, Dover, *Meth. Arch.*). A flurry of support for Mary ensued. For an account of these events, see Chilcote, *Wesley and Women,* 233-36. Cf. Hellier, "Some Methodist Women Preachers," 65-69.

93. For the full text of this letter, see Chilcote, *Wesley and Women*, 313-15; cf. 228-37. Pawson's letter (preserved in the *Meth. Arch.*), dated October 25, 1802, from Bristol, reads in part: "I seriously believe Mrs. Taft to be a deeply pious, prudent, modest woman. I believe the Lord hath owned and blest her labors very much, and many, yea very many souls have been brought to the saving knowledge of God by her preaching. Many have come to hear her out of curiosity who would not come to hear a man and have been awakened and converted to God. I do assure you there is much fruit of her labors in many parts of our Connexion. I would therefore advise you by no means oppose her preaching, but let her have full liberty, and try whether the Lord will not make her an instrument of reviving his work among you. I am an old man and have been long in the work, and I do seriously believe that if you yourselves do not hinder it, God will make Mrs. Taft the instrument of great good to you. Take care you do not fight against God. Many will come to hear her everywhere who will not come to hear your preachers. Let these poor souls have a chance for their lives; do not hinder them." Pawson wrote to the Tafts a second time at the beginning of the new year (1803), expressing his regrets concerning the storm that had arisen over their initial ministry in Kent. The storm having blown over, however, he encouraged them to press forward in hopes of a spiritual revival in that place. This letter is printed in full in the *AM* (BC) 4.1 (January 1825): 34-36.

94. Mary Tatham (1764–1837), Wesleyan stalwart and eminent biblical commentator, became a member of the Methodist Society at the age of 20. She provided distinguished leadership in a number of important Methodist centers including Leeds, Nottingham, and Halifax. Her *Memoirs*, edited by Joseph Beaumont and published in 1838, include many of her theological writings on subjects ranging from temptation to sanctification and her commentaries on biblical texts of interest to her.

95. The entirety of this letter may also be found in *AM* (BC) 5.10 (October 1826): 359.

96. Under the rubrics laid down by the Conference of 1803 and despite protracted discussion of the preaching of women within the Methodist structures, no action was taken to further restrict their activities.

97. Full details on the life of this itinerant preacher have not been available.

98. Following the death of her husband, Rev. John Fletcher, Vicar of Madeley, Mary Fletcher fitted up a tithe barn near her home for the regular preaching of Methodist itinerant preachers and the evangelical curates who succeeded her husband in the parish. William Tranter, historian of Methodism in Madeley, observed: "Here, also Mrs. Fletcher, after the removal of her holy husband to his heavenly rest, held her meetings for exposition of the Scripture, religious experience, and prayer" (*WMM* 60 [1837]: 901).

99. For a judicious summary of this discussion, see Valentine Cunningham, *Everywhere Spoken Against: Dissent in the Victorian Novel* (Oxford: Clarendon Press, 1975), 143-71; cf. William Mottram, *The True Story of George Eliot* (London: Griffiths, 1905); Gordon S. Haight, "George Eliot's Originals," in *From Jane Austin to Joseph Conrad*, ed. R. C. Rathburn and M. Steinmann (Minneapolis: University of Minnesota Press, 1958), 181-88; and Gordon S. Haight, *George Eliot: A Biography* (Oxford: Oxford University Press, 1968). It is probable, as well, that Sarah Crosby was the original model for Eliot's Sarah Williamson in the novel.

100. See Joseph Ritson, *The Romance of Primitive Methodism* (London: Edwin Dalton, 1909), 134; and H. B. Kendall, *The Origins and History of the Primitive Methodist Church*, 2 vols. (London: Edwin Dalton, n.d.), 1:142-44. In this same vein, A. W. Harrison described Elizabeth as "the most celebrated of Methodist women preachers." See "An Early Woman Preacher: Sarah Crosby," *PWHS* 14 (1924): 108.

101. Quoted in Church, *More About Methodist People,* 162.

102. See Taft, *Holy Women,* 1:155.

103. The evangelist William Bramwell. See note 77.

104. Elizabeth is articulating a central principle of Wesleyan theology—the negative and positive aspects of God's sanctifying grace in the life of the believer. "Christian Perfection," according to Wesley is both "freedom from sin" and the "fullness of righteousness." As Albert C. Outler claimed, this gracious experience "is the conscious certainty, *in a present moment,* of the fullness of one's love for God and neighbor, as this love has been initiated and fulfilled by God's gifts of faith, hope and love. This is not a state but a dynamic process: saving faith is its beginning; sanctification is its proper climax" (*John Wesley,* 31). Elsewhere, Outler summarizes the concept in this terse phrase: "Holy living was a life emptied of spiritual pride but filled with the serenities of holiness—understood always as the Christian's love of God and neighbour" (*Works,* 1:61). Wesley fully explicates this dynamic of emptying and filling in several sermons, but most particularly in "The Scripture Way of Salvation" in which he concludes: "If you seek it by faith, you may expect it *as you are*: and if as you are, then expect it *now*. It is of importance to observe that there is an inseparable connection between these three points—expect it by *faith,* expect it *as you are,* and expect it *now*" (*Works,* 2:169)!

105. As we have already seen, Bramwell, like Zechariah Taft, was one of the most vocal proponents of women preachers within the Methodist movement.

106. Here, Elizabeth expresses a very typical feeling among women who were called to a preaching ministry. There is, in this expression, a strong sense of solidarity with the experience of St. Paul as he describes it in

1 Cor. 9:16: "If I proclaim the gospel, this gives me no ground for boasting, for an obligation is laid on me, and woe to me if I do not proclaim the gospel!"

107. A county town in the English Midlands just coming into its own as a thriving manufacturing center. Methodism was introduced to this community in 1761.

108. With the assistance of Sarah Crosby, Mrs. Dobinson introduced Methodism to Derby. For an account of this evangelistic work, see Chilcote, *Wesley and Women*, 50, 120-21; cf. A. Seckerson, "An Account of Mrs. Dobinson," *WMM* 26 (1803): 557-66.

109. In her personal journal, under the date November 30, 1858, George Eliot described this whole incident as the seminal event that gave rise to her novel. "The germ of 'Adam Bede' was an anecdote told me by my Methodist Aunt Samuel (the wife of my Father's younger brother): an anecdote from her own experience. We were sitting together one afternoon during her visit to me at Griffe, probably in 1839 or 40, when it occurred to her to tell me how she had visited a condemned criminal, a very ignorant girl who had murdered her child and refused to confess. . . . The story, told by my aunt with great feeling, affected me deeply, and I never lost the impression of that afternoon and our talk together" (quoted in Cunningham, *Everywhere Spoken Against*, 154). With regard to Elizabeth herself, Leslie Church has maintained that "[f]rom that tragic hour she began her work as an evangelist" (*More About Methodist People*, 161). This experience of solidarity with outcast and suffering people did represent an important turning point in her life. Despite the fact that she encountered strong opposition to her evangelistic ministry in the months to follow, she remained resolute in her mission from that day forward. Refusing financial help from any of her supporters, she consistently raised her own funds for her many evangelistic campaigns by mending lace. Her first preaching tour carried her through the countryside for 16 weeks.

110. The text is that of the 1917 American Edition, published in New York by Charles Scribner's Sons.

111. Excerpt from chapter 2: The Preaching.

112. Excerpt from chapter 8: A Vocation.

113. Excerpt from chapter 45: In the Prison.

114. Excerpt from chapter 47: The Last Moment.

Part 4. Self-Images in Letters

1. See the important work of Godfrey Frank Singer, *The Epistolary Novel: Its Origin, Development, Decline, and Residuary Influence* (New York: Russell

and Russell, 1963), where the connection between correspondence and the evolving novel is explored.

2. For a fascinating study of the literary form of letters during this period, see Ruth Perry, *Women, Letters, and the Novel* (New York: AMS Press, 1980).

3. Robert Adam Day, *Told in Letters: Epistolary Fiction before Richardson* (Ann Arbor: University of Michigan Press, 1966).

4. See the groundbreaking work of Patricia Meyer Spacks, "Female Rhetorics," in *The Private Self: Theory and Practice of Women's Autobiographical Writings*, ed. Shari Bentock (Chapel Hill: University of North Carolina Press, 1988), 172-78.

5. Felicity A. Nussbaum, "Eighteenth-Century Women's Autobiographical Commonplaces," in Bentock, *The Private Self*, 156.

6. Wesley included an abridged version of Brother Lawrence's *Practice of the Presence of God* in his fifty-volume *Christian Library*. Extracts from the writings of this famous Catholic devotional writer were included in volume 38 of that work. Cf. David Butler, *Methodists and Papists: John Wesley and the Catholic Church in the Eighteenth Century* (London: Darton, Longman & Todd, 1995), 143-50.

7. See the following journal entries from *Works* 20: August 12, 1745, 82-86; June 1, 1751, 389-92; June 15, 1752, 429-31. The following are from *Works* 21: May 5, 1757, 95-101; December 23, 1757, 132-33; April 13, 1759, 184-87; December 20, 1760, 291-95. The following are from *Works* 22: March 21, 1770, 219-22; October 24, 1774, 432-35. And from *Works* 23: April 4, 1781, 197. In addition to Wesley's anonymous account reprinted here, he also published the death account of Elizabeth Hindmarsh in 1777.

8. See Henry Moore, *The Life of Mrs. Mary Fletcher, and Relict of the Rev. John Fletcher, Vicar of Madeley, Salop: Compiled from her Journal and Other Authentic Documents*, 6th ed. (London: Published and sold by J. Kershaw, 1824), 19-20; Paul Wesley Chilcote, *John Wesley and the Women Preachers of Early Methodism* (Metuchen, N.J.: Scarecrow Press, 1991), 137; and Telford's comments in *Letters* (Telford), 3:139-40. Cf. *Works*, 26:540-47, 573-74 for related letters from Mrs. Lefevre to Wesley. The following excerpt is from Wesley, *An Extract of Letters by Mrs. L——* (Bristol: William Pine, Wine-Street, 1769), 65-67.

9. Charles Wesley expressed this sentiment strongly in a hymn:

> To baffle the wise, And noble, and strong,
> He bade us arise, An impotent throng:
> Poor ignorant wretches We gladly embrace
> A Prophet that teaches Salvation by grace

(*HSP* [1749], "For the Kingswood Colliers," v. 5, 5:391). The Wesleys' employment of lay preachers, both men and women, was based on their

conviction that God calls and equips whomever God will for the work of ministry, and often those least expected, especially in extraordinary circumstances.

10. *AM* 34 (1811): 868-69. Cf. MS Letterbook, 1760–1774, Crosby Papers, Perkins Library, Duke University, 108-19; and Chilcote, *Wesley and Women*, 99-100. With regard to her experience of Christian perfection, see Susan J. Malin, "Jane Cooper: A Pattern of All Holiness," 1995 First Prize, John Ness Award, General Commission on Archives and History of the United Methodist Church.

11. See the two very helpful books by Gregory S. Clapper, *John Wesley on Religious Affections: His Views on Experience and Emotion and Their Role in the Christian Life and Theology* (Metuchen, N.J.: Scarecrow Press, 1989) and *As if the Heart Mattered: A Wesleyan Spirituality* (Nashville: Upper Room Books, 1997). See especially his article, "*Orthokardia*: The Practical Theology of John Wesley's Heart Religion," *Quarterly Review* 10, 1(Spring 1990): 49-66, where he coins this important terminology.

12. For an extended discussion of Charles Wesley's hymn of this title, see part 2, note 38. The biblical reference is to Genesis 32:1-32.

13. This letter was first published in the *WMM* 44 (1821): 361-62, with the title, "Original Letter from Mrs. [Ann] Ray to Miss [Elizabeth] Hurrell, on Faith in Christ."

14. On her life and work, see Chilcote, *Wesley and Women*, 156-59, 169-80.

15. Efforts to identify this work have led to no definitive conclusions.

16. For the essential connection between holiness and happiness in the Wesleyan tradition, and in the women's writings in particular, see Paul W. Chilcote, "Sanctification as Lived by Women in Early Methodism," *MethH.* 34 (1996): 90-103. Cf. Albert C. Outler, *Theology in the Wesleyan Spirit* (Nashville: Tidings Press, 1975), 81-82 and the Editor's introduction to this section.

17. For her indebtedness of Thomas Boston's fourfold typology of human states (by way of John Wesley), see *Works*, 1:263-66 and note 30 in part 1 of this book. Cf. Eph. 4:18.

18. Ray, here, suggests a form of Christian spirituality strikingly similar to "the practice of the presence of God" associated with the Catholic mystic, Brother Lawrence. For the indebtedness of the Wesleyan ethos to these sources, see Butler, *Methodists and Papists*, 141-50.

19. Edward Young, *The Complaint: or Night Thoughts on Life, Death, and Immortality* (1742–1746), Night 4, in *Complete Works* (n.p., 1854), 400-402.

20. For Wesley's references to the so-called "offices of Christ" in his preaching, see Sermon 1, "Salvation by Faith," *Works*, 1:121, §1.5 (note the variant reading in note 36); Sermon 14, "Repentance of Believers," *Works*, 1:352, §3.4; Sermon 36, "The Law Established through Faith, 2," *Works*, 2:37-

38, §1.6; and Sermon 43, "The Scripture Way of Salvation," *Works*, 2:161, §2.2.

21. Quoted in *Memorials of Hannah Ball*, ed. Joseph Cole, 3d rev. ed. (London: Wesleyan Conference Office, 1880), 28-29.

22. Her religious convictions were strengthened, by her own report, in reading the sermons of Thomas Walsh (ca. 1730–1759), one of Wesley's most gifted and saintly preachers. Born into Irish Roman Catholicism, he eventually found a spiritual home in the Methodist Society of Newmarket, served as a traveling evangelist in England and Wales, and was considered to be one of the most outstanding Hebraists of the day.

23. Matthew 15:28. It is most likely that this event took place on Tuesday, January 8, 1765. Wesley does not mention a morning service in his journal, only noting that he preached there on the evenings of January 7 and 10 (*Works*, 21:498). Hannah states explicitly in her own account: "I did not attend the preaching at night, yet I went at five in the morning. I was struck with the venerable appearance of Mr. Wesley; but more deeply affected with the words of his text, which were taken from Matt. xv. 28" (*Memoir*, 6-7).

24. See Chilcote, *Wesley and Women*, 129-31, 152-53.

25. *Memoirs of Mrs. Elizabeth Mortimer*, ed. Agnes Bulmer, 2d ed. (London: J. Mason, 1836), 45-46.

26. *Letters* (Telford), 6:104; dated July 31, 1774, from Madeley.

27. From the closing line of Charles Wesley's famous hymn "Love Divine, All Loves Excelling."

28. That is, at her Cross Hall orphan-school near Leeds. See the introduction to Letter 5. By this time, Mary Bosanquet had been at this new setting for her ministry for some six years. Despite that her close friend, Sarah Ryan, had died shortly after their relocation from Leytonstone, the work continued without interruption. Wesley, as well as the growing number of women preachers in northern England, visited there frequently. Mary would remain at Cross Hall until 1781 when she married the Reverend John Fletcher and subsequently moved with him to his parish in Shropshire. Nothing is recorded of this visit in Mary Fletcher's published *Life*.

29. Edward Smyth, *The Extraordinary Life and Christian Experience of Margaret Davidson, as Dictated by Herself* (Dublin: Dugdale, 1782), 144-47.

30. Margaret's friend and biographer, the Reverend Edward Smyth (1747/48–1823), who had come under severe criticism for his evangelical "cottage preaching" as an Anglican clergyman in Ireland.

31. Cf. Isa. 5:21. It must be remembered that the Evangelical revival had its beginning in Wesley's decision to engage in "field preaching" at the request of George Whitefield. On April 2, 1739, he confided to his *Journal*: "At four in the afternoon I submitted to 'be more vile', and proclaimed in the highways the glad tidings of salvation, speaking from a little eminence

in a ground adjoining to the city, to about three thousand people" (*Works*, 19:46).

32. Watts, *Hymns and Spiritual Songs*, book 2, Hymn 65, "When I can read my title clear." The original:

> Then shall I bathe my weary soul
> In seas of heav'nly rest,
> And not a wave of trouble roll
> Across my peaceful breast.

33. The origin of this couplet is yet to be discovered.

34. Zechariah Taft, *Biographical Sketches of the Lives and Public Ministry of Various Holy Women*, 2 vols. (London: Mr. Kershaw, 1825, vol. 1; Leeds: H. Cullingworth, 1828, vol. 2) 1:178-79. In this letter we have the record of interaction between two of the great women preachers of the early Methodist movement.

35. Meaning, plenty of opportunities for preaching.

36. Prior to her abandonment of preaching for unknown reasons and resettlement in London, she had a particularly active ministry throughout Yorkshire, Lancashire, and Derbyshire. "Oh that I but had my time to live again I would not bury my talent as I have done." Wesley visited her twice in London, in 1788 and 1790. She was buried at City Road Chapel on March 13, 1798. See Telford's introduction to Letter to Joseph Benson (October 30, 1775), *Letters* (Telford), 6:184.

37. Methodist pioneer in Derby and close associate of Sarah Crosby. See part 3, note 108.

38. Letter to Mrs. Rogers (October 12, 1787), *Letters* (Telford), 8:18.

39. With regard to literary and interpretive matters related to her experience, see Vicki Collins, "Perfecting a Woman's Life: Methodist Rhetoric and Politics in *The Account of Hester Ann Rogers*" (Ph.D. diss., Auburn University, 1993). On her life and work, see Annie E. Keeling, *Eminent Methodist Women* (London: Charles H. Kelly, 1889), 103-17; cf. Paul W. Chilcote, "John Wesley as Revealed by the Journal of Hester Ann Rogers," *MethH* 20 (1982): 111-23.

40. While Wesley never wrote to him directly, he is referred to on a number of occasions in letters written to other people. See *Letters* (Telford) 6: Robert Costerdine, March 26, 1776, 211; Mrs. Woodhouse, January 21, 1777, 252; William Tunney, January 29, 1780, 378. See *Letters* (Telford) 7: Arthur Keene, March 3, 1784, 212 and June 21, 1784, 222. See *Letters* (Telford) 8: Mrs. Ward, August 2, 1788, 80; Mr. Tegert, February 28, 1789, 120.

41. One of the first controversies in which the Wesleys were embroiled was with their Moravian friends in London. Generally known as the "Still-

ness Controversy," one aspect of the debate revolved around this issue of "degrees of faith." The Wesleys argued for them; their Lutheran Pietist friends strongly opposed their view. John Wesley collected his thoughts around the subject in his journal at the end of 1739 and subsequently published a brief tract on their differences in 1745. He wrote, in part, in his *Journal*: "I believe—There are *degrees of faith,* and that a man may have *some degree* of it before all things in him are become new; before he has the full assurance of faith, the abiding witness of the Spirit, or the clear perception that Christ dwelleth in him" (*Journal* [December 31, 1739], *Works,* 19:132). While this debate focused more on the issue of justification, Wesley applied the same reasoning to his doctrine of sanctification with its flying goal of Christian perfection as well. Cf. *John Wesley,* 354-60.

42. Note here the clear orientation of the doctrine of salvation and its fullness around the human will.

43. For a discussion of this concept of emptying and filling, see Paul W. Chilcote, "The Blessed Way of Holiness," *Journal of Theology* 100 (summer 1996): 30-33.

44. See Wesley's sermon "The Scripture Way of Salvation," one of his most mature statements of the doctrine. He concludes his appeal by stressing: "expect [Christian perfection] *by faith,* expect it *as you are,* and expect it *now!* To deny one of them is to deny them all: to allow one is to allow them all" (*Works,* 2:169).

45. The quotation is from Wesley's "Thoughts on Christian Perfection" (1760) as it appeared in a slightly revised form in Wesley's compilation of his "perfection" statements in *A Plain Account of Christian Perfection* (1766). Question 28 reads: "Is this death to sin and renewal in love gradual or instantaneous?" (*John Wesley,* 294). It is interesting to compare Wesley's original with Hester's statement, reproduced either from memory or redacted to suit the occasion of her letter. "A man may be dying for some time; yet he does not, properly speaking, die, till the instant the soul is separated from the body; and in that instant he lives the life of eternity. In like manner, he may be dying to sin for some time; yet he is not dead to sin, till sin is separated from his soul; and in that instant he lives the full life of love" (*Works* [Jackson], 11:402).

46. This was a primary preoccupation of Wesley's in his sermon on "Christian Perfection" (*Works,* 2:100-105) and reiterated in several different formulations in his *Plain Account of Christian Perfection.* The Christian who is perfected in love is not free from ignorance, mistake, infirmity, or temptation. This was his consistent teaching.

47. Here is a reiteration of Wesley's classic definition of sin, articulated initially and most succinctly in *Thoughts on Christian Perfection.* In his answer to Question 6 of that treatise, he defines "sin properly so called" as "a

voluntary transgression of a known law." "[S]in improperly so called," on the other hand, is "an involuntary transgression of a divine law, known or unknown." His point, therefore, that goes to the heart of his practical Christianity, is that "there is no such perfection in this life as excludes these involuntary transgressions, which I apprehend to be naturally consequent on the ignorance and mistakes inseparable from mortality" (*John Wesley*, 287). Cf. Colin Williams, *John Wesley's Theology Today* (Nashville: Abingdon Press, 1960), 126-28, 184-88; and Randy L. Maddox, *Responsible Grace: John Wesley's Practical Theology* (Nashville: Kingswood Books, 1994), 184-85.

48. *AM* 17 (1794): 328-29. The author of the letter is mistakenly identified as "Mr." E. C. but is most certainly the early woman preacher.

49. See Taft, *Holy Women*, 2:115-39; Leslie F. Church, *More About the Early Methodist People* (London: Epworth Press, 1949), 156-59; and Chilcote, *Wesley and Women*, 186-89, 205, 211, 284-85.

50. Taken from Mary Taft, *Memoirs of the Life of Mrs. Mary Taft: Formerly Miss Barritt*, 2 vols., 2d ed., enlarged (York: Printed for and sold by the author, 1828; Devon: Published and sold by S. Thorpe, 1831), 1:53-54.

51. Methodism in Margate, Kent, was established on precarious foundations in the mid-1760s by Thomas Coleman, local schoolmaster whom Wesley later disassociated from his movement. F. F. Bretherton, in his study of "John Wesley and Margate," describes the role that William Brewer played in securing a proper Methodist chapel under Wesley's supervision for the area, a preaching house he formally opened on his visit there, November 30, 1785, *PWHS* 7 (1910): 102-5. The success of this new Society was in no small measure due to the support and influence of Brewer. Cf. *PWHS* 17 (1929): 72-75; and *Journal* (November 30, 1785), *Works*, 23:382. Rogers was an itinerant preacher assigned to the circuit with George Sykes, but his identification here is uncertain.

52. The chapel at Sandwich was still little more than a room in a residence that had been willed to the Methodists there in 1776. See Journal entry (November 26, 1788), *Journal* (Curnock), 7:449.

53. George Sykes (1761–1825?) was born at Sheffield, served as a class leader in Nottingham, was admitted to the Methodist ministry in 1790, and, after a conversion to Calvinistic theology, became an independent pastor at Rillington, where he later died. Cf. Letter to George Sykes (April 8, 1790), *Letters* (Telford), 8:212. During the ministry of Mary and Zechariah Taft in Kent, he was one of Mary's strongest supporters and an avid protagonist of women's preaching. For his defense of her ministry, see Chilcote, *Wesley and Women*, 232-37.

54. See Chilcote, *Wesley and Women*, 192-98, 201, 205, 227-28, 273-74.

55. He frequently cared for her material needs, especially those related to her extensive travel in the ministry. See Wesley's letters to her in *Letters* (Telford), 8:15, 43-44, 77, 108-9, 190, 228-29, 250.

56. Joseph Harper (1729?–1813) was one of Wesley's Assistants for nearly fifty years and, like many of his most faithful itinerants, was named to the Legal Hundred in 1784, *WMM* (1813): 707.

57. In the early nineteenth century, Zechariah Taft possessed the original document, which he reproduced in Sarah's account. Natrass reprinted a version of the letter in *PWHS* 3 (1902): 74, which was dated October 27, 1787. It contains only minor textual variations.

58. This essentially expositional method of preaching is consistent with the style of most of her women counterparts in the movement.

59. [John Wesley], *A Short Account of the Death of Mary Langs[t]on, Of Taxall, in Cheshire; Who died January the 29th, 1769* (London: R. Hawes, 1770). This extract is from the edition of 1775.

60. The first four lines of "Hymn 38" (on Gen. 5:22) are joined with the second four lines of "Hymn 39" (on Gen. 5:29) to form the present verse, the last line being "All is well, if Christ is mine," *Scripture Hymns*, 9:13.

61. The editor notes that she "repeated Revelations xiv. 1, 2, 3, taking particular notice of those words, an hundred and forty four thousand."

62. Song of Solomon 5:16. This is the text she chose for her funeral sermon.

63. *Funeral Hymns* (1759), "Hymn 8," v. 4, 6:198.

64. *HSP* (1749), vol. 2, part 1, "For One Departing," 5:216. This is the opening line of the first verse, which reads in its entirety:

> Happy soul, thy days are ended,
> All thy mourning days below:
> Go, by angel guards attended,
> To the sight of Jesus, go!

Selected Bibliography

1. Original Sources

"An Account of Mrs. Crosby, of Leeds." *WMM* 29 (1806): 418-23, 465-73, 517-21, 563-68, 610-17.

"An Account of Mrs. Hannah Harrison." *WMM* 25 (1802): 318-23, 363-68.

"An Account of Mrs. Sarah Ryan." *AM* 2 (1779): 296-310.

Bennet, William. *Memoirs of Mrs. Grace Bennet.* Macclesfield: Printed and sold by E. Bayley, 1803.

Bramwell, William. *A Short Account of the Life and Death of Ann Cutler.* New ed., with an appendix by Zechariah Taft containing "An Account of Elizabeth Dickinson." York: Printed by John Hill, 1827.

Bulmer, Agnes, ed. *Memoirs of Mrs. Elizabeth Mortimer.* 2d ed. London: J. Mason, 1836.

Bunting, William M., ed. *Select Letters of Mrs. Agnes Bulmer.* London: Simpkin and Marshall, 1842.

Cole, Joseph, ed. *Memorials of Hannah Ball, the First Methodist Sunday-School Teacher.* 3d rev. ed. London: Wesleyan Conference Office, 1880.

Colston, Sarah. Manuscript Account of Religious Experience. *Meth. Arch.*

Cooper, Jane. "Christian Experience." *AM* 5 (1782): 408-9, 489-90.

Crosby, Sarah. Manuscript Letterbook, 1760–1774. Perkins Library, Duke University.

Dudley, Elizabeth, ed. *The Life of Mary Dudley.* London: J. & A. Arch, 1825.

"The Experience of Mrs. Ann Gilbert, of Gwinear, in Cornwall." *AM* 18 (1795): 42-46.

"An Extract from the Diary of Mrs. Bathsheba Hall." *AM* 4 (1781): 35-40, 94-97, 148-52, 195-98, 256-59, 309-11, 372-75.

[Lefevre, Mrs.]. *Letters upon Sacred Subjects, by a person lately deceased.* London: n.p., 1757.

Moore, Henry. *The Life of Mrs. Mary Fletcher, Consort and Relict of the Rev. John Fletcher, Vicar of Madeley, Salop: Compiled from her Journal and Other Authentic Documents.* 6th ed. London: J. Kershaw, 1824.

Pipe, John. "Memoir of Miss Isabella Wilson." *WMM* 31 (1808): 372-75, 410-15, 461-69, 516-18, 562-67, 595-97.

Ripley, Dorothy. *An Account of the Extraordinary Conversion, and Religious Experience, of Dorothy Ripley.* 2d ed. London: Printed for the authoress, by Darton, Harvey, 1817.

———. *The Bank of Faith and Works United.* 2d ed. Whitby: Printed for the authoress, by G. Clark, 1822.

Rogers, Hester Ann. *An Account of the Experience of Hester Ann Rogers.* New York: Hunt & Eaton, 1893.

Seckerson, Anthony. "An Account of Mrs. Dobinson." *WMM* 26 (1803): 557-66.

Smyth, Edward. *The Extraordinary Life and Christian Experience of Margaret Davidson, as Dictated by Herself.* Dublin: Dugdale, 1782.

Stokes, Mary. "The Experience of Miss Mary Stokes, in a Letter to Mr. Tho[mas] Rankin." *AM* 18 (1795): 99-101.

Sutcliffe, Joseph. *The Experience of the late Mrs. Frances Pawson, Widow of the late Rev. John Pawson.* London: Printed at the Conference Office, by Thomas Cordeux, 1813.

Taft, Mary. *Memoirs of the Life of Mrs. Mary Taft; Formerly Miss Barritt.* 2d ed., 2 vols., enlarged. York: Printed for and sold by the author, 1828; Devon: Published and sold by S. Thorpe, 1831.

Taft, Zechariah. *Biographical Sketches of the Lives and Public Ministry of Various Holy Women.* 2 vols. London: Published for the author, and sold by Kershaw, 1825; Leeds: Printed for the author and sold by Stephens, 1828.

———. *The Scripture Doctrine of Women's Preaching: Stated and Examined.* York: Printed for the author, by R. & J. Richardson, 1820.

———. *Thoughts on Female Preaching.* Dover: Printed for the author, 1803.

Wallace, Charles, Jr., ed. *Susanna Wesley: The Complete Writings.* New York: Oxford University Press, 1997.

Wesley, John. *An Extract of Letters by Mrs. L——.* London: n.p., 1769.

———. *Letters Wrote by Jane Cooper: To which is Prefixt, some Account of Her Life and Death.* London: Strahan, 1764.

[Wesley, John]. *A Short Account of the Death of Mary Langs[t]on, Of Taxall, in Cheshire; Who died January the 29th, 1769*. London: R. Hawes, 1775.

2. Books

Albin, Thomas R. *Full Salvation: A Descriptive Analysis of the Diary of Anna Reynalds of Truro, 1775–1840*. Cornish Historical Association Occasional Publication no. 17. St. Columb, Cornwall: J. Edyvean & Son, Printers, 1981.

Barker-Benfield, G. J. *The Culture of Sensibility: Sex and Society in Eighteenth-Century Britain*. Chicago: University of Chicago Press, 1992.

Beddoe, Deirdre. *Discovering Women's History: A Practical Manual*. London: Pandora, 1983.

Bentock, Shari, ed. *The Private Self: Theory and Practice of Women's Autobiographical Writings*. Chapel Hill: University of North Carolina Press, 1988.

Brown, Earl Kent. *Women of Mr. Wesley's Methodism*. New York: Edwin Mellen Press, 1983.

Carroll, Berenice A., ed. *Liberating Women's History: Theoretical and Critical Essays*. Urbana: University of Illinois Press, 1976.

Chilcote, Paul Wesley. *John Wesley and the Women Preachers of Early Methodism*. Metuchen, N.J.: Scarecrow Press, 1991.

Chilcote, Paul W. *She Offered Them Christ*. Nashville: Abingdon Press, 1993.

Church, Leslie F. *The Early Methodist People*. London: Epworth Press, 1948.

———. *More About the Early Methodist People*. London: Epworth Press, 1949.

Cline, Cheryl. *Women's Diaries, Journals, and Letters: An Annotated Bibliography*. New York: Garland, 1989.

Collins, Vicki. "Perfecting a Woman's Life: Methodist Rhetoric and Politics in *The Account of Hester Ann Rogers*." Ph.D. diss., Auburn University, 1993.

Crookshank, C. H. *Memorable Women of Irish Methodism in the Last Century*. London: Wesleyan-Methodist Book-Room, 1882.

Cunningham, Valentine. *Everywhere Spoken Against: Dissent in the Victorian Novel*. Oxford: Clarendon Press, 1975.

Davies, Rupert and E. Gordon Rupp, eds. *A History of the Methodist Church in Great Britain.* 4 vols. London: Epworth Press, 1965–1988.

Eltscher, Susan M., ed. *Women in the Wesleyan and United Methodist Traditions: A Bibliography.* Madison, N.J.: General Commission on Archives and History, 1992.

Fritz, Paul and Richard Morton, eds. *Women in the Eighteenth Century and Other Essays.* Toronto: Samuel Stevens Hakkert, 1976.

Heilbrun, Carolyn. *Writing a Woman's Life.* New York: W. W. Norton, 1988.

Heitzenrater, Richard P. *Wesley and the People Called Methodists.* Nashville: Abingdon Press, 1995.

Hill, Bridget, ed. *Eighteenth-Century Women: An Anthology.* London: Allen and Unwin, 1984.

Jelinek, Estelle C., ed. *Women's Autobiography: Essays in Criticism.* Bloomington: Indiana University Press, 1980.

Johnson, Dale A., ed. *Women in English Religion, 1700–1925.* New York: Edwin Mellen, 1983.

Johnson, Dale A. *Women and Religion in Britain and Ireland: An Annotated Bibliography from the Reformation to 1993.* Lanham, Md.: Scarecrow Press, 1995.

Jones, Vivien, ed. *Women in the Eighteenth Century.* London: Routledge, 1990.

Kanner, Barbara, ed. *The Women of England from Anglo-Saxon Times to the Present: Interpretive Bibliographical Essays.* London: Mansell, 1980.

Keeling, Annie E. *Eminent Methodist Women.* London: Charles H. Kelly, 1889.

Keller, Rosemary Skinner, ed. *Spirituality and Social Responsibility: The Vocational Vision of Women in the United Methodist Tradition.* Nashville: Abingdon Press, 1993.

Lloyd, Gareth. *Sources for Women's Studies in the Methodist Archives.* Manchester: John Rylands Library, 1996.

McClendon, James Wm., Jr. *Biography as Theology.* Nashville: Abingdon Press, 1974.

Maddox, Randy L. *Responsible Grace: John Wesley's Practical Theology.* Nashville: Kingswood Books, 1994.

Malmgreen, Gail. *Religion in the Lives of English Women, 1760–1930.* Bloomington: Indiana University Press, 1986.

Matthews, William, comp. *British Autobiographies: An Annotated Bibliography of British Autobiographies Published or Written Before 1951.* Berkeley: University of California Press, 1955.

Morrow, Thomas M. *Early Methodist Women.* London: Epworth Press, 1967.

Newton, John. *Susanna Wesley and the Puritan Tradition in Methodism.* London: Epworth Press, 1968.

Nussbaum, Felicity. *The Autobiographical Subject: Gender and Ideology in Eighteenth-Century England.* Baltimore: Johns Hopkins University Press, 1990.

Obelkevich, Jim, ed. *Disciplines of Faith: Studies in Religion, Politics, and Patriarchy.* London: Routledge & Kegan Paul, 1987.

O'Malley, Ida B. *Women in Subjection: A Study of the Lives of English Women before 1832.* London: Duckworth, 1933.

Phillips, Margaret and W. S. Tomkinson. *English Women in Life and Letters.* New York: Oxford University Press, 1927.

Rowbotham, Sheila. *Hidden From History: Rediscovering Women in History from the Seventeenth Century to the Present.* New York: Pantheon Books, 1974.

Rowe, Kenneth E. *Methodist Women: A Guide to the Literature.* Lake Junaluska, N.C.: General Commission on Archives and History, 1980.

Stevens, Abel. *The Women of Methodism: Its Three Foundresses—Susanna Wesley, the Countess of Huntingdon, and Barbara Heck.* New York: Carlton & Porter, 1886.

Thomas, Hilah F. and Rosemary Skinner Keller, eds. *Women in New Worlds: Historical Perspectives on the Wesleyan Tradition.* 2 vols. Nashville: Abingdon Press, 1981–1982.

Todd, Janet. *Sensibility: An Introduction.* London: Methuen, 1986.

3. Chapters and Articles

Baker, Frank. "John Wesley and Sarah Crosby." *PWHS* 27.4 (December 1949): 76-82.

———. "Salute to Susanna." *MethH* 7.3 (April 1969): 3-12.

Bates, E. Ralph. "Sarah Ryan and Kingswood School." *PWHS* 38.4 (May 1972): 110-14.

Beckerlegge, Oliver A. "Women Itinerant Preachers." *PWHS* 30.8 (December 1956): 182-84.

Boulton, David J. "Women and Early Methodism." *PWHS* 43 (1981): 13-17.

Brown, Earl Kent. "Standing in the Shadow: Women in Early Methodism." *Nexus* 17.2 (1974): 22-31.

Chilcote, Paul W. "The Blessed Way of Holiness." *Journal of Theology* 100 (1996): 29-51.

———. "An Early Methodist Community of Women." *Church History* 38 (2000): 219-30.

———. "John Wesley as Revealed by the Journal of Hester Ann Rogers." *MethH* 20.3 (April 1982): 111-23.

———. "Sanctification as Lived by Women in Early Methodism." *MethH* 34.2 (January 1996): 90-103.

———. "Songs of the Heart: Hymn Allusions in the Writings of Early Methodist Women." *Proceedings of the Charles Wesley Society* 5 (1998): 99-114.

"Dorothy Ripley, Unaccredited Missionary." *Journal of the Friends Historical Society* 22 (1925): 33-51; 23 (1926): 12-21, 77-79.

Harrison, A. W. "An Early Woman Preacher: Sarah Crosby." *PWHS* 14.5 (March 1924): 104-9.

Hellier, J. E. "Some Methodist Women Preachers." *Methodist Recorder*, no. 36 (Christmas 1895): 67.

Jones, Margaret. "Whose Characterisation? Which Perfection? Women's History and Christian Reflection." *Epworth Review* 20.2 (1993): 96-103.

McDermid, Jane. "Conservative Feminism and Female Education in the Eighteenth Century." *History of Education* 18 (1989): 309-22.

Malin, Susan J. "Jane Cooper: A Pattern of All Holiness." First Prize, John Ness Award, General Commission on Archives and History of the United Methodist Church, 1995.

Mounfield, Arthur. "Dorothy Ripley." *PWHS* 7.2 (June 1909): 31-33.

Parlby, William. "Diana Thomas, of Kington, lay Preacher in the Hereford Circuit, 1759–1821." *PWHS* 14.5 (March 1924): 110-11.

Rosen, Beth. "The Invisible Woman: The Historian as Professional Magician." In *Liberating Women's History: Theoretical and Critical Essays*, edited by Berenice A. Carroll. Urbana: University of Illinois Press, 1976.

Rosen, Ruth. "Sexism in History or, Writing Women's History Is a Tricky Business." *Journal of Marriage and the Family* 33 (1971): 541-44.

Smith, C. Ryder. "The Ministry of Women." In *Methodism: Its Present Responsibilities*. London: Epworth Press, 1929.

Spacks, Patricia Meyer. "Female Rhetorics." In *The Private Self: Theory and Practice of Women's Autobiographical Writings*, edited by Shari Bentock. Chapel Hill: University of North Carolina Press, 1988.

Swift, Wesley F. "The Women Itinerant Preachers of Early Methodism." *PWHS* 28.5 (March 1952): 89-94; 29.4 (December 1953): 76-83.

Waller, Dr. "A Famous Lady Preacher." *WMM* 130 (1907): 538-44.

Index of Names and Places